# Collecting and Using Classic SLRs

# Collecting and Using Classic SLRs

Ivor Matanle

*With 385 photographs*

Thames and Hudson

*For my wife and family, whose forbearance and good humour have been as essential as their images to the production of this book.*

Except where otherwise stated in the captions, all photographs are by the author.

Designed by Ben Cracknell

British Library Cataloguing-in-Publication Data

A catalogue record for this book is available from the British Library

ISBN 0-500-27901-2

Printed and bound in Spain by Artes Graficas Toledo S.A.
D.L.TO:346-1996

# Contents

# Foreword

In 1984, when I wrote the text and produced the photographs for *Collecting and Using Classic Cameras*, I had a head start. I began the task with some fifty per cent of all the pictures of cameras already in my negative files and perhaps a third of all the pictures taken with the classic cameras already to hand. I produced that book almost entirely in isolation, helped only by Colin Glanfield, Ricky Hood and Tony Hurst who provided pictures of some cameras that I had neither managed to obtain nor photograph.

When I began this book, it was with only around five per cent of the necessary pictures of classic SLRs already to hand. I had, perhaps, something like a tenth of the pictures taken with the cameras that the book would require. Much more original photography was therefore needed and that in turn meant that I needed to lay hands on a large number of cameras. Although I had at one time or another owned and used a very large proportion of the SLRs required, I had also, through regrettable economic necessity, sold most of them again.

I therefore had only a very modest collection. Obviously, I bought quite a few cameras that I needed to use or photograph as I went along, but could not possibly have had access to the immense range of cameras and lenses that the book required without the help of a small army of extraordinarily trusting and helpful friends.

I found that army in the Photographic Collectors Club of Great Britain (PCCGB). At the many camera fairs and collectors' meetings that the Club either organizes or encourages, I was offered help in abundance. Officers of the Club, dozens of its members all over Britain, stallholders at camera fairs and many enthusiasts who simply wanted to assist allowed me to borrow equipment, use it, photograph it and, in some cases, keep it for months until its potential had been at least realized to an acceptable degree. Some of those friends I had, of course, known for years. Others were new to me, but had clearly derived something from my earlier book and wanted to help.

Although I had been a member of the PCCGB for some time, it was the common goal of making this book successful that created and bonded friendships and made me realize just how valuable and rewarding membership of such a national, and indeed international, collectors' organization can be. I would urge all my readers to join either the PCCGB or another of the collectors' organizations listed in Appendix 4 at the end of this book.

To acknowledge everybody's help individually is almost impossible and in some ways invidious. Indeed, some collectors who helped enormously have asked me for security reasons not to mention their names as owning equipment which I have photographed. This is why quite a few beautiful cameras which I should love to own but do not are not credited to their owners in the captions. However, I should like to thank particularly Malcolm and Beryl Glanfield, Dave and Julie Todd, Doug Crawley and Bob and Margaret White, who allowed me to invade their homes to photograph cameras. Special thanks are also due to Mike Rees, who volunteered to shoot a substantial number of pictures of his cameras for me, and to Don Baldwin, David Coan, Gerry Cookman, Jim Anderson, Len Corner, Bob Davey and Alan Borthwick, all of whom lent me cameras on a long-term basis. I must also thank Ian Dear for his invaluable reference material on the darker reaches of the Konica system and the inimitable Bill O'Keeffe, who, when I needed a T4 zoom lens, simply gave me one!

The many others who allowed me to photograph their cameras, often on a small portable background by available light during camera fairs, are credited in the captions to the pictures. I owe them all a great debt of gratitude.

Because most of the pictures for this book have been shot during the eighteen months or so of its production, I have been better able to provide detailed information on the cameras, lenses, films and processing used than when writing my earlier book. I therefore decided early in the writing of *Collecting and Using Classic SLRs* to make the picture captions much more informative than hitherto. I hope that this will help those new to using classic cameras to understand more of how to achieve the best results from their cameras and lenses.

I also decided to try to shoot every picture of equipment in the book with a classic SLR, rather than, as previously, with whatever professional camera

I was using at the time. The results have been that I have used a considerable variety of classic SLRs for the photography of cameras and that a much larger proportion of the photographs of equipment in this book have been taken using 35mm cameras than was the case with *Collecting and Using Classic Cameras*. As anyone who has tried it will know, photographing old cameras is not always easy. I have been pleasantly surprised by the quality which many of the quite modest SLRs of the fifties and sixties can produce when used for this demanding work. One never stops learning.

Those who have encountered *Collecting and Using Classic Cameras* will also realize that this book spans a period of almost a century of SLRs, whereas my earlier tome covered only the (approximately) fifty years from the advent of the Leica to the demise of the Contarex. This is partly because the SLR, more than any other class of camera, has been a significant factor in both amateur and professional photography throughout the twentieth century, and partly because enthusiasts to whom both I and the publishers have talked seemed to want a book which covered a greater period.

The result of the longer time-span is, inevitably, a longer book. In fact, I found while writing about classic SLRs that this is a subject apparently capable of infinite growth. I have tried to introduce some mention of every significant SLR into the text, but must emphasize here, as I do in the book itself, that *Collecting and Using Classic SLRs* is not intended as a definitive history nor as an encyclopaedia. It is a book about collecting and using the SLRs of the classic age of cameras, with the emphasis on their capacity for use. I know that there are many SLRs which could have been illustrated and are not. I also know that it would not be difficult to write another couple of chapters on rare and unusual cameras, or to expand the book dramatically by writing separate chapters on Topcon, Olympus, Minolta, Konica and many others. I have, I fully realize, totally failed to mention some cameras. If this offends any reader, I apologize for causing disquiet, but not necessarily for leaving the cameras out.

The key point is that this is a very personal book. It represents my views, my experience and, to some extent, my interests. Others might write the book differently, hold different views, enjoy using different cameras. But that is the joy of collecting and using classic cameras. It is why people buy them, use them, tire of them and (sometimes) sell them again. It is why there is a specialist collectors' group for almost every major type and marque of SLR. This book pleases me, and I hope it pleases you.

*Ivor Matanle*

# Chapter 1

# The ugly duckling that became a swan

It is easy to forget that, only four decades ago, the single-lens reflex was considered an odd choice for general photography. Not only was it not then known as an SLR, but it was also regarded by most amateurs and by virtually all professionals as being slow to use, heavy to carry and too complicated for its own good.

There were, in fact, few regular professional users of single-lens reflex cameras in the mid-fifties. Some portrait photographers were still using their venerable Soho, Thornton-Pickard or Graflex reflexes of the twenties and thirties, although most had moved to the simpler, faster and more reliable twin-lens Rolleiflex. Many scientific photographers used Leica equipment, others the versatile 35mm Exakta SLR system. Adventurous laboratory photographers were taking an interest in the rival Alpa single-lens reflex system from Switzerland, whose models 4, 5 and 7 had appeared more or less simultaneously during 1952.

For amateur photographers the high price of SLRs inhibited European sales at a time of comparative austerity after the Second World War. In Britain, import controls prevented amateurs buying expensive new cameras until 1960. These controls kept second-hand prices high and limited ownership of expensive cameras to professionals and wealthy amateurs.

But, above all, it was the perception of the SLR as being slow and clumsy to use which made SLRs a minority interest among amateur photographers. Accepted photographic technique and fashions in the presentation of visual ideas were orientated to the standard lens, as a glance through a photographic magazine of the period will show. There was little penalty to the amateur's standing in being seen to use a fixed-lens camera. The principal benefit of the SLR – the ability to change lenses and see the picture as it would be taken, complete with depth of field – was unimportant to the majority of photographers. Those young enough not to be prejudiced about SLR speed, weight and handling did not usually have the money to buy such an expensive camera.

## How it all began

The invention of the single-lens reflex came and went largely unnoticed. In 1861, Thomas Sutton, the editor of *Photographic Notes*, patented the fundamental design, but the time was not right. It was not until the coming of the dry plate in the 1880s that the market for cameras suddenly grew and production of a single-lens reflex camera became a practical possibility.

There is continued debate among photographic historians about which was the first single-lens reflex to be marketed. However, one of the first SLRs to be manufactured in quantity was the American Patent Monocular Duplex of 1884. From then on new designs emerged on both sides of the Atlantic with gathering pace. The Shew Reflector, launched in London in 1897, was just preceded by another London-made camera, Loman's single-lens reflex from Hinton and Company, announced in 1896. In 1898, Goltz and Breutmann of Berlin and Dresden announced the Mentor Reflex, which established a style to be copied and adapted by many manufacturers. Essentially cubic in shape when closed, the viewing hood unfolded from the top, the lens board racked forward from the front on bellows (usually – some did not have the bellows) and the camera had a revolving back to simplify the taking of vertical or horizontal pictures. By 1899, the Shew Popular Reflector had a flexible-blind shutter, mounted in front of the lens, and in 1902, J.F. Shew and Company produced their Focal Plane Reflector, possibly the first SLR with a focal-plane shutter.

In the age of the folding Kodak and the hand-and-stand camera, the major disadvantages of the SLR were size and clumsiness. A $\frac{1}{4}$-plate single-lens reflex lacks the point-and-shoot capability of a 1A folding Kodak. Carrying $\frac{1}{4}$-plate slides loaded with glass-negative material tended to reduce mobility and increase irritability in all but the most resolute. Manufacturers therefore sought to reduce the size and weight of single-lens reflexes. In 1907, the Folmer Graflex Corporation of America, already marketing SLRs in the usual range of plate sizes, launched the world's first rollfilm SLRs in two sizes. The 1A Graflex used 116 film, then a popular rollfilm used by several Kodak models and many competitive cameras, to provide $2\frac{1}{2}" \times 4\frac{1}{4}"$ negatives. The 3A Graflex needed 122 'postcard' film, from which the negatives were $3\frac{1}{4}" \times 5\frac{1}{2}"$.

The Voigtländer Bijou of 1908 was reputedly the world's first 'miniature' single-lens reflex, and was

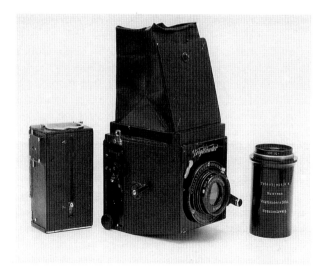

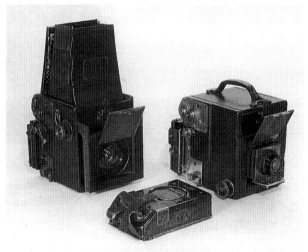

The Voigtländer Bijou, the world's first 'miniature' single-lens reflex, is rare and valuable. This example is fitted with a 10cm f/4.5 Anastigmat in a helical focusing mount. The lens alongside the camera is a 'Teleobjektiv 3', also from Voigtländer und Sohn of Braunschweig (Brunswick). This is a form of negative-converter lens which adds two elements to the standard lens to provide telephoto capability – the grandfather of the modern teleconverter. To the left of the camera is a push-pull plate magazine.

*Camera by courtesy of Paul van Hasbroeck. Shot by Colin Glanfield with Hasselblad 500CM fitted with 150mm f/4 T\* Sonnar on Ilford XP2, printed on Ilford Multigrade.*

The camera on the left is a 3¼" × 2¼" Auto Graflex Junior made in about 1917 and fitted with a 4" f/4.5 Anastigmat. That on the right is a Graflex Series B made in 1925 or 1926, with a 120mm f/4.5 Tessar. In front of the cameras is a Graflex cut-film magazine.

*Equipment by courtesy of Malcolm Glanfield. Shot with Topcon RE-2 fitted with 58mm f/1.8 RE-Topcor on Ilford Pan F Plus, developed in Aculux and printed on Ilford Bromide.*

designed to use the newly available 'vest pocket' (VP) plate size, 45mm × 60mm. Although this was approximately the same image size as that of the 127 rollfilm used in the tiny and pocketable 1912 folding Vest Pocket Kodak (not of course an SLR), it did not endow the Voigtländer Bijou with a similar degree of pocketability, mainly because the Bijou was an SLR and used plates. Although very small plates, they still imposed on the user the need to carry separate plate holders.

In 1907 (in the USA) and in 1910 (in Britain), Eastman brought its Kodak concept of low price and simple use to the SLR with the launch of the Premograph, described as 'A perfect reflecting camera for only Ten Dollars'. This used ¼-plate film packs, lighter and more convenient than glass plates but (of course) no longer available. The Premograph was, as far as I can determine, the first SLR in which the same control, in this case a small key, was used to set the mirror down for focusing and (by operating it in the other direction) to get the mirror up and fire the shutter.

Between the advent of the First World War and the mid-thirties, a succession of large-format SLRs was

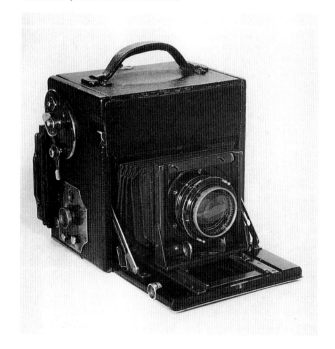

A postcard-format Compact Graflex of about 1920. This was fitted with a self-capping focal-plane shutter which was (as the name suggests) compact, but which was also sadly unreliable.

*Camera by courtesy of Malcolm Glanfield. Shot with Topcon RE-2 fitted with 58mm f/1.8 RE-Topcor on Ilford Pan F Plus, developed in Aculux and printed on Ilford Bromide.*

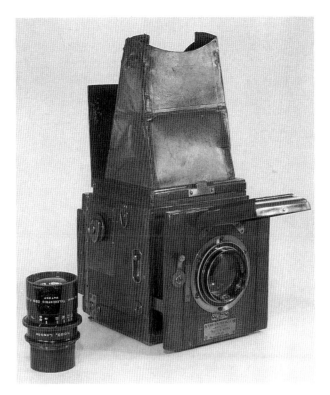

Notable examples made in Britain were the Thornton-Pickard Ruby Reflex series from 1920 onwards, the simple but effective Butcher Reflex Carbine announced during 1922 and the $2\frac{1}{2}'' \times 3\frac{1}{2}''$ Newman and Guardia Reflex, which was first manufactured in 1921 and was still being made as late as 1957. Marion & Co.'s Soho Reflexes were among the highest-quality British single-lens reflexes of the wood-and-brass era and a tropical Soho Reflex is a thing of beauty in its own right with polished teak set off by lacquered brass fittings.

From Germany came the Mentor Reflexes of Goltz and Breutmann, one of the longest-lived of all camera series, since cameras essentially similar in character to the Mentor Reflex first made in 1898 were still on sale in the 1960s. Their Mentor Compur Reflex of 1928, as the name suggests, was fitted with a Compur between-lens shutter. Because the shutter, unlike most of the focal-plane shutters in other single-lens reflexes of the period, is extremely reliable and eminently repairable if anything does go wrong, this is, with a suitable

There was a great vogue during the first quarter of the twentieth century for brass-bound teak 'tropical' cameras. Intended to overcome problems of rot and insect attack on conventionally built cameras in tropical conditions. Most tropical cameras rarely saw a tropic but were stylish expensive equipment for those who valued their own image as much as those they put on film. This is a ¼-plate Ensign Popular Reflex, Tropical Model, fitted with a 6¼" f/3.5 Cooke – various standard lenses were available for the camera, as there were for most plate reflexes of the period. Beside it is a 13" f/6.8 Ross Telecentric lens. This camera takes Sanderson slides, and it is not too difficult to find a rollfilm holder to fit it, making it extremely usable provided that the shutter is in good running order.

*Camera by courtesy of Malcolm Glanfield. Shot with Topcon RE-2 fitted with 58mm f/1.8 RE-Topcor on Ilford Pan F Plus, developed in Aculux and printed on Ilford Bromide.*

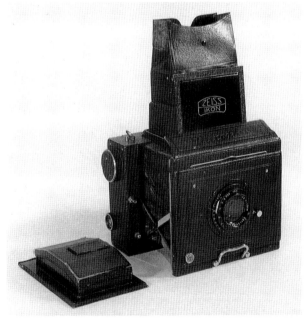

The Zeiss Miroflex was available in several formats (see page 13) and was a popular SLR which doubled as a press camera. This example is a 9cm × 12cm (¼-plate) and is fitted with a 15cm f/4.5 Triotar. The rollfilm holder beside the camera enables it to produce eight exposures 3¼" × 2¼" on readily available 120 film.

*Camera by courtesy of Malcolm Glanfield. Shot with Topcon RE-2 fitted with 58mm f/1.8 RE-Topcor on Ilford Pan F Plus, developed in Aculux and printed on Ilford Bromide.*

made available by manufacturers in the USA, Britain, Germany and elsewhere. This book does not set out to be a complete catalogue. Since most of these cameras were very similar in concept, it is a reasonable generalization that the degree to which any of them can be used many decades after their manufacture depends on whether they still work and whether means can be found to put film where it needs to be to take a photograph. Achieving that tends to be reliant upon the camera having, or being able to be fitted with, a rollfilm holder, or being of 5" × 4" format, for which cut film is easily obtainable.

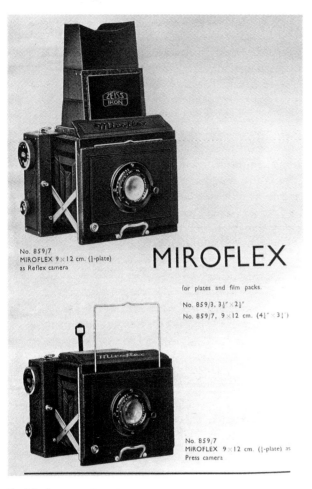

The Miroflex pages from the Zeiss catalogue of about 1930 – I do not have the exact date since I made half-frame copy negs of this catalogue, which belonged to somebody else, with a half-frame Alpa 10s in the mid-seventies and did not keep details. Note how the catalogue emphasizes the ability of the Miroflex to be used either as a single-lens reflex or as a conventional press camera.

*Shot with Alpa 10s half-frame during the seventies on Ilford Pan F, printed on Ilford Bromide.*

rollfilm holder, one of the most usable of the SLRs of the period.

There were, of course, many other German single-lens reflexes during this classic period of the large-format SLR. The Ica folding reflexes were, when collapsed, flatter than anything else available and were much appreciated by travellers.

The Ernemann Folding Reflex (or Klapp Reflex), produced between 1924 and 1926, was a magnificent triple-extension camera with an intermediate front which opened to the infinity position on a trellis strut when the camera was opened. Further extension of the bellows for closer focusing was then achieved as with a field camera, the lens standard moving out on an extendible rail bed. Its cousin, the Ernoflex, lacked the baseboard and the triple extension, but was lighter and somewhat less complex, and had been preceded by an earlier Ernoflex Folding Reflex in 1914. Confusingly, this one did have a drop bed and rack focusing.

From the same stable came the Miniature Ernoflex (also known as the Miniature Klapp-Reflex) of 1925. This has the distinction of being one of the smallest folding SLR cameras ever made and used 'miniature' 4.5cm × 6cm VP plates. It is downright rare and can fetch as much as £1,000 ($1,500) when one makes an appearance on the market.

One of the first 'available light' single-lens reflex cameras was Ernemann's Ermanox Reflex of 1926, a

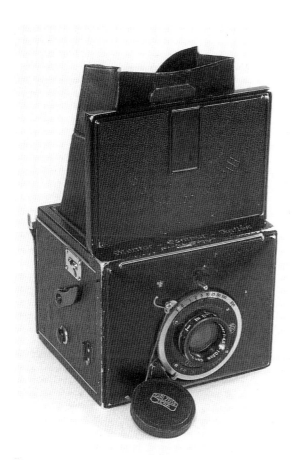

camera designed for Vest Pocket plates and equipped with a most impressively large 105mm f/1.8 Ernostar lens in a helical focusing mount. This mighty beast is also a major collectible, and anybody who spends enough to acquire one is usually too afraid of damaging it to risk trying to use it.

The Zeiss Miroflex of 1927 was available in two versions, one for 9cm × 12cm, the Miroflex B, while the other, smaller and less common, produced negatives 6.5cm × 9cm and was known as the Miroflex A. The latter, because it is more compact and produces negatives of a size compatible with modern enlarger carriers and equipment used by amateurs, is the more desirable if you intend using it.

In the USA, the Graflex series produced many variants which were among the most successful SLRs of the period in terms of sales. The revolving-back R.B. Graflex series, which began with the 5" × 4" Revolving Back Auto Graflex of 1906 to 1941, evolved through the Series B with either stationary or revolving back, the Series C of 1926 to 1935 and the Series D of 1928 to 1947 (in 5" × 4" form – the ¼-plate version was phased out in 1941). The line culminated with the R.B. Graflex Super D which had flash synchronization of its focal-plane shutter and an automatic stop-down diaphragm. This magnificently specified monster stayed in production until 1963 in its ¼-plate form.

The Mentor Compur Reflex of about 1930 was compact and easy to use because of the Compur shutter. It functions much like a modern Hasselblad, the shutter staying open for focusing. When the lever to the right of the camera body is pressed, the shutter closes, the mirror (which serves as a back shutter to protect the plate or film) rises and then the shutter fires at the preset speed. Since Compur shutters of the early thirties are inherently reliable, examples of this camera are readily usable given an appropriate rollfilm holder, although I have found it difficult to hold steady.

*Camera by courtesy of Malcolm Glanfield. Shot with Topcon RE-2 fitted with 58mm f/1.8 RE-Topcor on Ilford Pan F Plus, developed in Aculux and printed on Ilford Bromide.*

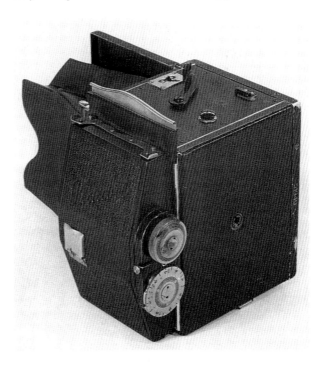

The underside and back of the Mentor Compur Reflex, in this case fitted with a Plaubel rollfilm holder. The upper knob is used to wind the film, after the lever has been pressed to free the point at the end of the arm from the detent in the counter. When the appropriate length of film has been wound, the point drops into the next notch to provide a positive end to the winding of one exposure. This works surprisingly well to space exposures without recourse to red windows and the numbers on the film backing paper.

*Camera by courtesy of Malcolm Glanfield. Shot with Topcon RE-2 fitted with 58mm f/1.8 RE-Topcor on Ilford Pan F Plus, developed in Aculux and printed on Ilford Bromide.*

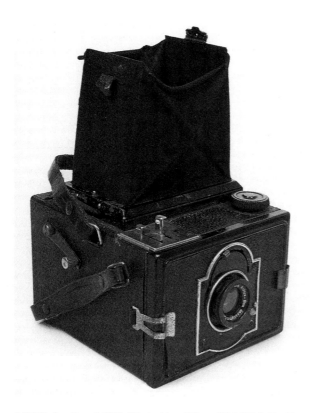

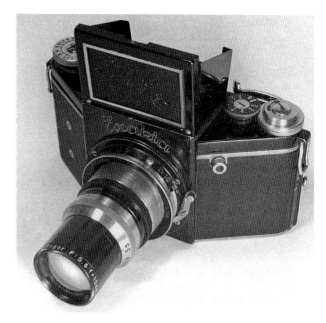

The VP Exakta B, here fitted with a 15cm f/5.5 Tele-Megor, was a major landmark in the development of the SLR. This example has lever-wind, so dates from about 1935.

*Camera by courtesy of Dr A. Neill Wright. Shot during 1970s – no data on which camera and lens were used.*

A KW Reflex-Box of 1933, fitted with a 105mm f/6.3 KW Reflex-Box Anastigmat. Although a very simple camera with shutter speeds of 1/25th, 1/50th and 1/100th, the KW Reflex-Box is a true reflex camera with apertures of f/6.3, f/8, f/11 and f/16 plus helical focusing from 2 metres to infinity. This one looks scruffy, its owner not having had the chance to clean it up before lending it to me for this book – but it works.

*Camera by courtesy of Don Baldwin. Shot with Minolta SRT101 fitted with 45mm f/2 Rokkor on Ilford Pan F Plus, developed in Aculux and printed on Ilford Bromide.*

## The advent of the true miniature SLR

By the early thirties, photography, particularly amateur photography, was undergoing a dramatic change. The Leica had not only proved from 1926 onwards that small negatives could produce big pictures, but had also shown the camera industry that the public liked the idea. In 1932, Zeiss Ikon produced the Contax, the first really comparable competitor for the Leica. In 1934, the Retina folding 35mm compact camera appeared. Many other small folding 35mm or small-format rollfilm 'miniature' cameras followed. None of these were reflexes, but they were so successful that, within a year or two, a large proportion of the amateur camera-buying public wanted miniature cameras.

Small negatives brought to SLRs the benefits of small mirrors, less mass and higher-speed mirror lift. Smaller negatives also meant smaller focal-plane shutters, less shutter noise and the possibility of greater blind-traverse speeds. The physical effort needed to raise the mirror and fire the shutter was greatly reduced, and pictures could be shot more quickly. Suddenly, there was the potential for an SLR capable of action photography, or even of being carried in the pocket.

The first sign of these benefits being realized was the advent of the Exakta series of cameras in 1933. These established for the first time the fundamental 'SLR shape' which continued through to the late eighties, when the fashion for cameras shaped like squashed doughnuts with handles on the side finally ended the reign of a shape fundamentally common to Nikon, Pentax, Olympus, Minolta, Leicaflex and Canon, among many others.

VP Exakta cameras all provided eight exposures 4.5cm × 6cm on 127 film and handled much like a modern manual SLR, with a single button which, when pressed, raised the mirror and triggered the shutter. With a series of interchangeable lenses

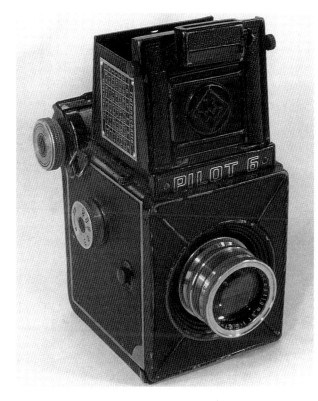

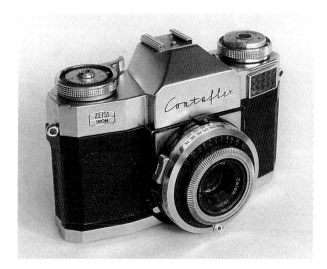

The comparatively scarce Contaflex Prima of 1959 is, like all the post-war Contaflex cameras, a leaf-shutter SLR with a Synchro-Compur shutter speeded 1 second to 1/500th second. There were, put simply, three groups of Contaflex SLRs – the initial models (I, II) with non-interchangeable 45mm f/2.8 Tessar, the budget-priced models (Alpha, Beta, Prima) with interchangeable 45mm f/2.8 Tessar, and a longer series of evolving models (III, Rapid, Super, Super B, Super BC, S) with 50mm f/2.8 Tessar.

*Shot with Pentax S1a fitted with 55mm f/1.8 Super-Takumar on Ilford Pan F Plus, developed in Aculux and printed on Ilford Multigrade III.*

The KW Pilot 6 was, like many KW cameras, a modestly priced, simply engineered camera which nonetheless delivered results comparable with more expensive cameras of its day. With the much more expensive and sophisticated Primarflex, also of 1936, it pioneered the box-shaped rollfilm reflex design which is familiar to us from such post-war cameras as the Kowa 6, Komaflex, Bronica and Hasselblad. This particular Pilot 6 is a late model of 1938 or 1939 with interchangeable 75mm f/2.9 Pilotar.

*Camera by courtesy of Malcolm Glanfield. Shot with Topcon RE-2 fitted with 58mm f/1.8 RE-Topcor on Ilford Pan F Plus, developed in Aculux and printed on Ilford Bromide.*

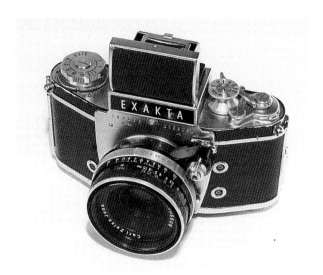

available, the VP Exakta was the first rollfilm SLR to rival (but not equal) the convenience and speed of 35mm rangefinder cameras.

By the mid-thirties, the box-shaped rollfilm SLR had been born, and the Primarflex, the Pilot reflexes and the first of the Reflex Korelle SLRs were making an impact upon both professional and amateur photography. But the hard facts are that, by comparison with twin-lens reflexes available at the same time, and even more by comparison with quality 35mm coupled-rangefinder cameras of the period, the Pilot and the Primarflex are clumsy, slow, unreliable and heavy. Even the VP Exakta faced an uphill struggle when the world's first 35mm SLR appeared.

The Exakta Varex IIa, here seen in its later version with black nameplate and the name in capital letters, is one of a long series of 35mm Exakta SLRs extending almost forty years from 1936 to the early 1970s. This camera is fitted with a 50mm f/2.8 Tessar with externally coupled fully automatic diaphragm.

*Shot with Pentax S1a fitted with 55mm f/1.8 Super-Takumar on Ilford Pan F Plus, developed in Aculux and printed on Ilford Bromide.*

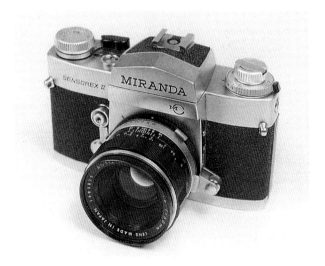

The Miranda Sensorex II is a comparatively late model in the long series of Japanese Miranda SLRs, which began in 1953 with the Miranda T and ended in the early 80s. The Sensorex II of 1971 has an open-aperture TTL CdS exposure meter, and this example is fitted with a 50mm f/1.8 Auto Miranda, the commonest Miranda standard lens of the seventies. The camera shown here is the example discussed in Chapter 2 (page 23), with which several pictures in this book were taken.

*Shot with Olympus FTL fitted with 50mm f/1.8 Zuiko Auto-S on Ilford Pan F Plus, developed in Aculux and printed on Ilford Bromide.*

## The coming of the 35mm SLR

The still smaller negative of the 35mm SLR (24mm × 36mm by comparison with 45mm × 60mm on VP film) further amplified the mechanical and design benefits of low-mass mechanisms for mirror and shutter. It again increased the potential speed and handling capability of the SLR as a type of camera.

In 1936, both Ihagee in Dresden and Gomz in the USSR launched 35mm single-lens reflexes. Ihagee, unsurprisingly, called their camera the Kine Exakta. Gomz called theirs the Sport (or Cnopm when rendered approximately from the Cyrillic). For many years, camera collectors and historians have disagreed about which came first, and the non-availability of documents and access to information in Russia and East Germany during the cold-war years made it impossible to resolve the issue. The consensus until 1994 was broadly in favour of the Sport.

However, research carried out in Britain and Germany by members of the Exakta Circle has recently made it seem likely that the Kine Exakta was launched and generally available in European markets

November 1967 advertisements in the British photographic press proclaim the Minolta SRT101 as 'new', although the camera and a full range of lenses were in the 1966 catalogue of the UK importer, Japanese Cameras Ltd, of which I have a copy. However, the heavy but effective 58mm f/1.2 MC Rokkor mounted on this example was not available in Britain until 1969, when Japanese Cameras Ltd's advertisements said that 'Each Rokkor f/1.2 is bench tested on the same SR T 101 camera with which it is to be sold'. This will sound a note of warning to perfectionists, who will fear that a 58mm f/1.2 Rokkor will not deliver adequate results unless it is matched to its original body. I have no evidence to support this – the lens illustrated was bought separately from the body to which it is fitted but focuses precisely at full aperture when used with it. Note the spacing of the 'SR T 101' camera name – Minolta tried to make this the standard presentation of the name in the late sixties and early seventies. Like most artificially presented brand names, it failed, and by the mid-seventies the camera was the SRT101 to everybody.

*Shot with Pentax S1a fitted with 55mm f/1.8 Super-Takumar on Ilford Pan F Plus, developed in Aculux and printed on Ilford Multigrade III.*

some months before the Sport. Thus, the 'round window' Kine Exakta, in any event certainly the more successful of the two cameras and the true progenitor of the 35mm SLR that we know and love, was probably also the first to be available. Research on this point continues, and nobody at the time of writing has conclusive evidence either way.

Even in 1936, the Kine Exakta boasted a flash-synchronized shutter, a feature found only on Exakta cameras at that time. Like the larger VP Exakta, it also had shutter speeds extending from 1/1000th second to 12 seconds, a range unequalled until the days of electronic shutter timing four decades and more later. It had lever-wind, which first appeared (for example) on a Leica in 1954 and on an Alpa in 1959, and was some twenty years ahead of its time.

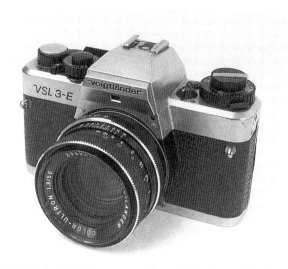

The Voigtländer VSL 3-E represents, along with the Pentax M series, the Nikon FE and FM, the Canon A series, the Minolta X series and many others, the point at which the mechanical classic SLR engineered in metal gave way to smaller electronically controlled SLRs with substantial plastics content in their construction. It was also the last of the illustrious Voigtländer line, although manufactured in Singapore rather than Germany after the merger of Voigtländer and Rollei. The 50mm f/1.8 Color-Ultron is probably identical to the 50mm f/1.8 Planar found on Singapore-made Rollei SL35 series cameras.

*Camera by courtesy of David Coan. Shot with Minolta SRT101 fitted with 45mm f/2 Rokkor on Ilford Pan F Plus, developed in Aculux and printed on Ilford Multigrade III.*

By the mid-fifties, the 35mm single-lens reflex was a realistic contender for the burgeoning post-war 35mm camera market. Preset and semi-automatic spring diaphragms overcame some of the focusing and speed problems, while the universally available pentaprism made virtually all 35mm SLRs suitable for pictures taken with the camera held vertically.

In 1954, Asahi had launched the world's first volume-produced SLR with an instant-return mirror, finally overcoming the problem of the screen which went blank after the shutter button was pressed. By the early sixties, most 35mm SLRs had instant-return mirrors, so were as fast to use and as easy to handle as a rangefinder camera.

The final factor which was to change the chrysalis of the Kine Exakta to the butterfly of the Nikon F and the Pentax SV was the contrast, quality and sheer brilliance of a new generation of lenses which emerged, principally from Japan, during the early and mid-fifties. Compare the negatives from a rangefinder Nikon with those from almost any European camera of the period and you will see higher contrast – not necessarily higher resolution, but certainly higher contrast – a quality which lends a brilliance to transparencies and prints which is irresistible. Japanese lenses of the late fifties were designed for colour, outdating many elderly European designs which, while quite capable of producing a bright and acceptable colour picture, lacked the hard, brittle contrast characteristic of the best Japanese lenses.

The beginning of the trend by which colour photography would overtake and almost eliminate black-and-white work among amateurs during the seventies before the recovery of monochrome during the eighties made it inevitable that Japanese cameras and lenses would dominate the market.

However, the great majority of people could still not afford these cameras and lenses, since the benefits of mass production had still to reduce manufacturing costs. Consequently, the growth of ownership was not as fast as might have been expected. However, by the early sixties, there was no doubt that it was a Japanese set of lenses and the slickness and handling qualities of Japanese 35mm SLRs that the discerning 35mm photographer wanted.

Only in rollfilm reflexes – the Hasselblad SLRs and the Rolleiflex TLRs, soon to be followed by the remarkable Rollei SL66 SLR – were the European manufacturers to remain pre-eminent until the eighties, although with increasingly effective competition from the Zenza Bronica series and various Kowa and Mamiya models as time went on.

This shot of a young actress, Veronica Thorp, gained me a lot of work in the mid-sixties. She sent it to an agent, who phoned me and asked me to shoot publicity pictures for all his aspirants to fame. I suspect it gained more work for me than it did for her. It was shot with the same Reflex-Korelle as the picture of the little girl on page 20, but this time fitted with a 150mm f/4 Zeiss Triotar taken from an elderly press camera and remounted into the top of an Austin 7 piston, obligingly adapted for the job by my brother-in-law. The piston was turned to fit into a BPM bellows to provide a focusing mechanism. This vignetted the 6cm × 6cm negative a little, but delivered delightfully 'plastic', slightly soft images ideal for some kinds of portraiture.

*Shot with Reflex-Korelle fitted with 150mm f/4 Triotar on Ilford FP3 with tungsten lights, exposure not recorded but the limited depth of field suggests f/4, printed on Ilford Multigrade III.*

The clock tower of the Custom House at Ramsgate has an attractive legend in flowing script advising mariners of the exact moment to set their chronometers to Greenwich Mean Time. This has been rendered clearly, although with low contrast, by the f/2.9 Pilotar of the Pilot 6 with which it was taken – the camera illustrated on page 15. The quality is not high by modern standards, but the Pilot can deliver a respectable image in the right circumstances.

*Shot with KW Pilot 6 fitted with 75mm f/2.9 Pilotar, exposure 100th at f/8, on Ilford FP4 Plus, developed in Aculux and printed on Ilford Multigrade III.*

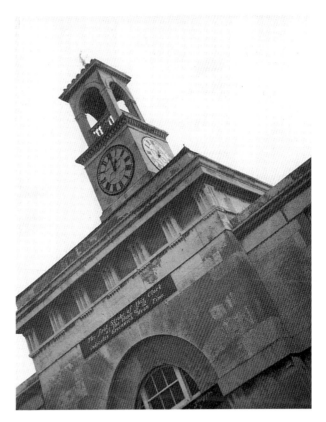

Shot from the quay at Ramsgate Harbour, Kent, with the Mentor Compur Reflex illustrated on page 13, this shot demonstrates by its static nature the principal problem which I encounter in using the old plate SLRs. This is the sheer slowness of operation which is a characteristic of all the breed – although the Mentor Compur Reflex is, because of its Compur shutter, easier and faster than most. Any subject capable of movement will usually have left by the time I get to the point of exposure with a large vintage SLR. Nonetheless, the image quality of this shot is very good and shows that a decent Mentor Compur Reflex with a rollfilm holder is a workable proposition for landscape photography or portraiture.

*Shot with Mentor Compur Reflex fitted with 105mm f/4.5 Tessar, exposure 1/100th at f/11, on Ilford FP4 Plus, developed in Aculux and printed on Ilford Multigrade III.*

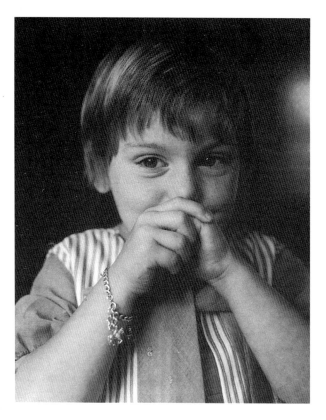

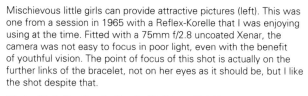

Mischievous little girls can provide attractive pictures (left). This was one from a session in 1965 with a Reflex-Korelle that I was enjoying using at the time. Fitted with a 75mm f/2.8 uncoated Xenar, the camera was not easy to focus in poor light, even with the benefit of youthful vision. The point of focus of this shot is actually on the further links of the bracelet, not on her eyes as it should be, but I like the shot despite that.

*Shot with Reflex-Korelle fitted with 75mm f/2.8 Xenar, exposure not recorded but probably about 1/50th at f/2.8, on Ilford FP3, printed on Ilford Multigrade III.*

The concentration of a little girl at war with her socks (right) makes an unusual study which I have always rather liked. It was shot during 1964 with a Praktica IV fitted with a 100mm f/2.8 Trioplan. This much-maligned lens has poor performance at full aperture, but the image sharpens up considerably at f/5.6 and f/8.

*Shot with Praktica IV fitted with 100mm f/2.8 Trioplan on Kodak Tri-X, developed in D-76. Reproduced from a print made at the time on Kodak Bromesko.*

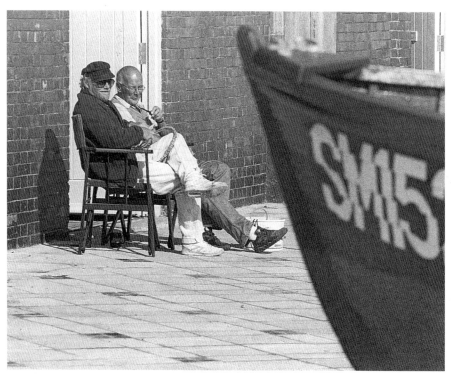

Shot from Brighton beach in the late-August sunshine in 1994, this shot uses the foreshortening effect of the long-focus lens to provide an interesting contrast of scale. The Topcon RE Super is a delightful, if heavy, camera which is a joy to use. The RE-Topcor lenses are first-class.

*Shot with Topcon RE Super fitted with 250mm f/5.6 RE-Topcor, exposure 1/500th at f/8, on Ilford HP5 Plus, developed in Aculux. Camera and lens by courtesy of Don Baldwin.*

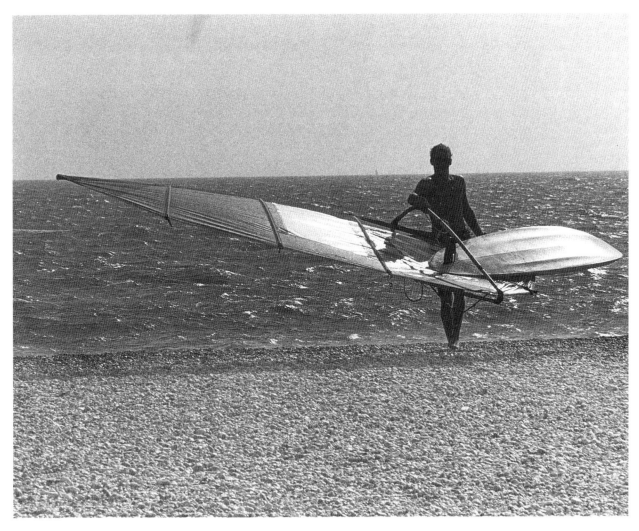

I literally turned around from shooting the last shot, walked a few steps and shot this one with the same equipment into the sun. I deliberately stopped down to throw the windsurfer into silhouette and render the bright reflections of the sun from his wet sail.

*Shot with Topcon RE Super fitted with 250mm f/5.6 RE-Topcor, exposure 1/500th at f/16, on HP5 Plus, developed in Aculux. Camera and lens by courtesy of Don Baldwin.*

I enjoyed a spell during the early eighties when I had a fairly full Contarex Cyclops (or Bullseye) outfit. Although the camera is something of an acquired taste, the Zeiss lenses are of the highest quality. This shot was taken one morning during an autumn caravan holiday.

*Shot with Contarex Cyclops fitted with 85mm f/2 Sonnar on Ilford FP4, developed in Aculux. Reproduced from a print made at the time on Kodak Bromide.*

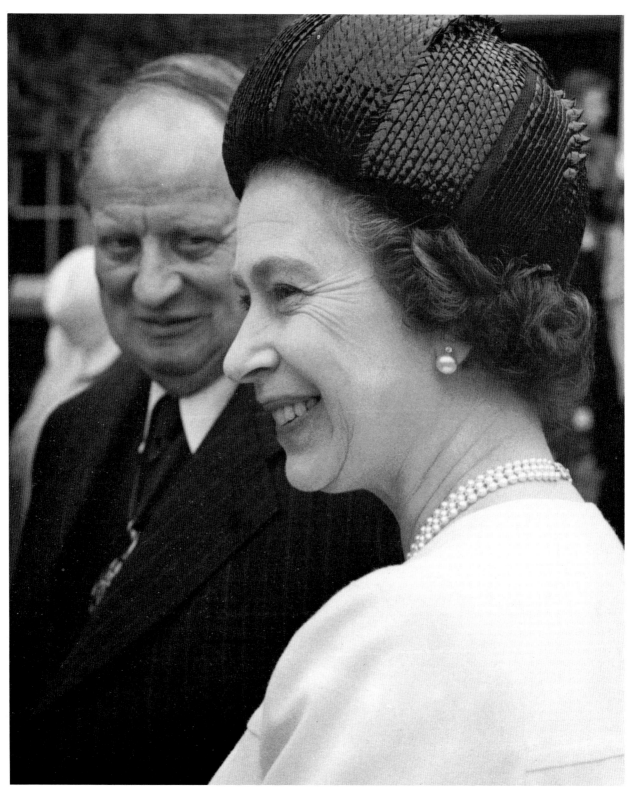

During the spring of 1979, my wife and I were part of a line-up meeting Her Majesty the Queen during a visit by her to East Sussex County Council. Councillor Gladwin, then the Chairman of the Council, introduced her to those assembled to meet her. I inadvertently demonstrated one of the benefits of the later Pentax series by having an automatic-exposure Pentax ME, a very much smaller camera than the preceding Pentax Spotmatics, in my pocket. As the Queen was introduced to the next person along the line, I produced it and shot this picture. I was not sent to the Tower.

*Shot with Pentax ME fitted with 50mm f/1.7 SMC Pentax lens, automatically set exposure, on Kodacolor. Reproduced from a colour print made by Colour Processing Laboratories, Edenbridge.*

# Chapter 2

## How to buy an SLR
## without buying a dog

Classic cameras, by their very nature, are old. Some, obviously, are older than others. Some cameras were designed for heavy professional use, some not. Some were designed well and built to last, some not.

Some types (the Nikon F, for example) are likely to have been bought and used initially by a professional photographer and therefore to have exposed thousands of films where a little-used amateur-owned camera might have exposed a dozen or two. Equally, some (e.g., the Miranda series or the Retina Reflexes) were almost certainly bought and used initially by amateur users, and will probably have had comparatively little use. The principal reason why Nikon equipment originally cost a lot more than its apparent Miranda equivalent is that it was built for a far longer MTBF (mean time between failures) and was inherently more reliable. However, that should not be interpreted to mean that buying a Nikon F as a classic camera will always result in being able to shoot more pictures before something goes wrong than buying a Miranda.

If the Nikon has had a hard professional life, it may already be past its specified MTBF while looking and sounding healthy. Nonetheless, because it is a Nikon, its reputation will go before it and the price will be high. If you buy it, and a shutter failure follows soon after, the repair will be quite expensive and your value for money will not be good in terms of shots taken per pound spent.

Although the specified life of a Nikon F was probably three times that of a Miranda, if the Miranda has been used for an average of three films a year for twenty years, it is still almost new mechanically. It will probably benefit from skilled professional cleaning and lubrication, but will be virtually unworn. Yet its reputation will also go before it, and the price will be comparatively low. If that camera then allows you to shoot a hundred films before anything goes amiss, your value for money will have been excellent – and the repair cost will probably still be a little lower than that of the Nikon repair.

I bought the Miranda Sensorex II illustrated on page 16 in virtually new condition with f/1.8 lens and ever-ready case for £40 (about $60). It sounds good, feels good and takes magnificent pictures – because, I suspect, it has been used only occasionally throughout its life. Even with quite vigorous amateur use, it will almost certainly run for years. A Nikon F in similar condition with a similar-specification lens would cost at least six times as much. Whether it would provide six times the future use depends on how it started life – contrary to popular belief, some professionals do look after cameras, have them serviced, keep them in cases and sell them looking quite smart after hundreds of films have been through them.

I hold no brief for Miranda, nor any grudge against Nikon. I have every respect for the magnificent engineering and optical qualities of everything Nikon, and share with most other classic-camera enthusiasts slight reservations about the wisdom of buying Mirandas for regular use *unless* they are obviously in little-used condition. I am simply quoting the two brands as examples, and could have drawn similar parallels between (for example) Canon and Mamiya. My point is simply that the arguments that might have led a buyer of a new camera to buy a particular brand or model in the sixties or seventies are not necessarily valid when comparing classics for potential use today.

One can only attempt to judge the condition of cameras which may have had professional use by knowing how to check an SLR, knowing something of the faults to which each main type seems to be subject in its old age and taking a view on the significance of external signs of wear and repair.

However, every camera is different in detail, and there are hundreds of different types of classic SLR. Working out exactly how to check the exposure-metering system (for example) and its functions on an unfamiliar camera is best done by reference to an instruction manual in cases where you can get hold of one, or by borrowing a book like *The Pentax Way* (or whatever is appropriate) from a public lending library or from a photographic friend. Regrettably, the present book cannot be long enough to provide full details for a total check on every type of camera. No single work could encompass fully that subject alone, never mind all the other information that must be provided.

In this chapter, I shall concentrate mainly on what can reasonably be checked in a few minutes, or, in the case of the older cameras, in an hour or so.

## The old 'uns

If you venture into the hazardous territory of buying pre-35mm large-format SLRs for use, you are to a large extent on your own. Virtually no camera-repair companies handle such cameras, and if you cannot tackle repairs yourself help may come only through a collectors' organization. There are, for example, one or two of the more venerable members of the Photographic Collectors Club of Great Britain who will sort out a large wooden camera for a modest consideration, but in their own time and only if they feel like it.

Most large-format SLRs have a cloth focal-plane shutter which may or may not be self-capping. This is the term used for a shutter whose exposure slit is closed by the first and second blinds locking together after the shutter has completed its travel, so that the slit is closed when the blinds are rewound. Non-self-capping shutters must only be wound with a lens cap covering the lens.

Early focal-plane shutters do not have shutter speeds marked on them. Instead, there is usually a graduated dial upon which slit width is set in inches or centimetres, and another tensioning control which

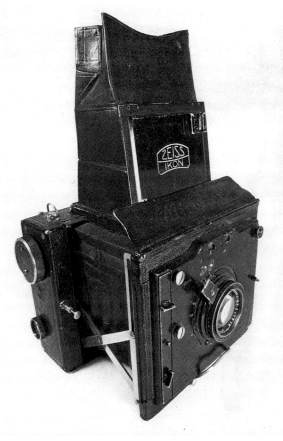

A distorted view of what constituted visual impact, possibly brought about by too much time spent in advertising creative departments, caused me in the late seventies to shoot this picture with a very wide-angle lens. This is another 9cm × 12cm format Zeiss Miroflex SLR of about 1930, in this case fitted with a 15cm f/4.5 Tessar. If you find one of these, check that the bellows are light-tight and that the shutter runs properly, at least on one speed. If it does, the chances are that the camera can be returned to full working order.

*Printed from a 35mm Kodak Plus-X negative on Ilford Bromide. No data on camera, lens or exposure*

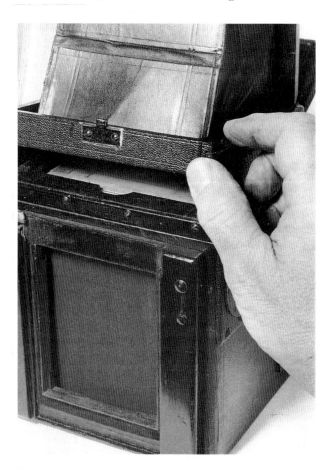

The focusing-hood assembly of early wooden single-lens reflexes is usually detachable to make cleaning possible. The ¼-plate Thornton-Pickard Junior shown here has a small catch (under the index finger) to the right of the hood frame. The whole hood lifts up and out.

*Shot with Minolta SRT101 fitted with 55mm f/1.7 MC Rokkor on Ilford Pan F Plus, developed in Aculux and printed on Jessop Variable Contrast.*

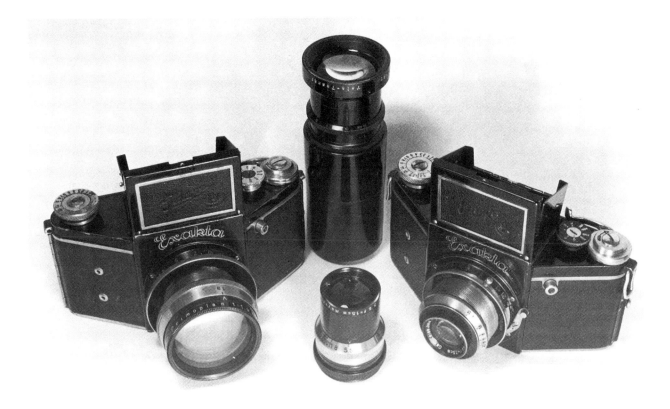

VP Exakta equipment needs to be checked with care, particularly for pinholes in the shutter blinds and for tapering or early closing of the self-capping shutter. This picture shows, on the left, a night Exakta with 80mm f/1.9 Primoplan and, on the right, a lever-wind VP Exakta B with 7.5cm f/3.5 Tessar. The lens at the front is a 15cm f/5.5 Tele-Megor, that at the back a 25cm f/6.3 Tele-Tessar.

*Cameras and lenses by courtesy of Dr A. Neill Wright. From a 35mm negative shot during the seventies, printed on Ilford Multigrade III. No data on camera, lens or exposure.*

effectively sets the speed with which the blind travels across the film aperture. A table, sometimes on the body of the camera, calculates the effective exposure time for a range of slit widths and tensions.

So far, so good. To check whether the focal-plane shutter works well (or at all), first remove whatever rear focusing screen or dark slide may be occupying the focal plane. Provided that the shutter is not jammed open (which it sometimes is), you will now be able to see the cloth of the shutter blind.

The following assumes a vertically running shutter. For a horizontally running shutter, just read 'across' for 'down' or 'up'. Remember when checking the functions of any camera, and particularly of very old ones, to apply effort very gently and smoothly, and never to use any unreasonable level of force. If it won't move, think about it and try to see a logical reason. Examples of good reasons are the presence of a shutter-release

lock, the existence of a mechanism which prevents the shutter being released unless the mirror has first been raised, and (simply) something being disconnected. If the last is the problem, trying to force a result will convert a minor problem into a major one. If you can't work it out, wait until you can ask someone who can.

With the blind visible, press the shutter release – usually a hefty lever on the right-hand side of large-format SLRs. If the shutter is wound, it should fire. If it does not, find the key or knob which, when turned, winds the blinds. Assuming that it turns without force, wind the shutter and, with your eyes on the shutter aperture, fire it and watch what happens at the end of its travel. There should be no obvious irregularity of speed of travel, and certainly no part of the shutter aperture left open when the second blind stops. If there is, then the shutter is certainly dirty, probably faulty, and definitely needs attention.

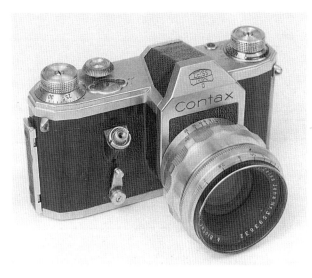

It is a source of sadness to me that the shutter of the delightful Contax S, D and F series of cameras, and their Pentacon F and FM equivalents, are rarely reliable, particularly forty or forty-five years after they were made. These cameras, particularly the later ones with automatic-diaphragm actuation which make it possible to use the automatic preset Biotar or Tessar, are a real pleasure to use and produce high-quality results. This Contax D has the alloy mount manual preset 58mm f/2 Biotar that is normal for its period.

*Camera by courtesy of Mike Rees. Shot with Pentax S1a fitted with 55mm f/1.8 Super-Takumar on Ilford Pan F Plus, developed in Aculux and printed on Ilford Bromide.*

Set the camera up on a tripod with the diaphragm wide open and the lens, ideally, pointing at a cloudy northern sky (not the sun!!). Fire the shutter and see if your eye retains an impression of the whole film-exposure frame. If it does, the shutter has completed its travel with a reasonably constant slit width, and the probability is that, at the current setting at least, the camera is capable of delivering an image.

Before trying to set different speeds, see if you can establish if and how you can set the mirror up without firing the shutter. Some cameras have provision for doing this, some don't. If there is a way, do it. Put a focusing dark cloth (or your jacket) over the camera and your head, and open the lens diaphragm wide. With the lens still pointing at a diffuse light source, move your eye around close to the cloth of the focal-plane shutter. See if you gain the impression of any points of light. If you do, the blinds are porous (or pinholed) and will probably have to be replaced before photographs can be taken.

Next, put the camera on a tripod in a room at night with the lights out. Cap the lens – if you don't have a lens cap that fits, one of those imitation-leather lens bags with a drawstring is often ideal. Open the focal-plane shutter on the time setting and once again put your head under a dark cloth while peering into the back of the camera. If you are double-jointed and fit, wave a light – a garage inspection lamp or a desk lamp will do – around on the outside of the camera while you peer inside from under the cloth. If you are clumsy and undexterous, like me, get somebody else to hold the lamp and move it around. The idea is to check whether you can see any light getting in, especially via any bellows that the camera may have, and if so where and to what extent.

Replacing a large set of bellows is very expensive, so avoid buying any large-format camera with pinholed bellows if you plan to use it. However, to be fair to collectors who might offer you cameras, it should be pointed out that the value of an elderly large-format SLR, particularly if it is a rare camera, is relatively little affected by whether or not it leaks light. Collectors tend rather to assume that nobody would be mad enough to use it, so value it as an antique. It is not particularly reasonable to try and beat the price of such a camera down because of faults which prevent it being used.

Examine the grooves into which the plate holder slides and the velvet light trapping which prevents light reaching the plate or film when the dark slide is out of the holder. It is certain to look old and worn, but needs to be complete if it is to be effective. Replacing these light traps is not a particularly difficult DIY job in principle, but can be tricky in practice with some cameras because of the inaccessibility of the surface the velvet strips adhere to.

Next, remember that using a large-format single-lens reflex depends almost entirely on being able to see an image to focus. The mirror has to reflect all the light that is available from the lens, and therefore has to be bright and reasonably unscratched. The ground-glass screen also needs to be clean and not cracked. Fortunately, in these old SLRs it is often possible to remove a few screws or just turn a couple of fasteners, take the ground-glass screen out and wash it in warm water and a touch of liquid detergent. Do not, however, try this approach until you own the camera.

If you do remove the focusing screen to clean it, watch out as you lift the screen from its bed for shims or spacers between it and the camera body. It may well be that a repairer has at some time set the reflex focus

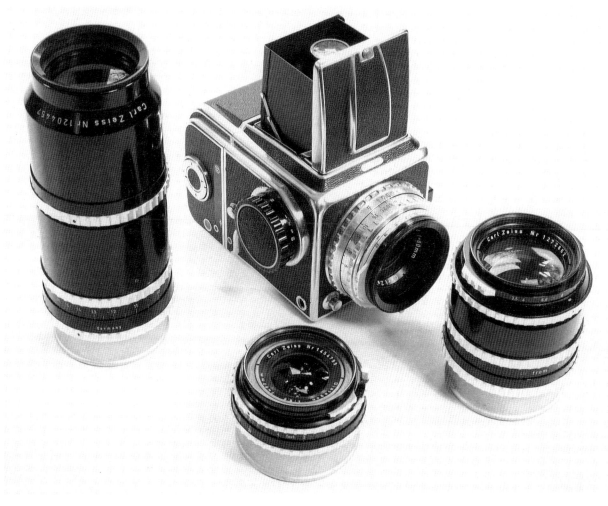

These were the key components of the Hasselblad 1000F outfit that I was using professionally throughout the second half of the seventies. The camera, which is fitted with a later 'C' type magazine, is fitted with an 80mm f/2.8 preset Tessar, the commonest standard lens on F-series Hasselblads. In front is the 60mm f/5.6 Distagon wide-angle, on the right the 135mm f/3.5 Sonnar, on the left the 250mm f/5.6 Sonnar. All have manual preset diaphragms – the Hasselblad 1000F had no provision for automatic diaphragm. None has a built-in shutter, because the 1000F had a metal (titanium foil) focal-plane shutter. This was and is its weakness. No spares are available from official sources and the only way in which a skilled repairer may be able to get a dead 1000F going again is by pillaging another, less beautiful, example which will itself probably be worth hundreds of pounds despite being in poor condition.

*Shot during the seventies with another Hasselblad 1000F fitted with 80mm f/2.8 Tessar. No data on exposure or film.*

of the camera by adjusting the exact position of the focus screen. If you mislay a shim, or fail to put it back in exactly the same place, the focus will probably need resetting.

Dirty mirrors need more care and thought than a mucky screen. The mirror in an early SLR is usually surface-silvered glass mounted on a thin metal carrier. Unlike a conventional rear-silvered glass mirror, you cannot simply take a cloth and a bottle of window-cleaning fluid to it, since the silvered surface is soft and extremely easily scratched. Any attempt to clean a mirror is fraught with risk, and cleaning should be avoided unless there is no hope of using the camera without cleaning the mirror.

If you must clean it, use a puffer brush to blow away every scrap of loose dust and dirt. Use an extremely old and much-washed cotton handkerchief torn in half, and moisten a little of one half with a small amount of ethyl alcohol or methylated spirit. Touch this to the extreme corner of the mirror with a simple light wipe,

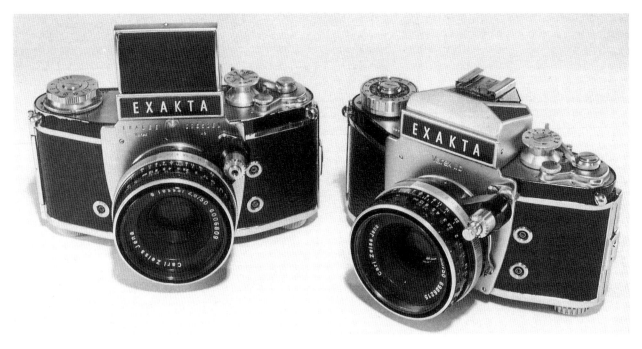

Two Exaktas of the late fifties and early sixties – on the left a late Exakta Varex IIa of about 1959 fitted with waist-level viewfinder, on the right an Exakta Varex IIb of 1963 fitted with a pentaprism. Both have 50mm f/2.8 Tessars with fully automatic diaphragm and the viewfinders are interchangeable between the two and several other models of the period. The key requirement for assessing an Exakta is either a detailed knowledge of how to use them, or the appropriate instruction book, or a book such as *The Exakta Guide* (Focal Press, UK), which gives detailed instruction on how to set the shutter and delay action. Exaktas are not as reliable as Japanese SLRs of the same period, and are not really as suitable for regular photography as, for example, a Pentax S1a or SV, a Minolta SR1 or SR7 or a Canon FX.

*Shot with Pentax S1a fitted with 55mm f/1.8 Super-Takumar on Ilford Pan F Plus, developed in Aculux and printed on Ilford Bromide.*

and then charge cloths. Pass the dry half over the same small area in one wipe, then wait for the spirit to evaporate. If you feel happy with the result, do the rest in the same way, but do not get over-enthusiastic with the number of wipes. The aim is to minimize the surface contact.

Check whether the focus is correctly set by focusing on a distant landmark with the camera on a tripod. Open the lens diaphragm fully to minimize depth of field and focus the landmark on the reflex focusing screen. Next, without moving the camera or the focusing mechanism, set the shutter to the time setting and fire it, first raising the mirror of the camera (if the mirror has to be raised before the shutter is fired). The shutter should now be open with the mirror up. Either use the camera's own rear focusing screen, if it has one, or take out the dark slide and hold a suitably sized piece of ground glass over the shutter aperture so that it is touching the rear body of the camera. With a dark cloth to exclude the light, check

the focus at the focal plane. If it is as sharp as the image on the focus screen, all is well. If not, some resetting may be needed – but a word of caution. Using a simple piece of ground glass held against the back of the camera may not replicate the film plane precisely, since the plate or film holder may be designed to position the sensitive surface slightly further from the lens. If you have no suitable rear focusing screen, the best check is to expose, process and enlarge a couple of pieces of film to see if the image is sharp.

If you get this far without incident, you probably have a runner – so turn to Chapter 12 for some further thoughts on getting results from the old 'uns.

### Checking more modern SLRs

The principles for checking veteran large-format SLRs apply to testing any SLR, although the actual ways of doing it are inevitably somewhat different.

You have to be sure that the shutter runs correctly at all speeds, that there is a clear focusing image, that the focus on the screen agrees with the focus at the focal plane and that the camera does not leak light. However, 35mm SLRs obviously have more functions to be checked than the older cameras.

You must ensure that the diaphragm actuation and the auto-diaphragm itself (if there is one) operate properly. You need to check the flash synchronization and the delay action, if they are fitted. You may have to evaluate the operation of a built-in exposure meter and the stop-down mechanism that is a part of operating it in the case of SLRs with stop-down meters. Worse still, if the camera in question is designed for automatic exposure setting, that too should be checked – and that can be difficult.

However, it is perhaps best to start with the fact that all rollfilm and 35mm SLRs have to transport film, and space their exposures correctly.

## Film transport

Many older SLRs, particularly rollfilm SLRs, have gearing defects which result in exposures overlapping or being unevenly spaced. Fortunately, this function is easy to verify with any SLR which has an interchangeable lens.

You simply load the camera with a scrap film, take out the lens, set the shutter to 'B' and press the shutter release, holding it down after the shutter opens. While it remains open, use a pencil (preferably) or a ballpoint pen that does not leak to draw (very carefully) on the film around the shutter aperture. This produces a rectangle roughly equivalent to the negative area, had a picture been taken. Remove the pencil, release the shutter button, wind the camera, press the release again and once again draw the rectangle on the film.

If this procedure is repeated for the whole of a film, and the film is then taken out of the camera and

The body of this Praktica IV is externally quite badly worn and has clearly seen life, but it still works well. The lens, while optically exactly as it should be, is mechanically less satisfactory. For some reason that I have never quite fathomed, this particular version of the 50mm f/2.8 Tessar (with fully automatic diaphragm) in M42 screw mount is much more prone to stiffness of the focusing mount and sluggish diaphragm problems than other versions of the Tessar or other M42 FAD lenses of the period. It is commoner for the cheaper and less prestigious 50mm f/2.8 Domiplan to function correctly than it is for one of these Tessars to do so.

*Shot with Minolta SRT101 fitted with 28–80mm Tamron SP zoom in Minolta mount on Ilford Pan F Plus, developed in Aculux and printed on Ilford Bromide.*

The Praktica Super TL of the late sixties was the TTL camera of the Praktica Nova I series of cameras. They provided stopped-down through-the-lens metering when the user pressed the large black button below the shutter release and just visible in this picture to the left (as we look at it) of the lens. This exposure meter is sadly unreliable, and a large proportion of the Praktica Super TL cameras that turn up at camera fairs look very smart but have a defective meter. The meter on this one worked after a fashion, but gave hopelessly optimistic exposure readings. The 50mm f/2.8 Tessar also had the usual stiff focusing mount.

*Shot with Minolta SRT101 fitted with 28–80mm Tamron SP zoom in Minolta mount on Ilford Pan F Plus, developed in Aculux and printed on Ilford Multigrade III.*

SLRs of the fifties and sixties with between-lens shutters have in many cases a sad reputation for unreliability. This unreliability is, not surprisingly, greater in the more complicated cameras, particularly in those cases where designers tried, in the days before electronic exposure control, to endow between-lens-shutter cameras with automatic-exposure facilities. Some of the electro-mechanical auto-exposure SLRs were very expensive and built with extremely high engineering standards, but are so difficult to repair adequately with any expectation of permanent success that many repairers will not touch them. This is an exceptionally beautiful Voigtländer Ultramatic CS, the redesigned late Ultramatic with CdS exposure meter, which is inherently more reliable than the earlier Ultramatic because it does not have an instant-return mirror. Perhaps as a consequence of that, this Ultramatic CS operates as it should, but relatively few of the earlier Ultramatics work at all, let alone well.

*Camera and picture by courtesy of Mike Rees. Shot with Contarex Cyclops fitted with 50mm f/2 Planar on Ilford Pan F Plus, developed in Aculux and printed on Ilford Multigrade III.*

This little Mamiya fixed-lens leaf-shutter SLR was marketed under several different names by a variety of large organizations – 'Korvette' was the name applied by Britain's Bennets photographic retailing chain, while the same camera was sold as the Saturn by Dixons, often on the opposite side of the same street. The price of a Saturn from Dixons was £24.17s.6d (then about $70) in September 1963. The Saturn/Korvette was essentially cheap and cheerful, with a 48mm f/2.8 Mamiya-Sekor lens in a shutter with a simple two-leaf diaphragm. Surprisingly, they often work quite well, the principal areas of unreliability being the exposure meter, which is often dead on arrival, and the film-transport mechanism, which sometimes jams. Accessory wide-angle and telephoto lenses were sold and are often still available at camera fairs.

*Shot with Minolta SRT101 fitted with 45mm f/2 Rokkor on Ilford Pan-F Plus, developed in Aculux and printed on Ilford Bromide.*

Edixa reflexes come in a surprising variety of models (see Chapter 6) but most have a common mechanical design and therefore similar strains of unreliability. The main problems seem to stem from the quality of materials used in their manufacture, since focusing mounts, film-transport mechanisms and the mountings for the viewfinders seem to wear to a much greater degree than on most other cameras. This makes most Edixa reflexes feel worn and imprecise in use. Nonetheless, many of them actually work well and are available quite cheaply at collectors' fairs. Check the lens-diaphragm functions with particular care.

*Shot with Pentax S1a fitted with 55mm f/1.8 Super-Takumar on Ilford Pan F Plus, developed in Aculux and printed on Ilford Bromide.*

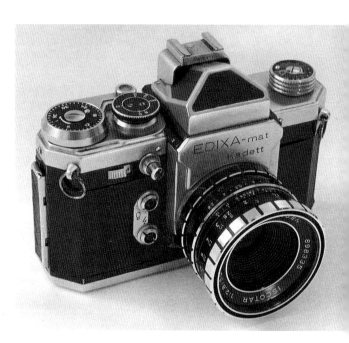

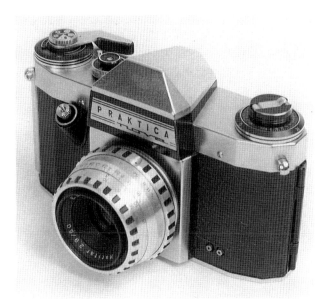

The Praktica Nova series superseded the Praktica IV/VF series and is mechanically inferior to them, although retaining the same shutter-speed setting principle. This was a case of the VEB company designing down to a cost set by accountants and, as usually happens when accountants take charge, the product was a failure in engineering terms, although commercially successful in terms of numbers sold. It is not a camera to buy if you plan to use it.

*Shot with Pentax Spotmatic fitted with 55mm f/1.8 Super-Takumar on Ilford Pan F Plus, developed in Aculux and printed on Jessop Variable Contrast.*

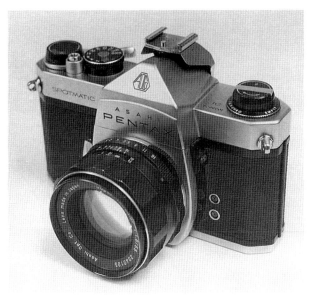

The original Pentax Spotmatic is an essentially reliable camera capable of delivering high quality consistently for a modest price. The commoner focal lengths of Super-Takumar lenses are also available for relatively little money and are excellent value. Weaknesses are the tendency for the wind-lever return spring to break and not infrequent problems with the meter switch (see the picture on page 32).

*Shot with Olympus FTL fitted with 50mm f/1.8 F Zuiko on Pan F Plus, developed in Aculux and printed on Ilford Bromide.*

examined, any uneven exposure spacing or over-lapping exposures become obvious.

If the camera does not have an interchangeable lens, the best way to check the film transport is to expose a film and develop it.

## Shutter and general serviceability

Checking the shutter on most rollfilm or 35mm SLRs is fairly straightforward. The first obvious step is to open the back of the camera, set the shutter-speed dial to each available speed in turn, and wind and fire the shutter on each setting.

In the case of focal-plane shutters, you need to be sure that the shutter blinds are taut and not wrinkled and that a metal-blade shutter (e.g., the Copal Square shutter of the Nikkormat series) is not corroded in any way or dented. Never touch the blades of a metal shutter – they are extremely thin and easily damaged.

Leaf shutters (e.g., Compur or Prontor shutters) should be inspected for corrosion, and for free oil on the shutter blades. Corrosion will eventually cause shutter failure and is usually unrepairable short of replacing the shutter. Oil on the shutter blades indicates a need for servicing.

The fast speeds should snap without squeaking or wheezing noises, the slow (i.e., 1/8th, 1/4, 1/2, 1 second) should sound like smooth-running clock-work (which in most cases they are) and should keep the blinds or blades open for approximately the right length of time. If the slow-speed 'buzz' is uneven, or stops half-way with the shutter open, the shutter needs a full service. The cost of that varies considerably, but at the time of writing will not be less than £35 ($55) in Britain and could (in the case of a Contarex or Leicaflex, for example) be well into three figures. Thus, buying a classic SLR whose shutter needs servicing is a step to be considered carefully.

Ensure that a focal-plane shutter is not tapering – the condition when the second blind of a focal-plane shutter travels during a 'fast' exposure (speeds of 1/30th second and shorter) marginally faster than the

first, and gradually catches the first blind during the travel of the shutter. In very minor cases, this results in the area of the film exposed last receiving less exposure than that exposed first, because the aperture between the blinds has become smaller during the travel of the shutter.

Tapering shutters often close before reaching the end of their travel, an effect which is worst at the higher shutter speeds. The 1/1000th-second setting may not open at all, and the 1/500th may close when less than half-way across the film aperture.

To check this, take the lens out of the camera, open the camera back, set 1/1000th second, hold the camera up to a diffuse light source and, while looking at the shutter, fire it. Your eye should be left with a retained image of the whole shutter area. If it is not, and if there is a dark area on the side to which the shutter travels, this indicates that the shutter closed before it reached the end of its traverse and that the shutter is tapering.

In the case of leaf shutters, a serious fault that is often overlooked is a failure of the blades totally to close after the shutter is fired. This usually results

from a defective mainspring, although other causes are possible. This fault, unlike the tapering focal-plane shutter described above, makes the camera completely unusable until it is rectified. To check for it, wind and fire the camera at all speeds while looking through the open back at a diffuse light source. Be sure that there is no point of light visible after the blades have closed. Watching the blades from the front is not always sufficient.

Other aspects of general serviceability include checking that a camera is light-tight. With comparatively small rollfilm and 35mm SLRs, the only really practical way to do this is to expose a fast film (e.g., 400 ISO) under a range of circumstances (ideally including bright sunlight) and process the result.

## Optical condition

Most people assess optical condition simply by looking at the lens. However, replacement standard lenses for most popular SLRs can be found at camera fairs for modest sums, whereas replacement bodies will usually be far more expensive. So be sure that the body optics are sound. Look at the mirror (but don't touch it) and at the focusing screen (and don't touch that either). Make sure that both are clean and unscratched, although a few hairline scratches on the mirror will not affect function if the mirror is clear and bright. Make sure that the viewfinder image is even and easy to focus. Find an 'infinity' subject and check that, when you focus on it, the lens achieves correct focus when at infinity on the focus scale. Shake the camera *gently* in your hand and be sure it doesn't rattle – rattling usually indicates either loose lens elements or a loose prism within the pentaprism housing. If there is a rattle, remove the lens, and gently shake it and the body separately to isolate the problem.

If the lens does not rattle, be sure that it is unscratched front and back and check if there are any of those tell-tale 'mirror spots' which indicate that the cement which holds lens elements together is failing. These 'balsam failures' rarely affect lens performance but generally make a lens more or less unsaleable for cosmetic reasons, unless it is a rarity.

## Diaphragm and diaphragm actuation

Most 35mm and rollfilm SLRs made since 1960 (and some before) have an automatic iris diaphragm which

The various Pentax Spotmatics (this is a Spotmatic II), despite their name, do not have the spot meter that the original Spotmatic was designed to have. Instead, their conventional averaging stop-down TTL meter is switched on by a sliding switch on the left-hand side of the mirror box (as the operator sees it). Sliding this up both stops the lens down and switches the CdS meter on. Firing the shutter should switch the meter off again and reset the automatic diaphragm to be wide open (provided that the auto/manual switch on the lens is set to 'auto'). However, this is often defective. The switch itself also has a way of being unreliable.

*Shot with Pentax S1a fitted with 55mm f/1.8 Super-Takumar on Ilford Pan F Plus, developed in Aculux and printed on Ilford Multigrade III.*

closes to the preset aperture when the shutter release is pressed, and opens again to full aperture for the focusing of the next shot as soon as the shutter has completed its travel. Most automatic-diaphragm mechanisms are within the lens and are actuated by a lever on the back of the lens which is pushed clockwise or anti-clockwise circumferentially by a matching lever in the camera body, against the spring pressure of the lens-diaphragm mechanism.

The exception among the internal automatic-diaphragm couplings is one of the commonest – that of the M42 screw Praktica/Pentax/Edixa mount (it has been known by association with various brands over the years). This mechanism is actuated by a spring-loaded pin which protrudes from the back of the lens mount, parallel with the axis of the lens, at the 6 o'clock position when the lens is fitted to the camera. When it is pushed, the diaphragm closes to the preset aperture. When it is released, the diaphragm opens again.

Some SLRs, such as Exaktas and Exas prior to the Exakta RTL 1000, Alpas and early Topcons, have external automatic-diaphragm coupling. This consists of a shutter button in an arm extending from the lens, which fits over the camera shutter button. When the lens is fitted, it is the shutter button on the lens which is pressed to fire the shutter, rather than that on the camera. Pressing this first stops down the diaphragm, then fires the shutter. Only when the finger pressure on the release is lifted does the diaphragm reopen to maximum aperture.

The commonest automatic-diaphragm fault is a failure of the diaphragm to stop down to the preset aperture quickly enough for the picture to be taken at the preset aperture. The problem is usually caused by dirt, and is solved by cleaning by a skilled technician – do not try and clean a diaphragm yourself. A tired and defective diaphragm spring or springs may also have a role in causing sluggishness. A diaphragm which needs cleaning may show the problem first by failing to reopen snappily after the exposure has been made.

The test is first to set the lens to its smallest aperture – f/16 or f/22 in most cases – and the shutter to a slow speed, perhaps 1/2 second. Then wind and fire the shutter. Watch the diaphragm closely and see if it closes instantly to its smallest aperture before the shutter opens, and snaps back to full aperture after the shutter closes (or when the pressure is taken off the shutter release in some cases). If it doesn't, reflect on

the value of the lens. Many common high-quality standard lenses are readily available for around £15 ($22.50) or less at British camera fairs, and for equivalent sums at events in Europe and the USA. This is less than most repairers would charge to clean one out.

If, as occasionally happens, the diaphragm does not close down at all when the lens is set to a small aperture and the shutter is fired, do not immediately assume that the fault is in the lens. Check whether the lever on the camera body that should actuate the diaphragm (or the pusher at the bottom of the lens throat in the case of M42 mount cameras) is moving when the shutter is pressed. I have had several elderly Praktica bodies in which the pusher has become disconnected from the actuating mechanism underneath it. A quick push on the actuating lever or pin on the back of the lens mount will establish whether the lens-diaphragm mechanism is performing well.

## Exposure-measurement system

Detailed checking of exposure meters and automatic-exposure systems in the vast number of types of SLRs that have been fitted with them since the early fifties requires almost as many different procedures as there are cameras. It is simply impossible to give full and detailed instructions for checking each model in a book of this size, type and scope. However, a few guidelines are appropriate here, particularly for readers who are newcomers to collecting and classic cameras.

Photo-electric exposure meters installed within SLRs have used two basic technologies. Until the introduction of the Minolta SR-7 in 1962, it was relatively uncommon for SLRs to have built-in exposure meters, and all those which were available were selenium-cell meters. Later-technology CdS exposure meters were available as clip-on extras or in alternative prisms (as with the Nikon F), but only selenium meters were built-in prior to the SR-7.

In a selenium-cell exposure meter, of which a Weston Master is an example, a galvanometer measures the current produced by light falling on a selenium photo-electric cell. Selenium-cell meters can be recognized by the relatively large light-gathering 'window' which such meters have, usually rectangular with a diffuser pattern on it. The windows on the front of the pentaprism of a Voigtländer Bessamatic, or beside the pentaprism of a Contaflex II or Contaflex IV, are examples.

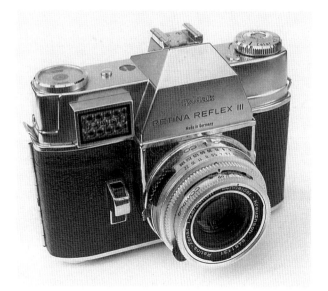

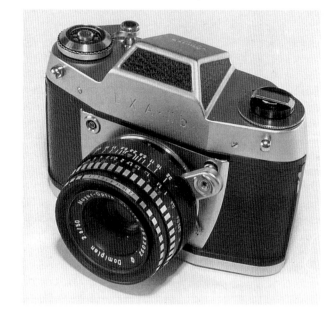

The Retina Reflex series of cameras are undeniably usable, of good-quality manufacture and capable of excellent image quality. When new, they were not cheap – the Retina Reflex III was advertised in Britain during 1963 at £102.6s.0d (then about $286) with f/2.8 lens, or £119.3s.2d (about $334) with f/1.9 lens. However, like all leaf-shutter reflex cameras with interchangeable lenses, they are susceptible to the ingress of dust and moisture when lenses are changed. The result is that, in time, almost any Retina Reflex will suffer from sticking slow speeds and other shutter problems. When this happens, the whole camera has to be dismantled for servicing to be carried out, and most repairers take the view that the amount of work makes the project uneconomic. They therefore either refuse to quote or ask a realistic price from their standpoint, which is likely to be as much as, or more than, the camera is worth on the open market. However, there is always somebody prepared to repair them, provided the owner accepts the cost.

*Camera and picture by courtesy of Mike Rees. Shot with Contarex Cyclops fitted with 50mm f/2 Planar on Ilford Pan F Plus, developed in Aculux and printed on Ilford Multigrade III.*

The Topcon RE-2 is a tough and ruggedly engineered camera with a Copal Square metal-bladed shutter like that in the Nikkormat series. It is reliable, nice to use and makes rapid focusing and shooting easy. Cameras with Copal Square shutters are relatively easy and inexpensive to service, and the Topcon RE-2 is a sound buy. Most sold in Britain were engraved, like this example, 'Hanimex Topcon', Hanimex being the importer. Similar engravings were added for importers in other countries.

*Shot with Pentax S1a fitted with 55mm f/1.8 Super-Takumar on Ilford Pan F Plus, developed in Aculux and printed on Ilford Multigrade III.*

This Exa IIb is typical of the II series Exas, which take Exakta lenses. The cloth focal-plane shutters of II series Exa cameras are more reliable than the simple shutters of the early Exa I series, but still have their problems with tapering. They are relatively simple to service.

*Shot with Pentax S1a fitted with 55mm f/1.8 Super-Takumar on Ilford Pan F Plus, developed in Aculux and printed on Ilford Multigrade III.*

Selenium-cell meters are entirely self-powered and have no requirement for a battery. The main problems which arise in elderly selenium-cell meters are reduced photo-electric output from (or complete failure of) the selenium cell, or mechanical or electrical failure of the galvanometer. The general rule is that you will not be able to get much done to improve the performance of a selenium-cell meter unless you are prepared to pay specialized repairers sums that are disproportionate to the value of most cameras of this type and age. Repairing such meters is time-consuming and difficult, and may not be possible at all if spares are not available. The sums usually charged are fair from the standpoint of the repairer – just not economically sensible from the viewpoint of somebody who just bought a Contaflex for £35 ($52.50).

Having written that, I should also stress that some selenium-cell meters, notably those in Zeiss Contaflex and Voigtländer Bessamatic cameras, usually continue to work well despite their age – some forty years or more. Those in Japanese cameras of the period are very much more suspect.

Cadmium-sulphide, or CdS, meters are powered by, and dependent upon, a battery. The resistance of the CdS cell decreases as the intensity of light falling upon it increases. Consequently, the current from the cell becomes greater as the light level rises. The micro-ammeter, or latterly the light-emitting diodes (LEDs), records the current and thereby indicates exposure. Since the cell does not have to be large enough to gather sufficient light to provide a measurable current, CdS meter cells are far more compact than selenium cells, and their large-scale availability at an economic price caused a rush among camera manufacturers, initially in Japan and then in Europe, to build exposure-measurement systems into cameras. After 1964, few SLRs were launched which did not incorporate a built-in CdS exposure meter. At first, as in the Minolta SR-7 or Canon FX, they gathered their light through a window somewhere on the front of the camera. But in 1964, the Topcon RE Super became the first SLR (not the first camera) with built-in coupled through-the-lens (TTL) exposure measurement. From then on, all other systems were effectively doomed.

CdS meters usually either work well or do not work at all, although intermittent faults caused by poor connections sometimes occur. The commonest fault is caused by leaving batteries in cameras that are

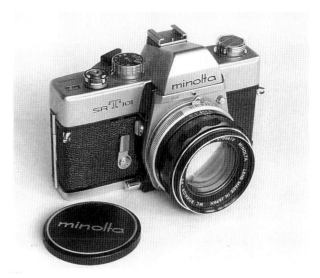

My experience of the Minolta SRT101, of which I have had about a dozen at one time or another and currently have four, has generally been very good. The optical quality of both camera and lenses is very high, and I have never experienced any difficulty with lens or diaphragm functions whatever. In the last year or so I have had one SRT101 body jam due to some wear in the film-transport interlock and another suffer from meter failure. Both problems were put right by Ed Trzoska of Euro Photographic Services in Leicester at modest cost. Until those two problems occurred, I had never had a servicing or repair job done on a Minolta reflex, although I have heard other users mention occasional exposure-meter problems.

*Shot with Pentax S1a fitted with 55mm f/1.8 Super-Takumar on Ilford Pan F Plus, developed in Aculux and printed on Ilford Multigrade III.*

infrequently used. Dead batteries corrode, damaging the battery contacts with white oxide, which is, however, quite easily removed with a little carborundum paper and spirit. Because the currents delivered by meter batteries are so small, it takes very little corrosion to cause sufficient resistance to prevent any significant current reaching the CdS cell.

The first step if a CdS meter does not work is to unscrew the cover of the battery compartment – they usually have a coin-screw slot. If the cover will not shift, you have probably found the problem, since it is likely to have been jammed by corrosion. If the cover comes off, you may well find that there is simply no battery, for which the obvious remedy is to buy one.

However, environmental legislation has in recent years outlawed mercury batteries. Some types of camera-meter batteries that were extremely common during the sixties and seventies – by far the most common is the PX 625 – have been made only as mercury batteries and have been discontinued. The

situation regarding any possible replacement lithium battery is, at the time of writing, unclear, and collectors of my acquaintance have been buying up large quantities of PX 625 batteries to last out their lifetime in the event of the supply of this battery drying up totally. So be warned and ask around!

Of course, not all cameras use the PX 625, and the batteries for later classic SLRs of the seventies are usually available in lithium form. So, with a new battery, and the contacts cleaned, the exposure meter will usually spring into life. If it does not, ask a friendly repairer. The problem can usually be fixed.

Classic SLRs that have automatic exposure-setting mechanisms have a way of being very unreliable because of the excessive complication of their electro-mechanical designs, although some are better than others, and I will attempt to explain more in the relevant chapters later in this book. In general terms, the best way to check them is to run a film through the camera and see what comes out. Using whatever over- or under-exposure results as a guide, either ask a repairer to investigate any problem, or examine it yourself, applying the general guidelines for selenium and CdS meters set out above. However, any automatic camera of the pre-electronic era is bound to be complicated and difficult to work on, unless you are an expert repairer. I would not recommend it.

I hope that, armed with these suggestions for assessing the cameras that you are offered, you will build a modest collection of cameras that work and which can be relied upon to produce pictures when required. So let us move on to consideration of which systems are the most effective and reliable between twenty and fifty years after their manufacture.

This available-light portrait was shot using a Reflex-Korelle with f/2.8 Xenar which I had bought just before the session during 1965. I like it as a shot – but there are several tiny black spots on the print caused by holes in the image on the film. These were almost certainly caused by dirt in the focal-plane shutter lodging on the film and preventing the developer processing that small area of the picture. The moral is to brush out an SLR carefully with a puffer brush, then wind and fire the shutter quite a few times before brushing it out again. If you take a large SLR like a Reflex-Korelle which has not been used for a while, open the back, put it shutter down on a sheet of white paper and fire the shutter a few times. You may well be amazed at the debris which appears on the paper.

Shot with Reflex-Korelle fitted with 75mm f/2.8 Xenar, exposure not recorded but probably about 1/50th at f/4, on Ilford FP3, printed on Ilford Multigrade III.

Bush House, the London headquarters of the BBC World Service, shot one very wet day in July with a VP Exakta fitted with a 7.5cm f/3.5 Exaktar, which is a less than brilliant lens. However, the principal camera problem revealed by this picture is not the lens quality but the inability of the pressure plate to keep the film flat. Note how the curvature of the film has both caused poor focus at the right of the picture and has caused slight distortion of the image. The cause is probably a combination of my using a well-outdated film which had become a little inflexible, and weak springs behind the elderly camera's pressure plate.

*Shot with VP Exakta B fitted with 7.5cm f/3.5 Exaktar, exposure 1/50th at f/4, on Verichrome Pan, developed in Aculux and printed on Ilford Multigrade III. Camera by courtesy of Mike Rees.*

This picture suffers from camera shake, despite being shot at an indicated 1/100th second at f/11 on the Mentor Compur Reflex. I had thought that I held this camera, which I had available only for one day, reasonably still, and suspect that the marked shutter speed was running a little slow. However, that is not the whole story. These largish old rectangular SLRs are surprisingly difficult to hand-hold, and I am sure that my technique would have benefited from a substantial tripod. Nonetheless, it pays to compare roughly by eye the marked shutter speeds on an old shutter with those on a fairly modern equivalent. Shutter springs do become weak, and speeds do become slow. This shot was taken in Wingham, Kent.

*Shot with Mentor Compur Reflex fitted with 10.5cm f/4.5 Tessar, exposure 1/100th at f/11, on Ilford FP4 Plus, developed in Aculux and printed on Ilford Multigrade III. Camera by courtesy of Malcolm Glanfield.*

Babies are introduced young to the enthusiasms of their parents. This scene was spotted at a steam fair in Sussex and shot with a Pentax S1a fitted with a 28mm f/2.8 macro wide-angle lens which has literally no identity whatever anywhere on it. This session proved that it is not a first-class lens – but I still like the picture for all that. I comfort myself that, when producing a book of this kind, one has a duty to show the results of the less effective equipment as well as that of the cameras and lenses that shine. The Pentax is a lovely camera to use. This particular lens I could do without.

*Shot with Pentax S1a fitted with 28mm f/2.8 macro lens of indeterminate origin, exposure 125th at f/11, on Ilford FP4 Plus, developed in Aculux and printed on Ilford Multigrade III.*

In my view, Miranda cameras and their lenses are seriously underrated. Prejudice causes many British amateur photographers to opine that 'Miranda lenses were all made by Soligor, so they can't be much good', and, while one cannot argue with their factual information, I would dispute their conclusion. This simple picture was shot on Shoreham beach, West Sussex with the Miranda Sensorex II illustrated on page 16, with its standard 50mm f/1.8 Auto Miranda lens. There has been some artifice employed in the printing (what is black-and-white photography for but to give rein to artifice?), nonetheless there is no denying that the negative and print quality are beautifully crisp.

*Shot with Miranda Sensorex II fitted with 50mm f/1.8 Auto Miranda, exposure 1/250th at f/11, on Ilford FP4, developed in Aculux and printed on Ilford Multigrade III.*

This portrait of my daughter Emma was shot during November 1995 in the loft of our small house, using a piece of black velvet as a non-reflective backdrop and three elderly Courtenay studio flash units. The camera was a Retina Reflex III with 50mm f/2.8 Xenar, not a camera one would instinctively turn to for portraiture. Nonetheless, it is capable of delivering entirely acceptable results.

*Shot with Retina Reflex III fitted with 50mm f/2.8 Retina-Xenar, electronic flash at f/8, on Ilford FP4 Plus, developed in Aculux and printed on Jessop Variable Contrast.*

The mechanism of my Waltham pocket watch. This is, in fact, one of a series of five similar shots taken with a succession of M42 cameras and lenses to demonstrate the point that there is not as much difference as photographers imagine between the results obtained under controlled conditions from expensive lenses and those delivered by simple lenses. At a Photographic Collectors Club of Great Britain regional meeting during the autumn of 1994, I produced four 12" × 16" enlargements of shots of this watch taken with a 50mm f/2.9 Meritar, a 50mm f/2.8 Domiplan, a 50mm f/2.8 Tessar and a 55mm f/1.8 Super-Takumar, all on the same film with identical lighting, processing and exposure. I also produced the lenses and asked some twenty members to say which shot came from which lens. The Super-Takumar was undeniably the sharpest when viewed very carefully, but there was little difference between any of them, and nobody provided a completely correct answer, despite generally held views about each of the lenses. Lack of time had prevented me from printing this fifth version, which subsequently proved to be even sharper than that from the Super-Takumar.

*Shot with Olympus FTL fitted with 50mm f/1.8 F Zuiko, exposure 1/2 second at f/16, on Ilford FP4, developed in Aculux and printed on Ilford Multigrade III.*

# Chapter 3

## Getting to grips with a left-handed East German

There are in most fields of endeavour idiosyncratic products or techniques which are loved by some and regarded with distinct reservations by the rest. As the owner of the Tiverton fish-and-chip shop once remarked when I arrived in my Citroën for my lunch, you either love them or hate them. He was, of course, referring to the Citroën, not to my plaice and chips.

I cannot but regard Exakta cameras with a certain degree of ambivalence. They fascinate me, if only because there seem to be more ways of making an Exakta whirr, click and thunk than there are with any other camera. The specification – slow speeds to 12 seconds, built-in film-cutting knife and the rest – is positively mouth-watering. On the other hand, they infuriate me because I find it so very difficult to use Exaktas effectively.

### Key facts about VP Exaktas

The Exakta rollfilm cameras using 127 film which we now refer to as VP Exaktas changed the course of SLR history. Developed between 1931 and 1933 by Ihagee of Dresden, a company which was already well known for successful folding and rigid single-lens-reflex plate cameras, the Exakta began the process which changed public perception of the SLR. It was the first SLR that looked, to modern eyes, like an SLR. It was the first camera in the world of any kind with internal flash synchronization. It was the first 127 rollfilm SLR.

I love this shot of my daughter Holly having fun on a swing when she was six. The obvious distortion caused by the 24mm lens somehow adds to the impact of the huge grin and flowing hair. I had not realized that I had this picture until I was carefully sorting through my old negatives looking for shots that could be used for this book. It had certainly never been printed before. It was taken when I was using a Canon F1 for my professional 35mm work. Although big, heavy and expensive, the Canon F1 is a superb instrument.

*Shot with Canon F1 (first type) fitted with 24mm f/2.8 Canon FD, exposure 1/1000th at f/4, on Ilford FP4 Plus, printed on Ilford Multigrade III.*

All VP Exakta cameras produce eight exposures nominally 4cm × 6.5cm on 127 rollfilm. Herein for the present-day enthusiast lies the first problem, for it becomes increasingly difficult to obtain 127 film. At the time of writing, black-and-white 200 ASA panchromatic film in 127 size is available only from Jessop Photo Centres in Britain.

Before winding, firing or loading any VP Exakta, twist the large knurled focusing collar to wind the lens out to its infinity position, where the infinity catch prevents you winding it further to focus closer until you release the catch. Winding the lens mount out is important because, on most VP Exaktas other than the very earliest, there is an exposure-prevention mechanism that prevents the shutter from being fired unless the lens has been brought out at least to the infinity position. With early cameras which lack this mechanism, it is reputedly possible to damage the mirror under some conditions if the shutter is fired with the lens collapsed, although I have never actually seen evidence of this.

All VP Exaktas load from right to left – new film in the right-hand side of the camera, empty spool in the left. After engaging the tongue of the film, use the knob or lever to wind one turn of backing paper, then close the back and use the red window (in subdued light) to wind the film through until the figure '1' is visible in the window. If the camera you are using has no sliding cover over the red window, be sure to stick a piece of black 'gaffer' tape or a knob of 'Blu-Tack' over it before venturing into daylight, otherwise your film is likely to become fogged. Fast panchromatic (red-sensitive) films were invented after the VP Exakta, which was designed for orthochromatic films. These were and are unaffected by red light – hence the red window.

Until 1937, all VP Exaktas were finished in black enamel, usually with nickel-plated bright parts, although one encounters some cameras that are black and chrome. From late 1936, when the chrome-finished Kine Exakta had appeared, VP Exakta cameras were supplied in either black and nickel or in chrome, with black leather-covered body in either case.

Unlike modern SLRs, VP Exaktas had few wide-angle lenses available to fit them. The reason for this was that retrofocus lens design, essential to all the modern wide-angle lenses for SLRs, had not been developed sufficiently when the VP Exakta was

The VP Exakta Model A of 1934 – not the very first type of Exakta, but very similar to it, in this case fitted with a 7cm f/3.5 Tessar. This particular example is in exceptionally good condition and could be expected to deliver high-quality results.

*Camera by courtesy of Dave and Julie Todd. Shot with Pentax Spotmatic fitted with 55mm f/1.8 Super-Takumar on Pan F Plus, developed in Aculux and printed on Jessop Variable Contrast.*

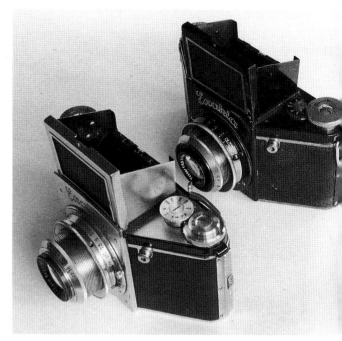

Two VP Exakta B cameras show some of the differences to be seen in the various versions of this model as it evolved. The lower left-hand camera is a chrome B with lever-wind, a chrome large speed dial, the infinity catch at 3 o'clock to the lens mount and a flat sliding catch to open the back of the camera. The upper right-hand camera has knob wind, a black small speed dial, the infinity catch at 9 o'clock to the lens mount (not actually visible in this picture) and a round protruding knob to operate the catch for the camera back. The black camera also has the long strap rings often seen on early VP Exaktas.

*Cameras by courtesy of Mike Rees. Shot with Minolta SRT101 fitted with 55mm f/1.7 MC Rokkor on Ilford Pan F Plus, developed in Aculux and printed on Ilford Bromide.*

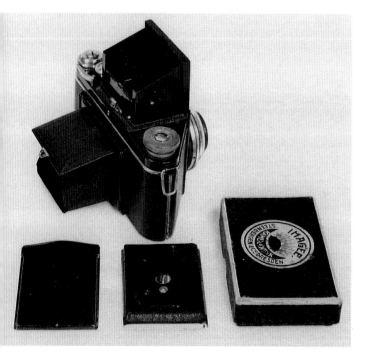

The VP Exakta C could be used with either VP-size plates or 127 rollfilm, but the middle section of the camera back had to be interchanged to do it. Here the camera has its rear focusing screen in place. In the foreground are (left to right) a VP plate holder, the rollfilm pressure plate assembly and a typical Ihagee box of the time in which the plate adaptor was supplied.

*Equipment by courtesy of Dave and Julie Todd. Shot with Pentax Spotmatic fitted with 55mm f/1.8 Super-Takumar on Pan F Plus, developed in Aculux and printed on Jessop Variable Contrast.*

current. Thus it was not possible to make practical lenses of high performance whose back focus (the distance from the rear element to the film) was significantly greater than their focal length. Because the minimum back focus that the VP Exakta can accommodate, even with a recessed lens mount, is roughly 55mm, the shortest focal length ever supplied was the 5.5cm f/8 Tessar, which is rare and highly desirable. There was also a 5.6cm f/6.8 Meyer Wide-Angle, and a British-made Dallmeyer 6cm f/11.

The rear view of the chrome VP Exakta B on page 44, with the camera back open, shows the smooth bright-metal pressure plate – here again there are several variants. At the bottom of the right-hand (take-up) film chamber is the catch which is designed to hold the spool in place, but which tends until one becomes very adept merely to prevent the take-up spool being loaded at all – the VP Exakta is anything but easy to load. The right-hand knob on the top-plate provides the shutter slow-speeds and delay-action settings. The cloth focal-plane shutter is clearly visible.

*Shot with Minolta SRT101 fitted with 55mm f/1.7 MC Rokkor on Ilford Pan F Plus, developed in Aculux and printed on Ilford Bromide.*

The restriction on wide-angle design was further complicated by the narrow-diameter (40mm) lens throat of the VP Exakta. Thus, even when retrofocus lenses which might have been adapted to the camera by enthusiasts did become available during the fifties, the throat was too narrow to accommodate them. This same problem of the narrow throat was also the reason for the lack of wide-aperture lenses of other than standard focal length. A special version of the VP Exakta B, known as the Night Exakta, was made available with an f/2 Biotar or an f/1.9 Primoplan.

No preset-diaphragm or (of course) automatic-diaphragm lenses were ever supplied for the VP Exakta series. Thus a VP Exakta is an inherently slow camera to use. For landscapes, still life or co-operative portrait subjects it is a workable proposition. For motor racing I would not recommend it.

Finally, it is worth noting, if you are by nature a camera collector who likes to categorize cameras precisely by model, that there is no absolutely fixed specification for any one model of VP Exakta. Like the Contax I, the VP Exaktas gradually evolved, acquiring improvements and variations as the designers and production team thought of them. To further complicate matters, the improvements were frequently added on a retrofit basis when cameras were returned to the factory for servicing, creating cameras with early numbers but late features.

VP Exakta B cameras are, for example, available with knob-wind (early) or lever-wind (late), and with the infinity catch at 9 o'clock or at 3 o'clock. Some have black-enamelled speed knobs, some alloy knobs, some polished steel. The pressure plates differ, as do the covers for the red window, the hood catch and all sorts of minor differences of trim.

## The VP Exakta models

The VP Exakta was initially launched with a 7.5cm standard lens which, although capable of being unscrewed from the body, was not strictly interchangeable. No lenses of other focal lengths were offered during the first year, and the thread by which the lens was attached was extremely fine in pitch (40mm × 0.5mm) and not intended for frequent interchanging of objectives.

This camera, known to collectors as an 'Original VP Exakta', is a scarce and very collectible piece of equipment. It can be identified by the fine lens thread. Supporting features include a red film-counter window on the back which has no cover (although this occurs on some later cameras) and a number below (approximately) 411,000. Shutter speeds were from 1/25th to 1/500th second plus B and Z (the equivalent of T or Time) without the many slow speeds or extensive delay-action capability of the later models. Desirable as it may be, an original Exakta is not a sensible camera to buy for photography, since it lacks versatility, is too valuable to risk in regular use and is likely to be even more frail mechanically than later VP Exaktas.

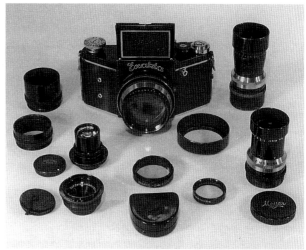

Each Night Exakta was supplied with a specially matched 80mm f/1.9 Primoplan of impressive dimensions. The size of the lens made it necessary for the camera to have a substantially larger focusing ring – compare the size of the knurled ring on this example with that on the ordinary VP Exakta B cameras on page 44. Some authorities assert that a Night Exakta with no number engraved on the focusing hood is a conversion (looked at kindly) or a fake (if one takes a more condemnatory view). I suspect that the Ihagee factory would have been quite prepared to provide such a conversion and that cameras like that illustrated here are as 'genuine' as a Leica II with a Leica Model A number – genuine factory conversions or, in the modern idiom, upgrades.

*Camera by courtesy of Dr A. Neill Wright. Shot during the seventies. No data on camera or lens available.*

The Night Exakta in this family group has, by contrast, its number engraved at the centre of the top edge of the focusing hood. Compare the camera with that in the last picture and you will see that this one has a black speed dial, a smaller hub for the lever-wind and long strap eyelets. In the picture with the camera are (to the left of the camera) Ihagee extension tubes, a 12cm f/6.3 Tele-Tessar and (in front) a 5.5cm f/8 Tessar with their respective caps. On the right of the camera are (at the back) an 18cm f/5.5 Tele-Megor and in front of it a 15cm f/5.5 Tele-Megor with its cap. Next to the lens on the camera is the hood for the 80mm f/1.9 Primoplan and typical Ihagee filters and a filter case or keeper are in front of the camera.

*Equipment by courtesy of Malcolm Glanfield. Shot with Topcon RE-2 fitted with 58mm f/1.8 RE-Topcor on Ilford Pan F Plus, developed in Aculux and printed on Ilford Bromide.*

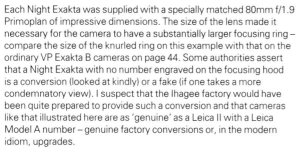

During 1934, Ihagee announced the Exakta A and Exakta B, together with a range of interchangeable lenses. The A was essentially the Original Exakta (no slow speeds) but with the new, coarser, lens thread of 40mm × 0.75mm and some minor cosmetic changes. The Exakta B, still with knob-wind, had added slow speeds from 1/10th second to 12 seconds and a variable delay-action facility set by winding the knob on the right-hand side of the camera and setting the delay required with the red figures, this time for up to 6 seconds. The 'fast' shutter-speed range of the VP Exakta B cameras that I have handled is unusual – 1/25th, 1/50th, 1/100th, 1/200th, 1/300th, 1/600th and 1/1000th – but is normal for early VP Exaktas. I understand that the 1/600th setting was replaced by the more normal 1/500th on later cameras.

At the 1935 Leipzig Fair, Ihagee introduced the VP Exakta B with lever-wind. During 1936, the VP Exakta C, essentially a B with an added plate back,

was launched on to a bemused market which even then seems to have regarded the camera as a retrograde step. Few were sold, and the VP Exakta C is a rare item. 1935 also saw the launch of the Night Exakta, essentially a VP Exakta B with a larger-diameter focusing grip to make it possible to focus when a larger-diameter lens was inserted. True Night Exaktas (as distinct from converted Exakta B cameras) can be identified by their serial numbers being engraved into the front of the focusing hood rather than into the focusing grip.

During 1936, a simplified VP Exakta A without the helical focusing mount or interchangeable-lens facility was introduced, initially under the name Ihagee Junior, although it later became the Exakta Junior. The 7.5cm f/3.5 Ihagee Anastigmat was extended by pulling out and twisting a draw-tube and had only front-cell focusing. Results were and are poor, but, because the camera is scarce, it can also be expensive.

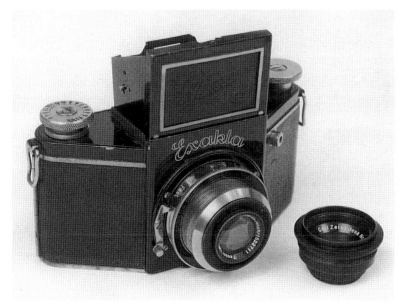

As mentioned in the caption on page 44, some VP Exaktas have the infinity catch on the focusing mount at 9 o'clock to the lens mount instead of at 3 o'clock. This is the black VP Exakta B illustrated there, shot from the other side to show this clearly. The slow-speeds and delay-action setting knob is also visible. Beside the camera is a very nice example of the 5.5cm f/8 Tessar, which is a scarce and desirable lens.

*Camera by courtesy of Mike Rees. Wide-Angle Tessar by courtesy of David Wilkinson. Shot with Pentax S1a fitted with 55mm f/1.8 Super-Takumar on Ilford Pan F Plus, developed in Aculux and printed on Ilford Bromide.*

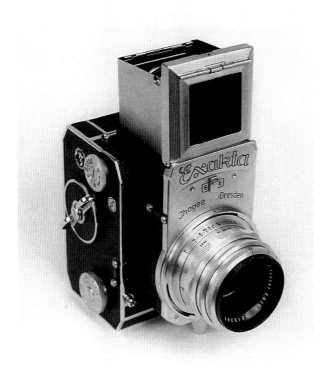

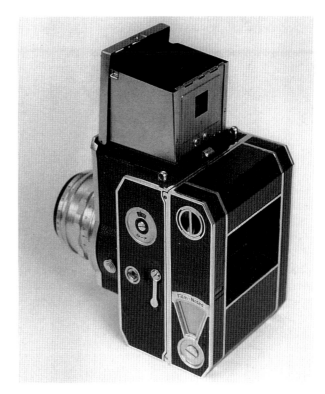

The very scarce post-war Exakta 66. Note the 'wing-nut' wind key, and the two speed dials similar to those on VP and 35mm Exaktas.

*Camera by courtesy of Dave and Julie Todd. Shot with Pentax Spotmatic fitted with 55mm f/1.8 Super-Takumar on Pan F Plus, developed in Aculux and printed on Jessop Variable Contrast.*

The rear view of the post-war Exakta 66. The 'magic' erasable notepad of this model is probably unique.

*Camera by courtesy of Dave and Julie Todd. Shot with Pentax Spotmatic fitted with 55mm f/1.8 Super-Takumar on Pan F Plus, developed in Aculux and printed on Jessop Variable Contrast.*

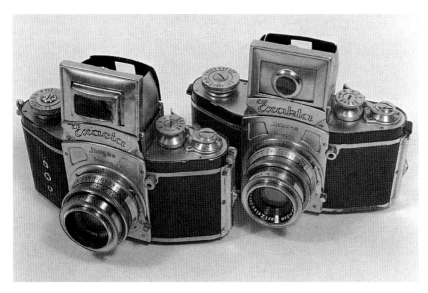

Another of those Exakta 'spot the difference' pictures. Two Kine Exaktas, but one is worth four or five times the value of the other. On the right is the rare first-type 'round-window' Kine Exakta, made only for a few months. On the left is the apparently common 'rectangular-window' Kine Exakta – but notice the spelling of the name on the scutcheon. This is not a pre-war second-type Kine Exakta but one of the scarce post-war cameras, possibly made from pre-war parts, which were made with 'Exacta' spelt with a 'c' for reasons that are less than clear (see page 53). Round-window Kine Exaktas have been sold for as much as £800 ($1,200), although the normal market price is less than that at the time of writing.

*Cameras by courtesy of Dr A. Neill Wright. Shot during the seventies. No data on camera or lens available.*

## VP Exakta lenses

Many fringe manufacturers produced or adapted lenses for the VP Exakta, particularly during the fifties when the camera had been discontinued. UK buyers in particular were starved of new equipment by import restrictions, so were hungry for British lenses mounted for the VP. It is difficult for any researcher to know where to draw the line and to define what is or is not a 'genuine' lens.

The list on page 49 is an effective, though probably not exhaustive, summary of the principal lenses which were available for the VP Exakta. One or two are so scarce that I do not know anyone who has had an example; others, like the 15cm f/5.5 Tele-Megor, are common and could be found at most large camera fairs.

For what it is worth, I have added to those of the lenses of which I have experience or reliable data a 'star rating'. Four stars mean good contrast and resolution, and the capability of producing results of publishable quality. One star means a lens whose results are barely acceptable. 'NDA' means 'No data available'. Where I do not have experience or data on a given lens mounted for Exakta, but have experience of a lens of the same name, focal length and period mounted for another camera, I have added a 'probably' rating, on the assumption that the Exakta lens was probably optically identical or at least very similar.

In this chapter and others where lenses are listed and referred to, I have normally defined the focal lengths of pre-war lenses in centimetres, as was the custom of the time, and those of post-war lenses in millimetres. Where the focal lengths of British or American lenses were always defined in inches, I have done the same, although in cases (such as the Dallmeyer Super Six) where the focal length was usually referred to in metric units, I have followed that pattern. My objective throughout has been to refer to lenses as they were referred to originally by users.

## Should you buy a VP Exakta to use?

It is more than ten years since, when writing my earlier book *Collecting and Using Classic Cameras* I ventured the opinion that virtually every VP Exakta was too worn to be an effective long-term tool for classic-camera photography. Since then, the cameras, like me, have become that much older, and I suspect, like me, even less mechanically reliable.

Nonetheless, there has been a rise in the popularity of true camera restoration – in which engineering refurbishment as well as cosmetic titivation is carried out – and there are examples of VP Exaktas which work well with a good chance of long-term reliability. To buy one of those would cost several hundreds of pounds, even if you can find a collector willing to liberate such a rare beast.

Buying unrestored VP Exaktas must be regarded as something of a lottery. If you are really determined, lash out and buy several after exhaustive research to

### VP Exakta lenses

#### Wide-angle lenses

| | |
|---|---|
| 5.5cm f/8 Wide-Angle Tessar | ★★★ |
| 5.6cm f/6.8 Meyer Wide-Angle Anastigmat | NDA |
| 6.0cm f/11 Dallmeyer Wide-Angle | NDA |

#### Standard lenses

| | | |
|---|---|---|
| 7.0cm f/3.5 Cassar | NDA | |
| 7.5cm f/3.5 Exaktar | ★★ | |
| 7.0cm f/3.5 Tessar | ★★★★ | |
| 7.5cm f/3.5 Tessar | ★★★★ | |
| 7.5cm f/3.5 Xenar | ★★★ | |
| 7.5cm f/3.5 Primotar | ★★ | |
| 7.5cm f/2.9 Cassar | NDA | |
| 7.5cm f/2.8 Tessar | ★★★ | |
| 7.5cm f/2.8 Xenar | ★★★ | |
| 7.5cm f/2.7 Makro Plasmat | NDA | (probably ★★★) |
| 8.0cm f/1.9 Primoplan | ★★ | (Night Exakta) |
| 8.0cm f/2.0 Biotar | ★★★ | (Night Exakta) |
| 8.0cm f/2.0 Xenon | ★★★ | (Night Exakta) |
| 8.0cm f/1.9 Dallmeyer Super Six | NDA | (Night Exakta) |
| 7.5cm f/3.5 Ihagee Anastigmat | ★ | |

#### Long-focus and telephoto lenses

| | | |
|---|---|---|
| 10.5cm f/4.5 Ihagee Anastigmat | NDA | (probably ★) |
| 10.5cm f/4.5 Exaktar (possibly the same lens as above) | NDA | (probably ★) |
| 12.0cm f/6.3 Tele-Tessar | ★★★ | |
| 15.0cm f/5.6 Dallon | ★★ | |
| 15.0cm f/5.5 Tele-Megor | ★★★ | |
| 15.0cm f/5.5 Tele-Xenar | ★★★★ | |
| 18.0cm f/6.3 Tele-Tessar | ★★★★ | |
| 18.0cm f/5.5 Tele-Megor | ★★★ | |
| 18.0cm f/5.5 Tele-Xenar | ★★★★ | |
| 24.0cm f/4.5 Tele-Xenar | NDA | (probably ★★★) |
| 25.0cm f/6.3 Tele-Tessar | NDA | (probably ★★★) |
| 25.0cm f/5.5 Tele-Megor | NDA | (probably ★★★) |
| 30.0cm f/5.6 Tele-Xenar | NDA | |
| 36.0cm f/5.5 Tele-Xenar | NDA | (probably ★★★) |

Exakta tele-lens adaptors in three versions for:

| | | |
|---|---|---|
| a) | All 7.5cm lenses except f/2.8 Tessar | NDA |
| b) | 7.5cm f/2.8 Tessar | NDA |
| c) | 8.0cm f/2 and f/1.9 lenses | NDA |

*Note:* Although I have no experience of the longer Tele-Tessars and Tele-Xenars mounted for VP Exakta and marked 'NDA' above, I have used various other Tele-Tessars and Tele-Xenars, probably of broadly similar specification but mounted for other cameras. I have yet to encounter an example of either type which is less than effective, and the probability is that all of these should have at least a ★★★ rating.

ensure that they do actually work without leaking light. Then, when one fails, you will still have the others to use – provided, of course, that you can still obtain the film. Repair of VP Exaktas is difficult and expensive, and you would need to find a repairer, probably through a collectors' organization, who had worked on VP Exaktas before to be sure of a worthwhile result.

## The Exakta 66

The original Exakta 66, which looked essentially similar to, although larger than, a chrome VP Exakta B, appeared in 1937 in Germany, but seems not to have been marketed elsewhere. This trapezoidal camera had a bayonet lens mount rather than the screw mount of the VP cameras, and a lever-wind on the base of the camera. Film spacing, unlike that of the VP Exaktas, was automatic once the first exposure had been positioned, which was a major advance in design. In this initial version, which I have never encountered, the wind lever was apparently 125mm long.

During the summer of 1939, just before the outbreak of the European war, a modified version of this camera with a shorter wind lever was imported into Britain and sold for a limited period before the war cut off supplies. The advertised standard lens options were as follows, although information is sadly lacking on which were actually sold to the public:

7.5cm f/3.5 TK Canter
8.0cm f/3.5 Tessar
8.0cm f/2.8 Tessar
8.5cm f/3.5 Exaktar
8.5cm f/3.5 Ihagee Anastigmat
8.5cm f/3.5 Primotar
10.0cm f/1.9 Primoplan
10.0cm f/2 Biotar

No accessory lenses were generally available, although Dr A. Neill Wright refers in his *Collectors' Checklist of Exakta and other Ihagee Cameras, Lenses and Accessories* to an advertisement found in a photographic magazine after the war which offered secondhand lenses for prewar Exakta 66 as follows:

6.5cm f/6.5 Wide-Angle Tessar
10.0cm f/2 Biotar
18.0cm f/6.3 Tessar

No official list of the intended range of additional lenses exists, as far as I am aware.

## The post-war camera

The trapezoidal Exakta 66, designed and produced before the Second World War, did not reappear after it. After a gap of some fifteen years, it was succeeded by an entirely different box-shaped camera, taller than it was wide, with some similarities in appearance to the later Japanese Kowa 6. Supplied always with a bayonet-mount 80mm f/2.8 Tessar with spring-loaded automatic preset diaphragm, the post-war Exakta 66 was a magnificently engineered camera whose very limited production was sold almost entirely in the United States. Not surprisingly, the camera is very rare in Europe, but much less scarce in the USA.

The cloth focal-plane shutter provided speeds, in the Exakta tradition, from 12 seconds to 1/1000th second, and variable delay action of up to 6 seconds. The shutter was wound with an unusual 'wing-nut' handle, which sprang back to its rest position after the wind was completed. The camera also had removable film chargers but lacked fully interchangeable magazine backs.

Other novel features were a split mirror which moved as two separate parts when the shutter was fired, this making possible a larger mirror and better screen coverage with long-focal-length lenses, and an erasable film-reminder panel like one of those 'magic pads' given to children, whose words are erased when a sliding bar separates the top surface from an adhesive carbon surface underneath it.

Launched apparently at the end of 1954 in the USA, the Exakta 66 was still available as a bargain-basement close-out during 1962, when it was priced at $130 (then about £46). Prices of cameras and lenses in 1957 were as follows:

| | |
|---|---|
| Exakta 66 with 80mm f/2.8 Tessar | $319.50 (approx. £114) |
| 135mm f/3.5 Meyer Primotar | $99.50 (approx. £35.10s.) |
| 180mm f/3.5 Meyer Primotar | $149.50 (approx. £53.8s.) |
| 400mm f/5.5 Meyer Primotar | $319.50 (approx. £114) |
| Ihagee bellows unit | $89.50 (approx. £32) |
| Ihagee extension tubes and adaptors | $46.00 (approx. £16.8s.) |

Few people ever get the chance to use an Exakta 66. The post-war camera is well built and was capable of first-class results in its day. However, both the pre- and the post-war Exakta 66 cameras have a reputation for unreliability, and it would probably not be sensible to try to make much use of either.

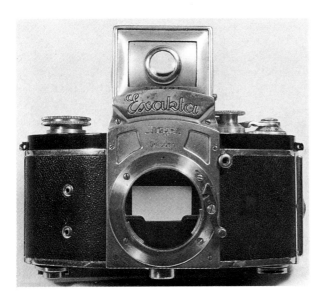

The more one looks at the original Kine Exakta, the clearer it becomes that, regardless of whether it or the Sport came first, the Kine Exakta is the true forebear of the 35mm SLR. This picture shows clearly the lens mount and lens catch and also the shape of the mirror inside the camera.

*Camera by courtesy of Dr A. Neill Wright. Shot during the seventies. No data on camera or lens available.*

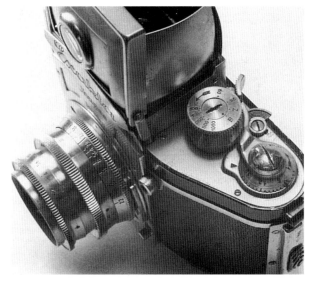

The compact design of the lever-wind, speed-setting dial and rewind lever are clearly shown in this view of the top-plate of the original round-window Kine Exakta. Note the curved plates from which the viewfinder hood is constructed.

*Camera by courtesy of Dr A. Neill Wright. Shot during the seventies. No data on camera or lens available.*

## The Kine Exakta – the world's first 35mm SLR

The Kine Exakta was undoubtedly one of the great landmark cameras of the twentieth century, comparable in its importance with the first Leica. Already committed from 1933 to the VP Exakta series, Ihagee recognized the trend towards precision 35mm cameras and built upon the successful design base of the VP camera. Not surprisingly, the Kine Exakta bore a strong resemblance to the 127 rollfilm camera when it was launched in 1936.

Like the VP Exakta, it had internal bulb-flash synchronization (although with what we would now regard as a non-standard synchronization socket). Flash bulbs (Sashalites in the UK, Photoflash lamps in the USA) had been marketed for the first time as recently as 1930. Ihagee therefore offered a significant advance, particularly for professional wedding and banquet photographers, when they included internal flash synchronization as part of the VP Exakta specification. Ihagee marketed their own Vakublitz bulb

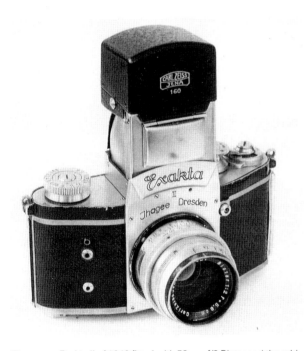

The scarce Exakta II of 1949 fitted with 58mm f/2 Biotar and the odd-looking Zeiss clip-on eye-level viewing prism that preceded the true pentaprism of the Exakta Varex V.

*Camera and picture by courtesy of Mike Rees. Shot with Contarex Cyclops fitted with 50mm f/2 Planar on Pan F Plus, developed in Acutol and printed on Jessop Variable Contrast.*

flash guns, and late examples of the second type (rectangular window) Kine Exakta were equipped with a socket to which the Mark II Vakublitz could be fitted, directly to the camera, with an attachment screw below the slow-speed knob.

The Kine Exakta also emulated the VP Exakta B in having an extended range of slow shutter speeds to 12 seconds and variable delay action of up to 6 seconds. The range of 'fast' speeds was, however, different: 1/25th, 1/50th, 1/100th, 1/150th, 1/250th, 1/500th, 1/1000th second. The Kine Exakta thereby joined a select group of cameras, including the Contax I and the twin-lens Contaflex, whose shutter included a speed of 1/150th second.

Perhaps regrettably, the Kine Exakta also emulated the VP Exakta in having a narrow lens throat, which, during the pre-war period at least, greatly limited the potential for the fitting of wide-angle lenses.

Fortunately for the modern classic-camera user, however, Ihagee did not carry forward into the 35mm Kine Exakta either the screw lens mount of the VP Exakta series or the clumsy 'wind and click' integral focusing mount that bedevils the VP. Instead, a new, neat and easy-to-use bayonet lens mount made its appearance, to which lenses equipped with conventional helical focusing mounts were fitted.

Because the new bayonet lens mount continued to be used, unchanged except in minor details, for 35mm Exakta and Exa cameras into the seventies (in the case of Exakta) and until about 1990 (in the case of the Exa), virtually all the Exakta post-war lenses, including the wide-angles, will fit a pre-war Kine Exakta. There is also an enormous range of post-war preset independent lenses still available with Exakta mounts, often at ridiculously low prices yet capable of delivering astoundingly good results.

Initially, the fold-up focusing magnifier in the hood of the Kine Exakta was circular. Since this magnifier is visible when collapsed into the front of the hood, this first model has become known to collectors as the 'round-window' Kine Exakta. Only some six thousand of these were made during 1936 and 1937, and the round-window camera is therefore scarce and much prized by collectors. The 'rectangular-window' camera succeeded it in November 1937, and some 24,000 of these were manufactured before a point during 1940 when a switch of production to specialized instruments for the German armed services ended Exakta production for the duration of the war.

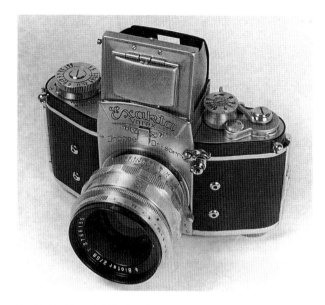

The Exakta Varex (or V in the USA) introduced the interchangeable viewfinder in 1950. This is the slightly modified Exakta Varex VX of 1951, which is an extremely usable camera. The lens on this camera is a 58mm f/2 manual preset Biotar.

*Camera by courtesy of Dr A. Neill Wright. Shot during the seventies. No data on camera or lens available.*

The operator's-eye view of the Harwix Examat mounted on the same camera as in the picture below left. The switch at top left activates the meter.

*Shot with Pentax S1a fitted with 55mm f/1.8 Super-Takumar on Ilford Pan F Plus, developed in Aculux and printed on Ilford Bromide.*

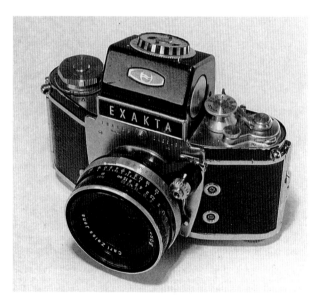

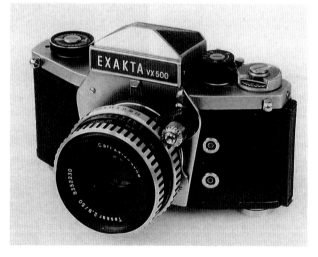

The very last Exakta made in Dresden – the Exakta VX500. Like the Exakta VX1000 of which it is a simplified 'budget' version, the VX500 was designed in the spirit of the earlier cameras, but is different in many ways. Note the altered shape of the ends of the body and the absence of the slow-speeds setting dial.

*Camera and picture by courtesy of Mike Rees. Shot with Contarex Cyclops fitted with 50mm f/2 Planar on Ilford Pan F Plus, developed in Aculux and printed on Ilford Multigrade III.*

This Exakta Varex IIa (late type) is fitted with the Harwix Examat TTL metering prism, which replaces the normal prism or waist-level finder. The battery cover is visible on the right of the meter prism as we look at it.

*Shot with Pentax S1a fitted with 55mm f/1.8 Super-Takumar on Ilford Pan F Plus, developed in Aculux and printed on Ilford Bromide.*

Following the Soviet occupation of East Germany, Kine Exakta production resumed in Dresden during 1946. Many (if not all) of these post-war cameras, prior to the modified Exakta II of 1949, had the word 'Exakta' on the front scutcheon spelt 'Exacta'. Opinions differ as to whether these were made for export to the USA (where they were certainly advertised for sale by Sterting-Howard for $147.50 (then equivalent to £52.13s.6d) with f/2 Biotar in July 1950) or whether they were intended for the USSR as part of war reparations. Possibly both versions are true, since the Soviet Union may have re-exported some to the USA to earn hard currency.

Pre-war prices for Kine Exakta cameras in Britain, taken from the Garner and Jones catalogue of 1938, were as follows (the approximate price in US dollars being shown at the then rate of exchange):

| | |
|---|---|
| Kine Exakta with 5.4cm f/3.5 Exaktar | £27.10s. (approx. $137.50) |
| Kine Exakta with 5.0cm f/3.5 Tessar | £34.10s (approx. $172.50) |
| Kine Exakta with 5.8cm f/1.9 Primoplan | £45 (approx. $225) |
| Kine Exakta with 5.8cm f/2 Biotar | £55 (approx. $275) |

*Kine Exakta lenses*

Three levels of lens quality were available for the Kine Exakta – low-specification three-element Ihagee standard lenses to provide the lowest entry price, Meyer lenses to make available a broad spread of capability at a comparatively modest price, and the Zeiss and Schneider lenses to offer the moneyed purchaser the best performance then available. All had only simple diaphragms and were uncoated, since coating technology did not exist until Zeiss first coated lenses during 1941. From a collecting and originality standpoint, one should perhaps therefore always seek examples of pre-war lenses which are uncoated. However, results from most of the pre-war lenses benefit greatly from coating, particularly in the cases of the more complex large-aperture designs, such as the 5.8cm f/2 Biotar. If your intention is to use the lenses to produce pictures, and you hope to emulate modern standards, an unscratched coated pre-war lens will produce brighter results with better contrast than its uncoated equivalent. Some collector/users aim to have both, cherishing not only a near-mint uncoated lens to put on to the camera for display but also a coated example to use when the camera is actually required to perform.

*Lenses available before the Second World War*

Once again, I have used the 'star rating' system where I have some experience of or information upon the lens. 'NDA' again means 'no data available'.

---

**Pre-war lenses for 35mm Exakta models**

***Wide-angle lenses***

| | |
|---|---|
| 4.0cm f/4.5 Wide-Angle Tessar | NDA |
| 4.0cm f/4.5 Wide-Angle Anastigmat | NDA |

***Standard lenses***

| | |
|---|---|
| 5.0cm f/3.5 Tessar | ★★ |
| 5.0cm f/2.8 Tessar | ★★ |
| 5.0cm f/2.8 Xenar | ★★ |
| 5.0cm f/2.0 Xenon | ★★ |
| 5.4cm f/3.5 Exaktar | NDA (probably ★) |
| 5.8cm f/2 Biotar | ★★ |
| 5.8cm f/1.9 Primoplan | NDA (probably ★★) |
| 5.8cm f/1.9 Dallmeyer Super Six | ★★ |

***Long-focus and telephoto lenses***

| | |
|---|---|
| 7.5cm f/1.9 Primoplan | NDA |
| 8.5cm f/4.0 Triotar | ★★ |
| 10.0cm f/5.6 Tele-Dallon | ★★ |
| 10.5cm f/2.8 Trioplan | ★★ |
| 10.5cm f/2.7 Makro-Plasmat | NDA (probably ★★) |
| 12.0cm f/4.5 Trioplan | NDA (probably ★★) |
| 13.5cm f/4 Triotar | ★★ |
| 15.0cm f/5.6 Tele-Dallon | NDA |
| 15.0cm f/5.5 Tele-Megor | ★★ |
| 18.0cm f/5.5 Tele-Megor | ★★ |
| 18.0cm f/6.3 Tele-Tessar | ★★ |
| 25.0cm f/5.5 Tele-Megor | ★★ |
| 25.0cm f/6.3 Tele-Tessar | NDA (probably ★★) |
| 50.0cm f/8.0 Fern Long Distance | NDA (probably ★★) |

---

**The post-war 35mm Exaktas**

The first truly post-war Exakta appeared during 1949, still essentially similar to the pre-war Kine Exakta. Known as the Exakta II, the new camera had a hinged cover which shielded the rectangular magnifier, a different rewind lever and other minor changes, but was in all important details the pre-war camera.

An important introduction was the launch of a clip-on pentaprism which fitted on to the erected viewfinder hood. Also suitable for the earlier Kine Exakta model, the pentaprism gave the Exakta a right-way-round, right-way-up eye-level image for the first time

**Post-war Exakta models**

| | Intro. date | Key features |
|---|---|---|
| Kine Exakta (post-war) | 1948 | Some have 'Exacta' spelt with a 'c'. |
| Exakta II | 1949 | 'II' on scutcheon. Cover over magnifier at front of hood. |
| Exakta Varex V | 1950 | Removable screen. Interchangeable prism/waist-level finder with overall chrome finish to the prism. Hinged back. 'Varex' on scutcheon (not USA). Electronic flash synchronization. |
| Exakta Varex VX | 1951 | More enclosed but not fully (Exakta VX in USA) enclosed exposure counter. Removable hinged back. Die-cast body. 'Varex' or 'VX' on scutcheon. |
| Exakta Varex VX (Exakta VX in USA) | 1956 | Fully enclosed exposure counter. Standard 3mm coaxial flash sockets. Two leather inserts on prism. |
| Exakta Varex II (VX II in USA) | 1957 | Additional 1/50th speed setting. Exakta name engraved and filled-in in black. |
| Exakta Varex IIa (VX IIa in USA) | 1958 | Name and 'Varex IIa' in script on bright chrome plate above finder catch. 1/150th deleted. Overall chrome finish to prism. |
| Exakta Varex IIa (VX IIa in USA) | 1961 | Name 'EXAKTA' in upper-case Roman (not script), white on black. 'Varex' or 'VX' engraved one side of finder catch; 'IIa' other side. Three leather inserts on a more flatly shaped prism. |
| Exakta Varex IIb (VX IIb in USA) | 1963 | New range of shutter speeds – 1/30th, 1/60th, 1/125th, 1/250th, 1/500th, 1/1000th. No finder catch. Prism or waist-level finder just lifts out. |
| Exakta VX1000 | 1969 | A substantial redesign, although cosmetically similar to the previous cameras. The first Exakta with instant-return mirror. |
| Exakta VX500 | 1970 | Essentially, a VX1000 with a top shutter speed of only 1/500th and no slow speeds. |
| Exakta RTL1000 | 1970 | A totally different camera of design similar to the Praktica VLC series, whose prism and metering head it accepts. |

but, as the picture shows (page 51) it looked strange and insecure and was not destined to last.

Ihagee had little option but to offer a true prism viewfinder, since Zeiss Ikon in Dresden had achieved a major world marketing coup with the announcement of the Contax S during 1948. Arguably the world's first eye-level pentaprism SLR, the Contax S effectively made waist-level viewing in 35mm SLRs obsolescent from the moment it appeared early in 1949 (see Chapter 4).

A year later, in the spring of 1950, Ihagee produced its real answer to the Contax S in the form of the Exakta Varex V, known as the Exakta V in the USA because of trade-marks problems with Argus. The Varex V introduced the removable focusing screen for the first time, together with a genuinely interchangeable waist-level viewfinder and pentaprism. The camera can be identified by the word 'Varex' on the scutcheon ('V' on examples originally marketed in the USA). It was the first 35mm Exakta with electronic flash synchronization and the first with a hinged back. The combined benefits of electronic flash synchronization and interchangeable focusing screens provided a powerful boost for the Exakta's position in the scientific and laboratory photography market.

New Exakta models followed thick and fast. It has to be beyond the scope of this book to provide exact details of every small change of specification, since they are adequately identified in other books listed in the bibliography. Therefore the summary on the left merely provides the basic information concerning the various Exakta models made in Dresden by Ihagee (excluding the rare 'West German Exakta' of 1963 and the 'Exakta Real' of 1967 and the Japanese-made cameras marketed as 'Exaktas' during the seventies). It is intended to make identification and dating possible for potential collectors.

## The Exa range

The Exa cameras were in most respects, other than their Exakta lens mount, totally different cameras from the same factory, although designed as lower-priced cameras to provide Exakta owners with a second body for their lenses at a modest figure.

There were two quite distinct lineages of Exa. The Exa I series has a simple vertical-running shutter of which the mirror mechanism forms part, a limited range of speeds and a very limited practical lens range,

## The Exa series

| | Intro. date | Key features |
|---|---|---|
| Exa I (Exa Ia in USA) | 1950 | Vertical shutter 1/25th – 1/150th. Speeds set with lever moving front to back on top of camera. Fixed waist-level finder. Inscribed nameplate. |
| Exa I | 1961 | As above, but nameplate has name in silver letters on black. |
| Exa I (Exa Ib in USA) | 1962 | Redesign with conventional shutter-speed dial, interchangeable finders (takes finders of Varex IIb onwards) and speeds 1/30th–1/175th. Single flash contact. |
| Exa Ia (Exa Ic in USA) | 1964 | Lever-wind, detachable back. |
| Exa Ib | 1977 | As Ia, but has 42mm screw lens mount. |
| Exa Ic | 1987–92(?) | Redesigned all-black camera with greater use of plastics. |
| Exa II | 1959 | True focal-plane shutter, speeds 1/2 sec. – 1/250th. Fixed prism. |
| Exa IIa | 1963 | Body similar to that of Exa I. |
| Exa IIb | 1965 | Instant-return mirror. Warning signal in finder shows film not wound. |
| Exa 500 | 1967 | Fully auto diaphragm, Fresnel screen with microprism, shutter speeds 1/2 sec. – 1/500th. |

since focal lengths greater than 100mm cause severe cut-off of part of the picture. The Exa II series has a conventional cloth focal-plane shutter, a pentaprism and normal lens interchangeability.

Both have a curiously narrow and tall shape which seemed old-fashioned even when the cameras were introduced. Many Exakta enthusiasts enjoy their Exas and produce effective results with them. I cannot claim to be one of them. However, the Exa I series achieved the remarkable distinction of being in production for at least 42 years with few changes of basic design, a record probably unmatched by any 35mm SLR. Even the redoubtable rangefinder Leica with screw lenses was manufactured only for some 35 years, and with a far greater development of specification. As a workhorse, particularly for routine laboratory photography, the Exa I series had few equals, producing high-quality results at a fraction of the capital cost of its West German or oriental rivals.

The Exa cameras are therefore worthy of consideration in their own right. Sound examples of the various

Exa models continue to be reliable and effective cameras in use, provided that the work falls within their limitations. Both series, with the obvious exception of the (European) Ib and Ic models, take standard Exakta lenses.

## Buying a 35mm Exakta or Exa

The 35mm Exaktas have lasted better than their rollfilm cousins, and it is not uncommon to find a pre-war Kine Exakta that is capable of delivering good results consistently. Their long-term reliability must, however, be questionable. Most collectors prefer to use a sound post-war camera – perhaps a Varex IIb or VX1000 – and then add one or two older cameras for occasional use to give the feel of the range.

Good Exaktas of the fifties and sixties are the basis of a reliable, low-cost camera outfit capable of extraordinary versatility and high-quality results. However, if you find bad examples, they are expensive to repair.

The commonest problems with the Varex series of cameras are sluggish lens diaphragms, stiff or worn focusing mounts, slack or crumpled shutter blinds and the usual range of focal-plane shutter problems, notably tapering at the high shutter speeds. Fortunately, all these are easy to check – see Chapter 2.

It is important to check the slow-speed mechanism. People not used to Exaktas tend to take the slow speeds for granted because they cannot figure out how to set them. This is unwise, since problems related to slow-speed function are a frequent cause of Exakta shutters jamming altogether.

To set slow speeds, set the normal shutter-speed dial on the left of the camera to B or T and wind the slow-speed knob on the right of the top-plate by twisting it clockwise as far as it will go. Next, lift the rim of the slow-speed knob and turn it so that the time you want to set in black figures is opposite the dot on the rim of the knob. When you press the release button, the shutter should open, stay open for the time set, then close. Slow speeds of up to 12 seconds are available. For delay action using any speed from 1/30th to 1/1000th, set the shutter speed required on the shutter-speed dial, wind the slow-speed knob, and set the delay required by adjusting the mark on the slow-speed dial rim against the appropriate red figure. Set it (for example) to 4 in red, and you should, when you press the shutter release, get a 4-second delay followed by the normal exposure.

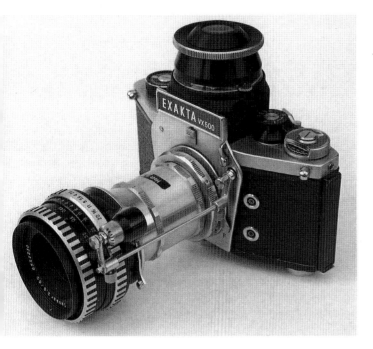

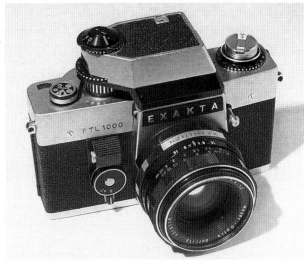

Exakta extension tubes, when used for close-up photography with a lens equipped with fully automatic diaphragm, need a means of transmitting the pressure from the release button on the lens to the shutter release on the camera. The solution is the Exakta shutter-release extension set shown here. In place of the normal prism or waist-level viewfinder, this camera is fitted with the Magnear viewfinder magnifier. The camera lens bayonet mount of the Magnear can just be seen below the standard magnifier which is fitted in this picture.

*Camera and picture by courtesy of Mike Rees. Shot with Contarex Cyclops fitted with 50mm f/2 Planar on Ilford Pan F Plus, developed in Aculux and printed on Ilford Multigrade III.*

The Exakta RTL1000 represented a total departure from the traditional Exakta shape and mechanical design. Often represented (even by me in my earlier book) as being derived from the Praktica VLC series, it in fact appeared some time before the Praktica VLC, but was undoubtedly the result of a common design process. However, unlike the Praktica, it has two shutter-release buttons, one on the right, the other on the left. Together with an Exakta bayonet mount, this made it possible to use earlier Exakta FAD lenses as well as the internally coupled automatic-diaphragm lenses specifically supplied for the RTL1000.

*Camera by courtesy of Don Baldwin. Shot with Topcon RE-2 fitted with 58mm f/1.8 RE-Topcor on Ilford Pan F Plus, developed in Aculux and printed on Ilford Bromide.*

## Exakta lenses post-war

There is a startling number of lenses available cheaply to fit 35mm Exakta cameras. The 'official' ranges of Zeiss, Meyer, Schneider and Steinheil lenses are easy to find and are little sought after, but there were also dozens of different independent preset 'T-mount' and automatic-diaphragm lenses available. These are always available cheaply at camera fairs: as an example I recently bought a preset 135mm f/3.5 Vivitar in Exakta T mount for £3 (yes, three pounds, or less than five dollars) and an 'official' 30mm f/3.5 Lydith for £8 ($12). Photographs taken with both are included at the end of this chapter. In each case, the performance would do credit to a lens costing ten or twenty times what I paid for them.

The list of lenses opposite, as the above comments will suggest, is far from exhaustive, and sets out simply to summarize the lenses which were catalogued by Ihagee at various times. Hundreds of other types of lenses to fit Exakta have been sold. In preparing the list, I am indebted to Dr A. Neill Wright, upon whose *Collectors' Checklist of Exakta and other Ihagee Cameras, Lenses and Accessories* I have relied for some of the information. Note that 'FAD' stands for fully automatic diaphragm.

T2 mounts for interchangeable-mount preset lenses were and are plentiful. There are Soligor T4 and early Tamron Adaptamatic mounts which make it possible to fit independent automatic-diaphragm interchangeable-mount lenses to Exaktas, but they are not easy to locate.

## Official post-war lenses for Exakta

### Wide-angle lenses

| | |
|---|---|
| 20mm f/4 Flektogon (FAD) | ★★★★ |
| 25mm f/4 Flektogon (FAD) | ★★★★ |
| 29mm f/2.8 Orestegon (FAD) | ★★ |
| 30mm f/3.5 Lydith (simple manual diaphragm) | ★★★★ |
| 35mm f/2.8 Flektogon (FAD) | ★★★★ |
| 35mm f/2.8 Makroflektogon (focus to 4") | NDA (probably ★★★★) |
| 35mm f/4.5 Primogon (simple manual diaphragm) | NDA |
| 40mm f/4.5 Tessar | NDA (probably ★★★) |

### Standard lenses

| | |
|---|---|
| 50mm f/3.5 Primotar-E (FAD) | NDA (probably ★★★) |
| 50mm f/2.9 Trioplan | ★ |
| 50mm f/2.9 Meritar (manual preset diaphragm) | ★★ |
| 50mm f/2.8 Primotar (manual preset diaphragm) | NDA (probably ★★) |
| 50mm f/2.8 Domiplan (FAD) | ★★ |
| 50mm f/2.8 Tessar (some marked 'T' instead of Tessar or 'aus Jena', for trade-mark dispute reasons; variously manual, preset, automatic preset, FAD and sunk mount for bellows) | ★★★★ |
| 50mm f/2 Exaktar (FAD – listed for Exa II in 1967) | NDA |
| 50mm f/2 Domiron (FAD) | NDA |
| 50mm f/1.8 Oreston (FAD) | ★★★ |
| 50mm f/1.8 Pancolor (FAD) | ★★★★ |
| 55mm f/2 Biotar (variously manual, preset [1952], automatic preset [1953] and FAD) | ★★★★ |
| 58mm f/2 Biotar (variously manual, preset and automatic preset) | ★★★★ |
| 58mm f/1.9 Primoplan (preset) | ★★ |

### Long-focus and telephoto lenses

| | |
|---|---|
| 75mm f/1.9 Primoplan (preset) | NDA |
| 75mm f/1.5 Biotar (manual, then preset) | NDA (probably ★★★) |
| 80mm f/3.5 Primotar (manual) | NDA |
| 80mm f/2.8 Biometar (preset, then FAD) | ★★★ |
| 80mm f/2.8 Tessar (manual) | ★★★ |
| 100mm f/2.8 Orestor (FAD) | ★★★ |
| 100mm f/2.8 Trioplan (manual, then FAD) | ★★ |
| 100mm f/2.8 Trioplan-N (high-refractive-index version of above lens, FAD) | NDA (probably ★★★) |
| 105mm f/4.5 Bonotar (manual) | NDA (probably ★) |
| 120mm f/2.8 Biometar (FAD) | ★★★★ |
| 135mm f/3.5 Primotar (manual) | NDA |
| 135mm f/2.8 Orestor (manual) | ★★★ |
| 135mm f/4 Kine Triotar (1950) | NDA |
| 135mm f/4 Triotar (manual, then FAD) | ★★ |
| 135mm f/4 Sonnar (manual, then FAD) | ★★★★ |
| 150mm f/5.5 Tele-Megor (manual, early post-war) | ★★ |
| 180mm f/6.3 Tele-Tessar (manual, early post-war) | ★★★ |
| 180mm f/2.8 Sonnar (FAD) | ★★★★ |
| 180mm f/3.5 Primotar (manual) | NDA |
| 180mm f/5.5 Tele-Megor (manual) | ★★ |
| 200mm f/4 Orestegor (manual) | ★★★ |
| 250mm f/5.5 Tele-Megor (manual) | ★★★ |
| 300mm f/4 Sonnar (manual, then preset) | ★★★★ |
| 400mm f/5.5 Tele-Megor (manual) | ★★★ |
| 500mm f/8 Fern (manual) | NDA (probably ★★★) |
| 500mm f/5.6 Orestegor (manual) | NDA |

## A word about Exakta accessories

The extensive range of accessories marketed during the fifties and sixties for the 35mm Exaktas rivals that of the Leica system. Sixteen different types of focusing screen, three different through-the-lens (TTL) exposure-meter prisms (if one includes that for the Exakta RTL 1000), lenses with built-in exposure meters, stereo equipment, two different kinds of microscope adaptor, and a quite remarkable spread of equipment for close-up photography were offered, as well as the usual and expected ranges of filters.

The two types of CdS TTL metering prisms which fitted the Varex series of cameras were the Schacht Travemat and the Harwix Examat, the latter being by far the more expensive unit when new. Regrettably, neither is particularly reliable, and it is unusual to find an Examat prism metering head which works properly.

The Magnear finder was and is probably unique among SLR viewfinder systems in that it is a vertical finder to which an Exakta camera lens can be fitted via the normal Exakta bayonet fitting to act as a magnifier for the viewfinder image. A 50mm lens is best for this, since it gives the greatest magnification while retaining a view of the whole focusing screen. Lenses of 40mm or less crop the image; lenses of focal lengths greater than 50mm enable one to see the whole screen, but with progressively less magnification.

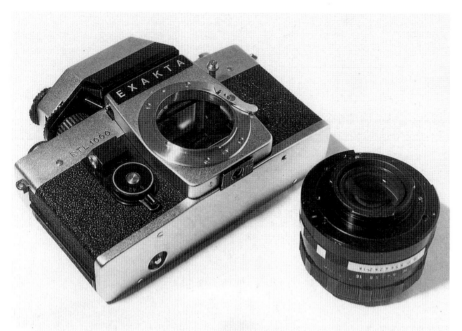

When the standard 50mm f/1.8 lens is removed from the Exakta RTL1000, it becomes possible to see the conventional Exakta bayonet lens catch. Note the simple variable delay action which provides some of the capability of earlier Exaktas with much simpler setting.

*Camera by courtesy of Don Baldwin. Shot with Topcon RE-2 fitted with 58mm f/1.8 RE-Topcor on Ilford Pan F Plus, developed in Aculux and printed on Ilford Bromide.*

The external automatic-diaphragm coupling of the FAD lenses introduced a problem when extension tubes were used for close-up work. Since pressure had to be applied to the arm of the lens for the diaphragm to be stopped down to the working aperture before the shutter was fired, the shutter had to be fired from the lens. To transmit this pressure from the lens several centimetres forward of the shutter button, Ihagee supplied a complicated system of rods which were used to link the lens arm to the shutter button. This is best explained with a picture – see page 56.

Then there was the extraordinarily versatile Vielzweck multipurpose bellows and copying system. When complete, this consisted of a copying stand with wooden baseboard, a focusing slide, a magnificently sturdy bellows unit and a transparency copier. For copying work it is unsurpassed.

It has to be beyond the scope of this book to list all the accessories. Suffice it to say that, if you like assembling toolkits of working accessories, you will love playing with an Exakta outfit.

## Using a 35mm Exakta

Using Exaktas takes practice. To a photographer used to a Pentax, a Nikon or a Praktica, an Exakta feels unbalanced and has all the controls where one would least expect to find them. What other camera

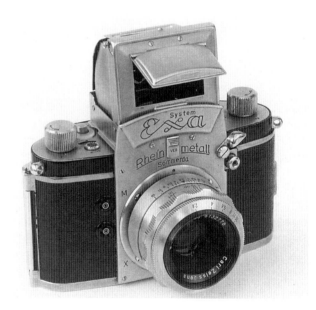

The scarce and desirable (at least from the collecting standpoint) Rheinmetall Exa. The manufacture of this batch of 1962-type Exa I cameras with interchangeable viewfinder hood was sub-contracted by Ihagee to Rheinmetall. Reputedly, the experiment was less than successful and Ihagee had to reassemble the cameras to ensure that they were suitable for sale. This example is photographed with its screen magnifier raised and its direct-vision viewfinder open ready for use.

*Camera and picture by courtesy of Mike Rees. Shot with Nikon F fitted with 55mm f/3.5 Micro-Nikkor on Ilford Pan F Plus, developed in Aculux and printed on Jessop Variable Contrast.*

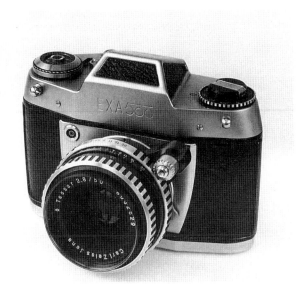

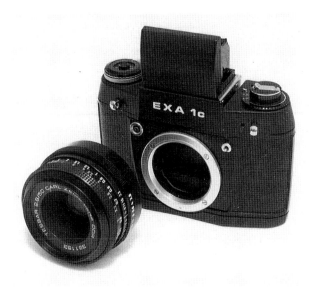

Last of the Exa II series was the Exa 500 of 1967, which had a fully speeded shutter from 1/2 second to 1/500th, a microprism focusing screen and other features which lifted its specification into the normal realms of SLR design of the time.

*Camera and picture by courtesy of Mike Rees. Shot with Nikon F fitted with 55mm f/3.5 Micro-Nikkor on Ilford Pan F Plus, developed in Aculux and printed on Jessop Variable Contrast.*

The Exa I series of cameras was in continuous production for an incredible 42 years, from 1950 until 1992. This is the very last Exa, the Exa Ic, which like the immediately previous model, the Ib, had the M42 screw lens mount instead of the Exakta bayonet. The 50mm f/2.8 Tessar has been removed to show the screw mount.

*Camera by courtesy of Mike Rees. Shot with Yashica FX-1 fitted with 55mm f/2 Yashica DSB on Ilford FP4 Plus, developed in Aculux and printed on Jessop Variable Contrast.*

combines a shutter release for the left hand with a rewind button on the top-plate and the slow speeds and delay action set from the same knob? What other camera draws blood when you lovingly check the smoothness of the film track and catch your thumb on the end of the built-in film-cutting knife?

I would not recommend anybody to use one occasionally as one of a spread of different cameras, since the results will be discouraging. Because I have always enjoyed using as many different cameras as possible, I am not a natural with an Exakta.

Equally, I would recommend the Exakta or Exa to any classic-camera user prepared to concentrate on it and use it as his or her main camera, particularly if they have limited funds and provided that the camera has been thoroughly checked and works properly. It may be eccentric, but like many notable eccentrics, it is capable of results which surprise and delight.

Walking with my wife in a lane on Romney Marsh, Kent, during early September 1994, I realized that we were about to get wet. There seemed no point in hurrying, so we bowed to the inevitable and took pictures of the approaching thunderstorm with the VP Exakta I was carrying. This particular camera, like several other VP Exaktas I have tried, has a tendency to put small scratches on the film – hence the slight blemish just above the horizon.

*Shot with VP Exakta B fitted with 75mm f/3.5 Tessar, exposure 1/100th at f/5.6, on Verichrome Pan, developed in Aculux and printed on Ilford Multigrade III using 80M filtration for the foreground and 0M/10Y for the sky to emphasize the clouds. Camera by courtesy of Mike Rees.*

The stunning detail of this picture, shot during the annual Tunbridge Wells sedan-chair races during August 1994, is a tribute to what can be bought for very little, for this shot was obtained using a 30mm f/3.5 Lydith bought for just £8 (about $12) at the Tunbridge Wells camera fair three weeks earlier. Because of the need for a high shutter speed and a relatively small aperture, it was shot on HP5 rated at 400 ASA.

*Shot with Exakta RTL1000, TTL metering prism, fitted with 30mm f/3.5 Lydith with manual diaphragm, exposure 1/500th at f/8, on Ilford HP5, developed in Aculux and printed on Multigrade III. Camera body by courtesy of Don Baldwin.*

Candid pictures of children busy with their interests often work well. My daughter Emma was very excited by insects and small organisms found in ponds, and used to filter pond water and put the resulting finds under my microscope. Here, the VP Exakta has caught her discovering her latest batch of specimens during 1978. Notice how the water dripping from the spout of the jug has been arrested in mid-air.

*Shot with VP Exakta B fitted with 75mm f/3.5 Tessar, exposure about 1/500th at f/4, on Kodak Verichrome Pan, printed on Ilford Multigrade III.*

A home studio portrait of Rob Baker (below left) shot in a bedroom with a velvet non-reflective backdrop and three Courtenay flash-heads. The focus, as so often with my Exakta shots, is not quite precise, but the overall effect is pleasing.

*Shot with Exakta Varex IIa fitted with 50mm f/2.8 Tessar, exposure 1/30th at f/8, on Ilford FP4 Plus, developed in Aculux and printed on Ilford Multigrade III.*

Below is an enlargement from a comparatively small section of an Exakta negative of Olivia Horlick, again shot in makeshift home studio conditions. The background for this was a sheet of brown Colorama paper.

*Shot with Exakta Varex IIb fitted with 50mm f/2.8 Tessar, exposure 1/30th at f/8, on Ilford FP4 Plus, developed in Aculux and printed on Ilford Multigrade III.*

Amelia Joyce photographed with the 135mm f/3.5 preset T2 Vivitar mentioned on page 56 and bought for just £3 ($4.50) at a camera fair. The shot was taken with the bargain lens on an Exakta Varex IIb, and was lit with three Courtenay flash-heads, using brollies to soften the light.

*Shot with Exakta Varex IIb fitted with 135mm f/3.5 T2 preset Vivitar on Ilford FP4 Plus, developed in Aculux and printed on Ilford Multigrade III.*

# Chapter 4

## Innovation and bargain prices from Eastern Europe

A minor consequence of the collapse of the Soviet Union was the sudden appearance at Western European camera fairs and collectors' meetings of a large number of comparatively unknown Soviet-made cameras. Some of the more impetuous collectors spotted elderly cameras which they had never seen before and paid huge prices for them, not realizing that there were hundreds more like that waiting to come over and bring the prices down.

The Soviet camera industry had, since the Second World War, made up for what it frequently lacked in quality with impressive quantity. Some Soviet models, notably the Zorki, Fed and Kiev rangefinder camera series, the Lubitel twin-lens reflex and some of the long series of Zenit SLRs, had been marketed extensively in Western Europe and the USA at heavily subsidized prices. Others, like the Start (Cmapm) of 1958, loosely derived from the 35mm Exakta series, and the remarkable 16mm Narciss (Hapyucc) were innovative SLRs which, although not unknown in the West, were certainly not generally recognized or used.

However, it was the East German camera industry, as might have been expected given its history of excellence, which provided the greatest Eastern European competition for the SLR market against the burgeoning camera industry of Japan. During the fifties, the Contax S, D and F series SLRs and their subsequent rebranded Pentacon clones, the Exaktas, the Praktina cameras and the 6cm × 6cm Praktisix

SLR all sold well, particularly in the USA where there were no import controls to inhibit the market. The early models of the Praktica and their Praktiflex forbears, because of their comparatively low prices, made a significant impact upon the UK market.

During the sixties, as the dominance of the Japanese manufacturers really made itself felt, the ever-changing series of Praktica cameras maintained volume sales throughout the decade. The Pentacon Six, successor to the Praktisix, was a much-used professional medium-format camera, particularly by travel and stock-shot professionals, and was ousted from its leading position among non-interchangeable-back medium-format SLRs only by the arrival of the Pentax 6 × 7 in 1969.

However, the beginnings of Soviet 35mm SLR innovation are to be found well before the Second World War.

### The Sport

Even among Russian cameras, which can be said to be a pretty odd lot, the Sport (Cnopm) holds premier place for sheer ungainliness. For years, collectors argued whether the Kine Exakta or the Sport had been the world's first 35mm single-lens reflex. Research carried out in Dresden since the reunification of Germany has now established that the Kine Exakta was the first to be marketed, if only by a short head. Even if the Sport had been first, it would have remained true that the Exakta was the camera which heralded future SLR design and that the Sport represented no more than an evolutionary path destined to lead nowhere.

Designed for sports and nature photography – hence the name – the Sport consisted of a compact camera body with rounded ends with a disproportionately large rectangular box perched on the top which contained the viewfinder lens and the shutter-control mechanism. The brass focal-plane shutter was, of course, in the lower part of the camera. A knob which protruded from the right-hand side of the box assembly advanced the film, cocked the shutter and also provided the shutter-speed setting for speeds from 1/25th to 1/500th second.

Only one lens was offered for the camera, a 5cm f/3.5 Industar 10 triplet, whose performance is reliably reported as having been grim. Resolution figures of 40 lines per millimetre at the centre and 12 lines per

Disused railways and rolling stock, albeit locomotives waiting to be restored by enthusiasts, have a certain rather eerie feel about them. In the yard of the Great Western Railway Society near Cheltenham I found this scene on an afternoon which promised to get rather darker and wetter quite soon.

*Shot with Exakta Varex IIb fitted with 30mm f/3.5 Lydith, exposure 1/60th at f/9, on Ilford Pan F Plus, developed in Aculux and printed on Ilford Multigrade III. Here the foreground was printed with the maximum magenta filtration my enlarger offers, 170M, and the sky was burned in at 0M filtration.*

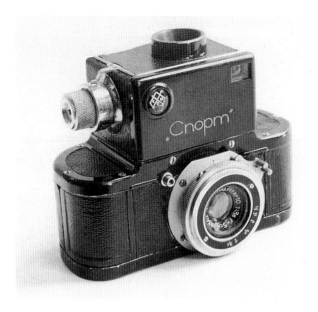

The Russian Sport must surely be one of the oddest and least usable 35mm SLRs ever made.

*Shot with Zenith 80 fitted with 80mm f/2.8 Industar 29 on Ilford XP2, printed on Jessop Variable Contrast.*

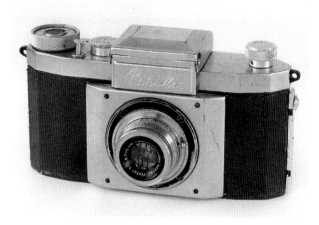

The first type of Praktiflex can be identified by its having the shutter release on the top of the body. Although normally regarded as a pre-war camera, some of these seem to have been made after the war. This example has the infamous 5cm f/2.9 Victar lens with the original 40mm Praktiflex screw mount.

*Camera and picture by courtesy of Mike Rees. Shot with Contarex Cyclops fitted with 50mm f/2 Planar on Ilford Pan F Plus, developed in Aculux and printed on Jessop Variable Contrast.*

millimetre at the edges of the field have been quoted. The lens had no focusing mount, but bayoneted into a focusing mount which, like that of the rangefinder Contax, formed part of the camera body.

Like many poorly designed cameras which nonetheless play a role in photographic history, the Sport did not sell well and is scarce, although less so since the demise of the Soviet bloc. It once commanded prices of £500 ($750) or more at auction as a collectible, but is now available for half that figure. As a camera for regular use it is a non-starter, although there is no reason why one should not try it if the camera works as it should.

### The Praktiflex

As much an ancestor of current SLRs as the Kine Exakta was the humble Praktiflex, launched in its original form by KW (Kamera Werkstätten Guthe & Thorsch of Dresden) in 1938 or 1939 – various sources differ on this point. The Praktiflex, probably the world's third 35mm SLR, was one of those designs which worked despite its simplicity and the comparatively poor engineering standards with which it was built. It was relatively inexpensive, could be obtained

with fine Zeiss lenses and was a way of gaining access to a high standard of photography on a limited budget. In 1939, the Praktiflex was available in Germany at a price equivalent to £15.15s. sterling (then $73), at a time when the least expensive Kine Exakta was sold in Britain for £27.10s. ($130).

The original Praktiflex had its shutter release in the conventional position on the right-hand side of the top-plate, slightly too close for comfort to the speed-setting dial, which revolved during exposure. The shutter finger could unwittingly contact the dial as it turned, acting as a brake and producing some strange results as the shutter-blind traverse was slowed half-way across the film.

The pressure on the shutter release, instead of releasing a mirror catch and allowing the mirror to rise powered by a spring, actually provided the power for raising the mirror. The temptation was to stab at the shutter release when photographing a fast-moving subject to get the mirror up and the shutter released quickly. This caused the whole camera to vibrate and camera shake to reduce picture quality.

Conversely, pressing the release very slowly tended to fire the shutter before the mirror was totally out of the way, causing vignetting. All these problems could

be overcome by the right shutter-release technique, however, and many fine photographs were taken with the early Praktiflex. Lenses supplied included the f/3.5 Tessar and the f/2 Biotar, and it is worth while trying to track down an example with one of these lenses. If you find one which works well – and they are to be found – there is no reason why excellent results should not still be obtained, provided that you can keep your fingers out of the way of the moving parts.

In 1948, the second version appeared, known as the Praktiflex II. Like the earlier camera, it had the unique 40mm screw lens mount, although it was usually sold equipped with the relatively poor-quality 50mm f/2.9 Victar. The Praktiflex II, although superficially similar, was a completely redesigned camera. The shutter release was relocated to the front of the camera, the mirror was spring-loaded and conventionally released and the general standard of engineering was much higher.

The detailed history of the Praktiflex is still being researched as I write, and those devoted to the minutiae tell me that, because the design evolved through several sub-versions, there is a whole range of Praktiflex types to be found, not least the version, available as an option from October 1948, which had a 42mm × 1mm screw lens mount instead of the earlier 40mm mount.

Anyone who has handled an early Praktica, the first model of which appeared with its 42mm screw lens mount during October 1949, will immediately see the similarity between it and the Praktiflex II. In fact, the front panel to which the lens flange is fitted is interchangeable between the two cameras, and I have had an example of a first-type Praktiflex which had had a 42mm screw lens panel grafted on to it. This camera was equipped with a 58mm f/2 Biotar of the type usually found on the Contax S – see the picture (above right).

### The Praktica line

The standard of engineering and reliability of KW 35mm SLRs rose steadily through the early fifties. The first Praktica of 1949 was succeeded by the Praktica FX in 1952, equipped with the 42mm lens mount and a separate slow-speed range of 1/2, 1/5th and 1/10th second activated by a smaller knob above the speed-setting dial. This aligned an arrow with a black triangle for the fast-speed range and with a

This apparently 'first-type' Praktiflex was, according to its number, made during 1940. However, it has a 42mm standard Praktica lens mount, and the lens is a 58mm f/2 Biotar with simple diaphragm in black mount, of the type usually found on a Contax S or original Praktica. It seems likely that somebody exchanged the original front plate for one from an early Praktica.

*Shot with Topcon RE-2 fitted with 58mm f/1.8 RE-Topcor on Ilford Pan F Plus, developed in Aculux and printed on Jessop Variable Contrast.*

red triangle for the slow speeds. As on the earlier Praktiflex, the shutter-speed dial rotated when the shutter was fired, but this was not a major problem, since the shutter release was on the front of the camera.

The Praktica FX2 of 1956 had a redesigned viewfinder optical system, to accommodate what we would now regard as a conventional prism sitting low above the focusing screen, and the FX3 of 1957 introduced the familiar M42 internal lens-diaphragm stop-down mechanism.

In 1959, Kamera Werkstätten became part of the newly merged VEB Kamera und Kinowerke Dresden. From this came the greatly improved Praktica IV, a fixed-pentaprism SLR of remarkable weight with the unusual feature of both knob-wind on the top of the camera and lever-wind on the baseplate. Early examples were usually supplied either with the automatic preset (spring diaphragm) version of the 50mm f/2.8 Tessar, which is a first-class lens, or with the 50mm f/1.9 Primoplan, which is big and impressive

The first Praktica of 1949 was essentially a post-war Praktiflex II with a 42mm lens mount, and it seems that, for a while, the names Praktiflex and Praktica were applied to otherwise identical cameras. I have a 'dead' Praktiflex FX body which differs from the Praktica camera illustrated here only in having full flash synchronization, as one would expect of a Praktica FX. This camera is fitted with 50mm f/2.8 Isco Westanar with an externally actuated automatic diaphragm.

*Camera and picture by courtesy of Mike Rees. Shot with Nikon F and fitted with 55mm f/2.8 Micro-Nikkor on Ilford Pan F Plus, developed in Aculux and printed on Jessop Variable Contrast.*

In my view the best of the Prakticas, the Praktica IV and V series are all variants of the camera shown here, which is a Praktica IV. This one has the alloy-mount automatic preset 50mm f/2.8 Tessar with which many early examples were fitted. Later cameras were sold with a fully automatic-diaphragm Tessar in an inferior-quality mount, or the much criticized Meyer 50mm f/2.8 Domiplan.

*Shot with Minolta SRT101 fitted with 55mm f/1.7 MC Rokkor on Ilford Pan F Plus, developed in Aculux and printed on Jessop Variable Contrast.*

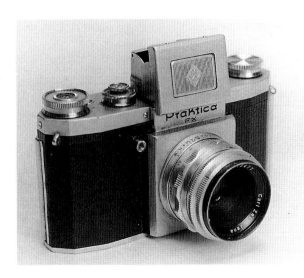

A Praktica FX fitted with the typical preset 50mm f/2.8 Tessar of the period. These cameras usually work well, although the shutter blinds need close inspection before you buy, as they are often pinholed or stiffened with age.

*Shot with Minolta SRT101 fitted with 55mm f/1.7 MC Rokkor on Ilford Pan F Plus, developed in Aculux and printed on Jessop Variable Contrast.*

but rather less effective in the image-making department. Other options included the 50mm f/2.9 Trioplan and the 50mm f/2.9 Meritar, neither of which is a favoured option among the Praktica cognoscenti, and the 58mm f/2 Biotar, which is very good indeed. The shutter was the same two-dial design as that of the earlier cameras.

By the time the Practika IV was being, in the American jargon, 'closed out' during 1964, the usual lens option was either the low-cost 50mm f/2.8 Domiplan or the 4-element 50mm f/2.8 Tessar, both by this time in fully automatic diaphragm versions. The Domiplan is a 3-element lens and is much maligned, but I have produced what are to me very pleasing pictures with various Domiplans. Use the lens within its limitations at apertures of f/5.6 or less and the results are indistinguishable from those of far more expensive lenses.

Meanwhile, during 1961, VEB had produced the Praktica IVB, a version of the IV with a built-in selenium exposure meter, and the scarce IVBM, the same camera with a rangefinder built into the focusing screen. In 1962 came the Praktica IVF, an improved

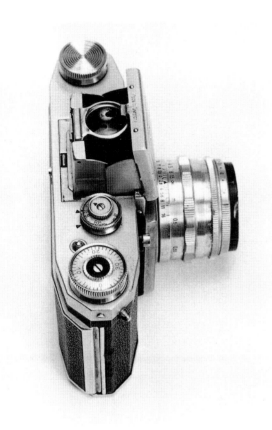

The top-plate of the Praktica FX, showing the waist-level finder and magnifier. The two-knob shutter-speed setting is typical of all the Prakticas from the first through to the VF – the arrow on the top knob is set to the red triangle for slow speeds and to the black for the speeds from 1/25th upwards. A red dot on the outer periphery of the lower dial is then set to whatever speed is wanted.

*Shot with Minolta SRT101 fitted with 55mm f/1.7 MC Rokkor on Ilford Pan F Plus, developed in Aculux and printed on Jessop Variable Contrast.*

version of the IV with a much brighter Fresnel focusing screen. Finally, during 1964, was launched the Praktica VF, essentially the same as a IVF but with an instant-return mirror.

A Praktica IV was my first SLR. I bought one with a 50mm f/2.8 Domiplan new for about £39 (then $109) in London's Oxford Street during 1964. It travelled about with me for four years and was only exchanged in the pursuit of progress for a Nikkormat FT during 1968. Recently I have bought another, this time with a spring-diaphragm automatic preset Tessar, and for only £18 (now about $27). I am enjoying it greatly.

The Praktica line took a decided turn for the worse when, during 1965, VEB replaced the IV and VF series

with the Praktica Nova cameras. These are lighter, altogether cheaper in feel and operation, and far less likely, thirty years on, to be working as they should. During the gestation of this book I have bought a Praktica Nova, a Praktica Nova IB and a Praktica Super TL. None of them works properly in all major respects, although the Nova survived about four films before the shutter developed problems. The Super TL takes pictures but has a wildly optimistic exposure meter. It is difficult to find a good example of this little sought-after series of cameras.

The Praktica Nova and Nova B (with selenium exposure meter) retained the two-dial shutter setting of the earlier Prakticas, but 1965 saw the advent of a truly landmark Praktica with all the shutter speeds on one non-rotating dial. This was the Prakticamat, the first European SLR to have directly coupled through-the-lens (TTL) CdS metering. At the time, this was extremely effective, but regrettably, like most features of the Prakticas of the Nova series, its excellent metering system rarely works properly today.

The one-dial shutter of the Prakticamat was transplanted to the basic Nova series in 1967 (albeit with the shutter-speed dial in a different place) whereupon the cameras were renamed the Praktica Nova I and IB (with meter). Unlike the Prakticamat, which had a top shutter speed of 1/1000th, the Nova I and IB had only 1/500th, but this was almost certainly for marketing rather than technical reasons. Similarly, the Praktica Super TL of 1968 had a top shutter speed of only 1/500th, although with a similar stop-down TTL metering system to that of the Prakticamat.

The M42 screw-thread-lens-mount Praktica line continued with the L and M series cameras well into the eighties, and the late screw cameras before the bayonet-mount B series cameras were among the last low-cost wholly mechanical SLRs to be available. For me, the golden age of the Praktica was during the late fifties and early sixties, during the IV, IVF and VF period. Find a good, little-used example of any of those, preferably with an f/2.8 Tessar or an f/2 Biotar, and you will have more picture-taking ability per pound spent than you could obtain from almost any other camera.

### The East German Zeiss and Pentacon cameras

We take a step back in time to 1948 and another landmark SLR, the Contax S. In 1948, this design,

conceived in the Zeiss Ikon works in Dresden during the war years, finally saw the light of day after the vast upheaval of the end of the war. As the US troops moved out of Jena and Dresden and the Soviet troops moved in, many of the Dresden-based Zeiss Ikon camera-design and manufacturing staff and a large number of the Carl Zeiss optical workforce from Jena went westward to what was to become the Federal Republic of Germany. There the Zeiss Ikon team established a new Zeiss Ikon camera factory in the former Contessa factory in Stuttgart, and the migrant optical technicians went to Oberkochen and established Carl Zeiss West.

Back in East Germany, many of the tools and machines from Zeiss Ikon, Dresden, were removed by the Soviet victors in the guise of war reparations. Thus the Contax rangefinder camera, after some initial postwar production in Dresden (the 'no-name' Contax), was transplanted to the Ukraine, to be modified and reborn as the Kiev. But much was left, and soon the Ikontas and Super Ikontas reappeared as Erconas, and Zeiss Ikon was back in business – or so it seemed. For the West German Zeiss companies launched a major offensive in the courts for recovery of their trade marks, a battle which was finally won in 1958.

However, in 1948, Zeiss Ikon in Dresden believed itself to be the legitimate user of the names which had so distinguished Zeiss before the war. Their Contax S was the first SLR to bear the Contax name and the world's first SLR with a built-in pentaprism. Although the Contax S was marketed at the same time as the Rectaflex, the Contax S patent was granted before that of its rival. Curiously, however, the Contax S which was shown to the photographic trade at a private presentation during 1948 is reported as not having had the 42mm screw lens mount. That did not appear until the camera was officially unveiled during the spring of 1949. Was this a last-minute rethink, or was the camera shown during 1948 an elaborate deception to throw rivals off the scent?

The Contax S had several unusual features, not least the positioning of its flash-synchronization socket in the tripod bush. It was normally supplied with a 58mm f/2 coated Biotar with a simple (i.e., not preset) diaphragm, often in a black mount. The shutter speeds were viewed through a window on the top-plate, and two ranges – fast speeds and slow speeds – were selected by moving the small sliding catch on the rear of the top-plate. Moving it to the left caused a red slow-speeds index mark to appear on the left of the

All the Praktica IV and V series (IV, IVF, IVFB, IVFBM, V, VF, VFB) are equipped with both a wind knob on the top-plate and a lever-wind on the base. The suffix 'F' indicates a Fresnel focusing screen, the 'B' a built-in selenium exposure meter and the 'M' a split-image rangefinder in the screen.

*Shot with Minolta SRT101 fitted with 55mm f/1.7 MC Rokkor on Ilford Pan F Plus, developed in Aculux and printed on Jessop Variable Contrast.*

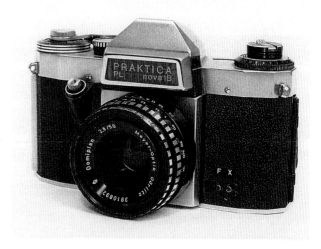

The Praktica Nova series (with two-dial shutter) and the subsequent Nova I cameras (single shutter-speed dial) were not an advance on the earlier cameras and are profoundly unreliable. This is a Praktica Nova IB with 50mm f/2.8 Domiplan.

*Shot with Minolta SRT101 fitted with 55mm f/1.7 MC Rokkor on Ilford Pan F Plus, developed in Aculux and printed on Jessop Variable Contrast.*

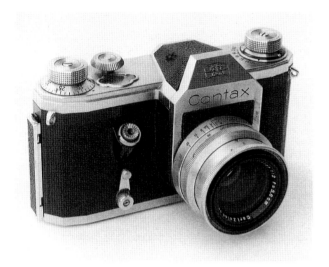

The Contax S was the first 35mm eye-level pentaprism SLR and the first of a series of cameras of broadly similar appearance. They were usually sold with a 58mm f/2 Zeiss Biotar with a simple diaphragm, either in a black or, as in this case, an alloy-finish mount.

*Camera by courtesy of Peter Loy. Shot with Minolta SRT101 fitted with 55mm f/1.7 MC Rokkor on Ilford FP4 Plus, developed in Aculux and printed on Jessop Variable Contrast.*

The Contax D illustrated on page 26 was also manufactured bearing the Pentacon name, as seen here. This example is unusual in having a 58mm f/1.9 Meyer Primoplan lens – most have either the Zeiss 50mm f/2.8 Tessar or the 58mm f/2 Biotar. The similarity of the mount of the Primoplan to that of the two Zeiss lenses makes one wonder whether the versions of the lenses supplied for the Contax/Pentacon series were designed to a common specification.

*Camera by courtesy of Dave and Julie Todd. Shot with Pentax Spotmatic fitted with 55mm f/1.8 Super-Takumar on Ilford Pan F Plus, developed in Aculux and printed on Jessop Variable Contrast.*

window; moving it right caused a black fast-speeds index mark to appear on the right. Speeds on the dial were colour-coded black and red to indicate against which mark the speed should be set. Depressing and turning a knurled knob on the top of the camera anti-clockwise changed the speeds.

In 1953, the Contax D appeared. The main differences were the moving of the flash-synchronization socket to the top-plate of the camera, next to the re-wind knob, a small capital 'D' under the Zeiss Ikon logo on the front of the pentaprism and the fitting of a preset version of the 58mm f/2 Biotar. As fitted to the Contax D, this seems always to have been in polished alloy finish. During this period, East German Zeiss cameras evolved, and the Contax D exists in several versions, each with minor differences. There are, for example, Contax D cameras with the automatic diaphragm actuator which is a feature of the Contax F, but these may have been the result of the retro-fitting of later features to earlier cameras when they were returned for servicing or repair.

In 1955, a development of the Contax with an uncoupled selenium exposure meter built on to the prism housing appeared. This was the Contax E. Two years later, the Contax F was announced – essentially a Contax D with automatic diaphragm actuation – and at the same time the Contax FB (with exposure meter) and the Contax FM (with interchangeable split-image focusing screen) were introduced.

Throughout the ten-year period between the launch of the Contax S and the loss by East German Zeiss of the rights to the Zeiss trade marks, it was increasingly apparent that the battle was going the way of West German Zeiss. The East German companies therefore backed both possibilities by marketing concurrently with the Contax series identical cameras branded 'Pentacon'. Thus a Pentacon is identical to a Contax D except for the substitution of the Pentacon name for Contax, and of the tower logo for the Zeiss Ikon logo.

After the final loss of the rights to the Zeiss names, the company initially became VEB DEFA, then in 1964 merged with VEB Kamera und Kinowerke Dresden to form VEB Pentacon, the company which took the Praktica line on its disastrous course downhill from the IV/VF series to the Nova series. In 1968, this

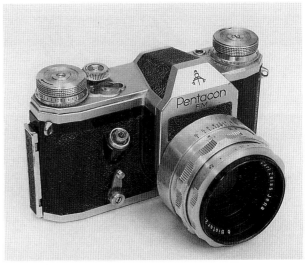

The Pentacon FB was a version, now very scarce, of the Pentacon F with a selenium exposure meter built into the prism housing. This example is fitted with an earlier version of the 50mm f/2.8 Tessar than is typical for the camera.

*Shot with Minolta SRT101 fitted with 55mm f/1.7 MC Rokkor on Ilford Pan F Plus, developed in Aculux and printed on Jessop Variable Contrast.*

The Pentacon FM is probably the commonest of the Contax/Pentacon series of cameras and has the built-in actuation for automatic-diaphragm lenses, making it an eminently practical camera for use. Unfortunately, it also suffers from the same problems of shutter unreliability as the rest of the series, although the shutter can usually be repaired if it is not too badly worn. This example has the 58mm f/2 automatic preset Biotar.

*Shot with Minolta SRT101 fitted with 55mm f/1.7 MC Rokkor on Ilford Pan F Plus, developed in Aculux and printed on Jessop Variable Contrast.*

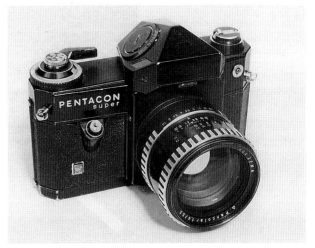

The top-plate of the Pentacon FB, showing the details of the exposure meter and the shutter-speed setting knob and dial. Sliding the lever on the back of the top-plate exposes either a red triangle on the left-hand side of the shutter-speed window or a black triangle on the right. Pressing and turning the knob then revolves the shutter-speed dial to set the speed against the appropriate arrow.

*Shot with Minolta SRT101 fitted with 55mm f/1.7 MC Rokkor on Ilford Pan F Plus, developed in Aculux and printed on Jessop Variable Contrast.*

The remarkable and very scarce Pentacon Super of the mid-sixties was the nearest the Pentacon factory ever came to a professional-quality 35mm camera. It is very heavy, particularly when equipped with the 55mm f/1.4 Pancolor 'aus Jena' seen on this camera. Unfortunately it was also very expensive.

*Camera by courtesy of Len Corner. Shot with Praktina IIA (by courtesy of Mike Rees) fitted with 135mm f/3.5 Tele-Ennalyt on short extension tube on Ilford Pan F Plus, developed in Aculux and printed on Jessop Variable Contrast.*

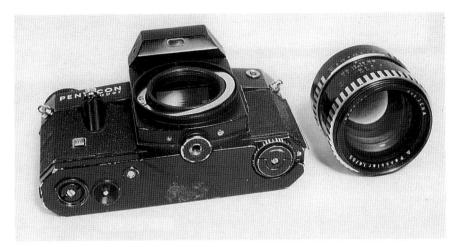

The underside of the Pentacon Super reveals a drive pawl for motor drive (left of picture). Everything about the Pentacon Super is massive and apparently over-engineered.

*Camera by courtesy of Len Corner. Shot with Praktina IIA (by courtesy of Mike Rees) fitted with 135mm f/3.5 Tele-Ennalyt on short extension tube on Ilford Pan F Plus, developed in Aculux and printed on Jessop Variable Contrast.*

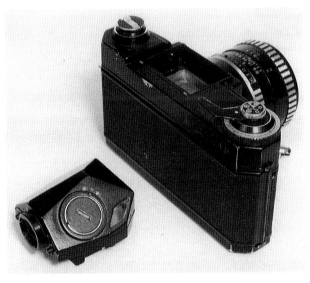

The TTL exposure meter of the Pentacon Super was mounted in the prism, which was removable to interchange with a waist-level finder. The battery compartment in the side of the prism can be clearly seen in this picture.

*Camera by courtesy of Len Corner. Shot with Praktina IIA (by courtesy of Mike Rees) fitted with 135mm f/3.5 Tele-Ennalyt on short extension tube on Ilford Pan F Plus, developed in Aculux and printed on Jessop Variable Contrast.*

in turn merged with VEN Feinoptisches Werk Görlitz to produce Kombinat VEB Pentacon Dresden. Thus it remained until German reunification when, under the pressure of competition, the company had to close.

So should you try to use a Contax or Pentacon SLR as your regular camera? Regrettably, the shutters installed in these attractive cameras have never been reliable and have a way of surrendering to age if put under the pressure of regular use. If one of these desirable instruments really appeals, why not buy a couple of reliable Prakticas of the pre-1965 era, plus a Contax or Pentacon, perhaps obtaining a Biotar on the Contax and other lenses on the Praktica? They are all M42 fit, so you get all the pleasure of using the lenses on the Prakticas, plus, just once in a while, a film or two through the Contax.

However, the Contax/Pentacon series was not the end of the Pentacon saga. In 1966, the company announced the formidable Pentacon Super, with a metal-curtained focal-plane shutter instead of the conventional cloth shutters of all the other Pentacon reflexes, with shutter speeds from 8 seconds to 1/2000th. It offered interchangeable viewfinders, a TTL exposure meter with open-aperture metering and displays of both the shutter speed and the aperture settings visible in the viewfinder. The range of accessories included a 250-exposure back, a motor and various other goodies.

Two things afflicted the Pentacon Super – its price and its origin. You had to spend almost as much as was needed to purchase a top-quality Japanese camera of the day. Photographers recognized that they were putting that much money into a camera whose image, however unjustly, was that of an overgrown Praktica. The result was that it did not sell well and is now scarce. Examples fetch £300 ($450) or more at auction.

### The Praktina

Many collectors regard the interesting and innovative KW Praktina cameras as an eccentric but engaging

aberration. Why did a successful manufacturer spend so much time on a camera with a direct-vision viewfinder as well as a reflex focusing screen, and with a breech-lock lens mount instead of the successful screw thread?

In fact, the Praktina cameras are superior in many ways to the Prakticas of the mid-fifties and are appreciably more pleasant to use. I suspect that the Praktina was to have been the main plank of KW camera development into the sixties, but that political and economic pressures during a period of change – KW becoming part of the merged VEB group during 1959 – coupled with the commercial success of the more cheaply produced Praktica, ensured that the Praktina took a back seat.

Consider the fact that the Praktina FX became in the mid-fifties the world's first single-lens reflex to have a motor drive. The neat and well-designed clockwork drive unit provided enough power for around twenty exposures and, of course, needed no batteries, so could be used in remote locations.

Reflect upon the fact that the Praktina was the first single-lens reflex to have a breech-lock lens mount, in which the bearing surfaces do not slide against each other, so never wear. Instead, as on the later and great Canon SLRs of the sixties and seventies, a locking ring rotates to secure the lens.

Consider also the benefit of a camera which can be used with a simple direct-vision viewfinder when circumstances make focusing less important than usual. An example of this is when shooting press pictures using flash and a wide-angle lens. A 35mm lens at f/11 has sufficient depth of field to ensure that, when the focus is set by estimation to a distance of ten feet, everything from six feet to a hundred feet is acceptably sharp. In days when the lack of an instant-return mirror meant that the screen went black when the shutter was fired, there was a lot to be said for a continuous view of one's subject before, during and after the flash. Under some conditions of poor ambient light, even with an instant-return mirror, there still is a good case for using a viewfinder in the accessory shoe, a powerful flash, a 28mm lens and as small an aperture as possible for press work. I speak from experience!

The other benefit of the Praktina was the high quality of most of the lenses supplied for it. The first model, the Praktina FX of (I believe) 1954 was usually supplied either with a 50mm f/2.8 Tessar or with a 58mm f/2 Biotar, similar to those found in the Contax D and F. Both were equipped with spring-loaded automatic preset diaphragms, as were supplied for Contax F and the various Pentacon reflexes. By the time the Praktina IIA appeared in 1959, the usual standard lens was a 50mm f/2 Jena Flexon from the

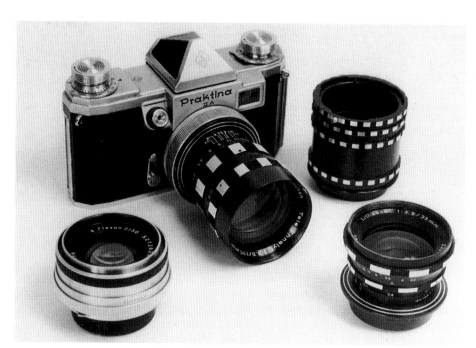

A Praktina outfit capable of top-quality results. The Praktina IIA is fitted with a 135mm f/3.5 Tele-Ennalyt with simple diaphragm – the combination used for several pictures in this chapter and elsewhere. On the left is the standard 50mm f/2 Zeiss Flexon with automatic diaphragm, on the right a 35mm f/3.5 Enna Lithagon. To the right of the camera is a set of Praktina extension tubes.

*Camera by courtesy of Mike Rees. Shot with Minolta SRT101 fitted with 55mm f/1.7 MC Rokkor on Ilford Pan F Plus, developed in Aculux and printed on Jessop Variable Contrast.*

former East German Zeiss works. The requirement for other focal lengths was serviced mainly during the early days of the Praktina by Meyer of Görlitz, whose 100mm f/2.8 Trioplan is the commonest non-standard Praktina lens, and later (paradoxically) by the Enna optical company in Munich, which was of course in West Germany.

I suspect that Enna's devotion to the cause of supplying Praktina lenses was a case of West German opportunism. Although production of the Praktina IIA continued into the seventies, it was apparent from the early sixties that VEB regarded its commercial future as being secured by the Praktica series. The same view seems to have been taken by the former Zeiss works at Jena and by Meyer, for relatively few lenses of non-standard focal length were produced by them for Praktina after about 1962. Enna filled the gap with some excellent lenses, such as the 135mm f/3.5 Tele-Ennalyt and 35mm f/3.5 Lithagon.

The Praktina was ahead of its time and an excellent design. Time has shown that the shutter of early examples can be unreliable some forty years after it was made, and it would be unwise to expect an early Praktina to perform as a heavily used camera into the

The neat lever-wind attachment for the Praktina utilized the motor-drive pawl in the base to provide an alternative lever-wind much like that of the Praktica IV.

*Camera by courtesy of Mike Rees. Shot with Minolta SRT101 fitted with 55mm f/1.7 MC Rokkor on Ilford Pan F Plus, developed in Aculux and printed on Jessop Variable Contrast.*

A rear view of the Praktina IIA when fitted with its standard 50mm f/2 Flexon mounted on extension tubes for close-up work at 1:1 reproduction ratio.

*Camera by courtesy of Mike Rees. Shot with Minolta SRT101 fitted with 55mm f/1.7 MC Rokkor on Ilford Pan F Plus, developed in Aculux and printed on Jessop Variable Contrast.*

The world's first motor drive for an SLR was a major innovation when it appeared as part of the Praktina range in the mid-fifties. Here it is attached to a Praktina FX fitted with a 58mm f/2 Biotar with automatic preset diaphragm.

*Camera and motor drive by courtesy of Dave and Julie Todd. Shot with Pentax Spotmatic fitted with 55mm f/1.8 Super-Takumar on Pan F Plus, developed in Aculux and printed on Jessop Variable Contrast.*

next century. On the other hand, if you can find a Praktina IIA that has had an easy life and looks and feels smooth and smart, it is a camera to enjoy.

There were T2 adaptors for Praktina, although they are scarce and hard to find. No independent lenses with automatic diaphragm were available.

### The post-war Russian SLRs

Between 1941 and 1945, during the 'Great Patriotic War', camera production for the Red Army and Air Force was primarily of the Fed and Zorki copies of the screw Leica, in various forms, and there is little evidence of SLR production.

Early in the 1950s, there appeared from the Krasnogorsk Mechanical Factory (KMZ) in Krasnogorsk, a suburb of Moscow, a camera of great simplicity which was derived directly from the Leica copies but with the addition of a mirror box and prism housing. This was the Zenit (frequently spelt 'Zenith' on cameras destined for the Western market). Like the Leica, it was base-loading and was dimensionally so similar to the Leica IIIB and earlier models that prewar Leica baseplates fit early Zenits more or less correctly. The lens mount was a 39mm screw thread, like that of the Leica and the various Russian Leica copies, but the flange-to-film register was, of course, greater than that of the Leica in order to provide space for the mirror assembly. Leica screw and compatible lenses will therefore fit, but will provide only close-focus capability.

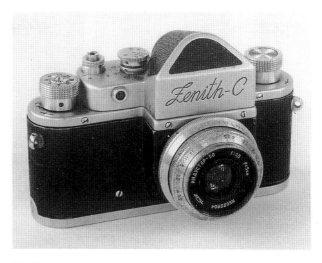

The Zenith- or Zenit-C, which has the curious distinction of having a baseplate of identical size and fitting to that of a Leica III – probably a result of production economies at a time when many Leica copies were being manufactured in the Soviet Union.

*Camera and picture by courtesy of Mike Rees. Shot with Nikon F fitted with 55mm f/2.8 Micro Nikkor on Pan F Plus, developed in Aculux and printed on Jessop Variable Contrast.*

Mechanically, the Zenit, and its immediate and very similar successor, the Zenit-C, were crudely made. The mirror-set mechanism was, for example, connected by a simple string. Nonetheless, they worked quite consistently. The standard lens was usually an f/3.5 Industar, whose primary deficiency was one of quality control – some of them are very good, most are truly awful, some are in between.

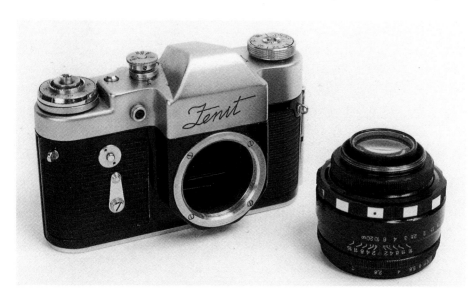

I acquired this unusual Zenit in non-running, but cosmetically beautiful, condition, fitted with the 58mm f/2 Jupiter in 39mm screw mount (Leica thread but not Leica register). It is very like the Zenit 3M, but lacks the model designation and has an obviously different shutter-speed dial assembly.

*Shot with Minolta SRT101 fitted with 55mm f/1.7 MC Rokkor on Ilford Pan F Plus, developed in Aculux and printed on Jessop Variable Contrast.*

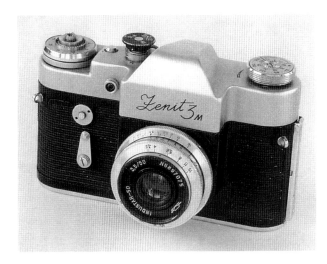

Huge numbers of Zenit 3M cameras were exported by the Soviet Union to Western-bloc countries at the end of the fifties. This one has the 50mm f/3.5 Industar lens, examples of which vary from very crisp to truly appalling performance – there seems to have been no quality control whatever applied to their optical performance.

*Camera and picture by courtesy of Mike Rees. Shot with Nikon F fitted with 55mm f/2.8 Micro Nikkor on Pan F Plus, developed in Aculux and printed on Jessop Variable Contrast.*

The Zenit-C was followed, in about 1956, by the Zenit 3M, which was altogether better designed and manufactured and was a workable and, in its younger days, reliable camera. A friend of mine from my schooldays, when I encountered him again recently after many years, reported that he still had and used, albeit infrequently, the Zenit 3M which I had earnestly recommended he should buy when we were both sixteen years old. I have to confess that I was more surprised than he was that it was still working tolerably well after thirty-nine years.

The most usual lens found on the Zenit 3M remained the f/3.5 Industar, but many were supplied with the far preferable 58mm f/2 Helios, a lens manufactured to the design and approximate specifications of the 58mm f/2 Biotar and with similar performance.

By the early sixties, the dominance of the 42mm screw lens mount for middle- and budget-range SLRs was so great that independent lenses with that mount were becoming available in all major world markets. The advent of high-quality Japanese SLRs with superior-quality lenses was putting enormous pressure on European manufacturers and it seemed that no budget-priced SLR camera would survive unless it had a 42mm lens mount.

KMZ responded with the Zenit-B, a completely redesigned and somewhat larger camera with a squarer shape and a more sophisticated mechanism. Although the 50mm f/3.5 Industar continued to be available, the great majority of Zenit-B cameras, and the subsequent models, were sold with 58mm f/2 Helios lenses with preset diaphragm. The Zenit-B was closely followed by the Zenit-E, often with the English spelling of the name on the face of the camera. This was essentially the same camera with a built-in uncoupled selenium exposure meter.

The Zenit-E, particularly, proved to be a very successful camera, and a great many of them were sold,

The new range of Zenit cameras during the sixties began with the Zenit-B (on the left) and the similar and much more common Zenit-E, which has a built-in uncoupled selenium exposure meter. The Zenit-EM was an E with automatic-diaphragm actuation. Both cameras here have the 58mm f/2 Helios, which for the B and E series had the 'universal' 42mm screw lens mount.

*Shot with Minolta SRT101 fitted with 55mm f/1.7 MC Rokkor on Ilford Pan F Plus, developed in Aculux and printed on Jessop Variable Contrast.*

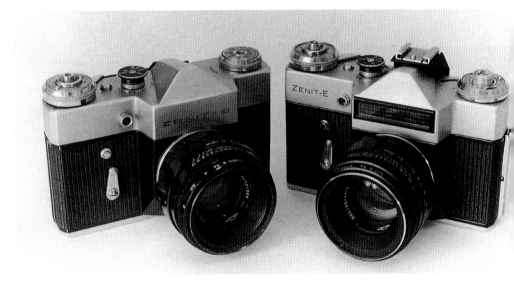

The Zenit SLRs with 42mm lens mount became gradually more sophisticated as the seventies wore on, although always well behind the general state of camera technology. This is my daughter Holly's Zenit TTL, the first model with TTL metering, fitted with a later version of the 58mm f/2 Helios.

*Shot with Topcon RE-2 fitted with 58mm f/1.8 RE-Topcor on Pan F Plus, developed in Aculux and printed on Jessop Variable Contrast.*

This Zenit TTL, fitted with the early-sixties 135mm f/2.8 Twin Tamron shown, was the camera/lens combination with which my daughter Holly photographed the crashing sports car (opposite). Such an outfit provides an extremely low-cost start in photography – you could buy camera, standard lens, and Twin Tamron with its matched converter for no more than £25 ($37.50) at a UK camera fair.

*Shot with Minolta SRT101 fitted with 55mm f/1.7 MC Rokkor on Ilford Pan F Plus, developed in Aculux and printed on Jessop Variable Contrast.*

particularly in Britain. Although it does not have the record of reliability of, say, a Pentax or a Minolta SRT camera, for its cost the Zenit-E was very good value. Find an example that has been carefully used, and which has the 58mm f/2 lens, and some excellent photography can be had for a very modest sum. The handling of the camera, however, feels rough and ready, and I personally would prefer a decent Praktica IV for much the same outlay.

The Zenit-EM, which followed the E, introduced fully automatic-diaphragm operation, and was followed by the Zenit TTL which, as the name suggests, has through-the-lens metering. This meter system of the TTL, however, has a way of being unreliable.

All the Zenit-B and E series have the advantage of the M42 lens mount and the ability thereby to accept virtually all ranges of independent lenses, given that you buy a lens with an M42 mount, or an M42 interchangeable adaptor.

### So should you buy them to use?

All post-war Eastern European and Russian cameras, with the arguable exception of the Exakta Varex series, offer lower standards of engineering, reliability and usability than Western European and Japanese cameras. When they were new, this difference was amply compensated for in terms of dramatically lower prices for the Eastern European article, often as a result of Eastern-bloc government subsidies. Now, when there is a vast pool of classic SLRs of all kinds available, it is often possible to buy a very much more serviceable camera, which feels better and delivers more consistently high-quality results for only a little more money. At UK camera fairs in 1995, for example, I bought a nice Ricoh Singlex TLS with f/2 lens for £32 ($48) and a Minolta SRT101 with f/1.7 lens for £40 ($60), both in fully serviceable and smart condition. While it is true that a decent Zenit-E or EM can be bought for £18 ($27) or so, and a Praktica IV for much the same figure, you may feel that your enjoyment would be better served by spending just a little more.

For me, if one disregards the Exakta and Exa range, the Eastern European cameras most worth buying are the Praktina, preferably a Praktina IIA, although one of those will certainly cost in the region of £70 ($105) or more, and the Praktica IV or VF, which, if in good condition (and many are not) is a sound, reliable camera for around £20 to £30 ($30–$45).

Paris, autumn 1964. I have always liked this shot, simple as it is. The camera was my first SLR, a Praktica IV, in this case fitted with a lens whose limitations were not too obvious when shooting a picture like this.

*Shot with Praktica IV fitted with 100mm f/2.8 Meyer Trioplan on Kodak Tri-X, developed in Kodak D76 and printed on Ilford Multigrade.*

At the Pestalozzi Hill Climb in Sussex during August 1994, this Caterham Seven hit the tyre wall in a fairly significant manner after losing it on a bend. I missed the moment because I was switching cameras after running out of film. My daughter Holly got the shot with a Zenit TTL fitted with a sixties 135mm f/2.8 Twin Tamron, using just the 135mm main lens. Had she had the converter on, the shot would have needed less enlargement and would have displayed less grain. On the other hand, instead of 1/500th at f/8, her exposure might have been (say) 1/250th at f/5.6, and the shot might have suffered from more movement.

*Picture by Holly Matanle. Shot with Zenit TTL fitted with 135mm f/2.8 preset Twin Tamron Tele on Ilford HP5 Plus, developed in Aculux and printed on Ilford Multigrade.*

Notre Dame, 1995, during the highly successful Photographic Collectors Club of Great Britain weekend trip to the annual photographic collectors' fair at Bièvres, south-west of Paris. Since Bièvres, probably the largest photographic collectors' event in Europe, effectively begins on Saturday evening, the earlier part of Saturday was spent wandering around the city looking for pictures.

*Shot with Pentacon FM fitted with 58mm f/2 automatic preset Biotar on Ilford FP4, developed in Aculux and printed on Jessop Variable Contrast. The camera is illustrated on page 72.*

Another shot from Paris in 1964, this time in the Place du Tertre, where the artists started painting and the accordion started playing every time a tourist bus toiled up the hill.

*Shot with Praktica IV fitted with 100mm f/2.8 Trioplan on Kodak Tri-X, developed in Kodak D76 and printed on Ilford Multigrade.*

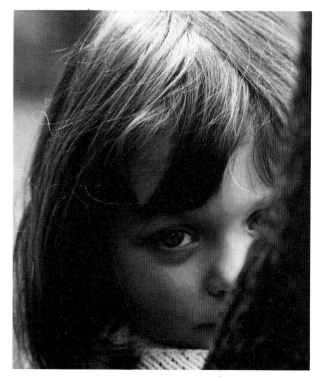

I won my first and only prize in a photographic competition with this picture of Rebecca Nicholson during 1964. The *Croydon Advertiser* duly exhibited it at Croydon Town Hall and Rebecca teased me by asking me if I wanted her to look round a tree every time I produced a camera in her presence for the next twenty years.

*Shot with Praktica IV fitted with 100mm f/2.8 Trioplan on Kodak Tri-X, developed in Kodak D76 and printed at the time, probably on Kodak Bromide.*

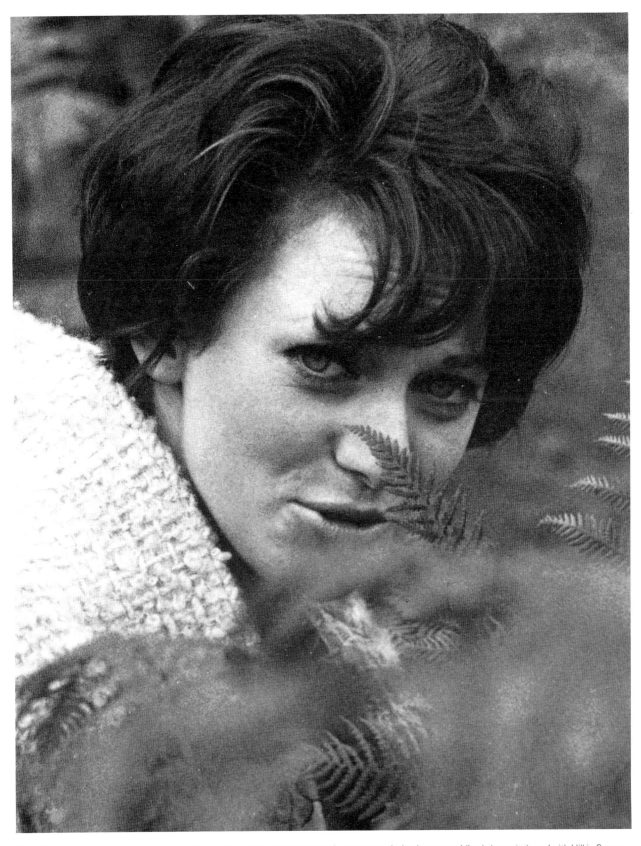

My wife Anne before we were married, offering a few terse comments on the camera pointing her way while sitting quietly on Leith Hill in Surrey. This, like other shots of mine taken during my twenties, now seem 'very sixties', but have a certain style which is appealing.

*Shot with Praktica IV fitted with 135m/225mm f/2.8 Twin Tamron Tele with the matched converter in place on Kodak Tri-X, developed in Kodak D76 and printed at the time, probably on Kodak Bromide.*

Possibly the most physically abused work of art in Europe, this reclining nude is exhibited in the Tuileries Gardens in Paris. It is a magnet for tourists and their cameras.

*Shot with Zenit-E fitted with an early 135mm f/4 Jupiter 11A lens with simple diaphragm on Ilford FP4 Plus, developed in Aculux and printed on Jessop Variable Contrast. This is a very great enlargement from a tiny section of the 35mm negative, and the quality does great credit to the Russian lens.*

The good citizens of Hanover seemed puzzled at the antics of the mad Englishman who set up a Zenit-E with a tripod on a traffic island in the middle of a tram terminus at 10 p.m. on a Wednesday night. The strangeness of my situation was increased by my just missing a tram and having to wait about fifteen minutes for another. During that time several locals enquired after my peace of mind. Patience was rewarded with roughly the shot that I was intending to get, with the lights of the tram making strange patterns as it lurched slowly round the bend during my guessed time exposure – the Zenit has no slow speeds.

*Shot with Zenit-E fitted with 58mm f/2 Helios-44 lens on Ilford FP4 Plus, developed in Aculux and printed on Jessop Variable Contrast.*

One ferry photographed from another in the port of Calais. Here I used the 37mm f/2.8 MIR wide-angle that was marketed during the sixties for the Zenit series. Although this lens has low contrast, its resolution is very good, and it repays a little adaptation of technique to accommodate its flatness of image.

*Shot with Zenit-E fitted with 37mm f/2.8 MIR lens on Ilford FP4 Plus, developed in Aculux and printed on Jessop Variable Contrast.*

An eerily atmospheric shot by a railway-enthusiast friend, Allan Mott, taken with his Zenit-E, now mine, while he was in the RAF in Germany in 1970. In a way, this picture demonstrates that Russian SLRs are capable of long and satisfactory service, since the other Zenit-E pictures featured with this chapter were shot during 1995 with the same camera, used here by its original owner in 1970.

*Picture by Allan Mott. Shot with Zenit-E fitted with 58mm f/2 Helios-44 lens on Ilford FP4.*

# Chapter 5

## How the West was lost – the 35mm focal-plane SLRs of post-war Western Europe

It was the Eastern European camera industry which made the running with SLR development during the aftermath of war. Theirs were the laurels for the first pentaprism, the subsequently ubiquitous 42mm lens mount, the world's first motor drive for an SLR and high-quality lenses at prices that made sense. When Eastern Europe was concentrating on SLRs and focal-plane shutters, Western Europe was principally occupied with rangefinder cameras and leaf-shutter reflex systems.

The few western European exponents of the 35mm focal-plane SLR during the first half of the fifties were Rectaflex of Italy between 1949 and 1956, Pignons of Switzerland, who launched the Alpa 4, 5 and 7 in 1952, Wirgin of Germany, whose first Edixa Reflex appeared during 1955, Wray of Britain, whose Wrayflex series began in 1950, and (arguably) the British Corfield Periflex, although this was not a true SLR.

Although each of those manufacturers (other than Rectaflex) continued to introduce new models during the late fifties, it was not until 1958, when the Contarex first appeared, that West German Zeiss launched a focal-plane shuttered SLR. It was another five years before Leitz first marketed the Leicaflex, and in so doing got it wrong by introducing during 1964 an SLR with a non-TTL meter just as the rest of the world was competing to market TTL models. Three years later, Zeiss Ikon launched its last new focal-plane shuttered camera and one of Western Europe's last new range of SLRs – the Icarex series. Between 1967 and 1973, together with the original

Another shot of one ferry from another as it left the port of Calais. Actually taken in daylight shortly before sunset, this picture was printed utilizing the particular benefits of variable-contrast papers. The lower half was printed to a hard paper grade, with magenta filtration of 110M, the sky with 0M filtration.

*Shot with Zenit-E fitted with 58mm f/2 Helios-44 lens on Ilford FP4 Plus, developed in Aculux and printed on Jessop Variable Contrast.*

Rolleiflex SL35 of 1970, which was briefly made in Germany before being exiled to Singapore, the medium-priced Icarex range represented the last-ditch stand of the European SLR.

By that time, the Japanese manufacturers had the world markets sewn up with cameras delivering more performance for less money. While both the Contarex and the Leicaflex were better engineered than most Japanese reflexes, their prices were dramatically higher. A little lower down the scale of engineering excellence, Alpa cameras, like Exakta, were an acquired taste. They too were more expensive than Japanese competitors, and stood little chance of capturing the mass market and the economic benefits of large-scale production. The Zeiss Ikon/Voigtländer Icarex series, while in many ways appealing to lovers of the classic European camera, were already outdated when they were launched and were quite unable to compete with the sheer style and technological excellence of their oriental counterparts.

### The Rectaflex

Shown initially during 1948 and marketed during 1949, just as was the Contax S, the Rectaflex Standard is usually regarded as failing to be the first single-lens reflex with a built-in pentaprism because its patent was filed after that for its East German competitor. Designed and manufactured in Rome, it had a bayonet lens mount and was usually marketed in Britain with an excellent 50mm f/2 Schneider Xenon lens, although examples with 58mm f/2 Biotar, 50mm f/1.8 Angénieux and 40mm f/2.8 Makro-Kilar can be found. A considerable range of lenses by Schneider, Angénieux, Schacht and Kilfitt was available.

The focal-plane shutter of the Rectaflex Standard was equipped with speeds from 1 second to 1/1000th during the first three years of production, with a new top shutter speed of 1/1300th (probably unique) being introduced during 1952. Full flash synchronization was provided via the two-pin plug system. Most examples of the Rectaflex which occur with conventional 3mm coaxial-socket synchronization have been converted subsequent to manufacture, although I understand that some late examples of the camera were equipped with 3mm sockets as standard.

During 1952, the Italian company launched the remarkable Rectaflex Rotor, essentially a Rectaflex Standard equipped with a revolving turret carrying

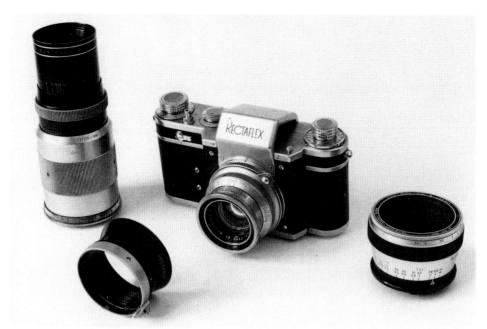

A Rectaflex 1300 (1/1300th second fastest shutter speed) with Angénieux 50mm f/1.8 Type S1 standard lens and its lens hood. On the right is a 40mm f/3.5 Kilfitt-Makro-Kilar E, on the left an Angénieux 135mm f/3.5 Type Y2, which is engraved 'Rectaflex OBI'.

*Shot with Minolta SRT101 fitted with 55mm f/1.7 MC Rokkor on Ilford Pan F Plus, developed in Aculux and printed on Jessop Variable Contrast.*

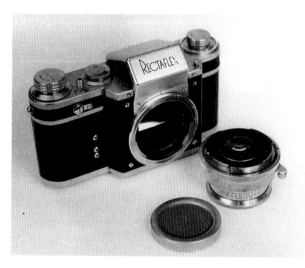

A Rectaflex 1000 with its f/1.8 lens removed to show the 3-claw bayonet. The engraved Rectaflex lens cap is in the foreground.

*Camera by courtesy of Dave and Julie Todd. Shot with Pentax Spotmatic fitted with 55mm f/1.8 Super-Takumar on Ilford Pan F, developed in Aculux and printed on Jessop Variable Contrast.*

three interchangeable lenses which could be clicked into the shooting position as required. Since the camera thus became almost unmanageable because of its weight forward of the body, a tripod-bush mounted grip was available which improved matters. The ultimate refinement was the Rectaflex gunstock, a rifle grip which made it possible to tuck the camera support into the shoulder and genuinely achieve stability. However, the result is extremely heavy.

The only other Rectaflex model was the Rectaflex Junior, which also first appeared during 1952. This was a simplified Rectaflex Standard with no slow speeds and a shutter speed range from 1/25th second to 1/500th.

The Rectaflex range never became commercially successful, nor did the range develop over a substantial number of years. Because Rectaflex cameras are scarce, particularly in Britain, they tend to achieve very high prices as collectibles which are not merited by their quality or performance. The camera, although in some respects over-engineered and quite heavy, was never particularly reliable. It is not a sensible choice for regular classic-camera photography, even if you can afford to buy one. However, it is an interesting and pleasantly idiosyncratic camera to put a film through if the chance offers.

### The Alpa

By contrast, the Alpa models designed and manufactured by Pignons S.A. of Ballaigues, Switzerland, were an unusually and individually designed range of cameras which did achieve considerable success, although in what would nowadays be termed a 'niche

market'. Never manufactured in the numbers typical of the successful Japanese brands of the sixties and seventies, the Alpa was designed for an exacting and methodical scientific user accustomed to the standards of laboratory instruments and appealed to other photographers who enjoy a beautifully engineered, heavy and immensely versatile camera.

Descended from the Alpa Reflex of 1942 and the Alpa Prisma Reflex of 1950, both of which had a narrow-throat bayonet lens mount which did not permit of the use of post-war retrofocus lens designs, the Alpa 4, 5 and 7 were, when launched during 1952, three versions of a totally new camera. All three models had a neoprene-blind focal-plane shutter speeded from 1 second to 1/1000th wound by a large knob which was also the speed-setting knob. All had a direct-vision optical viewfinder in addition to full reflex focusing and a removable back locked by a key on the baseplate. This back was removed from the camera in the same manner as that of a Contax rangefinder camera – by sliding it downwards away from the top-plate before lifting it free from the body. All were flash-synchronized for bulb and electronic, and were usually equipped with a 50mm f/1.8 Auto-Switar or 50mm f/1.8 Macro-Switar lens, in either case with an external automatic-diaphragm mechanism similar in principle to that of the Exakta. The shutter-release button on the front of the camera was covered by a similar button on the lens, The shutter was released by pressing the button on the lens, which stopped the lens down to the preset aperture before the shutter was fired.

The differences between the three initial models were that the Alpa 4 had a simple reflex viewing system without a prism, the Alpa 5 was similar but with a 45-degree roof prism and the Alpa 7 was essentially a 5 with the addition of a coupled rangefinder (coupled only to the 50mm lenses) and a multifocal version of the optical viewfinder.

All models were equipped with a 3-tongue simple bayonet lens mount which continued unchanged as the Alpa mount on successive models throughout the fifties, sixties and seventies. More significantly, all had a flange-to-film register, or distance, of only 37mm, by far the least of any 35mm single-lens reflex. This was to make it possible for the lenses of several other brands of cameras to be adapted to operate on the Alpa and to focus to infinity, since the difference between the 37mm flange-to-film distance of the Alpa, and the greater register of other brands – typically well over 42mm – provided the space for cleverly machined adaptors to be fitted without extending the lens further forward than was required for infinity focus.

Perhaps the most extraordinary feature of all three Alpa models was the provision, in addition to the ten marked shutter speeds, of sixty more shutter-speed settings between the normal speeds (except between 1/25th and 1/10th). These are approximately linear to

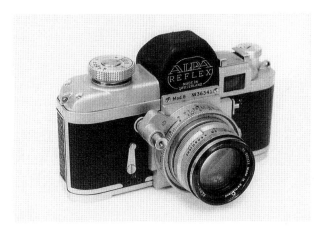

The Alpa Model 6, one of the commonest of the original series of knob-wind Alpa models, fitted with a 50mm f/1.8 Kern Switar.

*Camera by courtesy of Dave and Julie Todd. Shot with Pentax Spotmatic fitted with 55mm f/1.8 Super-Takumar on Ilford Pan F, developed in Aculux and printed on Jessop Variable Contrast.*

The pedantically engraved shutter-speed dial of the early Alpas has 1/2, 1/5, etc., instead of the usual 2, 5, 10 of most shutter-speed dials. The fine index line (at 6 o'clock in this picture) can be set anywhere between speeds to produce intermediate shutter speeds. The setting shown here would be about 1/33rd second.

*Camera by courtesy of Dave and Julie Todd. Shot with Pentax Spotmatic fitted with 55mm f/1.8 Super-Takumar on Ilford Pan F, developed in Aculux and printed on Jessop Variable Contrast.*

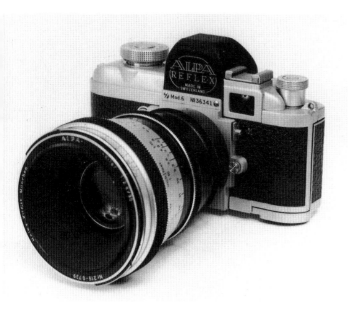

The bias of the Alpa system towards scientific photography caused Pignons to include more lenses and accessories designed for close-up work in their range than was normal at the time. The lens on the Alpa 6 here is a 90mm f/2.8 close-focusing Kilar by Kilfitt of Munich.

*Camera by courtesy of Dave and Julie Todd. Shot with Pentax Spotmatic fitted with 55mm f/1.8 Super-Takumar on Ilford Pan F, developed in Aculux and printed on Jessop Variable Contrast.*

Looking down on the same Alpa 6c (below left), one can see the wind lever and the milled shutter-speed dial (push down and turn) and the detail of the 50mm f/1.8 Kern Macro-Switar normally fitted to the camera. The curved rows of holes in the moving part of the focusing mount form a graphic depth-of-field scale – one can see here that, with the focus set to infinity, most of the holes are white, showing that depth of field extends from 25 feet to infinity at an aperture between f/5.6 and f/8. As the diaphragm setting is altered to a wider aperture, and/or the lens is wound out to its closest focusing distance, fewer holes show white. Stop down, and more become white.

*Shot with Hasselbad 1000F during the seventies on Ilford HP5, developed in Aculux and printed on Jessop Variable Contrast.*

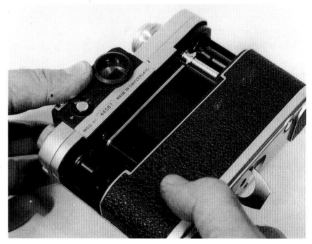

The Alpa 6c was the first of the second series of Alpa cameras, which included the 9d. This 6c body is fitted with the NIBAG adaptor for the use of Nikon lenses with automatic-diaphragm actuation and has the hard-to-locate white incident-light diffuser fitted over the cell of its exposure meter (top right).

*Shot with Hasselbad 1000F during the seventies on Ilford HP5, developed in Aculux and printed on Jessop Variable Contrast.*

The back of an Alpa slides off after the centre release catch is turned. Note the film-reminder dial at the top left and the plate giving the model of camera and serial number on the back of the camera. Only the 6c, 9d and 9f have the model number on the back – on all other models it is on the front.

*Shot with Hasselbad 1000F during the seventies on Ilford HP5, developed in Aculux and printed on Jessop Variable Contrast.*

the marked speeds, so that, for example, the indexed position on the dial one third of the way between 1/25th and 1/50th delivers 1/33rd second.

During 1957, the Alpa 6 was added to the range. This was an Alpa 5 with the addition of a split-image rangefinder screen, which may seem commonplace today but was an innovation sufficient to justify a separate model designation in 1957.

A year later came the Alpa 8, now a very scarce model much sought after by Alpa enthusiasts. This combined the split-image screen of the Alpa 6 with the optical coupled rangefinder of the Alpa 7, so offered reflex focusing and two kinds of rangefinder focusing, all in the one camera.

In 1959, lever-wind and an instant-return mirror were added to each of the models to produce the 'b' series – the 4b, 5b, etc. However, unlike other manufacturers, Pignons did not cease making the knob-wind models, and it is by no means uncommon to find an Alpa 5 with a number later than that of a 5b. In fact, Pignons' policy throughout was to make what the customer wanted, and it remained true when I was an Alpa dealer in the late seventies that Pignons would make an Alpa 7 to order – albeit at a price. However, routine production of the earlier knob-wind models was gradually phased out during the late fifties and early sixties.

The lever-wind mechanism was and remains unusual in that it operates in the opposite direction to that of virtually every other lever-wind camera ever made. Instead of propelling the lever with the thumb past your right eye and out to your right and towards the front of the camera, on an Alpa you wrap your right index finger around the lever and pull it a short distance towards your face. Using this is strange and disconcerting at first, but it becomes second nature and very fast and effective in practice.

Little more than a year after the advent of the front-to-back lever-wind, in the autumn of 1960, Pignons launched the first of what collectors think of as the middle series of Alpa models. This was the 6c, the first Alpa with a conventional pentaprism whose viewing axis was parallel to that of the lens. It was also the first Alpa with a built-in exposure meter, an uncoupled Metraphot selenium-cell meter which was and is a joy to use.

In 1963 came the through-the-lens metering version of this camera, the 9d, which was the first TTL SLR to have the CdS meter cells located within the

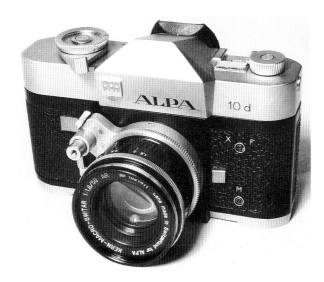

First of the third series of Alpa models was the 10d, a match-needle stopped-down TTL metering camera. Note the unique front-to-back lever-wind. This example is fitted with the 50mm f/1.8 Kern-Macro-Switar, whose focusing mount seems to wind out for ever, eventually reaching a reproduction ratio of 1:2.

*Shot with Hasselbad 1000F during the seventies on Ilford HP5, developed in Aculux and printed at the time on Kodak Bromide.*

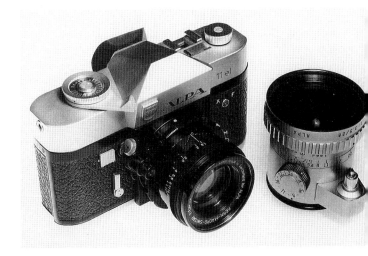

With the Alpa 10d appeared the 11e, a camera with illuminating diodes in the viewfinder to indicate under- and over-exposure. The meter electronics of the 11e proved somewhat fragile, and the model was quite quickly replaced with the very successful 11el, in which correct exposure is indicated when both diodes are equally illuminated. This example has the late 50mm f/1.9 Macro-Switar standard lens. Beside it is the 28mm f/3.5 Alpa Angénieux Retrofocus wide-angle lens. The unusual rotating dial for setting the apertures can be clearly seen.

*Shot with Hasselbad 1000F during the seventies on Ilford HP5, developed in Aculux and printed at the time on Kodak Bromide.*

prism, a practice subsequently adopted by manufacturers worldwide. With its match-needle exposure measurement and smart appearance, the 9d is the commonest of the Alpa models in general circulation, and one of the nicest to use.

By 1968, another update was due, and Pignons launched the third series of Alpa cameras – the 10 and 11 series with a redesigned top-plate, prism housing and shutter. For the first time, Alpa supplied a camera whose shutter-speed setting dial did not revolve when the shutter was fired. The 10d and 10s have cross-coupled conventional CdS exposure meters with needles visible in the viewfinder. The 11e, 11el and 11si show correct or incorrect exposure setting using coloured diodes visible in the viewfinder – arrows in the 11e and 11el, coloured spots in the 11si. A perhaps under-appreciated fact is that all Swiss-built Alpas with TTL meters metered at the working aperture – there was no full-aperture metering Alpa until the Japanese-built badge-engineered Alpa 2000Si appeared at the end of the seventies.

Only after I had had an ordinary (i.e., full-frame) black 10s for a couple of years in the late seventies, and had bought new from Pignons a specially ordered half-frame 10s which I used for a particular lengthy job and then sold again, did I realize just how few Alpa 10s cameras were made, and how unwise I was to sell the two I had as normal secondhand cameras. Only around 100 Alpa 10s bodies ever left the factory and I had owned and used two of them at once, and one of those a half-frame, without realizing their significance!

Throughout the period from 1952 to 1979, when Pignons resorted to importing Japanese cameras instead of manufacturing their own models, many other limited-edition special-purpose models were made and sold. Many, like the Alpa 9f (a 9d with no meter) were sold in limited numbers to the general public. Yet the Alpa model of which most were made is one you are unlikely ever to see – the Alpa 11a, a non-reflex post camera.

## Alpa lenses

From the outset, an impressive range of additional lenses was available for the Alpa. By 1960, the range included lenses by Kern, Schneider, Schacht, Kilfitt, Kinoptik, Oude [Old] Delft and Angénieux and had reached its zenith. The table below sets out the range of lenses then available. I have at one time or another used most of the lenses listed and once again include my own star rating based on subjective assessment.

### Alpa lenses

#### Wide-angle lenses

| | | | | | |
|---|---|---|---|---|---|
| 24mm | f/3.5 | Alpa Retrofocus | Angénieux | (FAD) | ★★★★ |
| 28mm | f/3.5 | Alpa Retrofocus | Angénieux | (PS or FAD) | ★★★★ |
| 35mm | f/3.5 | Alpa-Alpagon | Schacht | (SAD) | ★★ |
| 40mm | f/2.8 | Alpa Makro-Kilar | Kamerabau-Anstalt, Liechtenstein | (PS) | ★★★ |

#### Standard lenses

| | | | | | |
|---|---|---|---|---|---|
| 50mm | f/3.5 | Alpa-Alorar | Spectros, Basel | (CS) | NDA |
| 50mm | f/2.8 | Alpa-Alfinon | Old Delft | (PS) | NDA |
| 50mm | f/1.9 | Alpa-Xenon | Schneider | (PS, later FAD) | ★★★ |
| 50mm | f/1.8 | Kern Switar Apochromat | Kern, Aarau | (FAD) | ★★★★ |
| 50mm | f/1.8 | Kern Macro-Switar Apochromat (seven element) | Kern, Aarau | (FAD) | ★★★★ |
| 50mm | f/1.9 | Kern Macro-Switar Apochromat (six element) | Kern, Aarau | (FAD) | ★★★★+ |

#### Long-focus and telephoto lenses

| | | | | | |
|---|---|---|---|---|---|
| 75mm | f/3.5 | Alpa-Xenar | Schneider | (PS) | ★★★ |
| 90mm | f/2.8 | Alpa-Altelar | Schacht | (PS) | ★★ |
| 90mm | f/2.5 | Alpa-Alfitar | Angénieux | (FAD) | ★★★★ |
| 90mm | f/2.8 | Alpa Makro-Kilar | Kilfitt, Munich | (PS) | ★★★ |
| 100mm | f/2 | Alpa Apochromat | Kinoptik, Paris | (PS, later FAD) | ★★★★ |
| 135mm | f/3.5 | Alpa Tele-Xenar | Schneider | (FAD) | ★★★★ |
| 135mm | f/3.5 | Alpa-Algular | Old Delft | (PS) | ★★ |
| 150mm | f/2.8 | Alpa Apochromat | Kinoptik, Paris | (FAD) | ★★★★ |
| 180mm | f/4.5 | Alpa-Alitar | Angénieux | (FAD) | ★★★★ |
| 180mm | f/4.5 | Alpa-Alefar | Old Delft | (PS) | ★★★ |
| 210mm | f/2.8 | Kinoptik | Kinoptik, Paris | (Manual) | NDA |
| 300mm | f/3.5 | Kinoptik | Kinoptik, Paris | (Manual) | NDA |
| 360mm | f/5.5 | Alpa Tele-Xenar | Schneider | (PS) | ★★★ |
| 500mm | f/5.6 | Reflektar (Mirror) | Zoomar, USA | (no diaphragm) | NDA |
| 500mm | f/5.6 | Kinoptik | Kinoptik, Paris | (Manual) | NDA |
| 36–82mm | f/2.8 | Voigtländer-Zoomar Varifocal lens | Zoomar, USA | (SAD) | ★★ |

FAD, SAD, PS and CS stand for Fully Automatic Diaphragm, Semi-Automatic Diaphragm, Preset Diaphragm and Click Stops respectively. NDA stands for No Data Available.

It is worth noting that there were reputedly also Reflektar (mirror) lenses from the Zoomar Corporation available for the Alpa in focal lengths of 1,000mm, 2,000mm, 2,500mm, 3,750mm and 5,000mm.

There were T2 adaptors in Alpa bayonet for the many independent T2 preset-lens ranges, but no automatic-diaphragm adaptors for the Tamron, Soligor T4 and TX or Vivitar T4 lens ranges. Even the T2 adaptors are difficult to find. However, Tamron Adaptall or Soligor T4/TX lenses can be fitted to an Alpa with automatic-diaphragm operation via one of Pignons' own adaptors to fit M42 automatic or Nikon lenses to an Alpa – in other words, you find a Nikon or Pentax lens to Alpa camera adaptor, then buy the Tamron or Soligor adaptor for that fitting. Complicated, but it works as a means of putting modern zoom or ultra-wide-angle lenses on to your Alpa.

## Alpa accessories

The range of accessories marketed for the Alpa was among the most extensive offered for any brand of camera, principally because of its technical and scientific applications. Collecting Alpa catalogues is an interest in itself, and accumulating all the exciting pieces of equipment that were available is one of the more daunting tasks available to collectors of modern classic 35mm equipment.

Like the Exakta system, which it rivals for complexity, the Alpa had available a variety of different bellows units and close-up copying devices, with a double cable-release to retain the action of the automatic diaphragm of the delightful Kern Macro-Switar, which focused unaided to a range of only 7". The Extensan socket mount in which several of the lenses, notably the 75mm f/3.5 Xenar, were supplied as standard, enabled the user to unscrew the lens head and interpose extension tubes forward of the focusing mount, while retaining the option for a bellows or further TUBAN tubes aft of the lens mount.

The Macrostat modular copying stand and macro-photography equipment included translucent specimen Macrotables for botanic and biological specimens, a range of specialized lighting attachments, such as a ringlight, a fill-in mirror and a micro-spotlight. Fear-some metal ground-spikes were offered (at very high prices) for supporting specimens for photography in the field.

Filters with a unique spring mount for rapid attachment to the lens were offered in size A (for the 50mm f/1.8 Switar and the 75mm f/3.5 Xenar) and in size B (for the 50mm f/1.8 and the later f/1.9 Macro-Switars and for one or two other lenses in the range). Special hoods, all emblazoned with the Alpa logo, were supplied for each of the lenses.

## Is the Alpa a good choice?

The sad fact is that increasing interest in Alpa, and the inherently small supply of cameras and lenses, has driven prices sky-high during the past ten to fifteen years. Any of the Alpa models, particularly the middle series (6c, 9d, 9f), if in well-cared-for condition, can be absolutely delightful and extremely satisfying cameras to use, and the quality of the Macro-Switar lenses, provided that the focusing mounts are not excessively worn, is very high. The later f/1.9 Macro-Switar delivers a noticeably crisper and higher-contrast image than the earlier 50mm f/1.8.

The principal problem that you may encounter with an Alpa is the likelihood of a tapering focal-plane shutter. In principle, this is not difficult to have serviced and reset. However, there are relatively few workshops that are prepared to work on Alpa cameras, and you should check with a few sound repairers whether they are willing to service an Alpa before you go out and buy one for regular use.

One also has to balance a view of what one buys for, say, £1,000 ($1,500) if you are buying Alpa with what might be obtained in other equipment for the same money. If your main objective is optical quality coupled with a fine reliable camera, it has to be said that you will buy a great deal more photographic equipment for your money if you purchase (say) a Canon FT or FTb and a set of lenses. Even the middle-range Alpa lenses cost a great deal more than their Canon or Minolta equivalents, and are similarly priced to Nikon or Contarex lenses in many cases. In practice, the results of the Canon or Minolta cameras and lenses will probably be distinctly superior.

What you do obtain if you buy Alpa is a unique feeling of character and quality, coupled with generally excellent reliability once you have overcome any shutter tapering that may be present.

## The Wrayflex

The Wrayflex series of cameras has the distinction of having been the only commercially successful English-made single-lens reflex system. Manufactured by the Wray Optical Company of Bromley, Kent, the Wrayflex was born in 1950 and flowered briefly, only to die less than a decade later as the ending of UK import restrictions brought a flood of highly developed imported cameras from Europe and Japan.

Three models were made. The Wrayflex I is renowned among collectors for its 24mm × 32mm format, yielding more than 40 exposures on a normal load of 35mm film. This version, which fetches a substantially higher price than the Ia with standard 24mm × 36mm format, is distinguishable without opening the camera by its film counter, which has figures and graduations for more than 40 exposures, whereas the Wrayflex Ia has a conventional counter to 36 exposures.

Both the Wrayflex I and the Ia provide eye-level viewing and focusing, but via a mirror assembly rather than a prism. This has the disconcerting effect of providing an image reversed left to right, although the right way up. The image is also not bright by modern standards. A horizontally running cloth focal-plane shutter has speeds from 1/2 second to 1/1000th second.

The rare Wrayflex II, of which only between 200 and 300 were made, has a pentaprism instead of a mirror, and therefore provides a conventional right-way-round SLR image.

A distinctive feature of all three Wrayflex models is the key-wind for shutter and film. This large key is in the centre of the baseplate and is surprisingly effective. However, it does pose a problem when the camera is used on a tripod. Wray solved this by supplying an accessory cradle which has a large knurled and slotted wheel with a diameter greater than the width of the baseplate. The key fits in the slot in the wheel, the cradle fits on the tripod. The camera can then be wound simply by turning the knurled wheel.

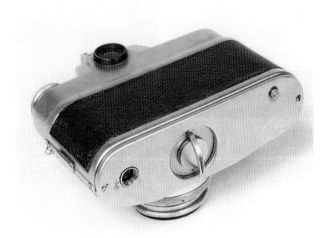

The shutter and film transport of a Wrayflex – this is the underside of a Wrayflex II – were wound by turning a large flip-out key in the baseplate.

*Shot with Topcon RE-2 fitted with 58mm f/1.8 RE-Topcor on Ilford Pan F Plus, developed in Aculux and printed on Jessop Variable Contrast.*

Most of the Wrayflex British-made SLRs had a mirror-system eye-level viewfinder rather than a prism, resulting in a lower profile than most prism reflexes. This example has a 50mm f/2 Unilite lens – the top of the range – with, in front of the camera, a 35mm f/3.5 Lustrar wide-angle, on the left a 90mm f/4 Lustrar and on the right a 135mm f/4 Lustrar.

*Shot with Canon FTb QL fitted with 50mm f/1.8 Canon FD on Ilford Pan F Plus, developed in Aculux and printed on Jessop Variable Contrast.*

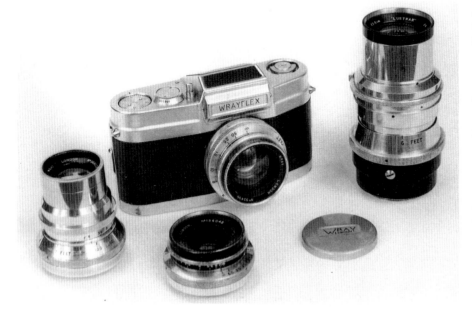

The camera had a screw lens mount. The standard lenses for the Wrayflex were alternative 50mm f/2.8 Unilux 4-element and 50mm f/2 Unilite 6-element objectives. Both perform well. 35mm, 90mm and 135mm Wray Lustrars, all with simple preset diaphragms, were also available and are fairly common on the secondhand market.

## The Contarex system

The most frequent comment heard among collectors and enthusiasts for classic SLRs about the Contarex series of cameras is 'Wonderful lenses – shame about the cameras.' They refer not to any shortcoming of engineering, quality or reliability afflicting Contarex

Winding the camera with a key in the base-plate gave Wrayflex users a problem when they wanted to use a tripod. Wray therefore came up with this neat gadget (right of camera) which enabled the user to wind the shutter and film by rotating the large milled wheel. The lens of the camera is removed to show the fine lens thread.

*Shot with Canon FTb QL fitted with 50mm f/1.8 Canon FD on Ilford Pan F Plus, developed in Aculux and printed on Jessop Variable Contrast.*

The scarce Wrayflex II had a genuine pentaprism, providing a much brighter right-way-round image. This example has a 50mm f/2.8 Unilux lens, the lower-priced option when the camera was new. The uv filter on the right is the type originally supplied for the camera.

*Shot with Topcon RE-2 fitted with 58mm f/1.8 RE-Topcor on Ilford Pan F Plus, developed in Aculux and printed on Jessop Variable Contrast.*

The original Contarex, known for obvious reasons as the 'Cyclops' in Britain and as the 'Bullseye' in the USA. This example is fitted with the 50mm f/2 Planar, and is Mike Rees's camera, with which he shot several pictures of other cameras for this book.

*Camera and picture by courtesy of Mike Rees. Shot with Nikon F fitted with 55mm f/2.8 Micro-Nikkor on Ilford Pan F Plus, developed in Aculux and printed on Jessop Variable Contrast.*

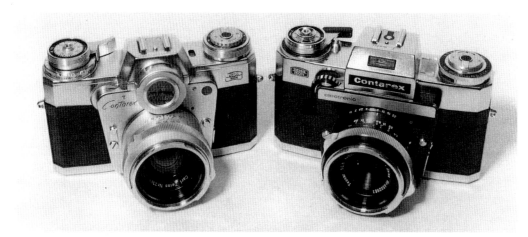

Early and late Contarex cameras – a Contarex Cyclops with 50mm f/2 Planar on the left and a Contarex Super Electronic with 50mm f/2.8 Tessar on the right.

*Shot with Bronica EC fitted with 75mm f/2.8 Nikkor on Ilford HP5, developed in Aculux and printed on Jessop Variable Contrast.*

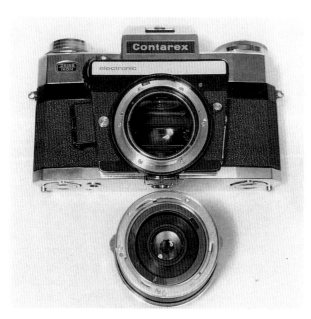

A Contarex Super Electronic with its lens removed, showing the complex lens mount of the Contarex system.

*Shot with Bronica EC fitted with 75mm f/2.8 Nikkor on Ilford HP5, developed in Aculux and printed on Jessop Variable Contrast.*

A Contarex interchangeable film back, shown with its dark-slide partly pulled out to demonstrate its position and shape. The dark-slide of a loaded back would of course normally be pushed fully home when the back was off the camera.

*Shot with Hasselblad 1000F fitted with 80mm f/2.8 Tessar during the seventies on Ilford HP5.*

The inner view of a Contarex interchangeable film back, with the dark-slide removed and the cassette retaining shell lifted. The light-type chamber on the left of the picture keeps exposed film safe while the loaded back is off the camera.

*Shot with Hasselblad 1000F fitted with 80mm f/2.8 Tessar during the seventies on Ilford HP5.*

equipment, but simply to the way they handle; their weight, balance and general feel.

There is no denying, even among those who are Contarex enthusiasts, that any Contarex, particularly any of the early models, is a brute of a camera. It is not just the weight, which is considerable, but the apparent size and clumsiness of the design which alienates many who might otherwise be its friends. And yet....

There is really no quality among SLRs to match that of the Contarex. If you buy just one SLR to admire, stroke, hold in front of the fire on a winter's evening and never load with film, it should be a Contarex Cyclops (in Britain) or Bullseye (in the land of the free). The perfection of the engineering is breathtaking. It also comes expensive, so you need to be fairly well endowed with available cash to be able to afford one as a substitute for a Siamese cat.

Infuriatingly, especially to someone who loves to adapt lenses to operate on cameras for which they were never intended, the Contarex lenses are virtually unadaptable to any other SLR because of the way in which their internal bayonets fit to the camera. The only adapted Contarex lens which I have ever owned was a 21mm f/4.5 Biogon, for which a friend made an adaptor so that it fitted and focused to infinity (without the assistance of the rangefinder) on a Leica M3. So, if you want the experience of Contarex lens quality, you must also undergo the experience of using the camera, which is not that bad once you get accustomed to it. In fact, I have rather enjoyed my Contarex experiences, but then I also like using Alpas, so perhaps my judgment is not to be trusted.

The Contarex appeared during 1958 and became generally available during the following year. The first model, the above-mentioned Cyclops or Bullseye, was in production for between seven and eight years, and is by far the most common of the Contarex types, all of which (other than the scarce Contarex microscope camera) are helpfully emblazoned with the word 'Contarex' on the front. The single huge 'eye' in the front of the prism housing is an extremely accurate coupled selenium-cell exposure meter. The large wheel protruding from the housing to the right of the top of the lens mount (as one holds the camera) is the focusing wheel, a mechanism reminiscent of the rangefinder Contax.

This first Contarex was made only in chrome finish, the camera bodies being finished in a bright chrome, the lens mounts with a matt effect. It is usually found

fitted with the superlative 50mm f/2 Planar, less frequently (and much more expensively) with the 55mm f/1.4 Planar. Sometimes they are found with a 50mm f/2.8 Tessar. Although black-mounted versions of these lenses were made for the later models, and both fit and operate perfectly well, a Contarex Cyclops should have a chrome lens to be in original condition. A complete range of similarly finished chrome lenses was available in focal lengths of up to and including 135mm, with black-finished lenses of 180mm and greater focal lengths.

A feature of Contarex cameras was the availability of interchangeable magazine backs. These have a built-in dark slide, so make it possible, as with several medium-format SLRs, to change backs (and therefore from colour to black and white, or from fast film to slow) in mid-film. Unfortunately, the light-traps of Zeiss interchangeable backs deteriorate in time. One should therefore examine them carefully and buy with caution if buying interchangeable backs for regular use. The light traps can be replaced, but it is a job for an expert and not cheap. Testing for light leaks is simply a matter of loading the back, using it in bright daylight and processing the film.

When buying a Contarex Cyclops, it is worth turning it over and looking at the bottom of the rear of the camera to see if it has a small slot, about 4mm wide, for the 'data strip'. This feature was introduced to the camera during 1964, and enabled the user to write information about the shot being taken on a special strip, which, when inserted into the slot, imprinted that information on to the film. Data-slot Contarex Cyclops cameras fetch almost twice the price of the earlier, almost identical, cameras.

The second Contarex model to appear was the Contarex Special. This had no exposure meter, and therefore no 'eye' or exposure-meter linkage, a fact which made it possible to provide the camera with an interchangeable viewfinder, in the manner of the Nikon F or Exakta. A detachable pentaprism and a waist-level finder hood were available. The Special is scarce and comparatively expensive at around £400 ($600) in 1995, but is in some ways a more agreeable camera to use than the heavier Cyclops.

In 1967, the next model of the Contarex to appear, and the first of the second generation of the Contarex breed, was the Contarex Professional, readily identifiable by the word 'Professional' on the front. Although this made its appearance before the Contarex Super,

it was in effect a derivative of the Super. It again had no exposure meter, but was fitted with a fixed pentaprism. Only 1,500 of these were made, most were bought by professional photographers, and very few have survived in really clean condition. You would be doing well at 1995 prices to buy a decent one for £500 ($750).

The Contarex Super, which emerged during 1968, almost two years after production of the Cyclops had ceased, was a totally redesigned camera with a TTL CdS exposure meter, but exactly the same lens mount with no additional couplings or refinements. Lenses were now all black, the bodies were available in either chrome or black finish. The Contarex Super has the word 'Super' on the front and was made in two sub-versions, the first with the exposure-meter switch on the front of the camera at 2 o'clock to the lens mount, the later and scarcer model with the switch under the wind lever on the top-plate.

Finally, during 1970, there appeared the Contarex Electronic, looking much like the Super, but with the word 'Electronic' on the front. This had a new exposure meter, is comparatively rare and sells for prices between £600 and £900 ($900–$1,350), depending on condition. There was, of course, also the Contarex Hologon, a very scarce special wide-angle version with a fixed 15mm f/8 Zeiss Hologon wide-angle lens, which is not a fisheye lens, and renders straight lines as straight lines. If you get one of those at a car-boot sale, put it in the bank quickly, but only if you feel that the bank is trustworthy.

## Contarex lenses

Any attempt to rate Contarex lenses by the star system is superfluous. The standards of engineering, optical design and quality control applied to Contarex lens production by Carl Zeiss at Oberkochen were so high that any Contarex lens, even the comparatively humble 50mm f/2.8 Tessar, will be found to be superb. It is probable, although I have no evidence of this, that Zeiss applied a policy of selection rather than simple quality assurance to the designation of lenses for the Contarex system, just as Linhof have done for several decades in designating lenses for their cameras. Any Schneider Xenar or Zeiss Tessar in a shutter engraved with the word Linhof will perform to a standard well above the average for that particular focal length and aperture. So too will any Contarex Tessar.

I have not used every lens in the Contarex system, but I have taken photographs with all the common lenses, from the 21mm Biogon and 25mm Distagon through to the 180mm Olympia-Sonnar. All that I have used would rate at least four stars in a four-star system and some might qualify for four and a half.

No independent lenses have, to my knowledge, been available for the Contarex.

### Contarex lenses

#### Wide-angle lenses

| | | | | |
|---|---|---|---|---|
| 16mm | f/2.8 | Distagon (fisheye) – rare | 11.2442 | 1973 |
| 18mm | f/4 | Distagon | 11.2418 | 1967–1973 |
| 21mm | f/4.5 | Biogon (mirror-up, non-reflex for Cyclops only) | 11.2402 | 1960–1963 |
| 25mm | f/2.8 | Distagon | 11.2408 | 1963–1973 |
| 35mm | f/4 | Distagon | 11.2403 | 1960–1973 |
| 35mm | f/4 | Blitz-Distagon (flash GN diaphragm) | 11.2413 | 1966–1973 |
| 35mm | f/4 | PA Curtagon (perspective-control shift lens) | 11.2430 | 1973 |
| 35mm | f/2 | Distagon | 11.2413 | 1965–1973 |

#### Standard lenses

| | | | | |
|---|---|---|---|---|
| 50mm | f/4 | S-Planar (macro lens) | 11.2415 | 1963–1968 |
| 50mm | f/2.8 | Tessar | 11.2501 | 1965–1973 |
| 50mm | f/2 | Planar (chrome) | 11.2401 | 1960–1963 |
| 50mm | f/2 | Blitz Planar (black – flash diaphragm) | 11.2412 | 1966–1973 |
| 55mm | f/1.4 | Planar | 11.2407 | 1965–1973 |

#### Long-focus and telephoto lenses

| | | | | |
|---|---|---|---|---|
| 85mm | f/2 | Planar | 11.2404 | 1960–1973 |
| 85mm | f/1.4 | Planar (very rare) | 11.2444 | 1974 |
| 115mm | f/3.5 | Tessar | 11.2417 | 1960–1973 |
| 135mm | f/4 | Sonnar | 11.2405 | 1960–1973 |
| 135mm | f/2.8 | Olympia-Sonnar | 11.2409 | 1965–1973 |
| 180mm | f/2.8 | Olympia-Sonnar | 11.2425 | 1967–1973 |
| 250mm | f/4 | Sonnar (manual preset) | 11.2406 | 1960–1963 |
| 250mm | f/4 | Olympia-Sonnar (auto stopdown) | 11.2421 | 1963–1973 |
| 400mm | f/5.6 | Tele-Tessar (very rare) | 11.2434 | 1970–1973 |
| 500mm | f/4.5 | Mirotar (very rare) | 11.2420 | 1963–1973 |
| 1000mm | f/5.6 | Mirotar (extremely rare) | 11.2422 | 1964–1970 |
| 85-250mm | f/4 | Vario-Sonnar (very rare) | 11.2424 | 1970–1973 |

## Is it for you?

The pleasure of photography with a Contarex lies for most people who venture forth with one in the quality of the results rather than in the actual experience of using the camera itself. If, like Ansel Adams, you would actively consider carrying a 5" × 4" view camera up a mountainside because it was the only way to achieve the result you wanted, then you view photography in the spirit for which the Contarex was intended. No other 35mm system subjugates convenience to quality to the same degree or with equivalent success.

The Contarex, particularly the early Cyclops/Bullseye, is not an easy camera to use well, although it amply repays practice and perseverance. Like some other heavy cameras, it is particularly suited to hand-held or rudimentarily supported short time exposures. I have produced extremely sharp shots at 1/10th second using a 50mm f/2 Planar simply by resting the camera on what is politely called a beanbag but was actually a sock filled with polystyrene packing chips and tied at one end. Placed on any firm surface, however uneven, a beanbag makes it surprisingly possible to hold long exposures still, particularly if the camera is heavy and has a smooth and well-engineered shutter release.

The high quality of the lenses, and their outstanding full-aperture performance, make the Contarex a good choice for available-light photography. The Contarex tends also to suit photographers who are at their happiest with the minimum number of additional lenses. Even SLR users who have a bagful of lenses for their chosen system will, if they are honest, admit that a high percentage of their photographs are shot with two or three favourite lenses or focal lengths – I tend to gravitate towards 28mm and 85mm or 90mm lenses in addition to the standard lens of the camera of the moment and to make more use of the standard lens than do most people.

Economy of choice of lenses reduces the weight disadvantage of the Contarex system. Any loss of versatility at the long-focus end of the lens range is at least partially compensated for by the high-quality image and the extraordinary capabilities of modern films, since smaller portions of the negative can be enlarged without significant loss of quality. However, if you cannot bear to leave any lens behind, in case you need it, then buy something smaller and lighter.

## The Edixa Reflex series

During the mid-fifties and on into the mid-sixties, a substantial number of the ten focal-plane-shuttered models of the Edixa Reflex was sold in Britain, Germany and the USA. Designed and manufactured by Wirgin of Wiesbaden, West Germany, the Edixa Reflex cameras were of moderate cost (£58.8s.4d [then about $163.50] for an Edixa Reflex B with 50mm f/2.8 Cassarit, as compared with £88.16s.11d [about $249] for an Exakta Varex IIb with 50mm f/2.8 Tessar in 1963). They were also only of moderate quality, and this often becomes apparent in normally used examples bought some thirty to forty years after they were made.

At a camera fair which I attended recently, there were five Edixa Reflex cameras of different models on sale. Only one worked properly in all respects that could be checked without actually shooting pictures, and even that example suffered from a slack focusing mount which gave substantial backlash when the direction of rotation was changed. On the other hand, the prices were low, and I bought the one that worked well for £25 ($37.50) after some bargaining. It *is* possible to buy a good working Edixa Reflex outfit, but you have to be patient, observant and take your time.

All focal-plane Edixa Reflexes (i.e., with the exception of the Compur-shuttered Edixa Electronica) have

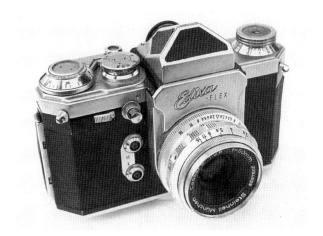

The Edixa Flex of 1958, one of the early Edixa reflex models, which had no slow speeds. This particular camera is fitted with a 50mm f/2.8 Cassar, a lens of fairly mediocre performance.

*Camera and picture by courtesy of Mike Rees. Shot with Contarex Cyclops fitted with 50mm f/2 Planar on Ilford Pan F Plus, developed in Aculux and printed on Jessop Variable Contrast.*

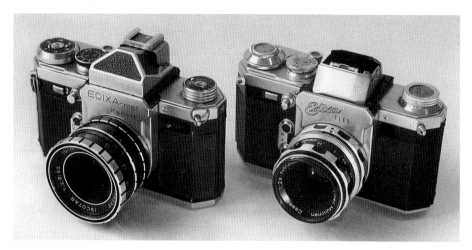

The Edixa Reflex series are very versatile cameras. The Edixa-mat Kadett on the left has the interchangeable prism with its 50mm f/2.8 Iscotar; the Edixa Flex on the right has a 50mm f/2.8 Cassar and a waist-level finder. The finders are interchangeable between the cameras. Both lenses have the characteristic striated mount of Edixa lenses.

*Shot with Pentax S1a fitted with 55mm f/1.8 Super-Takumar on Ilford Pan F Plus, developed in Aculux and printed on Jessop Variable Contrast.3*

the 42mm × 1mm Praktica/Pentax screw mount, and can therefore be fitted with an enormous variety of lenses, many of them available for a song. Models launched during and after 1959 (the first being the Edixa Flex B) have the conventional M42 internal automatic-diaphragm actuator. The quality and performance of the lenses originally marketed for and with the Edixa series varies sharply from the downright poor to excellent lenses such as the 50mm f/1.9 Schneider Xenon, and a similar broad spread of price and capability extended throughout the lens range, providing original buyers with a range from 'entry-level' SLRs to cameras capable of fine pictures and modern classic-camera buyers with reasons for caution.

The Edixa Reflex cameras began with the Edixa Reflex of 1955, sold with a waist-level viewfinder and a choice of 50mm f/2.8 Isconar and Westanar lenses, neither of whose results is likely to excite. Both of these lenses produce low contrast without compensating high resolution. Three years later, the range of cameras was expanded to include the Edixa Flex, essentially an Edixa Reflex without slow speeds; the Edixa Reflex B, which was an Edixa Flex with an interchangeable pentaprism; and the Edixa Reflex C, which added a built-in selenium-cell exposure meter to the specification of the Edixa Reflex B.

By 1958, the range of standard lenses had increased, and Wirgin and the various importers of Edixa equipment had adopted the logical, if commercially unusual, policy of cataloguing all their cameras on a 'body only' basis, and all their normal focal-length lenses separately, with separate prices. Thus, whereas most manufacturers (Asahi with their Pentax range and Minolta are examples) listed and priced their cameras with standard lenses which they considered appropriate to the specification of the body, and discounted the price of the standard lenses to maintain a competitive price for the package, Edixa buyers were openly offered the option of adding a top-specification lens to a fairly basic body, or vice versa. There are, as a result, virtually no 'normal' combinations of Edixa bodies and lenses, as there tend to be with most makes.

This should have provided the user with practical choice and benefits. What it actually did was to make it easier for the oriental manufacturers to undercut the Edixa series and gradually run them off the market through sheer force of price and quality.

In 1959, the model range changed again with the first introduction of internal automatic diaphragm actuation, first in the Edixa Flex B, which was essentially an Edixa Flex (no slow speeds) with added diaphragm actuation, and then in the Edixa Reflex D, which was like the Edixa Reflex B but with both the internal diaphragm actuation and an extended range of slow speeds to 9 seconds.

Early in the sixties, Wirgin launched an economy version of their Edixa Reflex, and in this case made an exception to their policy of pricing the bodies and lenses separately. The Edixa-mat Kadett was sold only with a 50mm f/2.8 Steinheil Cassaron, and is therefore usually found with that lens. The Kadett had a waist-level (interchangeable) finder, a shutter speeded from 1/30th second to 1/500th without slow speeds and, like the earlier models, no instant-return mirror.

Shortly afterwards, the Edixa-Mat series cameras appeared, bringing the benefit of an instant-return

mirror to Edixa users. The Edixa-Mat BL of 1961, still sold 'body only', had the 1-second to 1/1000th-second version of the Edixa cloth focal-plane shutter, instant-return mirror and interchangeable finders. However, it was still offered as standard with the waist-level finder, unlike other brands which marketed a pentaprism as standard and a waist-level finder as an optional extra. The latter was in keeping with the spirit of the age, and Wirgin lost another phase of the battle for the SLR market. As with earlier models, the Edixa-Mat CL was a BL with an added uncoupled Metrawatt selenium exposure meter, and the DL was a BL with an extended slow-speed range to 9 seconds.

In 1965, in the face of falling sales and battles already lost to the quality of Japan and the subsidized prices of Eastern Europe, Wirgin launched a new model which abandoned interchangeable waist-level and pentaprism viewfinders in favour of a fixed pentaprism with microprism focusing. This camera was marketed in two versions, the Edixa Prismaflex and the Edixa Prismat, the Prismaflex having shutter speeds from 1/30th to 1/500th and the Prismat a full speed range from 1 second to 1/1000th. The Edixa-Mat BL, CL and DL continued to be marketed alongside these cameras until 1967, and the Edixa series was finally closed out in 1968 and 1969.

## Edixa Reflex lenses

My experience of lenses specifically supplied for the Edixa is not as great as that of lenses of other systems. This is partly because, like most people who rely on cameras for at least part of their living, I tend to shy away from unreliable equipment, and I have never found Edixa equipment to be particularly robust. It is also partly because the lenses originally sold for the Edixa, usually finished in a distinctive style with glossy black-enamel and polished-metal segments to the focusing ring, are not easy to acquire.

The Edixa series was available new during the great boom period of the M42 mount, when the amateur SLR market was dominated by Pentax and Praktica, and a vast variety of inexpensive M42 screw preset and (later) automatic-diaphragm lenses was available at very reasonable prices. Because the prices of the Western European Edixa lenses were high by comparison with both their Eastern European equivalents and the independent-brand oriental lenses, relatively few 'genuine' Edixa lenses were sold.

However, since 'genuine Edixa' lenses were lenses from well-known manufacturers which were also in some cases available mounted for other cameras (Exakta for example), I am able to give a star rating for many of them. Since the information is available in this instance, I have also given, in the table overleaf, the number of elements of each lens as some guide to original cost and quality. However, beginners should never assume that the performance of a lens is directly related to the number of elements. There exist 3-element lenses capable of superb performance, and some terrible 7-element lenses.

## Edixa accessories

For a system which was from the outset intended for the amateur market at a comparatively low price, the Edixa range included a surprisingly complete range of accessories, although one hardly ever encounters them now. Every item in the catalogue was given a five-letter code, on the same lines as those given by Leitz to Leica accessories and by Pignons to the Alpa accessory range. Thus, MIBIS was a split-image interchangeable focusing screen, ITERM was a set of four extension tubes, and so on. The list extends through five pages of the 1963 catalogue, rather less by 1965. Accessory prices were fairly high – when a complete Edixa Flex B with f/2.8 Cassarit was costing £58.8s.4d ($163.50) in Britain, a set of extension tubes with automatic-diaphragm actuation (ZWAKA) was priced at £4.15s.8d ($13.40).

In general, despite their prices when new, Edixa accessories suffer when elderly from the same problems of below-average materials, above-average wear and poor reliability as the cameras and lenses they were designed to fit. They are rarely in particularly good condition.

## Should you buy Edixa?

It is difficult to make a case for buying Edixa for regular use, unless you can find an outfit that has been well looked after and little used during the last thirty to forty years. While interesting as one of the very few complete post-war Western European single-lens reflex camera systems to achieve volume sales, and certainly worth a place in a collection on those grounds alone, Edixa equipment rarely operates well for very long and is not particularly easy to repair.

### Edixa lenses

| | Diaphragm | | No. of elements | Star rating |
|---|---|---|---|---|
| **Wide-angle lenses** | | | | |
| 24mm f/4 | Enna-Lithagon | PS | 7 | NDA (★★★?) |
| 28mm f/3.5 | Enna-Lithagon | PS | 6 | NDA (★★★?) |
| 28mm f/4 | Schneider Curtagon | FAD | 7 | ★★★ |
| 30mm f/2.8 | Rodenstock Eurygon | Manual | 7 | ★★★ |
| 35mm f/2.8 | Schneider Curtagon | FAD | 5 | ★★★ |
| 35mm f/2.8 | Auto-D Quinaron | FAD | 7 | ★★ |
| 35mm f/2.8 | Isco Westromat | FAD | 5 | ★ |
| 35mm f/3.5 | Schacht Travegon | FAD | 6 | ★★ |
| 35mm f/3.5 | Enna-Lithagon | Manual | 4 | ★★★ |
| 40mm f/2.8 | Makro-Kilar E (Inf. – 4") | PS | 4 | ★★★ |
| 40mm f/2.8 | Makro-Kilar D (Inf. – 2") | PS | 4 | ★★★ |
| **Standard lenses** | | | | |
| 50mm f/1.8 | Schacht Travelon | FAD | 6 | ★★ |
| 55mm f/1.9 | Auto-D Quinon | FAD | 6 | ★★ |
| 50mm f/1.9 | Isco Westromat | FAD | 6 | ★★ |
| 50mm f/1.9 | Schneider Xenon | FAD | 6 | ★★★ |
| 50mm f/2.8 | Isco-Iscotar | FAD | 3 | ★ |
| 50mm f/2.8 | Schacht Travenar | FAD | 4 | ★★ |
| 50mm f/2.8 | Schneider Xenar | FAD | 4 | ★★★★ |
| **Long-focus and telephoto lenses** | | | | |
| 85mm f/1.5 | Enna-Ennalyt | FAD | 6 | NDA (★★?) |
| 90mm f/2.8 | Makro-Kilar | PS | 4 | ★★★★ |
| 90mm f/2.8 | Schacht Travenar | SAD | 4 | ★★ |
| 90mm f/3.5 | Schneider Xenar | PS | 4 | ★★★★ |
| 100mm f/3.5 | Cassarit | PS | 4 | ★★ |
| 100mm f/3.5 | Auto D-Quinar | SAD | 4 | NDA |
| 100mm f/4 | Isco-Isconar | Manual | 3 | ★ |
| 135mm f/2.8 | Wirgin Edixar | PS | 4 | NDA (★★?) |
| 135mm f/2.8 | Ennalyt | PS | 5 | ★★★★ |
| 135mm f/2.8 | Steinheil Quinar | PS | 5 | ★★★ |
| 135mm f/3.5 | Isco Tele-Westanar | FAD | 5 | ★★ |
| 135mm f/3.5 | Schacht Travenar | SAD | 4 | ★★ |
| 135mm f/3.5 | Tele-Xenar | FAD | 5 | ★★★★ |
| 135mm f/4 | Isco-Isconar | Manual | 3 | ★ |
| 180mm f/4 | Isco Tele-Westanar | Manual | 4 | ★★ |
| 200mm f/5.5 | Tele-Xenar | PS | 4 | ★★★★ |
| 240mm f/4.5 | Enna Tele-Ennalyt | Manual | 5 | ★★★ |
| 300mm f/4.5 | Wirgin Edixar | PS | 4 | NDA |
| 360mm f/5.5 | Tele-Xenar | PS | 4 | ★★★ |
| 400mm f/4.5 | Tele-Ennalyt | Manual | 5 | NDA (★★★?) |
| 600mm f/5.6 | Tele-Ennalyt | Manual | 5 | NDA (★★★?) |
| **Zoom lenses** | | | | |
| 85–250mm f/4 | Enna-Zoom | NDA | NDA | NDA |
| 95–205mm f/6.3 | Edixa-Zoom | NDA | NDA | NDA |

## The Leicaflex system

By 1964, the SLR market was changing fast. The professional market was more competitive, with the new Topcon RE-Super challenging Nikon and Pentax. In the budget-priced volume market, SLR prices were falling and sales of focal-plane-shuttered SLRs in Britain and the USA were dominated by East German Praktica, Exakta and Exa, the Russian Zenit and the Japanese Miranda. Throughout Japan and Europe, manufacturers were rushing to complete their TTL SLR designs for launch over the next two to three years amidst doubts about the viability of the volume market and the likelihood of prices being sustained.

Into this cauldron of innovation and doubt, Ernst Leitz of Wetzlar introduced an expensive, already outdated yet beautifully engineered SLR with something of the character of a trusted yet overweight aunt. It speaks quietly, with a deep voice of reassuring authority. It is more rounded than you expect, heavier than it looks and lends an air of restrained unostentatious competence to the user. Not for nothing has it been called the diesel Leica.

The original Leicaflex had a built-in coupled non-TTL CdS exposure meter with its cell in the front of the prism. Like the Contarex Cyclops and several other cameras designed during the fifties, it had a focusing screen which, while extremely bright, actually permitted visual focusing only within a ring in the centre of the screen, the remainder of the screen being simply a bright viewfinder. This is very disconcerting to modern users and quite difficult to use, particularly for moving subjects. It is also almost incompatible with retrofocus extreme wide-angle lenses of focal lengths shorter than 28mm, which cause the screen to vignette in a dramatic and unacceptable manner. The quiet cloth focal-plane shutter had speeds from 1 second to 1/2000th, and was beautifully designed and built. It rarely gave or gives trouble. The shutter speeds were displayed at the foot of the focusing screen.

The first Leicaflex had no meter switch, and had a crescent-shaped exposure counter and three screw heads around the tripod bush. The later (so-called) Leicaflex II had a meter switch built into the lever-wind stand-off and is recognizable by having a circular exposure counter and no screws around the tripod bush. For use, there is little to choose between them. The occasional Leicaflex with a crescent-shaped counter and a meter switch is a common Leitz conversion.

The magnificently solid Leicaflex – this is a Leicaflex II (so-called) with the circular film-counter window – fitted with the 50mm f/2 Summicron-R. In front to the left is the lens hood which reverses over the lens when not in use, and a Leitz Series 6 UVa filter, fitted beneath and retained by the milled ring visible at the front of the lens. To the right of the camera are, in the background, the 135mm f/2.8 Elmarit-R and, in the foreground the 35mm f/2.8 Elmarit-R.

*Shot with Zenith 80 fitted with 80mm f/2.8 Industar on FP4, developed in Aculux and printed on Jessop Variable Contrast.*

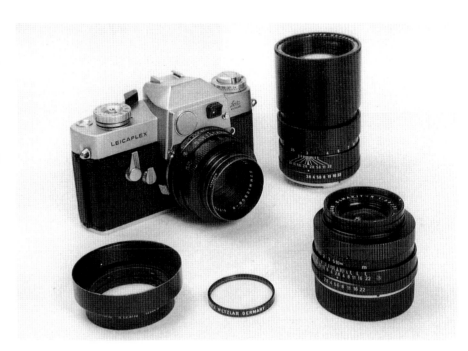

Late in 1968, Leitz launched the Leicaflex SL as a TTL replacement for the Leicaflex. Superficially similar apart from the absence of the meter window and battery compartment on the front of the prism housing, the Leicaflex SL was actually a significantly redesigned camera. It had a remarkably bright and clear non-interchangeable conventional focusing screen with an extremely effective central microprism to aid focusing. Its TTL exposure meter measured exposure at full aperture.

During the early seventies, technology in Japan was outstripping Leitz's ability to invest sufficiently in research and development. Negotiations with Minolta in Japan launched a partnership which was to result in the Leica R3 of 1976. Meanwhile, in 1974, the short-lived, and now scarce, Leicaflex SL2 appeared. This had both aperture and shutter speed displayed in the viewfinder, had a viewfinder illuminator to show the displays clearly in poor light and was fitted with a new exposure meter three times more sensitive than that of the SL. Prices asked for Leicaflex SL2 cameras are, purely because of rarity, astronomical by comparison with those asked for the common Leicaflex SL. From a user's point of view, there is no benefit in paying the premium.

The advent of the Leica R3 of 1976 effectively marked the end of the classic Leitz reflex cameras, for the R3 was in most essential mechanical and electronic respects a Minolta XE-1 with many external modifications. The R3 is not as reliable a camera as the Leicaflex series, and is prone to exposure-metering problems. Perhaps because of this, and some similar problems with the collaboratively designed Leica CL, the manufacturing relationship between Leitz and Minolta for the production of cameras did not last. Later Leica reflexes of the R4, R5 and R6 series are the products of a refinanced Leica organization, after its acquisition by Wild of Switzerland.

*Leicaflex lenses*

Leicaflex lenses of the sixties and seventies provide exceptional resolution, but without that extremely high contrast which distinguished the best Japanese lenses of the sixties from their European rivals. Like Contarex lenses, they are universally of superb quality, making star ratings superfluous.

The only standard lens that was supplied throughout the non-TTL Leicaflex period was the 50mm f/2 Summicron-R, and the same lens in its twin-cam version continued as the usual 50mm lens for the Leicaflex SL and SL2, although the 50mm f/1.4 Summilux-R was available for the Leicaflex SL from 1969. These versions of the standard lenses used series VI filters on the 50mm f/2 and either 48mm screw-in or series VII filters on the 50mm f/1.4.

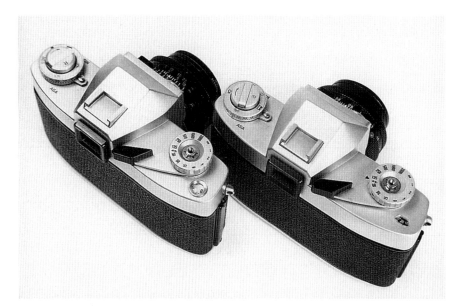

The two versions of original Leicaflex. The first type is on the right, with the exposure counter in an arc-shaped window. The second type with meter switch actuated by the wind lever is on the left, identified by the circular exposure-counter window.

*Shot with Zenith 80 fitted with 80mm f/2.8 Industar on FP4, developed in Aculux and printed on Jessop Variable Contrast.*

The Leicaflex SL was the first TTL metering Leicaflex and is usually found in chrome finish with 50mm f/2 Summicron-R (twin-cam), as seen here. The lens hood is in this picture reversed over the lens to protect it, and so that the lens hood can be carried inside the ever-ready case.

*Camera and picture by courtesy of Mike Rees. Shot with Nikon F fitted with 55mm f/2.8 Micro-Nikkor on Ilford Pan F Plus, developed in Aculux and printed on Jessop Variable Contrast.*

Both forms of original Leicaflex had a mirror lock-up to permit insertion of the non-reflex 21mm f/3.4 Super Angulon-R, a superb if inconvenient lens which required a Leitz 21mm brightline viewfinder for mounting in the camera accessory shoe. Nowadays, these 21mm mirror-up lenses are scarce and expensive and frequently lack the viewfinder, without which they are virtually useless. Unless you are getting the lens for a song, do not buy one without the viewfinder, for Leitz 21mm viewfinders are hard to find.

A limited range of lenses in focal lengths from 35mm to 135mm was launched alongside the first Leicaflex. These 'single-cam' lenses had one bright steel cam visible within the circumference of the 3-claw bayonet mount at the rear of the lens to provide data on the lens aperture to the camera's exposure meter.

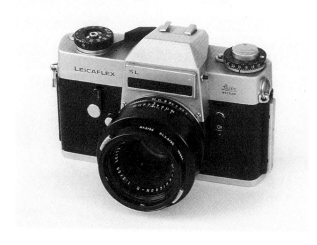

The full-aperture metering of the Leicaflex SL required more information from the lens. Instead of needing to know only the preset aperture, the SL exposure meter also required data on the maximum aperture of the lens in use. To supply this information, a second cam was fitted, diametrically opposite to the first in the rear of the lens. Thus, lenses supplied for the Leicaflex SL became known as 'twin-cam' lenses, and Leitz offered a service to convert single-cam lenses to twin-cam. Many were thus converted, and single-cam lenses, while in no sense rare, are not easy to find in good condition.

From 1969, new lenses began to appear. The first, because the Leicaflex SL had no mirror lock-up and

could not use the 21mm f/3.4 Super Angulon-R, was a new retrofocus 21mm f/4 Super Angulon-R, a superb lens whose performance is almost unbeatable at this focal length. The 50mm f/1.4 Summilux-R appeared during 1969, followed by a 90mm f/2 Summicron-R and, in 1970, by a 28mm f/2.8 Elmarit-R. Further lenses appeared progressively throughout the early seventies.

Three new lenses launched with and for the SL2 will not fit the earlier Leicaflex and Leicaflex SL cameras. These are the 16mm f/2.8 Fisheye Elmarit-R, the 19mm f/2.8 Elmarit-R and the 24mm f/2.8 Elmarit-R.

The lens mount of the Leicaflex SL2 was modified to accept these lenses (while still accepting all earlier Leicaflex lenses except the mirror-up Super Angulon), and attempts to force the 'extra three' lenses on to an SL will seriously damage the camera. Do not try it!

When the Leica R3 appeared in 1976, new versions of the 50mm f/2 Summicron-R and 50mm f/1.4 Summilux appeared, the former with a 55mm filter mount, the latter taking series VII filters. The automatic-exposure system of the R3 introduced the requirement for a third cam within the rear assembly of Leica R lenses, which, on an R3, superseded the other two cams. The third cam was closer to the centre of the circle represented by the lens mount and mounted on the assembly within which the rear lens elements are situated. Once again, Leitz offered the facility of adding the third cam to earlier lenses, although some early single-cam Leicaflex lenses could not be so updated. Once 'triple-cammed' as the dealers say, the earlier lens could be used in auto mode on an R3 (or later Leica Reflex), and could still be used normally on earlier Leicaflex models.

The supply of twin-cam lenses in their original state has been greatly reduced by the tendency of Leica dealers to have every twin-cam lens that came into stock triple-cammed to increase its saleability. From a collector's standpoint, this is sad, since in ten or twenty years' time every collector will want original single- or twin-cam lenses and the price will rocket.

The final stage in the three-cam saga came when Leitz, from the late seventies, made the lenses only with the third cam, thus making them suitable for the R series of cameras but not for the earlier Leicaflex models. It is therefore essential to glance at the back of any Leica R-series lens to determine which cameras it will operate correctly. References in the table on page 105 to triple-cam lenses fitting 'all models' apply to lenses with all three cams. All Leicaflex lenses, except those listed as Leicaflex SL2 and R-series only, can be used with the original Leicaflex (I and II).

There are very few fixed-mount independent lenses available to fit the Leicaflex series of cameras. However, both the Soligor T4 automatic-diaphragm interchangeable-mount system and the Tamron Adaptall system briefly included mounts for the Leicaflex SL, although neither was totally reliable. I was told by a repairer that this was because the spring rate of the camera diaphragm actuator was too demanding for the independent lens systems.

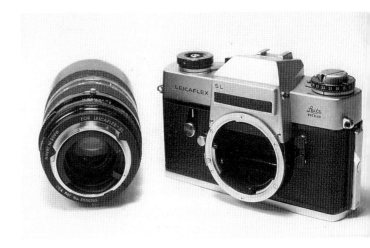

The availability of the Tamron Adaptall Leicaflex SL adaptor made it possible for me to use this 38–100mm f/3.8 Tamron zoom on my Leicaflex SL cameras for several years. The camera and lens mounts can be clearly seen.

*Shot with Bronica EC fitted with 75mm f/2.8 Nikkor on Ilford HP5, developed in Aculux and printed on Jessop Variable Contrast.*

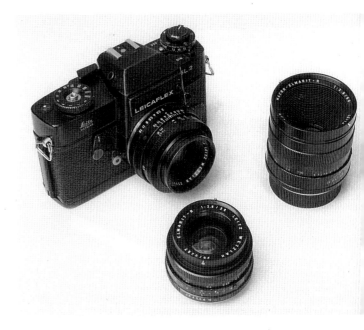

The Leicaflex SL2 is capable of accepting the late 19mm and 24mm Leitz lenses, and also the Leitz Vario-Elmar. It is comparatively scarce and mint examples command very high prices – as much as £800 (about $1,200) for the camera and 50mm f/2 Summicron-R. In front of this SL2 is a twin-cam 28mm f/2.8 Elmarit-R, a magnificent lens. On the right is the 60mm f/2.8 Macro-Elmarit-R.

*Camera and lenses by courtesy of Peter Coombs. Shot with Minolta SRT101 fitted with 55mm f/1.7 MC Rokkor on Ilford Pan F Plus, developed in Aculux and printed on Jessop Variable Contrast.*

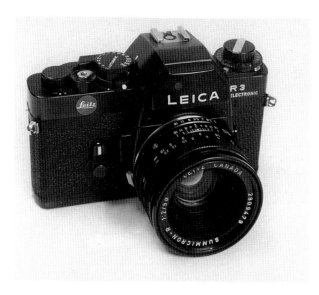

The Leica R3 Electronic was the first Leitz reflex not to be called a Leicaflex, and introduced the new series of 50mm lenses with 55mm conventional filter mounts instead of Series VI and VII ring-retained filters. It was also the first Leica with automatic exposure.

*Shot with Zenith 80 fitted with 80mm f/2.8 Industar on FP4, developed in Aculux and printed on Jessop Variable Contrast.*

Nonetheless, I have successfully used Tamron Adaptall lenses on Leicaflex SL bodies over a lengthy period of years, although my repairer had to adjust the adaptors before all worked properly. I have also used a Soligor T4 zoom lens on a Leicaflex SL, although not on a regular basis.

Points to watch are as follows:

a) The Tamron Adaptall adaptor needed for a Leicaflex SL or SL2 is an Adaptall 1 (not Adaptall 2) adaptor, with 'Leicaflex SL' engraved on it. These are scarce and are commoner in the USA than in Britain. They sell for as much as £50 ($75) each in Britain, by comparison with normal Tamron adaptor prices of around £8 ($12).

b) The Tamron Adaptall 2 adaptor marked 'Leica' (for Leica R4, R5, R6) does not fit Leitz reflexes prior to the R4. Although the lens mount is the same, the adaptor physically fouls the prism housing of a Leicaflex SL. The adaptor does not, in any case, have the 'twin-cam' configuration that is necessary for a Leicaflex SL.

c) No Tamron adaptor works effectively on the original Leicaflex (either version) with non-TTL

metering. Although the adaptor fits, the spring rate of the diaphragm is different from that of the SL, and the diaphragm actuation of the Tamron lens does not work properly. As a result, if a Tamron lens is fitted to an original Leicaflex, the mirror will sometimes stay up after the shutter is fired. The same problem on a Leicaflex SL fitted with a Tamron lens indicates that adjustment to the adaptor is needed.

### Using the Leicaflex

I have a great affection for Leicaflex SL cameras and their twin-cam lenses and used them professionally for all my 35mm work for several years in the seventies and again in the late eighties and early nineties. As my dependence on spectacles grew, I began to find the Leicaflex SL screen difficult to focus with wide-angle lenses. Eyesight-correction lenses were no help because, without spectacles, I could not see to set the aperture or check the exposure counter. So, at that point I returned, after some experiment, to using screw Pentax and Minolta SRT cameras, both of whose viewfinder optics seem to suit my sight and spectacles better than other brands.

But for this purely personal eyesight problem, I might still be shooting a great many negatives using Leicaflex SL cameras and their lenses. They are very reliable, simple to handle and deliver first-class results. If they have drawbacks, they are their weight and cost, particularly the weight of the longer lenses such as the superb but huge 180mm f/2.8 Elmarit-R. To use a Leicaflex with versatility, one has to be able to put a substantial amount of money into buying the lenses and accessories and a lot of effort into carrying them. If the cash and energy are available, I would definitely recommend them.

### The Zeiss Ikon/Voigtländer Icarex system

During the late sixties, Zeiss Ikon was in trouble. Its premium-priced top-quality Contarex system was being outsold and rendered obsolete by the Nikon F and its amateur-market leaf-shutter Contaflex SLRs were being driven from the market by cheaper and more versatile Pentax, Minolta, Nikkormat and other Japanese cameras.

As they purchased an ever-larger proportion of the ancient but troubled Voigtländer company, they had the opportunity to adapt and utilize an as yet

## Leicaflex and Leica Reflex lenses

### Wide-angle lenses

| | | | Introduced | Fits |
|---|---|---|---|---|
| 16mm | f/2.8 | Elmarit-R | 1974 | Leicaflex SL2 and R-series only. |
| 19mm | f/2.8 | Elmarit-R | 1975 | Leicaflex SL2 and R-series only. |
| 21mm | f/3.4 | Super Angulon-R | 1964 | Original non-TTL Leicaflex (I and II) only (mirror-up). |
| 21mm | f/4 | Super Angulon-R | 1969 | Twin-cam for Leicaflex and SL/SL2. Later triple-cam, all models. Fits non-TTL Leicaflex, but screen vignettes. |
| 24mm | f/2.8 | Elmarit-R | 1974 | Leicaflex SL2 and R-series only. |
| 28mm | f/2.8 | Elmarit-R | 1970 | Twin-cam for Leicaflex SL/SL2. Later triple-cam, all models. |
| 35mm | f/2 | Summicron-R (9-element) | 1972 | Twin-cam for Leicaflex SL/SL2. |
| 35mm | f/2 | Summicron-R (6-element) | 1976 | Triple-cam for all models. |
| 35mm | f/2.8 | Elmarit-R (Series VI filter mt) | 1964 | Single-cam for Leicaflex. Twin-cam for Leicaflex and SL/SL2. |
| 35mm | f/2.8 | Elmarit-R (Series VII filter mt) | 1974 | Twin-cam for Leicaflex and SL/SL2 Triple-cam for all models. |
| 35mm | f/2.8 | Elmarit-R (E55 filter) | 1979 | Triple-cam for all models. |
| 35mm | f/4 | PA Curtagon (Perspective control/shift) | 1969 | All models – manual diaphragm and no meter coupling. |

### Standard lenses

| | | | | |
|---|---|---|---|---|
| 50mm | f/2 | Summicron-R (Series VI filter mt) | 1964 | Single-cam for Leicaflex. Twin-cam for Leicaflex SL and SL2. |
| 50mm | f/2 | Summicron-R (E55 filter) | 1976 | Triple-cam for all models. |
| 50mm | f/1.4 | Summilux-R | 1969 | Twin-cam for Leicaflex and SL/SL2. Triple-cam for all models. |
| | | | 1978 | Compact redesigned lens with third cam only. |
| 60mm | f/2.8 | Macro-Elmarit-R | 1972 | Twin-cam for Leicaflex and SL/SL2. |
| | | | 1976 | Triple-cam for all models. |

### Long-focus and telephoto lenses

| | | | | |
|---|---|---|---|---|
| 90mm | f/2 | Summicron-R | 1969 | Twin-cam for Leicaflex and SL/SL2. |
| | | | 1976 | Triple-cam for all models. |
| 90mm | f/2.8 | Elmarit-R | 1964 | Single-cam for Leicaflex. Twin-cam for Leicaflex and SL/SL2. Triple-cam for all models. |
| 100mm | | Macro-Elmar-R | 1968 | For bellows mounting – manual diaphragm. |
| | | | 1978 | Full triple-cam mount. |
| 135mm | f/2.8 | Elmarit-R (concave rear element) | 1964 | Single-cam for Leicaflex. |
| 135mm | f/2.8 | Elmarit-R (convex rear element) | 1968 | Twin-cam for Leicaflex and SL/SL2. Triple-cam for all models. |
| 180mm | f/3.4 | Apo-Telyt-R | 1975 | Triple-cam for all models. |
| 180mm | f/2.8 | Elmarit-R | 1968 | Twin-cam for Leicaflex SL and SL2. Triple-cam for all models. |
| 180mm | f/4 | Elmar-R | 1976 | Triple-cam for all models. |
| 250mm | f/4 | Telyt-R | 1970 | Twin-cam for Leicaflex and SL/SL2. Triple-cam for all models. |

### Zoom lenses

| | | |
|---|---|---|
| 45–90mm f/2.8 Angénieux Zoom | 1969 | Twin-cam for Leicaflex and SL/SL2. Triple-cam for all models. |
| 80–200mm f/4.5 Vario-Elmar Zoom | 1974 | Leicaflex SL2 and R-series only. |

unmarketed Voigtländer SLR with excellent yet relatively low-cost Voigtländer lenses and, they reasoned, to compete more effectively. Thus was born in 1967 the short-lived, uncelebrated yet quite effective Icarex series.

Angular, heavy and chunky to hold, the 1967 Icarex 35 had a cloth focal-plane shutter speeded 1/2 second (typically Zeiss) to 1/1000th second, interchangeable pentaprism and waist-level viewfinders, no built-in exposure meter and a unique two-tongue breech-lock lens mount in which was fitted either a three-element 50mm f/2.8 Pantar or a four-element 50mm f/2.8

Tessar. The fact that, at that stage, no f/2 or f/1.8 standard lens was available put the new camera at an instant disadvantage by comparison with its oriental competitors.

By 1968, Zeiss Ikon recognized that, without TTL exposure metering, the project was doomed to failure, so launched the Icarex 35CS, an adaptation of the Icarex 35 with a stop-down metering CdS match-needle uncoupled exposure meter built into a removable prism. This had a prismatic viewing system, or 'Judas window', to present an image of the aperture in use within the viewfinder. Adding the CS

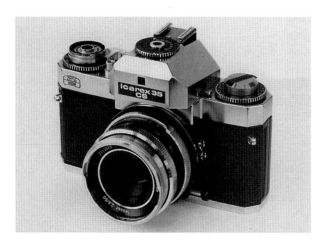

The Icarex 35CS of 1968 is an attractive camera but was not commercially successful. This example has a 50mm f/2.8 Tessar in the Icarex breech-lock lens mount.

*Camera and picture by courtesy of Mike Rees. Shot with Nikon F fitted with 55mm f/2.8 Micro-Nikkor on Ilford Pan F Plus, developed in Aculux and printed on Jessop Variable Contrast.*

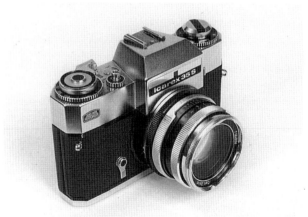

The Icarex 35S of 1970 was available with either 42mm screw-thread mount (with 'TM' on the front) or the Icarex bayonet mount ('BM' on the front). This is a bayonet-mount camera – the 'BM' is hidden by the lens.

*Camera and picture by courtesy of Mike Rees. Shot with Nikon F fitted with 55mm f/2.8 Micro-Nikkor on Ilford Pan F Plus, developed in Aculux and printed on Jessop Variable Contrast.*

prism to an earlier Icarex 35 effectively converted it into the later model. During 1969, the excellent 50mm f/1.8 Ultron was added to the range of standard lenses, whereupon the Icarex became reasonably competitive in specification terms, but uncompetitive in price.

Still sales were poor, so Zeiss Ikon decided to try a 42mm screw lens mount, thereby making a vast range of independently marketed interchangeable lenses compatible with the camera. During 1969, the Icarex 35 TM appeared – simply an Icarex 35 with 'Thread Mount'. Then, in 1970 they launched a new camera, the Icarex 35S, in two forms, the TM with 42mm screw mount and the BM with the breech-lock bayonet mount. The Icarex 35S featured a fixed pentaprism and a built-in coupled stop-down CdS exposure meter.

At some point in 1970 or 1971, another Icarex, now very rare, also appeared, the Icarex SL706. This was a camera of redesigned, more rounded appearance than the Icarex 35S, with the 42mm screw lens mount, but of essentially similar specification.

The various forms of Icarex continued to be manufactured and marketed alongside each other as a range until 1973, acquiring in 1970 a new Zeiss Ikon/ Voigtländer logo. The range ended with the end of Zeiss camera production at Stuttgart – but see the Rollei SL35M details below.

## Icarex lenses

Although received mythology among camera collectors is that Icarex lenses were built down to a price – and that may be true – I have used all the lenses except the 400mm at one time or another and have found them to deliver very crisp high-resolution images, even at full aperture. Most also seem to retain good mechanical

| Icarex lenses | | | Cat. No. BM | Cat. No. TM | Star rating |
|---|---|---|---|---|---|
| **Wide-angle lenses** | | | | | |
| 25mm | f/4 | Distagon | None | 11.3503 (rare) | ★★★★ |
| 35mm | f/3.4 | Skoparex | 11.2003 | 11.3510 | ★★★★ |
| **Standard lenses** | | | | | |
| 50mm | f/2.8 | Pantar | 11.2001 | None | ★★ |
| 50mm | f/2.8 | Tessar | 11.2002 | NDA | ★★★ |
| 50mm | f/1.8 | Ultron | 11.2014 | 11.3502 | ★★★★ |
| **Long-focus and telephoto lenses** | | | | | |
| 90mm | f/3.4 | Dynarex | 11.2004 | None | ★★★ |
| 135mm | f/4 | Super-Dynarex | 11.2005 | 11.3511 | ★★★★ |
| 200mm | f/4 | Super-Dynarex | 11.2008 | None | ★★★★ |
| 400mm | f/5 | Telomar | 11.2010 | None | NDA |
| 36–82mm | f/2.8 | Zoomar | 11.2012 | None | ★★★ |

condition, although the diaphragms sometimes become sluggish and need cleaning.

Nine Zeiss lenses (most of Voigtländer design) were available for the bayonet-mount Icarex cameras, five for the 42mm screw-thread TM models.

Independent lens manufacturers supplied T2 mounts for T2 preset lenses to fit the Icarex bayonet, but, as far as I know, there are no automatic-diaphragm independent lenses available for Icarex bayonet-mount cameras. Icarex screw-mount cameras accept any of the vast number of M42 automatic-diaphragm lenses available, and can also be used with Tamron, Vivitar and Soligor interchangeable M42 lens mounts.

## Using the Icarex system

The Icarex breech-lock bayonet mount has much to recommend it. Like the similar mounts of the Canon reflex, the Praktina and the Praktisix, it is wear-free, quick and precise. Icarex cameras are for people who like solid, heavy Germanic equipment. To many they seem unimaginative; in fact they perform well, reliably and are good value for money. They are also fairly scarce, although as yet not too expensive because there is comparatively little market in them. If you can acquire one of the bayonet-mount cameras and a set of lenses, you will have a sound outfit. The screw-mount cameras are no less sound, although to my mind less collectible.

## The Rollei SL35 series

Franke and Heidecke of Brunswick were, of course, best known for their twin-lens reflexes, but launched during the sixties and seventies a series of innovative and well-engineered rollfilm and 35mm SLRs. The 35mm series was introduced in 1970 with the Rolleiflex SL35, a camera which was, like several other European aspirants to the 35mm SLR market, too little, too late. An attractive, compact camera, the SL35 nonetheless featured stop-down metering like that of the Pentax Spotmatic two years after the Konica Autoreflex T had offered open-aperture TTL metering, and just at the point when it was becoming known that the other leading Japanese manufacturers were getting ready to launch their open-aperture metering cameras.

The 50mm f/1.8 Zeiss Planar or 50mm f/1.8 Schneider Xenon standard lens introduced a com-

pletely new unique bayonet mount just when the market was beginning the process of rationalizing its range of lens mounts, led by the pressure of consumers to be able to buy independent lenses to fit their cameras. If there was a Tamron or Vivitar inter-changeable lens mount for a camera, it boosted the sales prospects of the marque dramatically. Although a Tamron mount for Rollei SL35 did eventually appear, it came late in the life of the series of cameras.

Rollei did, nonetheless, offer M42 screw and 39mm (Leica) screw adaptors to fit lenses of those fittings to the camera, but, of course, without automatic-diaphragm facilities.

The gathering pace of open-aperture metering quickly made the Rollei SL35 obsolescent, and by 1974, Rollei was about to launch an open-aperture Rollei SL350. However, adding open-aperture meter-ing involved adding another sensor to the lens mount (like the second cam of Leica reflex lenses) and the company held back. They also had other matters in hand.

During 1972, Rollei had taken over Voigtländer from Zeiss, and with it acquired the Icarex range, about to disappear as a brand name. Recognizing in their own business the problems of high labour costs that had afflicted Zeiss Ikon, Rollei had looked to the East, and in 1972 moved its SL35 production progressively to Singapore, adapting as it did so the design of the last Icarex, the SL706, to open-aperture metering, and from it creating the Voigtländer VSL1 with M42 screw mount and open-aperture metering, launched during 1974. A bayonet-mount version of this camera was also made and marketed during 1975 as the Voigtländer VSL1 BM.

In 1976 the Rollei SL35M appeared. This had a differently shaped prism housing, a split-image rangefinder screen and the Rollei two-prong bayonet lens mount. The standard lens was usually the 50mm f/1.8 Planar, although a 50mm f/1.4 alternative was also available.

Alongside the all-black Rollei SL35M appeared the Voigtländer VSL-2, which was in most respects the same camera. The VSL-2 was little different to a VSL1 BM but had no external meter repeater window. This was fitted with a 50mm f/1.8 Ultron which, although bearing a Voigtländer name, was identical optically to the Planar.

It soon became apparent that the SL35M/VSL-2 was a marketing stop-gap, for later in 1976, the

SL35ME and Voigtländer VSL-2 Automatic appeared, again an exercise in badge engineering with one basic camera design.

This was the first Rollei with an electronically governed focal-plane shutter and also the first to offer automatic exposure. The aperture-priority CdS metering system in this heavy black camera was effective but battery-hungry, the cloth focal-plane shutter providing slow speeds of up to 4 seconds. The lens mount in both Rollei and Voigtländer versions was now the latest version of the 3-tongue Rollei bayonet. An oddity of this design was that the exposure-metering system worked only when the camera was in aperture-priority automatic mode. Set to manual, the camera effectively had no meter.

By 1978, Rollei was ready to offer the last in this series, and the last Voigtländer SLR of them all – the Rolleiflex SL35E and the Voigtländer VSL-3. These had a new vertically running metal-bladed shutter with electronically governed speeds of 16 seconds to 1/1000th second plus a mechanically operated 1/125th second which was not battery-dependent. The exposure-meter cell was now a silicon dioxide ($SiO_2$) cell. Although arguably not of our classic SLR period, this camera is compact, effective and undeniably the last of a line.

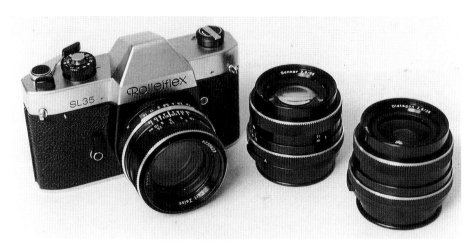

The original Rolleiflex SL35 is a very pleasant and effective camera, although its features were seen as inadequate for the market's needs at the time when it was launched. The range of lenses marketed with it was compact, well engineered and optically excellent. Immediately to the right of the camera is the 85mm f/2.8 Sonnar, and on the extreme right the 35mm f/2.8 Distagon.

*Camera and lenses by courtesy of Alan Borthwick. Shot with Minolta SRT101 fitted with 55mm f/1.7 MC Rokkor on Ilford Pan F Plus, developed in Aculux and printed on Jessop Variable Contrast.*

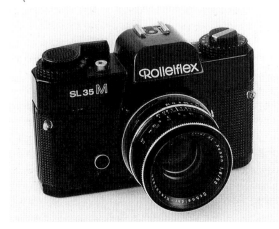

The hunky black Rolleiflex SL35M is an impressive piece of equipment. This one is unusual in having a 50mm f/1.8 Rollei SL-Xenon lens.

*Camera and picture by courtesy of Mike Rees. Shot with Nikon F fitted with 55mm f/2.8 Micro-Nikkor on Ilford Pan F Plus, developed in Aculux and printed on Jessop Variable Contrast.*

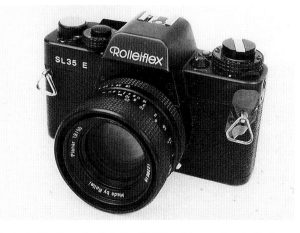

The last of the line – the Rolleiflex SL35E, in this case fitted with the 50mm f/1.8 Planar 'made by Rollei'.

*Camera by courtesy of Len Corner. Shot with Minolta SRT101 fitted with 45mm f/2 MD Rokkor on Ilford Pan F Plus, developed in Aculux and printed on Jessop Variable Contrast.*

### Rolleiflex/Voigtländer series lenses

#### Wide-angle lenses

| | | | Star rating |
|---|---|---|---|
| 16mm | f/2.8 | Distagon HFT | ★★★★ |
| 21mm | f/4 | Rolleinar-MC | ★★★ |
| 25mm | f/2.8 | Color-Skoparex | ★★★ |
| 28mm | f/2.8 | Rolleinar-MC | ★★★★ |
| 35mm | f/2.8 | Angulon | ★★★★ |
| 35mm | f/2.8 | Rolleinar-MC | ★★★ |
| 35mm | f/2.8 | Color-Skoparex | ★★★★ |

#### Standard lenses

| | | | |
|---|---|---|---|
| 50mm | f/1.4 | Planar HFT | ★★★★ |
| 50mm | f/1.4 | Rolleinar-MC | ★★★ |
| 50mm | f/1.8 | Planar HFT | ★★★★ |
| 50mm | f/1.8 | Color-Ultron | ★★★★ |

#### Long-focus/telephoto lenses

| | | | |
|---|---|---|---|
| 85mm | f/1.4 | Planar HFT | ★★★★ |
| 85mm | f/2.8 | Sonnar | ★★★ |
| 85mm | f/2.8 | Color Dynarex | ★★★ |
| 135mm | f/2.8 | Planar HFT | ★★★★ |
| 135mm | f/2.8 | Rolleinar-MC | ★★★ |
| 135mm | f/3.5 | Tele-Xenar | ★★★★ |
| 135mm | f/4 | Color Dynarex | ★★★★ |
| 135mm | f/4 | Tele-Tessar | ★★★★ |
| 200mm | f/3.5 | Rolleinar-MC | ★★★ |

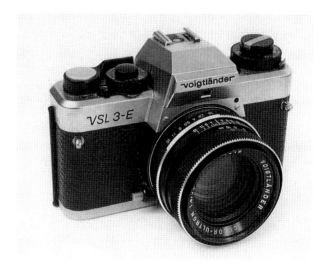

Essentially similar in most mechanical respects to the Rollei SL35E was the Voigtländer VSL 3-E, although it was externally different in many ways and the lens was marked as being a 50mm f/1.8 Voigtländer Color-Ultron. It seems likely that this lens was identical to the 50mm f/1.8 Planar of the Rollei SL35E.

*Camera by courtesy of David Coan. Shot with Minolta SRT101 fitted with 45mm f/2 MD Rokkor on Ilford Pan F Plus, developed in Aculux and printed on Jessop Variable Contrast.*

## Rollei SL35/Voigtländer VSL lenses

There is a degree of confusion among collectors, not elucidated by any available information from the former manufacturers, as to which of the various lenses offered for the Singapore-made Rollei and Voigtländer SLRs were badge-engineered identical optics, and which were individual designs.

The table above, to the best of my knowledge, gives a reasonably complete list of lenses offered. The Rolleinar series of lenses was offered at the time as a budget-priced alternative to the more expensive Distagon/Planar/Sonnar range.

There were some independent-brand lenses marketed with the Rollei SL35 mount, and there is available, although it is not always easy to find, a Tamron Adaptall mount for SL35, making it possible to fit the excellent Tamron SP lenses to the cameras.

## Should you buy one?

Lenses for the Rollei SL35/Voigtländer VSL are not easy to find, and are not always as sound as one would wish. The early cameras are heavy but pleasant to use, the late versions are compact, battery-dependent and very enjoyable if only marginally classic pieces of equipment.

If your wish is to build a large outfit of lenses, there are easier ways, although Rollei 35mm SLR prices are quite reasonable. If you like using a standard lens plus one or two others, and are prepared to wait while you find decent examples of the additional lenses, the Rollei SL35 series could be for you. Bear in mind, however, that the exposure meters in the pre-electronic cameras are prone to problems and are expensive to repair. Check them very carefully if you want to be able to rely upon the exposure meter.

None of the Alpa lenses of the fifties and sixties has the bite and contrast of the great Japanese marques which swept the market by the mid-seventies. But the quality is extremely pleasing. This picture of Patrick Cox was shot in 1973 using one of the Angénieux lenses which have a knob on top to control the apertures.

*Shot with Alpa 9d fitted with 90mm f/2.5 Angénieux Alfitar on Kodak Tri-X, printed on Jessop Variable Contrast.*

The 90mm Angénieux lens on the Alpa 9d again shows that curious blend of sharpness of line and softness of image that is characteristic of the Angénieux lenses of the fifties and early sixties which I have had the opportunity to use. This is Morven Cox, mother of the two children featured in the other Alpa pictures here.

*Shot with Alpa 9d fitted with 90mm f/2.5 Angénieux Alfitar on Kodak Tri-X, printed on Jessop Variable Contrast.*

Another Alpa shot (opposite), this time with the 50mm f/1.8 Kern Macro-Switar. Emma Cox, photographed on the same day as her brother, was sitting by a swimming pool, and the light reflected from the water has brightened her face.

*Shot with Alpa 9d fitted with 50mm f/1.8 Kern Macro-Switar on Kodak Tri-X, printed on Jessop Variable Contrast.*

Ullswater in England's Lake District on a cold day in March 1993. This lake has had a strong appeal for me since I first visited it as a small child. The print was produced with 120M filtration for the foreground and 25M filtration to bring out the detail in the background.

*Shot with Leicaflex SL fitted with 28mm f/2.8 Elmarit-R twin-cam lens on Ilford FP4, developed in Aculux and printed on Jessop Variable Contrast.*

A scene in Rye, one of south-eastern England's most picturesque towns. The overall sharpness of Leitz lenses shines out from the original print, the notice on the wall being easily read through a magnifier.

*Shot with Leicaflex SL fitted with 90mm f/2 Summicron-R on Ilford FP4, developed in Aculux and printed on Ilford Multigrade.*

My daughter Emma, who recently took a post-graduate degree in War Studies, seems to have begun her research early. I had totally forgotten that I had this picture, obviously shot beside HMS Victory in Portsmouth dockyard, and had certainly never previously printed it. It dates from about 1977.

*Shot with Leicaflex SL on Ilford Pan F, printed on Jessop Variable Contrast. Lens details not recorded, but I suspect it was a 35mm f/2.8 Elmarit-R.*

A happy family group watches the fun of the Tunbridge Wells sedan-chair races in August 1994. This was shot from the spectators' barrier on one side of the course across to the other side, and is a substantial enlargement from an HP5 negative. Despite a certain amount of visible grain, the range of tones is very pleasing.

*Shot with Edixa-mat Kadett fitted with a prism and 135mm f/2.8 Twin Tamron Tele on Ilford HP5, developed in Aculux and printed on Ilford Multigrade.*

The strange perspective created by using an ultra-wide-angle lens rather too close for comfort lends a certain arresting quality to this picture shot in Rye, East Sussex. It shows how good independent lenses can be, for this was taken with a 17mm f/3.5 Tamron SP.

*Shot with Leicaflex SL fitted with 17mm f/3.5 Tamron SP, via a Leicaflex SL adaptor like that illustrated on page 103, on Ilford FP4, developed in Aculux and printed on Ilford Multigrade.*

In March 1993, I obtained permission to shoot pictures on behalf of a client at a dress rehearsal of The Gladiators' arena show at the Wembley Arena in London. I took shots of one particular contest, the equipment for which incorporated my client's products, and had very little time to get the shots once the game began. On occasions like this, one is there on sufferance, and I had to work at a greater distance than I would have liked, by available stage lighting on colour-negative film. I used a Leicaflex SL, and shot some pictures with a 180mm f/2.8 Elmarit-R and the rest with the 90mm f/2 Summicron-R. The 180mm pictures were technically good, but the whirling figures never once gave me a decent picture. The best pictures came from the 90mm lens and were published in colour with a much smaller degree of enlargement than is used here. Despite the excessive grain, this image works well, and shows that exciting graphic images do not necessarily have to be photographically clear.

*Shot with Leicaflex SL fitted with 90mm f/2 Summicron-R on Kodacolor Gold 400, printed on Jessop Variable Contrast. Reproduced by kind permission of London Weekend Television. 'Gladiators' is a registered trade mark.*

Thatcher John Hall of Hailsham, East Sussex, demonstrates his skills. This was shot against the sunlight, close in to the subject, and is not an easy negative to print. The best solution proved to be an extremely soft grade – filtration of 20Y – to hold the detail both in the shirt and in the subject's face.

*Shot with Rolleiflex SL35 fitted with 35mm f/2.8 Distagon on Ilford FP4 Plus, developed in Aculux and printed on Jessop Variable Contrast.*

Buying secondhand vehicles never was easy. Shot at Michelham Priory, East Sussex, during a country event at Easter 1995, this was a true snapshot – the moment did not last long enough for me to adjust exposure and the negative is, as a result, undeniably thin. But how often do you get the chance to photograph a monk, albeit a phoney monk, assessing a coracle?

*Shot with Rolleiflex SL35 fitted with 85mm f/2.8 Sonnar on Ilford FP4 Plus, developed in Aculux and printed on Jessop Variable Contrast.*

This girl was being taught the rudiments of wood-turning using traditional equipment at a country-craft fair. She was quite oblivious to my being nearby taking photographs.

*Shot with Rolleiflex SL35 fitted with 85mm f/2.8 Sonnar on Ilford FP4 Plus, developed in Aculux and printed on Jessop Variable Contrast.*

## Chapter 6

# When the world held its breath – and a Pentax

One of the most memorable advertising campaigns ever devised to promote cameras invited photographers to 'Just hold a Pentax'. Used to launch the Pentax SV and S1a in Britain between 1962 and 1964, the campaign was brilliantly successful primarily because it told what was at the time a significant truth. One had (and has) only to hold, focus, wind and fire a nice Pentax SV to appreciate the enormous leap in viewfinder brilliance, smoothness of focusing, quietness and 'feel' that it represented by comparison with any comparably priced European reflex of its day. It was that campaign, and those cameras, which made the Pentax a major contender on the British photographic market, and it was those qualities which were a massive influence on the development of Japanese SLR supremacy worldwide.

Yet the Pentax S-series cameras, of which the S1a was one of the longest in production (1963 to 1971), had begun with the Pentax S some five years earlier in 1957. This was six years after Asahi Kogaku of Tokyo showed Japan's first 35mm SLR as a prototype late in 1951 and subsequently launched it commercially in 1952 as the Asahiflex I.

### The Asahiflex series

Collectors in the USA will know the Asahiflex series of SLRs rather better than will collectors in Europe, particularly Britain, since import controls during the fifties greatly limited their availability in the UK and elsewhere. No such controls hindered sales in the USA, and Asahiflex cameras were also sold under the Tower name by the ubiquitous Sears Roebuck catalogue. The result is that Asahiflex equipment is decidedly scarce in Britain, but relatively common in the USA, although frequently under the Tower name.

All four Asahiflex models (I, IA, IIB, IIA – the order in which they were launched) were squat, angular-ended reflexes of a shape and style so reminiscent of the pre-war Praktiflex that it has been suggested that their basic design was to some extent 'borrowed' from KW. Like the Praktiflex, the Asahiflex I had a fixed waist-level viewing and focusing hood, speeds from 1/20th to 1/500th second and a mirror which was raised and lowered directly in response to pressure on the shutter button. Like the Praktiflex, the Asahiflex series had a screw lens mount of small diameter – 37mm on the Asahiflex, 40mm on the Praktiflex. Beyond that, however, there is little similarity, for the standard of engineering of the Asahiflex is decidedly higher than that of the KW camera. All four models sported a direct-vision optical viewfinder in addition to the reflex finder – a feature like that of the KW Praktina, launched more than a year after the Asahiflex. Was there a Japanese mole at KW?

The standard lens of the short-lived and scarce Asahiflex I was a 50mm f/3.5 Asahi-Kogaku Takumar with manual diaphragm and chrome finish. Only one other lens was available at this stage, a 100mm f/3.5 Asahi-Kogaku Takumar, also in chrome finish. There is some dispute as to whether this model was ever sold by Sears as a Tower, the balance of probability being that it was not. In 1953, the Asahiflex IA (first-type Tower 23) appeared with two (non-coaxial) flash contacts instead of one and modified shutter speeds (1/25th, 1/50th, 1/100th, 1/200th, 1/500th) instead of the earlier Leica-style 20/30/40/60/100/200/500 series.

The real leap forward of the Asahiflex period was the appearance at the end of 1954 of the Asahiflex IIB (second-type Tower 23), which had the world's second instant-return mirror in a 35mm SLR (the Hungarian Gamma Duflex of 1947 was the first) and the first such instant-return mirror to be internationally marketed and achieve commercial success. The Asahiflex IIB also introduced standard coaxial flash contacts to the range and was offered with either a 50mm f/3.5 preset lens or a 58mm f/2.4 Asahi-Kogaku Takumar.

In February 1955, the Asahiflex IIA at last brought slow speeds of 1/2, 1/5th and 1/10th second to the Asahiflex. These were selected with a separate slow-speeds knob mounted on the front of the camera in a position reminiscent of the slow-speeds knob on a screw Leica. In 1957, the Asahiflex IIA appeared in the Sears catalogue as the Tower 22 – nobody has yet explained why they waited two years; perhaps it was simply until the price came down. At this time, 83mm f/1.9, 135mm f/3.5 and 500mm f/5 lenses had been added to the Asahiflex range, as had a close-focusing bellows unit and a set of extension tubes.

## The coming of the Pentax

Between 1955 and 1957 a major design investment at Asahi produced a completely new camera with a fixed pentaprism, lever-wind, a folding rewind crank and a cloth focal-plane shutter with speeds from 1 second to 1/500th, the slow speeds being set on a separate slow-speed dial on the front. This was the original Pentax, sometimes referred to as the Pentax AP and marketed by Sears in the USA as the Tower 26 and fitted, in that case, with the 58mm f/2.4 Takumar. Most significantly, the new Pentax, launched during 1957, was fitted with the 42mm × 1mm screw lens mount already established on the world market by the Contax/Pentacon reflexes, the Praktica line and the Edixa reflexes of West Germany. With the new Pentax came a new top-quality 55mm f/2 Takumar with preset diaphragm and 42mm versions of the Takumar lenses marketed for the Asahiflex, together with adaptors to fit Asahiflex lenses to the new camera.

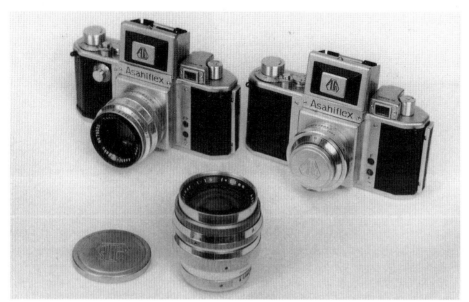

It is one of the oddities of Asahi history that the Asahiflex IIB of 1954 (on the right) preceded the Asahiflex IIA (on the left) by a year. Both had instant-return mirrors (the earlier I and IA did not have this feature) and the Asahiflex 37mm thread lens mount. In the foreground is one of the rare brass-and-chrome additional lenses for Asahiflex, in this case an 83mm f/1.9. Note the 'AOC' (Asahi Optical Company) lens caps.

*Cameras by courtesy of Dave and Julie Todd. Shot with Pentax Spotmatic fitted with 55mm f/1.8 Super-Takumar on Ilford Pan F Plus, developed in Aculux and printed on Jessop Variable Contrast.*

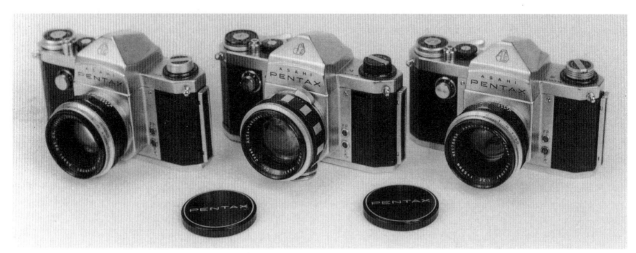

A valuable row of early Pentax reflexes. On the left is the original Pentax or Pentax AP, in the centre the Pentax K and on the right the Pentax S. Note the separate slow-speeds dial on the front of each camera.

*Cameras by courtesy of Dave and Julie Todd. Shot with Pentax Spotmatic fitted with 55mm f/1.8 Super-Takumar on Ilford Pan F Plus, developed in Aculux and printed on Jessop Variable Contrast.*

The top view of a Pentax K, with the slow-speeds dial set to 1 second. The 55mm f/2.2 Auto-Takumar has to be cocked to full aperture after each exposure, using the chrome lever to the right of the depth-of-field scale.

*Camera by courtesy of Dave and Julie Todd. Shot with Pentax Spotmatic fitted with 55mm f/1.8 Super-Takumar on Ilford Pan F Plus, developed in Aculux and printed on Jessop Variable Contrast.*

The Pentax S1a was one of the most successful Pentax cameras, combining high quality, superb performance and a relatively low price. This example is fitted with the 55mm f/2 Super-Takumar.

*Shot with Topcon RE-2 fitted with 58mm f/1.8 RE-Topcor on Ilford Pan F Plus, developed in Aculux and printed on Jessop Variable Contrast.*

Later in the same year, the Pentax S appeared, essentially the same camera but with 'international' shutter speeds (1, 1/2, 1/4, 1/8th, 1/15th, 1/30th, 1/60th, etc.). More significant was the coming in 1958 of the Pentax K (Tower 29), the first Pentax to have an automatic diaphragm actuator. With it was offered the first of Asahi's semi-automatic diaphragm lenses, the 55mm f/1.8 Auto-Takumar, whose spring-loaded diaphragm had to be manually cocked for focusing. It then closed to the preset aperture when the shutter button was pressed. A further refinement was a fastest shutter speed of 1/1000th second.

The Pentax S2 of 1959, also sold as the H2, was essentially a Pentax K with all the shutter speeds on one dial on the top of the camera and shutter speeds initially only to 1/500th, although later examples apparently have a top speed of 1/1000th. Another standard lens appeared, this time the 55mm f/2 Auto-Takumar. A Pentax Super S2, sold only in Japan, was the same as the S2 but with a top shutter speed of 1/1000th and was probably identical to the later version of the S2 in Europe. The Pentax S1, which appeared two years after the S2, was virtually identical but was usually sold with a 55mm f/2.2 Auto-Takumar.

The Pentax S3 (H3 in USA) of 1961 introduced the auto/manual sliding switch to enable automatic-diaphragm lenses to remain stopped down to the preset aperture and was initially sold with a 55mm f/1.8 Auto-Takumar, later with the new 55mm f/1.8 Super-Takumar with fully automatic diaphragm.

Finally, in 1962 and 1963 came the definitive non-TTL Pentax cameras, the SV (H3v in the USA) and the S1a (H1a in the USA). The SV was an improved S3 with a delay-action mechanism, a really excellent microprism focusing screen and a self-resetting exposure counter. It was usually sold with either the 55mm f/1.8 Super-Takumar or the 55mm f/2 Super-Takumar. The S1a was a similar camera with a top shutter speed of 1/500th, nearly always sold with the 55mm f/2 Super-Takumar.

The Pentax matured as a system camera with the advent of the fully automatic diaphragm Super-Takumar lenses and the improved microprism screen. The focusing mounts were better engineered than earlier lenses, the new screen made focusing faster and more accurate, and its light weight and slick handling made it, in the view of many, the first SLR genuinely to rival the versatility and speed of the rangefinder Leica, Canon and Nikon rangefinder cameras. A vogue for grainy black-and-white candid and action pictures in advertising and editorial caused many advertising and fashion professionals to espouse the Pentax,

despite the Nikon F already having pride of place as the journalists' workhorse. The Pentax was established – and a good Pentax SV or S1a is still capable of sensational results in skilled hands.

### The Pentax Spotmatics

Asahi was among the earliest among SLR manufacturers to venture a through-the-lens metering camera on to the market. The Pentax Spotmatic, so called because it was designed originally to have a true spot-measurement exposure meter, actually reached the market in 1964 with what subsequently became the market norm – a centre-weighted averaging exposure meter. Nonetheless, the name remained and was applied to a series of TTL screw-mount SLRs which was marketed until 1977, two years after the first bayonet-mount Pentax had appeared.

Although superficially similar in many ways to the Pentax S1a and SV, which continued to be available alongside the new camera, the Spotmatic was in fact a total redesign. The most obvious external difference was the broader mirror housing, which no longer had parallel sides, and the presence of a sliding meter switch on the left of the mirror housing (as one holds the camera). However, the camera was slightly larger and heavier than its predecessors, although Asahi claimed in their literature that the Pentax Spotmatic was the most compact 35mm SLR available. The Spotmatic had a tougher lever-wind mechanism, a pull-up knob backlatch, a repositioned delay action and other changes including a much larger speed dial, in addition to the major change of the built-in TTL exposure meter.

The exposure measurement was, of course, made with the lens stopped down to the working aperture. This was achieved by sliding the meter switch upwards, which both switched on the exposure meter and stopped the lens diaphragm down. Exposure could then be adjusted by centring a needle visible in the viewfinder, either by changing the aperture, or by changing the shutter speed – in other words, the meter was fully coupled. Switching off the meter returned the automatic-diaphragm lens to full focusing aperture. It also helped to stop the battery running flat – leaving a Spotmatic meter switched on produces a flat battery within hours.

With the Spotmatic came the 50mm f/1.4 Super-Takumar, an excellent compact lens much beloved of

available-light photographers and photo-journalists in the days before they were seduced away from 50mm lenses by ultra-wide-aperture wide angles. The Spotmatic was usually sold with either the f/1.4 Super-Takumar or the 55mm f/1.8, and was available, like the SV in either chrome or black finish. At about this time, it began to be fashionable to be seen with a black camera, it being thought to imply a link with professional photo-journalism. Demand for black cameras grew and, as a result, there is quite a large number of black Pentax Spotmatics to be found on the collector's market, although few of them are in anything approaching mint condition.

Alongside the Spotmatic was offered the Pentax SL, a camera with the body, shape and features of the Spotmatic but no exposure meter.

The standard Spotmatic was not capable of being fitted with motor drive and, by 1966, this was becoming a limitation in the professional market as news photographers switched en masse to 35mm SLRs. Asahi therefore produced in 1967 a camera known (and engraved) as the Spotmatic Motor Drive. This had the necessary drive pawl in a special baseplate, and accepted a new motor-drive unit which is quite scarce in Europe, though less so in the USA.

By 1970, the Spotmatic was beginning to fall behind the times as rival SLRs with full-aperture TTL overtook it in the market place. In the amateur market, the Nikkormat FTn and the Minolta SRT101 and 303 (for example) already offered full-aperture metering, and the Miranda Sensorex was about to be launched. In the professional market the Nikon Photomic FTn reigned supreme and was about to be joined by the Nikon F2. The Canon FTb and Canon F-1 were also soon to appear. The screw lens mount of the Pentax was seen, probably unjustifiably, as outmoded and amateurish.

Asahi fought back by launching a series of facelifts and budget-priced models. The Spotmatic 1000 of 1970 lacked the delay action of the Spotmatic and was significantly cheaper; the Spotmatic 500 of 1971 had a top shutter speed of only 1/500th, was also without delay action and was offered at an even lower price. However, the Spotmatic II, announced later in 1971, was somewhat more significant. This was not because it had a built-in hot shoe, or because its range of ASA exposure-meter settings was increased, but because it ushered in the SMC (Super-Multi-Coated) Takumar lenses. Not only did these have multi-layered anti-

Black cameras became very fashionable in the mid-sixties. This Pentax Spotmatic is still very smart and glossy, despite heavy use. The lens is the 55mm f/1.8 Super-Takumar. This camera was used to shoot many of the pictures of equipment which appear in this book.

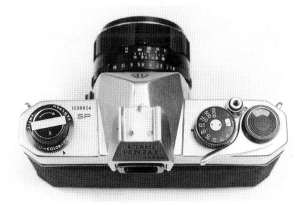

This Pentax Spotmatic, identical to that featured above left except for its chrome finish, is fitted with the optional accessory shoe. To the left of the camera is the scarce and optically excellent 85mm f/1.8 Auto-Takumar with automatic preset diaphragm, to the right is the 35mm f/3.5 Super-Takumar.

Three generations of Pentax which effectively spanned the period of screw-mount Pentax dominance. On the left, a Pentax S1a with 55mm f/2 Super-Takumar, the lens with which this model was most often sold new. In the centre is the Spotmatic II, the first Spotmatic with a hot shoe, fitted in this case with a 55mm f/1.8 Super-Multi-Coated (SMC) Takumar. On the right is a Spotmatic F, the only screw-mount Pentax to have a manual open-aperture TTL exposure meter. This has the 50mm f/1.4 SMC Takumar.

*All photographs shot with Minolta SRT101 fitted with 45mm f/2 MD Rokkor on Ilford Pan F Plus, developed in Aculux and printed on Jessop Variable Contrast.*

A top view of the chrome Pentax Spotmatic with the clip-on accessory shoe. Note the uncluttered layout with the ASA setting for the film speed in the centre of the shutter-speed dial.

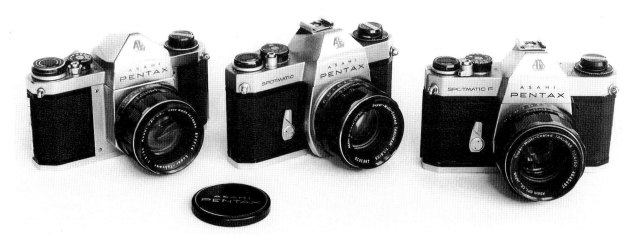

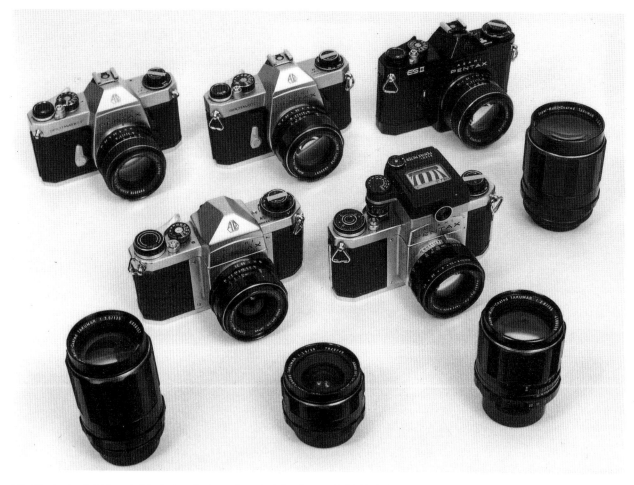

More Pentax family history. In this shot are, back row from the left, a Spotmatic F with the late 55mm f/1.8 SMC Takumar with rubberized focus grip, a Spotmatic II with 50mm f/1.4 SMC Takumar, and an ESII, last of the screw models, with the late-type 50mm f/1.4 SMC Takumar. In the centre row are (left) a Pentax SV with a 35mm f/3.5 SMC Takumar, a Pentax S1 with a 55mm f/2.2 Auto-Takumar and coupled accessory exposure meter, and a 135mm f/2.5 SMC Takumar. In front from the left are a 135mm f/3.5 SMC Takumar, a 28mm f/3.5 SMC Takumar and a 105mm f/2.8 SMC Takumar. The Pentax SV has the unique feature of a delay-action mechanism wound by twisting the ring under the rewind knob.

*Shot with Rolleiflex SL66 fitted with 80mm f/2.8 Planar on Ilford FP4 Plus, developed in Aculux and printed on Jessop Variable Contrast.*

reflection coating which significantly increased contrast and light transmission, they also had the small additional lever at the back which was to be the means of transmitting information about the set aperture to the full-aperture TTL metering system of the Spotmatic F, still almost two years away from market.

Be warned that the 50mm f/1.4 SMC Takumar should be used only on Spotmatic cameras (of any type) or on Pentax SV or S1a cameras with an orange 'R' on the rewind knob. Fitting a 50mm f/1.4 SMC Takumar to any earlier Pentax (and possibly to other M42 cameras) can damage the rear element.

In the USA, a Spotmatic IIa was marketed by the importers, Honeywell. This incorporated a sensor for automatic-flash exposures when the camera was used with a Honeywell-dedicated flashgun. The Spotmatic IIa was not available outside the USA.

Research at Asahi into electronically controlled shutters had meanwhile borne fruit with the launch of the Pentax ES, the first Pentax with automatic aperture-priority exposure control. This was one of the earliest SLRs to have automatic exposure. Outwardly it resembled the Spotmatic series closely, but was often supplied in black finish.

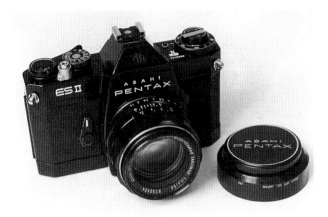

The Pentax ESII of 1973 gave effective aperture-priority automation of exposure with rather less drastic battery consumption than the earlier ES. This example is fitted with the excellent 50mm f/1.4 SMC Takumar, the hood and cap for which are on the right.

*Shot with Minolta SRT101 fitted with 55mm f/1.7 MC Rokkor on Ilford Pan F Plus, developed in Aculux and printed on Jessop Variable Contrast.*

The Pentax K1000 of 1977, although arguably intended at the time as a marketing pot-boiler to keep the Pentax flag aloft until the launch of the M series, was a model which became so popular that it was on sale for longer than any other Pentax except the S1a. It remains much in demand as a students' camera because colleges of photography recommend it, and prices are consequently robustly high. This one is photographed without lens to show the Pentax K lens mount.

*Camera by courtesy of Bob Davey. Shot with Minolta SRT101 fitted with 58mm f/1.4 MC Rokkor and a No. 1 close-up lens on Ilford FP4, developed in Aculux and printed on Jessop Variable Contrast.*

Among the first three models of the new bayonet-mount Pentax camera series in 1975 was the Pentax KM, with a new shape but similar size and weight to the Spotmatic F. The lenses with bayonet mount were renamed 'Pentax SMC' and the time-honoured Takumar name was dropped, but, at this stage at least, the lenses appear to have been optically identical to the last series of screw lenses.

*Camera by courtesy of Dave and Kate Miller. Shot with Minolta SRT101 fitted with 58mm f/1.4 MC Rokkor and a No. 1 close-up lens on Ilford FP4, developed in Aculux and printed on Jessop Variable Contrast.*

Manual full-aperture TTL metering arrived in the Pentax range with the Spotmatic F in 1973. The full-aperture metering works only with SMC Takumar lenses. If earlier Super-Takumar lenses are fitted, the meter is used in stop-down mode, just as though the

camera were a Spotmatic II. Both the Spotmatic II and the Spotmatic F were on sale into the middle of the decade. 1973 also saw the advent of an improved version of the Pentax ES, known as the Pentax ESII.

### The Pentax K and M series

Asahi finally acknowledged in 1975 that the quality market had turned against the 42mm screw mount. The first three models of the Pentax K series, the Pentax K2, KX and KM, all appeared during the year, each equipped with a new 3-tongue bayonet mount, which immediately became known as the 'K-mount'. Lenses with this mount were known as SMC Pentax lenses; the Takumar name was dropped.

The initial Pentax K cameras, and the Pentax K1000 of 1977, were of a size and weight similar to a Spotmatic, and were wholly mechanical in design and operation. So successful was the K1000 that the model continued in production long after various electronically controlled Pentax models which were expected to supersede it had been launched. Its production run did not end until 1988, and it remains much in demand among photography students, being recommended by some colleges as the ideal reliable, high-quality 35mm SLR of moderate cost.

Each of the K-series cameras had full-aperture TTL match-needle metering, essentially similar to that of a Pentax Spotmatic F. They differed from each other primarily in the extent of the information displayed in the viewfinder.

No sooner had the K-series been made available than Asahi was preparing to launch a new, much smaller series of cameras whose bodies were manufactured partly of engineering plastics and which were therefore a great deal lighter. These were the Pentax ME and MX. The ME of 1976 had fully automatic aperture-priority exposure, to the extent that the camera had no shutter-speed dial. Shutter speeds could not be selected other than by the route of estimating the exposure and contriving to set an aperture which corresponded to the speed the action seemed to demand. This was less than popular, and the Pentax MX of 1977 was a match-needle full-aperture TTL-metering version of the same camera. Both had the K lens mount. In 1980, the Pentax ME-Super remedied the deficiencies of the ME by providing alternative automatic and manual operation.

The M-series camera, and the subsequent L and A series, take us out of the classic period, for these were plastics and electronics designs. By 1980, the classic Pentax, other than the K1000, was out of production.

## Pentax lenses

Asahi Optical Co. has been manufacturing successive ranges of lenses for its SLRs since the early fifties. During that time, many major developments in lens technology have been progressively reflected in Asahi design, including the advents of click stops, lightweight mounts, rare-earth glasses, preset, semi-automatic and automatic diaphragms, multi-coating, computer-aided design and, as a result, greatly more compact computations yielding higher contrast and resolution.

The table opposite summarizes the Asahi lens ranges, but is not exhaustive in that many lenses exist in several successive computations with the same apparent specification and there are specialized lenses which the amateur/collector is unlikely to encounter. The table also makes no distinction between the three kinds of Pentax K-bayonet lenses – SMC Pentax, SMC Pentax-M and SMC Pentax-A – since most of the variations occurred after the classic period. Only zoom lenses launched prior to the bayonet-lens period

are listed, since virtually all subsequent zooms were post-classic, and space is limited. There are several books dedicated to Pentax which cover the subject in more detail. An asterisk in a column indicates that the lens exists in the form covered by that column.

The M42 screw mount was so universally recognized, and used by so many camera manufacturers between the mid-fifties and the mid-seventies, that a huge number of types of independent preset and automatic-diaphragm lenses with the M42 mount was made and marketed. Every camera fair is knee-deep in them at give-away prices. Classic-camera users who are not too worried about the prestige and collectibility of the equipment they use and who enjoy trying and producing pictures with a great many different lenses, can do no better than Pentax screw. With a little bargaining, one can buy four lenses for £30 (about $45) at almost any fair.

Naturally, the major brands of interchangeable-mount lenses – Tamron, Vivitar, Soligor – also included Pentax/Praktica M42 screw auto-diaphragm adapters, and Tamron subsequently continued to offer Pentax K bayonet adapters, which remain easily available.

## Pentax accessories

Even during the Asahiflex period, Asahi marketed an excellent bellows unit and several other useful accessories. By the early sixties, the range was extensive and when the Spotmatics were current the accessory catalogue was almost as comprehensive as those of Nikon, Olympus and other major Japanese manufacturers. Manual and auto extension tubes, manual and auto bellows, close-up lenses and microscope adaptors provided for close-up work. Right-angle finders and close-up magnifiers simplified precise focusing and copy-stand work. There were stereo adapters, mirror adapters, filters, lens hoods and reversing rings. There was also an adaptor ring to enable owners of Asahiflex lenses to use them on any 42mm screw Pentax (or indeed any other M42 camera).

One intriguing oddity was the Short Soft Case. This was a soft ever-ready case which lacked the nose cone which usually covers the lens, and had apertures and a button-down flap to permit focusing, firing the shutter and winding on without opening the case. This was claimed to reduce the noise of the camera's operation and make faster shooting possible.

## Pentax lenses

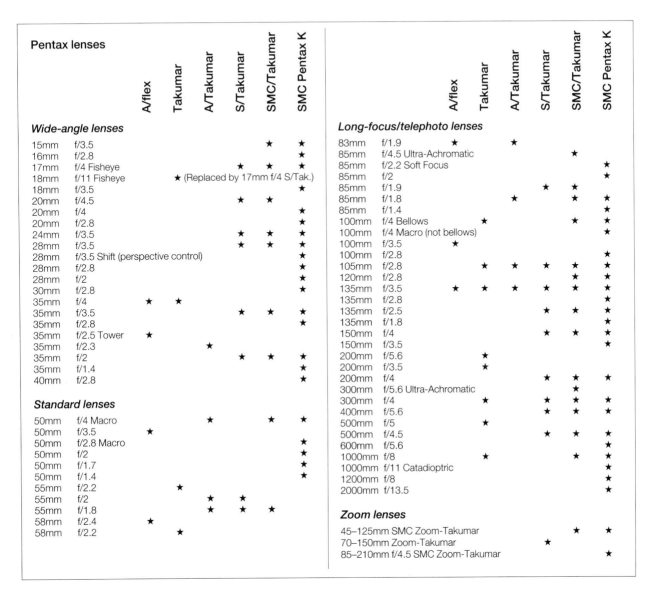

### Wide-angle lenses

| Wide-angle lenses | A/flex | Takumar | A/Takumar | S/Takumar | SMC/Takumar | SMC Pentax K |
|---|---|---|---|---|---|---|
| 15mm f/3.5 | | | | | ★ | ★ |
| 16mm f/2.8 | | | | | | ★ |
| 17mm f/4 Fisheye | | | | ★ | ★ | ★ |
| 18mm f/11 Fisheye | | ★ (Replaced by 17mm f/4 S/Tak.) | | | | |
| 18mm f/3.5 | | | | | | ★ |
| 20mm f/4.5 | | | | ★ | ★ | |
| 20mm f/4 | | | | | | ★ |
| 20mm f/2.8 | | | | | | ★ |
| 24mm f/3.5 | | | | ★ | ★ | ★ |
| 28mm f/3.5 | | | | ★ | ★ | ★ |
| 28mm f/3.5 Shift (perspective control) | | | | | | ★ |
| 28mm f/2.8 | | | | | | ★ |
| 28mm f/2 | | | | | | ★ |
| 30mm f/2.8 | | | | | | ★ |
| 35mm f/4 | | ★ | ★ | | | |
| 35mm f/3.5 | | | | ★ | ★ | ★ |
| 35mm f/2.8 | | | | | | ★ |
| 35mm f/2.5 Tower | ★ | | | | | |
| 35mm f/2.3 | | | ★ | | | |
| 35mm f/2 | | | | ★ | ★ | ★ |
| 35mm f/1.4 | | | | | | ★ |
| 40mm f/2.8 | | | | | | ★ |

### Standard lenses

| Standard lenses | A/flex | Takumar | A/Takumar | S/Takumar | SMC/Takumar | SMC Pentax K |
|---|---|---|---|---|---|---|
| 50mm f/4 Macro | | | ★ | | ★ | ★ |
| 50mm f/3.5 | | ★ | | | | |
| 50mm f/2.8 Macro | | | | | | ★ |
| 50mm f/2 | | | | | | ★ |
| 50mm f/1.7 | | | | | | ★ |
| 50mm f/1.4 | | | | | | ★ |
| 55mm f/2.2 | | | ★ | | | |
| 55mm f/2 | | | ★ | ★ | | |
| 55mm f/1.8 | | | ★ | ★ | ★ | |
| 58mm f/2.4 | ★ | | | | | |
| 58mm f/2.2 | | | ★ | | | |

### Long-focus/telephoto lenses

| Long-focus/telephoto lenses | A/flex | Takumar | A/Takumar | S/Takumar | SMC/Takumar | SMC Pentax K |
|---|---|---|---|---|---|---|
| 83mm f/1.9 | | ★ | | ★ | | |
| 85mm f/4.5 Ultra-Achromatic | | | | | ★ | |
| 85mm f/2.2 Soft Focus | | | | | | ★ |
| 85mm f/2 | | | | | | ★ |
| 85mm f/1.9 | | | ★ | ★ | | |
| 85mm f/1.8 | | ★ | | | ★ | ★ |
| 85mm f/1.4 | | | | | | ★ |
| 100mm f/4 Bellows | | | ★ | | ★ | ★ |
| 100mm f/4 Macro (not bellows) | | | | | | ★ |
| 100mm f/3.5 | | ★ | | | | |
| 100mm f/2.8 | | | | | | ★ |
| 105mm f/2.8 | | ★ | ★ | ★ | ★ | ★ |
| 120mm f/2.8 | | | | | ★ | ★ |
| 135mm f/3.5 | | ★ | ★ | ★ | ★ | ★ |
| 135mm f/2.8 | | | | | | ★ |
| 135mm f/2.5 | | | | | ★ | ★ |
| 135mm f/1.8 | | | | | | ★ |
| 150mm f/4 | | | | ★ | ★ | ★ |
| 150mm f/3.5 | | | | | | ★ |
| 200mm f/5.6 | | ★ | | | | |
| 200mm f/3.5 | | ★ | | | | |
| 200mm f/4 | | | | ★ | ★ | ★ |
| 300mm f/5.6 Ultra-Achromatic | | | | | ★ | |
| 300mm f/4 | | ★ | | ★ | ★ | ★ |
| 400mm f/5.6 | | | | ★ | ★ | ★ |
| 500mm f/5 | | ★ | | | | |
| 500mm f/4.5 | | | | ★ | ★ | ★ |
| 600mm f/5.6 | | | | | | ★ |
| 1000mm f/8 | | ★ | | | ★ | ★ |
| 1000mm f/11 Catadioptric | | | | | | ★ |
| 1200mm f/8 | | | | | | ★ |
| 2000mm f/13.5 | | | | | | ★ |

### Zoom lenses

| Zoom lenses | A/flex | Takumar | A/Takumar | S/Takumar | SMC/Takumar | SMC Pentax K |
|---|---|---|---|---|---|---|
| 45–125mm SMC Zoom-Takumar | | | | | ★ | ★ |
| 70–150mm Zoom-Takumar | | | | ★ | | |
| 85–210mm f/4.5 SMC Zoom-Takumar | | | | | | ★ |

## Is the screw Pentax a sound classic investment?

The Asahiflex cameras are nicely engineered but command quite high collector prices because of their scarcity. The lenses are even scarcer and cost too much for the average user.

Pentax cameras prior to the Spotmatic series feel a little flimsy by comparison with a comparable Nikon, Canon or Minolta, and this is reflected in a higher failure rate of Pentax lever-wind mechanisms and wind return springs. However, this should not be overstated, for a carefully used Pentax S3, SV, S1a or similar model is likely to be a reliable, fast, easy-to-use and effective camera, particularly for candid and photo-reportage photography. Pentax cameras and lenses are smaller and lighter than most others of their time and the shutters are quieter than almost any other SLR, certainly in its price range.

Both the cameras and the lenses are relatively plentiful and inexpensive, and Takumar and Super-Takumar lenses which are easily found for around £30 ($45) or even less will deliver superb results. There is also a vast range of non-Pentax M42 lenses of all focal lengths readily available at very low prices, particularly at collectors' and enthusiasts' events and fairs.

As was the fashion at the time, the Pentax ME (fully automatic exposure without the manual option) and MX (fully manual match-needle without the option of automation) were much smaller and lighter than their predecessors, and mark the point at which Asahi moved from traditional engineering and mechanical timing to extensive use of engineering plastics and electronics (although, of course, the two ES models had had electronically timed shutters). This MX has the compact 50mm f/1.4 SMC Pentax-M lens.

*Camera by courtesy of Bob Davey. Shot with Minolta SRT101 fitted with 58mm f/1.4 MC Rokkor and a No. 1 close-up lens on Ilford FP4, developed in Aculux and printed on Jessop Variable Contrast.*

Arguably the start of the autofocus revolution, this version of the Pentax ME, known as the ME F was supplied with its own special 35–70mm f/2.8 SMC Pentax AF Zoom, complete with on-off switch at the front for the autofocus facility. Clumsy, slow and ugly by modern standards, this outfit was a landmark in photography.

*Camera by courtesy of Barry and Angela Spencer. Shot with Minolta SRT101 fitted with 58mm f/1.4 MC Rokkor and a No. 1 close-up lens on Ilford FP4, developed in Aculux and printed on Jessop Variable Contrast.*

Pentax Spotmatic cameras are somewhat more robust in the mechanical departments, although the sliding exposure-meter switch is prone to give trouble. Remember that the full-aperture metering of a Spotmatic F works at full aperture only if SMC Takumar lenses are fitted, and that the auto/manual switch of a Super-Takumar or SMC Takumar lens must be left at auto when fitted to a Spotmatic F.

If the objective is to buy a lightweight, quiet and reliable camera outfit that delivers top-quality images at a modest price, then a Pentax Spotmatic or SV/S1a outfit must be a strong contender. If you are also concerned to achieve a financial return on your investment, then the Pentax is rather less attractive. The screw lens mount is not attractive to collectors, the cameras and lenses are common, and there is no sign of Pentax prices rising.

Most repairers are happy to work on Pentax screw cameras, and, although many spares are no longer available, repairers are able to obtain plenty of scruffy cameras from which to pillage secondhand parts. Thus it is likely that a Pentax screw outfit will remain operational for a good many years with care.

## And the bayonet models?

The first series of Pentax K cameras, and the long-lived Pentax K1000, have the advantage (obviously) of being newer than the screw cameras and therefore, presumably, of being likely to have had less use. They also offer the considerable benefit from the standpoint of operational quality of being able to accept more recent Pentax bayonet zoom and wide-angle lenses.

However, you may feel that that strays from the objectives of using classic SLRs just a little too far. The first 'small' Pentax M-series models, the all-auto Pentax ME and the all-manual MX, suffered from a persistent film-transport weakness, and I would not recommend them unless they have been little used and come fairly inexpensively.

The fun of the traditional steam roundabout on a Sunday in August. Taken at the Bluebell Railway Steam Fair, this shot is less than technically brilliant but has a vitality which communicates something of the way the subjects felt when the picture was taken.

*Shot with Pentax S1a fitted with 55mm f/1.8 Super-Takumar on Ilford FP4 Plus, developed in Aculux and printed on Ilford Multigrade.*

Two little girls on steps leading down to the bank of the Seine in Paris – another of those shots where one has to be ready and fast. The Pentax Spotmatic is a very good camera for candid photography because the focusing is light and positive and the shutter-button pressure is light.

*Shot with Pentax Spotmatic fitted with 85mm f/1.8 Auto-Takumar on FP4, developed in Aculux and printed on Jessop Variable Contrast.*

A magnificent eagle owl, photographed during a demonstration of falconry at Michelham Priory, East Sussex.

*Shot with Pentax ESII fitted with 50mm f/1.4 SMC Takumar on Ilford FP4 Plus, developed in Aculux and printed on Jessop Variable Contrast.*

The human side of the Pompidou Centre is seen in the fun of the entertainers in the square outside. This clown was throwing his bouquet to women in the crowd and causing considerable gentle embarrassment.

*Shot with Pentax Spotmatic fitted with Russian 135mm f/4 Jupiter 11A on Ilford FP4 Plus, developed in Aculux and printed on Jessop Variable Contrast.*

Man imprisoned by his technology – the less appealing aspect of the Pompidou Centre in Paris.

*Shot with Pentax Spotmatic fitted with Russian 135mm f/4 Jupiter 11A on Ilford FP4 Plus, developed in Aculux and printed on Jessop Variable Contrast.*

The bright spark of Network South-East, a term sometimes used to describe railway enthusiast and photographer Allan Mott, but actually his title for this shot, taken in 1988, showing the moment when conductors beneath the electric train sparked brilliantly on the live rail.

*Picture by Allan Mott. Shot with Pentax Spotmatic fitted with 55mm f/1.8 Super-Takumar, printed on Jessop Grade 2 paper.*

A quiet Saturday-morning meeting at a Paris bar afloat on the Seine – a distinct touch of Parisian style is evident. This was shot from the pavement above the quay.

*Shot with Pentax Spotmatic fitted with Russian 135mm f/4 Jupiter 11A on Ilford FP4 Plus, developed in Aculux and printed on Jessop Variable Contrast.*

Running repairs on a traction engine at the Bluebell Railway Steam Fair in August 1994 make an agreeable shot for the Pentax.

*Shot with Pentax S1a fitted with unidentifiable 28mm f/2.8 M42 macro-wide-angle on Ilford FP4 Plus, developed in Aculux and printed on Jessop Variable Contrast.*

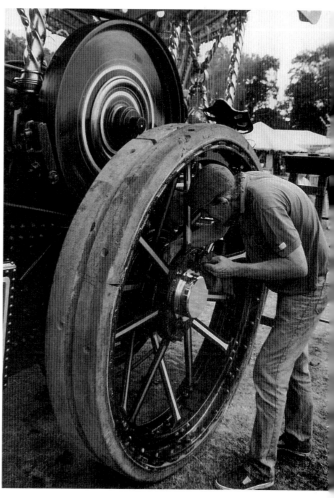

The concentration of musicians can be a study in itself – this was a direct-flash snapshot at a New Year's party.

*Shot with Pentax Spotmatic fitted with 85mm f/1.8 Auto-Takumar on Ilford FP4 Plus, developed in Aculux and printed on Jessop Variable Contrast.*

# Chapter 7

## Striking pictures with a blunt instrument

A Pentax-loving friend once described the Nikon FTn Photomic as 'too great a burden for one man to bear alone'. Compare a Pentax Spotmatic and 55mm f/1.8 SMC Takumar with a Nikon F Photomic FTn and 50mm f/2 Nikkor and you will understand what his gross exaggeration was intended to convey. The Pentax has the delicacy of a wristwatch, the Nikon many of the characteristics of a station clock.

Ask, on the other hand, an Antarctic scientist or explorer which of the two cameras one should trust during a polar winter and he or she is almost certain to back the Nikon. Ask any war correspondent which camera is most likely to come through riot, revolution, battle, murder and sudden death and the answer will be the same. The classic Nikon cameras are tough. The lenses are superb. The results can be magnificent.

A *Life* magazine photographer photographing the war in Bangladesh once dropped his Nikon F, complete with film full of irreplaceable shots, in the sea. He recovered it, dropped it into a bucket of fresh water, and set off for the airport. Next day he arrived at the Life offices in the USA, still carrying the camera in the bucket of water. Not only were the shots saved, but the camera still worked and, once dried out and lubricated, was quickly back in commission.

In Vietnam, a photographer dropped his Nikon out of a helicopter flying slowly at treetop height and about to land. Once on the ground, he found the camera. It was a little bent but still worked normally.

There are stories like that about Leica rangefinder cameras which are probably also true. No other brand of 35mm camera has that reputation.

### The Nikon F

First launched in 1959, the Nikon F was far from the first fine Japanese SLR, but it was arguably the first SLR capable of challenging the great rangefinder cameras systems for the affections of photo-journalists worldwide. Even the price of a Nikon F with f/1.4

Nikkor was almost identical to that of a Leica M3 with f/2 Summicron.

The coming of the Nikon F, with fast and precise focusing of telephoto or wide-angle lenses, with interchangeable finders and focusing screens and with the precision, feel and reliability of a Leica, changed the way journalists worked. To be fair, most photojournalists continued (and many still continue) to carry a Leica rangefinder camera, particularly for low-light and wide-angle shots or for circumstances where near silence is essential. But the 200mm Nikkor was a revelation with which the Leica could not compete.

The Nikon F was a beautifully engineered all-metal SLR with an interchangeable viewfinder system and a superbly reliable titanium-foil focal-plane shutter. Like almost no other SLR, the Nikon F viewfinder showed exactly what would be on the negative or transparency – no more, no less. The wind lever had a very short sweep of only 140 degrees, much less than the 185 degrees of a Pentax of the period, and, most important to the professional, could be 'inched'. This means that the shutter/film transport could be wound with a series of short sharp movements of the lever totalling 140 degrees if that was preferred to a single more obvious movement.

The first batch of 1,000 cameras was conventionally numbered, from 640,000 to 640,999, but soon afterwards Nippon Kogaku began to number Nikon F cameras so that the first two digits of the extended serial number represented the year of manufacture, making it unusually easy to establish the exact age of Nikon bodies. This practice was continued into the Nikon F2 era.

The Nikon F was launched initially with a simple pentaprism, followed shortly afterwards by a conventional interchangeable waist-level finder. Later an 'Action Finder' was added to the range of viewfinders without exposure meters. This enabled spectacle wearers, or a photographer who was wearing (for example) goggles or a protective hood, to see the whole viewfinder and focus the camera with the eye some centimetres from the actual viewfinder.

During the first three years of Nikon F production, three successive clip-on meters were produced: the almost circular Model 1, the similar Model 2, which had a long meter window, and the commonest and most numerous of the three, the Model 3. All were selenium-cell meters which fitted externally to the Nikon F, with a pin-and-socket coupling to the shutter-

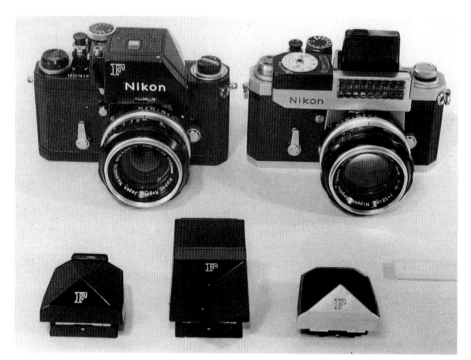

The Nikon F body remained the same throughout its long life. Only the amazing variety of attachments kept changing. In this picture, the chrome Nikon F on the right is fitted with the early non-TTL Model 3 exposure meter and a waist-level viewfinder. The black Nikon F on the left has a Photomic Tn TTL exposure-meter head incorporating a pentaprism. The camera on the right is fitted with the early 5.8cm f/1.4 Nikkor-S. That on the left has the later 50mm f/1.4 Nikkor-S. In front, on the right, is the ultra-scarce incident-light attachment for the Exposure Meter 3. In front of that are three viewing heads – a chrome pentaprism on the right, the eye-level 'Action finder' in the centre and a black pentaprism on the left.

*Equipment by courtesy of Malcolm Glanfield. Shot with Minolta SRT101 fitted with 55mm f/1.7 MC Rokkor on Ilford Pan F Plus, developed in Aculux and printed on Jessop Variable Contrast.*

speed dial, and a pin which located into the fork on the aperture ring of all Nikon automatic-diaphragm lenses of the classic period. Then, in 1962, the first Nikon CdS metering head appeared, which, when fitted to the camera, converted it to what was referred to in the catalogue as a Nikon F Photomic. This Photomic head (no suffix) can be recognized by its circular meter window in the front of the prism, for it was not a TTL meter.

The trend to TTL exposure measurement produced in 1965 the Photomic T metering head, one of the earliest full-aperture TTL exposure systems. The design of this was marred only by the need, every time a lens was changed, to set the maximum aperture of the new lens against the film speed on a lift-and-drop knob in the centre of the head's shutter-speed knob. The Photomic T meter averaged the luminosity of the entire image, unlike most later TTL systems, which take a disproportionate part of their reading from the centre of the screen. It is worth noting, if you buy a very early Nikon F, that the Photomic T head was not compatible with a few of the earliest F cameras unless very minor modifications were made to the nameplate on the front of the camera body. Most have had this done, but you may encounter one where the head will not fit.

In 1967, Nippon Kogaku abandoned the 100% averaging metering of the Photomic T head, and introduced the Photomic Tn, similar in most respects but identifiable by its having an 'N' engraved on the top of the meter next to the power off button. The Photomic Tn metering head used 60% centre weighting when measuring the luminosity of the image, which makes a casually or quickly taken exposure reading of most subjects more likely to be accurate.

By 1968, the requirement to reset the maximum aperture of each lens was clearly outdated, and the improved Photomic FTn head appeared. This design introduced the double-twist technique of setting the meter for the maximum aperture of the lens in use. The lens was mounted while set to f/5.6, then the diaphragm-setting ring was twisted first to minimum aperture, then to maximum aperture. The action caused the pin beneath the metering head, locked into the shoe on the diaphragm-setting ring of the lens, to be set in a position which represented the largest aperture available on the lens. This familiar twist-twist routine is so ingrained in many older Nikon users that the ones with grey hair still do it on their Nikon F3 and F4 cameras, even though it is unnecessary.

So good was the Nikon F that it lasted well into the seventies unchanged, despite the introduction in 1971

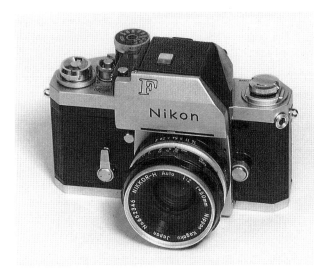

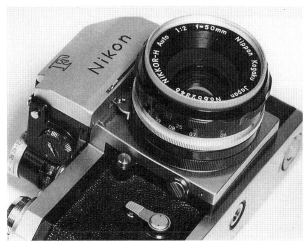

A closer view of a chrome Nikon F, this time with a Photomic T TTL exposure-metering head and the superb 50mm f/2 Nikkor-H lens. This camera and lens were used to shoot the extremely sharp picture on page 142 of my wife laughing.

*Camera by courtesy of Len Corner. Shot with Praktina IIa (by courtesy of Mike Rees) fitted with 135mm f/3.5 Tele-Ennalyt on Ilford Pan F Plus, developed in Aculux and printed on Jessop Variable Contrast. The camera and lens are illustrated on page 74.*

This shot shows clearly how the pin underneath the Photomic finder (in this case the Photomic T head) engages with the shoe on the top of the pre-AI Nikkor lens. Also visible are the engraved lens apertures around the circumference of the ASA speed dial on the top of the T head – the maximum aperture of the lens in use had to be set against the ASA speed of the film in use for the meter to operate correctly.

*Camera by courtesy of Len Corner. Shot with Praktina IIa (by courtesy of Mike Rees) fitted with 135mm f/3.5 Tele-Ennalyt on short extension tube on Ilford Pan F Plus, developed in Aculux and printed on Jessop Variable Contrast.*

The Photomic T head, removed from the camera and laid on its back, shows the underside of the viewing prism and (above it in this picture) the pin which extends downwards to engage the shoe on the top of the lens. To the left is the underside of the extension shutter-speed knob which forms part of the Photomic T head. The U-shaped aperture engages the pin on the camera's shutter-speed knob when the head is fitted, enabling the knob on the head both to set the shutter speeds of the camera and to couple the exposure meter to those settings.

*Equipment by courtesy of Len Corner. Shot with Praktina IIa (by courtesy of Mike Rees) fitted with 135mm f/3.5 Tele-Ennalyt on short extension tube on Ilford Pan F Plus, developed in Aculux and printed on Jessop Variable Contrast.*

The back of a Nikon F is removed in a manner reminiscent of the Zeiss (rangefinder) Contax from which some aspects of its design were distantly derived. The key on the baseplate, on the left of the picture, was turned, and the back eased away from the top of the camera before being lifted off entirely.

*Camera by courtesy of Len Corner. Shot with Praktina IIa (by courtesy of Mike Rees) fitted with 135mm f/3.5 Tele-Ennalyt on short extension tube on Ilford Pan F Plus, developed in Aculux and printed on Jessop Variable Contrast.*

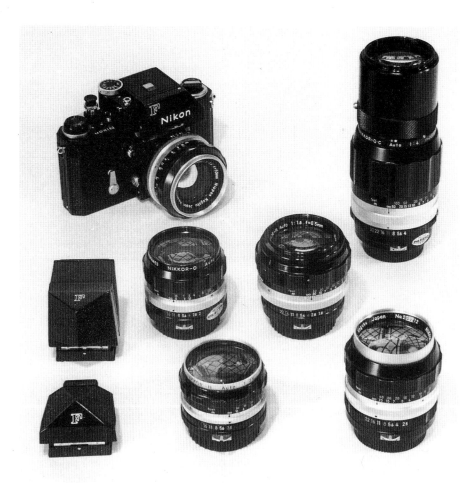

This Nikon F outfit is of later date than those featured earlier – in fact the F is one of the last, made in 1973, well after the launch of the Nikon F2. The black camera is fitted with a 50mm f/1.4 Nikkor and a Photomic Tn head. To the right in the back row is a 200mm f/4 Nikkor-QC. In the middle row, left to right, are a Nikon Action Finder, a 35mm f/2 Nikkor-O and an 85mm f/1.8 Nikkor-H. In front are a black F prism, a 28mm f/3.5 Nikkor-H and a 105mm f/2.5 Nikkor-P.

*Equipment by courtesy of Malcolm Glanfield. Shot with Minolta SRT101 fitted with 55mm f/1.7 MC Rokkor on Ilford Pan F Plus, developed in Aculux and printed on Jessop Variable Contrast.*

of the Nikon F2 with its less severe, rounder, appearance and extended shutter-speed range from 10 seconds to 1/2000th second. So loyal were professional Nikon F users that the Nikon F2 was only slowly accepted, and Nippon Kogaku reputedly maintained Nikon F production for longer than it had intended to meet demand.

The Nikon F2 continued the Nikon policy of non-obsolescence, and also of modularity to provide many alternative specifications from a single basic camera. Like the Nikon F, the F2 could be equipped with a simple pentaprism without meter (head DE-1), its own development of the Photomic head (head DP-1) or, from 1973, the solid-state metering head (DP-2) which provided meter readings from illuminated diodes rather than a swinging needle. With this head, the camera became a Nikon F2S.

In 1977, the advent of Nikon AI (auto-indexing) lenses produced the Nikon F2A and F2AS, which carried Nikon success into the eighties. Only with the arrival of the Nikon F3 and F4 did the electronics and plastics begin to intrude, albeit effectively, since both are fine cameras in the Nikon tradition.

## The Nikkorex series and the Nikkormats

It was almost the same story of simplicity and longevity in the amateur market, although things did not go easily for Nippon Kogaku with its early essays into the amateur SLR market. Uncharacteristically, Nippon Kogaku failed with its first series of amateur cameras, marketed between 1960 and 1966 under the Nikkorex name. The Nikkorex 35 and 35-2 both had a non-interchangeable 50mm f/2.5 Nikkor and a leaf shutter and were followed by the Nikkorex Auto 35 in 1964 which sported a 48mm f/2 non-interchangeable Nikkor, still with a leaf shutter. Between these, in 1963, there had emerged the curiously un-Nikon-like

Nikkorex Zoom, whose viewing system employed mirrors rather than prisms to focus the fairly dim image from a non-interchangeable 43–86mm Nikkor zoom. This unsuccessful camera's only mark of distinction was that it was the world's first 35mm camera with a non-interchangeable zoom lens.

Alongside these sadly uncompetitive cameras, Nippon Kogaku offered another, quite different, Nikkorex. A weighty, nicely engineered SLR with a focal-plane shutter and provision for a clip-on shutter-coupled CdS exposure meter, the Nikkorex F was reputedly manufactured by Yashica as a vehicle for the sale of Nikkor lenses. A virtually identical camera, also with Nikon lens mount, was available at the same time as the Ricoh Singlex (a totally different camera to the later Ricoh Singlex series with screw-thread lens mounts). The Rikenon 55mm f/1.4 lens with which this was sold was rumoured to be a 58mm f/1.4 Nikkor by another name and with poetic licence applied to the focal length. Certainly, this original Ricoh Singlex is a fine camera and well worth buying if you can get one at a reasonable price. The Nikkorex F typically fetches substantially more, although it is to all intents and purposes an identical camera.

In 1965, the Nikkormat series emerged, and Nikon finally got the amateur market on its side. Costing roughly the same as a comparable Pentax, each successive Nikkormat model was unarguably heavier, tougher and a more 'professional' feeling camera than the Pentax. The first Nikkormat was the FS with no meter, and was launched alongside the Nikkormat FT. This latter had full-aperture TTL exposure measurement some eight years before the first full-aperture TTL Pentax was launched. The CdS exposure meter of the Nikkormat FT required external setting of the maximum aperture of the lens in use. It was followed in 1967 by the long-lived and extremely successful Nikkormat FTn, whose meter obtained its maximum-aperture data in the same 'twist-twist' way as the Nikon F Photomic FTn.

The coming of hot shoes for flash brought about the appearance of the Nikkormat FT2. The birth of Nikon AI (auto-indexing) lenses, which no longer needed the 'twist-twist' maximum-aperture setting routine, ushered in the Nikkormat FT3. Yet there is actually very little difference between a Nikkormat FT of 1964 and a Nikkormat FT3 of the early eighties. Just two fundamental models with a succession of gradually improving viewing and metering heads, plus

the introduction of AI lenses kept Nikon ahead in the professional market for more than twenty years. Just one model in five successive little-altered versions took a major share of the amateur market for around the same length of time.

So how did they do it when other manufacturers produced new models practically every year?

Part of the answer is, simply, that Nikon announced at the outset that all future Nikon reflex models and their lenses would be developed in such a way that Nikon cameras and lenses of all ages would remain compatible for decades. This gave users, particularly professionals, confidence that their considerable investment in Nikon equipment would not be wasted or rendered obsolescent. It also reassured professionals that they would be able to hire compatible lenses for specialized shoots without worrying about the match of their camera with the hired lenses.

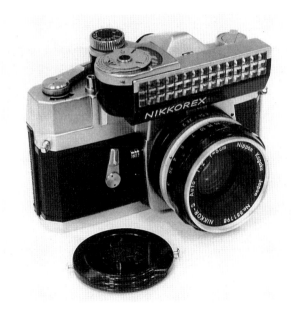

The Nikkorex 35 referred to on page 134 bears an extremely close resemblance to the original Ricoh Singlex (see Chapter 9). However, once the clip-on meters are fitted, the two cameras look totally different, and it becomes clear that the exposure meter supplied for the Nikkorex, shown here, is a close relative of the Exposure Meter 3 made for the Nikon F. This Nikkorex is unusual in being in near-mint condition and in having its original 5cm f/2 Nikkor-S lens. Note the lens cap of the period as supplied for the Nikkorex. It has the spring-loaded metal prongs either side like a Nikon F cap, but is of quite different surface design.

*Camera by courtesy of Barry and Angela Spencer. Shot with Minolta SRT101 fitted with 58mm f/1.4 MC Rokkor and Minolta No. 1 close-up lens on Ilford FP4 Plus, developed in Aculux and printed on Jessop Variable Contrast.*

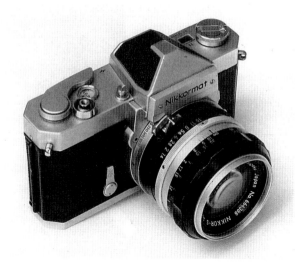

The classic Nikkormat – not the first, or even the second, but definitively the Nikkormat that people think of when asked about Nikkormats. This is a Nikkormat FTn, which achieved great popularity and is therefore quite commonly available, although rarely in condition as good as that of this example. This camera is fitted with a 50mm f/1.4 Nikkor-S, but you are more likely to find Nikkormats with the f/2 lens.

*Camera by courtesy of Derek Finch. Shot with Minolta SRT101 fitted with 55mm f/1.7 MC Rokkor on Ilford Pan F Plus, developed in Aculux and printed on Jessop Variable Contrast.*

This close-up of the top of the Nikkormat in the previous picture shows the identifying 'N' above the meter repeater window. A Nikkormat FS (the first, meterless model) has 'FS' before its number, with no 'N'. An FT has FT before its number, again with no 'N'. The FTn, confusingly, still has FT before the number, but with the N above the window. The later FT2 and FT3 have those descriptions straightforwardly engraved upon them.

*Camera by courtesy of Derek Finch. Shot with Minolta SRT101 fitted with 55mm f/1.7 MC Rokkor on Ilford Pan F Plus, developed in Aculux and printed on Jessop Variable Contrast.*

A further key part of the answer is the fact that Nikon produced two fundamentally sound, reliable designs in the Nikon F and the Nikkormat, and did it again when they produced the Nikon F2. Until the advent of auto-focus, almost any Nikkor lens made for a Nikon reflex (as distinct from Nikon rangefinder cameras) was compatible with any Nikon or Nikkormat SLR, provided that one accepted that some minor features of the later cameras were not available when used with the earliest lenses – the exception being that the early non-reflex 'mirror-up' 21mm f/4 cannot be fitted to a Nikkormat with no mirror-lift mechanism. Any Nikon F viewing and metering head fits any Nikon F of any age.

## Nikon lenses

Whole books can be, and indeed have been, written about the successive generations of Nikon lenses, and, given the scope of the present book, it is therefore possible here to do little more than summarize the options available and offer some useful information for those not totally familiar with the Nikon jungle.

From the outset, Nippon Kogaku offered a full range of Nikkor lenses, although the range was extended considerably between 1960 and 1970. Some produced during the earliest years of the Nikon F had preset diaphragms, and these are very collectible (and entirely usable) nearly forty years on. From the early sixties onwards, most lenses for the Nikon F and (later) the Nikkormat series were equipped with lever-actuated internal automatic diaphragms.

All Nikon lenses of the F period go under the Nikkor name, and the precise types were defined not only by their focal length, aperture and name, but also by a letter. This indicated the number of elements in the lens, using initials derived from Latin and Greek. Thus an early 50mm f/2 Nikkor-S had seven elements (Septem) and a later 50mm f/2 Nikkor-H six elements (Hepta). 'T' is a 3-glass lens, 'Q' a 4-glass, 'P' a 5-glass, 'O' an 8-glass and 'N' a 9-glass.

Because of the extremely long period for which most of the Nikkor lenses were, or have been, produced, there are several versions of most of them. Changes range from the simply functional or cosmetic – the change from partially chrome to all-black

The earlier Nikkormat FT, like the Nikon Photomic FT head, required the user to set the maximum aperture of the lens in use against the ASA speed of the loaded film every time a lens was changed if the exposure meter was to yield accurate results. The scale for doing this is visible (above left) between the meter prong at 12 o'clock and the lens release catch at 3 o'clock. The ASA speeds can just be seen on the surface at right-angles to the lens axis between the engraved dots and the black milling of the lens. The projecting lever at 5 o'clock to the lens mount is the shutter-speed setting lever (see next picture).

*Camera by courtesy of Dave and Kate Miller. Shot with Minolta SRT101 fitted with 135mm f/2.8 MC Rokkor and No. 1 close-up lens on Ilford FP4 Plus, developed in Aculux and printed on Jessop Variable Contrast.*

The shutter speeds on all Nikkormat models were set by aligning speeds engraved on a ring behind the lens mount with a large dot on the camera body (above centre). The ring was turned with a lever (see above left) on the other side of the lens. The great advantage of the Copal Square shutter in the Nikkormat at the time was its ability to synchronize with electronic flash at 1/125th second, as is set on this camera.

*Camera by courtesy of Derek Finch. Shot with Minolta SRT101 fitted with 135mm f/2.8 MC Rokkor and No. 1 close-up lens on Ilford Pan F Plus, developed in Aculux and printed on Jessop Variable Contrast.*

One of the trickier aspects of using a Nikkormat FTn was this fiddly ASA setting scale on the underside of the lens mount (above right) – a sure-fire way of eliminating long fingernails.

*Camera by courtesy of Derek Finch. Shot with Minolta SRT101 fitted with 135mm f/2.8 MC Rokkor and No. 1 close-up lens on Ilford Pan F Plus, developed in Aculux and printed on Jessop Variable Contrast.*

mounts, for example, or the change during the seventies from black-enamel scalloped focusing rings to rubberized focusing rings – to total redesigns producing replacement lenses of improved performance. The change mentioned above, from the 50mm f/2 Nikkor-S to the 50mm f/2 Nikkor-H, which occurred in the mid-sixties, is an example of a total redesign. The Nikkor-H provides significantly higher contrast and better resolution. This book does not have space to describe all these multiple changes, but most are covered in books devoted entirely to the Nikon system.

Nikon lenses of the classic period (before the eighties) feel, and are in most cases, heavier than comparable lenses of other top-quality systems, with the exception of Canon. They are certainly both heavier and larger than equivalent lenses of the Pentax and Olympus ranges, and are heavier than Minolta lenses, although of approximately similar size. This greater weight is a direct result of more substantial engineering which produces higher reliability and it is rare for the diaphragm mechanism of Nikkor lenses

to fail or become sluggish. They also suffer less than other brands (with the exception of Leicaflex/Leica and Canon lenses) from being dropped, although I would not recommend this as a qualitative test.

A number of lenses for specialized purposes were produced. Notable among these was the 45mm f/2.8 GN Nikkor, whose aperture control was coupled to its focusing mount to provide automatic correction of exposure while using a flashgun. Before the advent of electronically controlled computer flashguns, every flash from a given gun was at full power for the full flash duration (unless it could be switched to half power). The user therefore had to set the lens aperture according to the distance the camera was from the subject by reference to the guide number for the flash unit for the film speed in use. So, if the guide number for feet with 100 ASA film was 64, the camera needed to be at f/8 at a subject 8 feet from the camera (8 × 8 = 64), and at f/16 for a subject 4 feet from the camera. On the 45mm f/2.8 GN Nikkor, the user set the guide number for the flash in use against the ASA rating of the film on a scale on the underside of the lens mount.

The lens aperture then automatically opened and closed as the lens was focused so that the lens aperture always conformed to the guide number, and correct flash exposure was obtained. For fast-working social and press photography it was invaluable. Unfortunately, the cammed mechanism of the GN Nikkor wears badly, so that the lenses are rarely in good mechanical condition a quarter of a century or so after they were made. They are also scarce, sought after and expensive.

All Nikkor lenses, without exception, are of extremely high optical quality, although some of the early lenses are of lower contrast than rival Japanese lenses of their period. Colour rendition tends to be cool, and many Nikon users using transparency emulsions to photograph people routinely use at least a skylight 1A filter or sometimes an R3 to warm up the skin tones. I used Nikon F2 equipment and a set of pre-AI Nikon lenses for much of my professional 35mm work from 1982 through to 1989, and, for purely subjective reasons, was always happier using them for black-and-white work than I was using them for colour. For some time, I had a Leicaflex SL outfit alongside the Nikons, and used that for the colour work. Eventually, the decision on which to use was resolved by my eyesight. I found it increasingly difficult to focus wide-angle lenses with the Nikons, so sold the outfit. Five years later, the Leicaflex equipment went in the same way and I settled down with a Minolta outfit.

The table on the right sets out the Nikkor lenses available during the classic period with some useful additional information.

So successful were the Nikon and Nikkormat cameras that every significant independent lens manufacturer responded by making preset and/or automatic-diaphragm lenses for Nikon, introducing AI versions of their lenses when the F2A and Nikkormat FT3 appeared. Tamron and Soligor interchangeable-mount systems also include Nikon adapters for Nikon and Nikon AI.

## Buying and using the Nikon F and F2

The body, film transport, shutter and mirror mechanisms of the Nikon F and F2 are extremely robust. It is unusual to find one which does not work reasonably well. However, they are pieces of precision machinery, and they do wear. As discussed in Chapter 2, any

### Nikon SLR lenses

| | | Diaphragm | Min. aperture | Filter size |
|---|---|---|---|---|
| **Wide-angle lenses** | | | | |
| 7.5mm | f/5.6 Fisheye | Manual | f/22 | Built-in |
| 20mm | f/3.5 | Automatic | f/22 | 72mm |
| 21mm | f/4 (mirror-up) (needs accessory viewfinder) | Manual | f/16 | 52mm |
| 24mm | f/2.8 | Automatic | f/16 | 52mm |
| 28mm | f/3.5 | Automatic | f/16 | 52mm |
| 35mm | f/2 | Automatic | f/16 | 52mm |
| 35mm | f/2.8 | Automatic | f/16 | 52mm |
| 35mm | f/3.5 PC (perspective control) | Preset | f/32 | 52mm |
| **Standard lenses** | | | | |
| 45mm | f/2.8 GN Nikkor (GN = Guide Number; diaphragm coupled to focusing) | Automatic | f/22 | 52mm |
| 50mm | f/1.4 | Automatic | f/16 | 52mm |
| 50mm | f/2 | Automatic | f/16 | 52mm |
| 55mm | f/1.2 | Automatic | f/16 | 52mm |
| 55mm | f/3.5 Micro | Automatic | f/32 | 52mm |
| 58mm | f/1.4 (preceded 50mm f/1.4) | Automatic | f/16 | 52mm |
| **Long-focus and telephoto lenses** | | | | |
| 85mm | f/1.8 | Automatic | f/22 | 52mm |
| 105mm | f/2.5 | Automatic | f/22 | 52mm |
| 105mm | f/4 | Preset | f/22 | ??? |
| 135mm | f/2.8 | Automatic | f/22 | 52mm |
| 135mm | f/3.5 | Automatic | f/22 | 52mm |
| 200mm | f/4 | Automatic | f/22 | 52mm |
| 200mm | f/5.6 Medical (built-in ringflash) | Automatic | f/45 | None |
| 300mm | f/4.5 | Automatic | f/22 | 72mm |
| 400mm | f/4.5 | Automatic | f/22 | 122mm |
| 600mm | f/5.6 | Automatic | f/22 | 122mm |
| 800mm | f/8 | Manual | f/64 | 122mm |
| 1200mm | f/11 | Manual | f/64 | 122mm |
| **Mirror lenses** | | | | |
| 500mm | f/5 Reflex | None | f/10 | 39mm |
| 1000mm | f/11 Reflex | None | f/11 | Built-in |
| **Zoom lenses** | | | | |
| 43–86mm | f/3.5 zoom | Automatic | f/22 | 52mm |
| 50–300mm | f/4.5 zoom | Automatic | f/22 | 95mm |
| 85mm –250mm | f/4 f/4.5 zoom | Automatic | f/16 | Series 9 |
| 200mm –600mm | f/9.5 f/10.5 zoom | Automatic | f/32 | Series 9 |

A pair of Nikon F2 cameras. The chrome F2 on the left is equipped with a standard chrome prism and a late 50mm f/1.4 AI Nikkor with rubberized focusing grip. The similar camera on the right has the black DP2 Photomic head which is usual on the Nikon F2 and a late 50mm f/2 Nikkor. Note the parallel rails either side of the rewind crank – these are for the Nikon hot-shoe flash coupler, which slides on to the rails, making electrical contact with the shutter synchronization through contacts in the rails. This means of using a flashgun is effective in that the flash, unlike most hot-shoe-mounted flashguns, is positioned away from the axis of the lens. It is not so good when you want to rewind a film in a hurry and have to take the flashgun off first.

*Cameras by courtesy of Malcolm Collins. Shot with Zenit-B fitted with 58mm f/2 Helios on Ilford Pan F Plus, developed in Aculux and printed on Jessop Variable Contrast.*

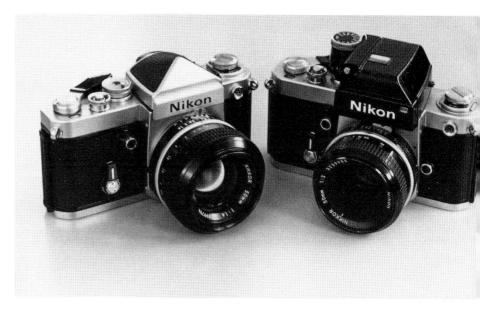

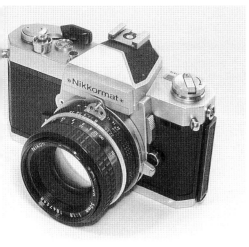

My daughter Emma's Nikkormat FT2 with its 50mm f/1.8 AI Nikkor. She has used this camera from Tokyo and Beijing to New York, to Zambia, to Melbourne, generating effective pictures in huge quantities wherever she goes. It has failed her only once, at Heathrow Airport on her way to the USA. She took one of my Minolta SRT101 cameras instead, but still prefers the Nikkormat. She took the photograph of the young woman seated at the window (page 146) using this camera.

*Shot with Minolta SRT101 fitted with 55mm f/1.7 MC Rokkor on Ilford Pan F Plus, developed in Aculux and printed on Jessop Variable Contrast.*

The Nikkormat FT2 lying on its back shows the black-topped depth-of-field preview button beside the prism housing, the beautifully clear exposure counter, common to all Nikkormats, and the hot shoe. The clarity of all settings makes the Nikkormat a gem to use.

*Shot with Minolta SRT101 fitted with 55mm f/1.7 MC Rokkor on Ilford Pan F Plus, developed in Aculux and printed on Jessop Variable Contrast.*

The Nikkormat EL was the first Nikkormat with automatic exposure, and was competitive with the Canon EF and the Minolta XE-1, among others. Aside from a reputation as a battery-eater, it is a very effective and pleasant camera to use. This beautiful example is fitted with an originally non-AI 28mm f/3.5 Nikkor which has been converted to AI specification.

*Camera by courtesy of Douglas Crawley. Shot with Yashica FX-1 fitted with 50mm f/1.9 Yashinon on Ilford Pan F Plus, developed in Aculux and printed on Jessop Variable Contrast.*

Nikon F or F2 that looks externally worn has almost certainly been a professional camera, and will have transported a very large number of films. Take care not to pay too much for such a camera.

The weak spot of the Nikon F is the carbon potentiometer of the Photomic-head exposure meters. The carbon track wears, producing erratic or inaccurate readings. No spares are available, and repairers cannot cannibalize old heads for spares because they all have the same problem. It is usually best to buy a Nikon F with a plain pentaprism, and then look for a Photomic head that works properly. Never buy a Photomic head without first putting it on your camera and mounting and removing a lens. If the pin under the front of the head is misaligned, which may not be obvious from just looking at it, the pin may not engage the lens shoe correctly. It is also common for the mechanism of heads which have seen a lot of use to become stiff, so that changing the aperture on a lens with the Photomic head mounted becomes very difficult.

The metering heads of the F2 series are differently designed and retain their accuracy and function very well. For some reason, it is commoner to find a Nikon F2 with malfunctioning slow speeds than it is to find a Nikon F with the same problem, even though the F is likely to be a much older camera. It is generally true, however, that any Nikon F2 in reasonable external condition is likely to function well, provided that it has not been subject to an amateur repairer's attentions.

Nikon lenses of the shorter focal lengths – the 28mm, 24mm and 20mm – were, at the time early examples were made, almost always bought by professionals. It was, in the early sixties, not yet fashionable other than in arcane graphics circles to use wide-angle lenses for creative effect, so most were bought for their practical benefits of squeezing a lot of subject into the frame when shooting in a confined space. Consequently, many older examples of these focal lengths have seen a great deal of use and the focusing mounts and diaphragm setting rings are often slack as a result of wear. This can be difficult to put right, so check wide-angle lenses on a camera for smooth focus without backlash.

Using Nikon F or F2 equipment is different from using most other 35mm SLR systems. It feels heavy, solid and precise. It is very fast to use, comparatively quiet and very effective. If you can supply the ideas and expertise, your Nikon will deliver the pictures.

## Choosing and using a Nikkormat

The Nikkormat series of cameras has one substantial advantage over the great majority of other SLRs of its period – the Copal Square shutter is synchronized for flash at 1/125th second rather than only 1/60th. Anyone in the habit of using fill-in flash for outdoor photography will recognize the benefit. The user has a greater choice of working apertures in any situation, and therefore greater control of depth of field. In situations where subjects may move during the exposure, there is much less risk at 1/125th that the ambient-light exposure will blur the flash image.

Nikkormat cameras are tough and usually work well. They can have battery-compartment problems which make the exposure meter function erratic, but these are usually easily rectified. The only fault I have encountered several times is jamming of the film transport in mid-stroke when the gearing becomes worn. The transport mechanism seems not to have quite the lifespan of the rest of the camera, but this should not be over-emphasized as a problem. Just listen carefully to the transport mechanism of a Nikkormat before you buy it, and maybe load a test film and transport it through. Make sure it feels smooth to wind.

The shutter-speed setting of a Nikkormat is around the circumference of the lens mount, and a red mark is moved around the speeds by a lever on the mount. Some people find this difficult to use. As a spectacle wearer, I find the speeds easier to read than those on most shutter-speed knobs.

## Is Nikon for you?

Nikon and Nikkormat equipment is never cheap, although one can sometimes acquire Nikkormat outfits at a reasonable price. Because so much of it has had professional use, one should be very selective and cool-headed about checking any Nikon F or F2, and recognize that a little-used camera can genuinely be worth twice the value of a battered professional tool.

Having been away from Nikon for some six years, I find the aperture setting of a Nikon F2 or F with a Photomic head jerky and uncomfortable by comparison with my Minoltas or many other cameras used for this book. I would personally not return to Nikon, but not for any reason of quality of performance or results. If you like them, they deliver the goods every time.

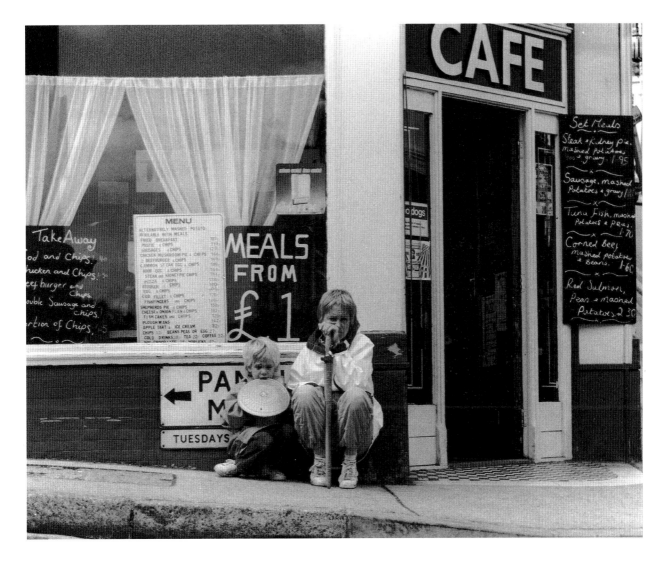

This picture seems to be trying to tell a very sad story, although I have no idea of what went on in the heads of the woman and child at the time. I shot it in Bideford, Devon, during 1988 while trying Ilford XP1 chromogenic film for the first time.

*Shot with Nikon F2 fitted with 105mm f/2.5 Nikkor on Ilford XP1, processed C41 and printed on Ilford Multigrade.*

The Great Wall of China from the Great Wall of China. Printed from a Kodacolor negative shot by my daughter Emma during a visit to China in 1993.

*Picture by Emma Matanle. Shot with the Nikkormat FT2 featured on page 139 fitted with the standard 50mm f/1.8 AI Nikkor, printed on Jessop Variable Contrast.*

My son Greg went to a race meeting with friends and came back with this action shot, taken over the heads of other spectators.

*Picture by Greg Matanle. Shot with Nikkormat FTn fitted with 50mm f/2 Nikkor-S on Ilford HP5, developed in Aculux and printed on Jessop Variable Contrast.*

My wife Anne cannot always take my photography seriously, especially when I am trying to remember how to use a borrowed Nikon F. This is a home studio shot, using a black-velvet backdrop with two front lights in brollies and a high hairlight behind the backdrop.

*Shot with Nikon Photomic FT fitted with 50mm f/2 Nikkor-S on Ilford FP4 Plus, developed in Aculux and printed on Jessop Variable Contrast. Camera by courtesy of Len Corner.*

You might think this shot has worked its way into the wrong chapter. However, it was taken with a Nikkormat FT and 135mm f/3.5 Nikkor during 1969. It shows my father behind his Prakticamat fitted with a 35mm f/2.8 Mamiya-Sekor, which he regarded as a first-class lens. Note the spectacles repaired with Sellotape – my mother despaired of ever getting him to visit an optician. Sadly, the negative of this picture is lost, and this is reproduced from a 5" × 7" print made at the time.

*No details of film or processing available.*

Ducking for apples was one of the obligatory games which contestants in the Tunbridge Wells sedan-chair races had to play as part of their circuit.

*Picture by Emma Matanle. Shot with Nikkormat FT2 fitted with 50mm f/1.8 Nikkor on Ilford FP4 Plus, developed in Aculux and printed on Jessop Variable Contrast.*

Gypsy children, photographed on an industrial estate on the outskirts of Tunbridge Wells during 1967.

*Shot with Nikkormat FT fitted with 135mm f/3.5 Nikkor on Ilford FP3, printed on Jessop Variable Contrast.*

*Facing page:* Every photographer seeks a vantage point. This one found his at the top of a pile of pebbles on the beach at Westward Ho! in Devon.

*Shot with Nikon F2 fitted with 28mm f/3.5 Nikkor on Ilford HP5, developed in Aculux and printed on Ilford Multigrade.*

Refreshments on a hot day – and where better than at Dippers Hall?

*Picture by Emma Matanle. Shot with Nikkormat FT2 fitted with 50mm f/1.8 Nikkor on Ilford FP4 Plus, developed in Aculux and printed on Jessop Variable Contrast.*

I did this shot on top of a desk in an advertising agency by the light of a desk lamp for an urgent layout in 1968. The wallet belonged to the art director and we had to bully everybody in the agency to find enough cash for the shot – this was, after all, at a time when £1,800 (then about $4,320) a year was not a bad salary in England.

*Shot with Nikkormat FTn fitted with 50mm f/2 Nikkor on Ilford Pan F, printed on Jessop Variable Contrast.*

# Chapter 8

## How Canon moved from rangefinders to SLRs

Unlike Asahi, which made reflex cameras from the start, Canon, like Nippon Kogaku, was one of the world's major rangefinder camera manufacturers throughout the fifties. SLRs were almost an afterthought.

### The Canonflex series

The Canonflex of 1959 and its successors of the Canonflex series were in many ways fine cameras. Engineered to exacting Canon standards, they were reliable, heavy and handled well. I have owned and used a Canonflex outfit with Canonflex RP, R2000 and RM bodies (see the picture on page 150) and have enjoyed its feeling of solid dependability and the excellent optical quality of its lenses.

Like the Nikon F which it attempted to rival, the original Canonflex had a removable prism which could be interchanged with a waist-level viewfinder. Its cloth focal-plane shutter was set with a single non-rotating dial and had speeds from 1 second to 1/1000th. The most noticeable characteristic was its baseplate-mounted trigger-wind for shutter and film. A fairly limited range of lenses known as the Canon R series was manufactured to fit the Canonflex, and these introduced the celebrated Canon breech-lock mount, not unlike the earlier Praktina breech lock.

Larger and heavier than Asahi or Nikon lenses of the time, and much larger than the Canon FL and FD series of lenses which were to follow, Canon R lenses look as though they should fit later Canon reflexes. Mechanically, the bayonet mount is identical. However, the diaphragm actuation is quite different, and for this reason it is wiser not to try to fit R lenses to later Canon bodies of the FL or FD lens periods. Nonetheless, the longer lenses do fit and can be used successfully, provided that one accepts that the diaphragm is always stopped down to whatever aperture is set and that focusing is at that working aperture. However, try it at your own risk!

The original Canonflex, of which 17,000 examples were made, is quite scarce and difficult to find, and was marketed for less than a year. Its removable black prism interchanged with a neat black eye-to-magnifier finder and it had a top shutter speed of 1/1000th second and a folding trigger-wind on the baseplate. The very earliest 50mm f/1.8 Super-Canomatic lenses can be identified by having index lines from the aperture engravings (1.8, 2.8, etc.) to the point at which the dot has to be aligned. A friend with a gadget for measuring lens curvature tells me that this version is optically quite different to the general run of later 50mm f/1.8 Super-Canomatic lenses. There are also examples of at least the 100mm f/2 Super-Canomatic with these index lines, as I have, since gleaning the above piece of information, seen such a lens at a camera fair. Probably, similar 35mm and 135mm lenses can be found.

The Canonflex was superseded in 1960 by two models derived from it. The Canonflex RP, of which 31,000 were manufactured, retained the trigger-wind but had a fixed all-chrome prism. The Canonflex R2000, also with trigger-wind, retained the interchangeable black prism and was the first SLR ever produced with a fastest shutter speed of 1/2000th of a second. Only 8,800 of these were made. Both of these models survived in production until 1962. Meanwhile, the trend for adding built-in exposure meters had caused Canon to launch during 1961 the Canonflex RM, the commonest of the Canonflex series, which had a match-needle selenium-cell exposure meter included in the top-plate of the camera and a conventional wind mechanism. Far more of these were sold, with a production run of 72,000.

Confusingly, Canon manufactured for a short time, concurrently with the Canonflex RM, a fixed-lens focal-plane-shuttered SLR named the Canonex. Aside from the distinction of being the first Canon SLR with automatic exposure, the Canonex failed signally to make its mark. Few were manufactured and it is comparatively rare.

While not a commercial failure, in that significant numbers of the later models were manufactured and

A lovely pensive portrait shot at the window of an old house in Aberdeen by my daughter Emma while at the university there. The subject was her friend Jenny.

*Picture by Emma Matanle. Shot with Nikkormat FT2 fitted with 50mm f/1.8 Nikkor on Ilford FP4, developed in Aculux and printed on Jessop Variable Contrast.*

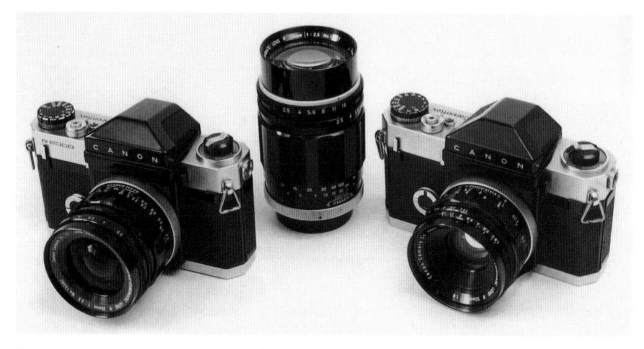

Given its inherent scarcity by comparison with many other SLRs of the period, early Canonflex equipment is relatively low in price. It is not uncommon to see a Canonflex RP or R2000 with standard lens for a little more than £100 ($150). On the right of this picture is an original Canonflex with the early type of 50mm f/1.8 Super-Canomatic lens with index lines between the f/numbers and the index dot. On the left is the Canonflex R2000, the first SLR with a 1/2000th shutter speed. In the centre is a 135mm f/2.5 Super-Canomatic.

*Shot with Minolta SRT101 fitted with 55mm f/1.7 MC Rokkor on Ilford Pan F Plus, developed in Aculux and printed on Jessop Variable Contrast.*

sold, the Canonflex cameras did not capture the spirit of the market at the time, as did the Pentax S3 and its predecessors and the redoubtable Nikon F. If you can find a smart-looking Canonflex at a reasonable price, it is well worth buying, for they are usually reliable, are fun and enjoyable to use and can deliver first-class results. The principal weak spot is the selenium meter in the Canonflex RM, which has a way of developing intermittent electrical faults, but in most other respects few problems arise. Unfortunately, there is a good deal of collector interest in Canonflex equipment, the price has been driven up and some of the lenses, which were always on the scarce side, can now be difficult to find. This is particularly true of the 50–135mm f/3.5 Super-Canomatic zoom.

## The ones that got it right

The Canon FP and FX of 1964 which superseded the Canonflex RM were the first of a line of extremely successful Canon SLRs which lasted fifteen years in production and, perhaps more even than the Nikkormat series, brought professional build quality to cameras designed for the serious amateur market. The design was a total rethink – there is no discernible similarity between Canonflex cameras and the F series other than the presence in both of a breechlock lens mount and the manufacturer's name.

The Canon FP was a compact yet heavily built focal-plane SLR with conventional lever-wind, a cloth focal-plane shutter speeded 1 second to 1/1000th, a fixed-prism viewfinder and the Canon FL lens mount – again breech-lock, but with a single actuation pin for the diaphragm. Like many other SLRs of the time, it had provision for a detachable CdS exposure meter which coupled to the shutter-speed setting knob. The Canon FX was similar but with a built-in CdS meter providing read-out via a window in the top-plate.

Two years later, in 1966, came the first through-the-lens-metering Canon SLR, the much-loved FT QL, the QL indicating the presence of Canon's effective quick-load system which removed the need to thread

the film into the take-up spool. The Canon FT QL added stop-down TTL metering to the specification of the Canon FP, but was otherwise similar. It was and remains an attractive, reliable and enjoyable workhorse backed by a magnificent range of lenses. Because so many Canon FL lenses were made, and because they are still seen as being less desirable than the later Canon FD lenses, Canon FL optics offer, equally with Asahi Super-Takumars, some of the best value in the whole classic SLR spectrum.

However, between the FP and the FT came one of Canon's more remarkable excursions into radical camera design. The Canon Pellix was and is still the only SLR to have been made with a non-moving mirror. This semi-silvered 'pellicle' split the light from the lens 30% to the viewfinder and 70% to the film and thereby eliminated the inertia and camera-shake problems caused in other SLRs by the mirror movement. Unfortunately, it also caused the viewfinder image to be curiously lacking in 'bite' and made it advisable to use the Pellix with an f/1.4 standard lens and wide-aperture lenses in other focal lengths unless light conditions were bright. The fixed-pellicle mirror also limited the range of wide-angle lenses that could be employed, and special 38mm f/2.8 Canon FLP and 19mm f/3.5 FLP lenses were made for the camera.

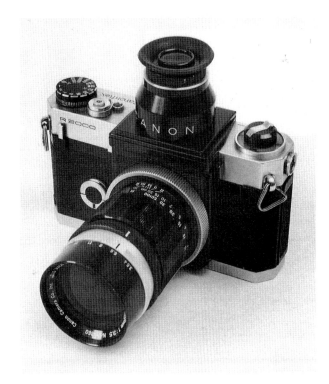

The interchangeable pentaprism of the original Canonflex and (as here) R2000 made it possible to fit a neat 90-degree finder with a magnifier. This has dioptric control, making it ideal for spectacle wearers who prefer to discard the specs for close-up work. The lens on the camera is a 100mm f/3.5 Super-Canomatic.

*Shot with Minolta SRT101 fitted with 55mm f/1.7 MC Rokkor on Ilford Pan F Plus, developed in Aculux and printed on Jessop Variable Contrast.*

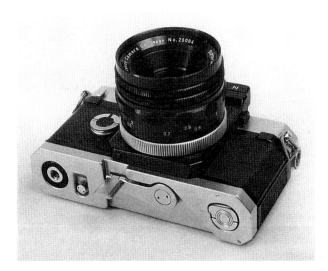

Notice in the picture above right the lack of an obvious wind knob or lever – the answer is to be found beneath the camera, as shown here. This is the film and shutter wind lever of the original Canonflex in the last picture.

*Shot with Minolta SRT101 fitted with 55mm f/1.7 MC Rokkor on Ilford Pan F Plus, developed in Aculux and printed on Jessop Variable Contrast.*

The CdS TTL exposure meter of the Pellix measures the light falling on the centre third of the image, and the meter cell drops into the lower recesses of the mirror box to get it out of the light path during exposure. Despite these characteristics, the Pellix had a loyal following and is now much prized by collectors as a landmark camera. A Pellix QL with the quick-load system appeared in 1966 and continued in production until 1970.

A further venture into side issues arose when, during 1969, Canon launched the EX-EE, an SLR for amateurs who needed only a limited range of lens interchangeability. The camera had a fixed 50mm f/1.8 Canon EX lens, could be fitted with supplementary 35mm f/3.5, 95mm f/3.5 and 125mm f/3.5 lenses and offered automatic TTL CdS exposure metering. Unfortunately, it was priced (standard lens only) at

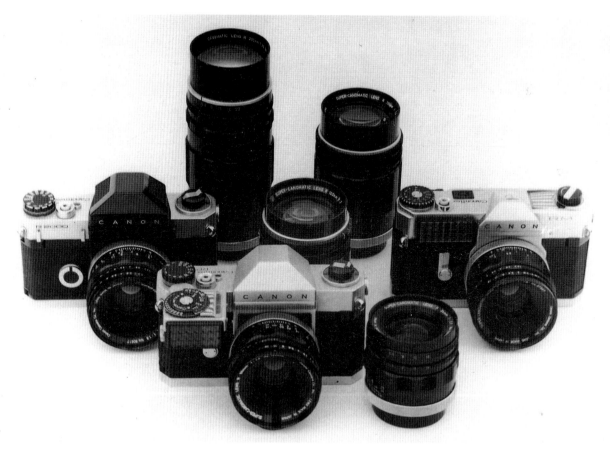

This outfit, referred to on page 147, was used for the pictures of Princess Alexandra and my son in 1979 (page 161), and was my 'fun' equipment at that time. At the back are (left) a 200mm f/3.5 Canomatic R (i.e., semi-automatic) and a 135mm f/2.5 Super-Canomatic. In the centre row are (l. to r.) a Canonflex R2000 with 50mm f/1.8 Super-Canomatic, the 100mm f/2 Super-Canomatic used for the Princess Alexandra pictures and the Canonflex RM that that lens was mounted on at the time. In front is a Canonflex RP complete with the clip-on coupled selenium-cell meter (a similar meter was made for the R2000 with 1/2000th as the highest shutter speed) and a 35mm f/2.5 Super-Canomatic wide-angle lens.

*Shot with Hasselblad 1000F fitted with 80mm f/2.8 Tessar on Ilford HP5 late in the seventies, printed on Jessop Variable Contrast.*

£99.19s.8d (then $240) in Britain (*Amateur Photographer*, 10 June 1970) at a time when the infinitely more versatile Canon FT QL, admittedly without automatic exposure, could be bought for £109.19s.6d ($264) (Greens, *Amateur Photographer*, 30 July 1969). Relatively few were sold, and it is a moderately scarce and quite interesting collectible which usually works very well a quarter of a century and more after its introduction.

During 1968, Canon reacted to the trend for budget-priced simplification of mainline models among other manufacturers and introduced the Canon TL QL – essentially an FT QL with a fastest shutter speed of 1/500th instead of 1/1000th and no delay action. When in 1971 the definitive classic Canon reflex, the FTb QL, was introduced, it was rapidly followed in 1972 by a TLb QL with the same differences, and the later type of FTb QL was similarly paired with the Canon TX of 1975. Canon seemed to have accepted that budgetary differences between prospective buyers in the market-place were best accommodated by offering simpler versions of standard specifications.

The Canon FTb of 1971 was an improved version of the FT QL, with full-aperture TTL metering made possible by a new range of Canon FD lenses. Many SLR enthusiasts (and not a few reference books) fail to realize that there are two quite distinct versions of the FTb QL. The first (1971) type, identifiable by its all-

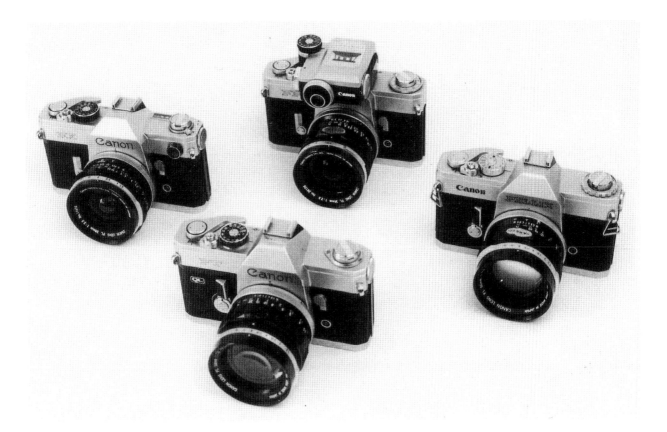

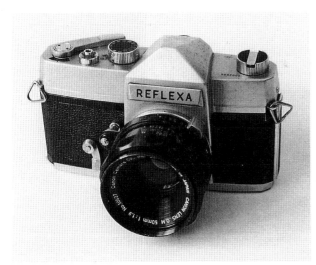

The camera is not Canon, but the lens is. One of camera collecting's more endearing oddities is the Reflexa, fitted with a 50mm f/1.9 Canon lens in – wait for it – Exakta mount. The lens has a semi-automatic spring-loaded diaphragm.

*Shot with Minolta SRT101 fitted with 55mm f/1.7 MC Rokkor on Ilford Pan F Plus, developed in Aculux and printed on Jessop Variable Contrast.*

The shape of things to come in the mid-sixties. On the left, a Canon FX with its CdS meter in the top-plate, fitted with a 28mm f/3.5 Canon FL lens. At the back, a Canon FP, complete with its coupled clip-on CdS exposure meter and a 35mm f/2.5 FL lens, optically similar to the earlier Super-Canomatic lens of the same focal length and aperture. At the front, the much-loved Canon FT QL with the greatly sought-after 58mm f/1.2 Canon FL lens. To the right, the Canon Pellix with 50mm f/1.4 FL lens.

*Shot with Minolta SRT101 fitted with 55mm f/1.7 MC Rokkor on Ilford Pan F Plus, developed in Aculux and printed on Jessop Variable Contrast.*

metal film-advance lever and wedge-shaped delay-action lever, has only the exposure-meter needle and index marker, which also serve as a battery check, visible in the viewfinder with the reflex image. A later model, referred to at the time as the Canon FTbn, but not marked as such on the camera, is identifiable by its plastic-tipped wind lever and flat delay-action lever. This type has displays of shutter speeds and apertures in the viewfinder and is rather more common. Both are among the *crème de la crème* of classic SLRs, with the feel, engineering, reliability, performance and usability that mark out the very few.

Between the two came the Canon EF, the first full-system Canon SLR with automatic exposure. Built within a similar-looking body shell to that of the FTb and made only in black finish, the Canon EF had a metal focal-plane shutter instead of the cloth blinds of the main range, and offered shutter speeds from 30 seconds through to 1/1000th with a combination of mechanical and electronic timing. Speeds from 1/2 second to 1/1000th were mechanically timed in the traditional manner. Those from 1 second to 30 seconds were electronically timed. The exposure system provided TTL shutter-priority automation (the user sets the speed, the meter sets the aperture). It did not sell particularly well. Conventional wisdom is that its lack of success was due to its inability to accept a motor drive and the fact that it was over-shadowed within two years by the enormously successful AE-1 and its auto-wind facility. I think it is far more likely that the EF's reputation for battery consumption went before it.

## The professional cameras

Unlike Nippon Kogaku, whose Nikon F for the professional market was well established for years before the company succeeded in the amateur market, Canon had achieved a major share of the enthusiastic and moneyed amateur market with the FT before it made any real assault on the professional market for a modular 35mm camera system. Although the Canon FT, and then the FTb in fact achieved far greater usage among professionals than did the Nikkormat FT and FTn, they did not have interchangeable view-finder heads nor interchangeable screens, and were not able to accept a motor drive or data back. The important prestige professional markets among news photographers and photo-journalists at the time of the Vietnam war were vital to the image of a professional camera, and Nikon was the camera to be seen with.

To redress this balance, Canon launched in 1971 the Canon F-1, a black-only heavyweight camera with

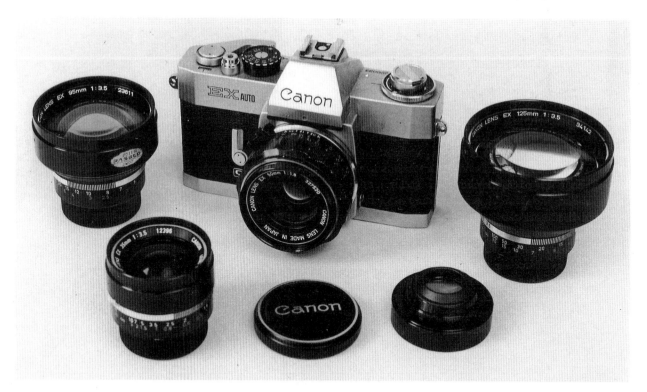

A very nice Canon EX Auto outfit. The camera is fitted with the Canon EX 50mm f/1.8 lens, the front elements of which are interchangeable as a unit. Another 50mm f/1.8 front unit is inverted in front of the camera to the right to show what the screw mount looks like. To the right is the impressively large 125mm f/3.5 Canon EX lens, to the left of the camera is the 95mm f/3.5 EX lens and in front of the camera, beside the lens cap, is a 35mm f/3.5 Canon EX lens.

*Shot with Minolta SRT101 fitted with 55mm f/1.7 MC Rokkor on Ilford Pan F Plus, developed in Aculux and printed on Jessop Variable Contrast.*

interchangeable screens, alternative prism, waist-level and high-viewpoint viewfinders and a more user-friendly motor drive than Nikon was able to offer at the time. Although the Canon F-1 never dislodged the Nikon F, nor the Nikon F2 which appeared shortly after the Canon camera, from their pre-eminence among the hard men of journalism, it achieved a substantial following and an excellent reputation for ruggedness and reliability. Even more than the FT/FTb series, the Canon F-1 feels like a whole lot of camera for the money. Nonetheless, there are fewer original F-1s to go around than there are FT and FTb bodies and prices are not low, although a great deal less than a comparable Nikon F2. A clean Canon F-1 provides substantially better value than a Nikon F2 in terms of performance per pound spent.

Just as with the two versions of the FTb QL, which are engraved with identical model descriptions, Canon upgraded the F-1 in 1976 without altering the inscription on the camera. Confusingly, the new version was advertised and marketed as the F-1n (small n) but this designation was nowhere to be found on the camera. Viewfinder information was improved and there were minor cosmetic differences, but the F-1n was essentially similar to the original F-1 and used the same viewfinders, screens and other accessories.

To make matters worse, Canon then designed a completely new professional system camera, launched in 1981, which, although quite different and marketed as the F-1N (large N), was still engraved – yes! – F-1. This version was not compatible with the earlier F-1 models and needs different screens and heads.

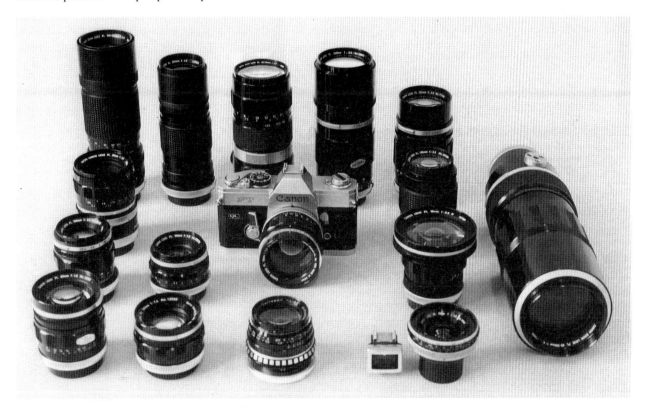

If you are really dedicated, photography with a Canon FT QL can be demanding of muscle. This outfit is extremely impressive, is capable of almost anything any reasonable photographer would wish ever to do with 35mm equipment, and yet, apart from a few genuine rarities, could be accumulated gradually at camera fairs without massive expense. In the picture are (l. to r.): (Back row) 100mm–200mm f/5.6 Canon FL zoom, 200mm f/4.5 Canon FL, 55mm–135mm Canon FL zoom, 200mm f/3.5 Canon FL, 135mm f/2.5 Canon FL. (2nd row) 55mm f/3.5 Canon FL Macro with its 1:1 tube, Canon FT QL fitted with 58mm f/1.2 Canon FL, 135mm f/3.5 Canon FL. (3rd row) 100mm f/3.5 Canon FL, 28mm f/3.5 Canon FL and (one of the rare ones) a 19mm f/3.5 FL retrofocus. (4th row) 85mm f/1.8 Canon FL, 50mm f/1.4 Canon FL, 35mm f/4 PA Curtagon for Canon (decidedly scarce) and (also rare) the original 19mm f/3.5 mirror-up lens with its shoe-mounting viewfinder. (On the right) The huge 85mm–300mm f/5 Canon FL zoom, another lens you are unlikely to find every weekend.

*Shot with Minolta SRT101 fitted with 55mm f/1.7 MC Rokkor on Ilford Pan F Plus, developed in Aculux and printed on Jessop Variable Contrast.*

## The lightweights

Canon was among the first of the leading SLR manufacturers to espouse plastics and electronics for 'serious' amateur cameras. The first was the hugely successful and very agreeable Canon AE-1 of 1976. Using the same series of breech-lock Canon FD lenses as the preceding models (and the F-1), the AE-1 provided the user with a choice between automatic shutter-priority operation or manual use. A compact, relatively inexpensive and easy-to-use auto-winder made it a natural for action photographers.

From an engineering standpoint, the AE-1 was a radical departure. The apparently chrome-finished metal top-plate was actually moulded in lightweight ABS. The cloth focal-plane shutter, speeded 2 seconds to 1/1000th, was electronically controlled by a circuit board. If the shutter failed, the only remedy in most cases was and is to replace the board – which is expensive by 'drop of oil' standards. From a collector's standpoint it also bodes ill, for the ability of anyone to repair the camera is totally dependent upon the availability of electronics spares. The days of the agreeably eccentric mechanical fix were over.

In fairness to Canon, it should be emphasized that these warnings apply to all electronically controlled cameras. Long-term collecting and using is best served by high-quality mechanical equipment.

The Canon AT-1 of 1977 was essentially the AE-1 but with match-needle full-aperture TTL metering and no automatic mode. The AV-1 of 1979 backed the other horse and provided automatic aperture-priority operation (set the aperture and the camera sets the shutter speed) without a manual option. But between the two was launched the A1, the first Canon with multi-mode automation. Grey-haired photographers who merely wanted to take pictures were now beginning to lose touch.

I do not propose to describe the A1 in detail because I have never tackled the problem of understanding the benefits or otherwise of its functions fully. I am unclear as to whether they actually help produce better and more telling images. Like computer games, they are probably fun, but I suspect they do little to advance our culture.

## Canon lenses

The number of different Canon SLR lenses produced between 1959 and around 1980 is quite remarkable. The following list covers most of the ground and provides a fairly comprehensive indication of which focal-length/aperture combinations were available in which variations of the Canon mount.

Prior to the advent of modern lens mounts categorized as Canon AC and EOS, which are outside the

My own black Canon FTb QL with 50mm f/1.8 Canon FD SC lens, which delivers superbly crisp negatives, although I find it less easy to focus with spectacles than my Minolta SRT101.

*Shot with Minolta SRT101 fitted with 55mm f/1.7 MC Rokkor on Ilford Pan F Plus, developed in Aculux and printed on Jessop Variable Contrast.*

Inside the Canon FTb QL is this simple quick-load device (hence the QL of the name). Simply placing the leader of the film on the film guides so that the QL plate comes down on top of it as the back of the camera is closed is sufficient to ensure that the film takes up perfectly.

*Shot with Minolta SRT101 fitted with 55mm f/1.7 MC Rokkor on Ilford Pan F Plus, developed in Aculux and printed on Jessop Variable Contrast.*

scope of this book, there were four successive Canon lens-mount variations.

*The R series* was for the Canonflex series of cameras. All automatic-diaphragm lenses were designated Super-Canomatic-R; semi-automatic-diaphragm lenses (e.g., the 200mm f/3.5), Canomatic-R. The long-focus lenses with manual diaphragm were Canon-R. All had rotating-ring breech-lock mount, with the same bayonet fitting as the later three series. Of the two diaphragm actuators seen at the rear of the Super-Canomatic lenses, one is driven by the camera to arm or cock the diaphragm, the other is driven to release the diaphragm when the shutter is fired. Hence Super-Canomatic lenses remain stopped down until the camera is wound after exposure, when the act of winding opens the diaphragm. Canomatic lenses have to be manually cocked open.

*The FL series* was introduced for the Canon FX and FP in 1964 and continued through the Canon FT QL period until 1971. Although with the identical bayonet and breech-lock mount, FL lenses have a single rear coupling pin for the diaphragm, permitting only stopped-down metering on all subsequent manual-metering Canon SLRs. Early FL lenses have a satin-chrome aperture ring with protruding 'ears' or grips. Later FL lenses lack these.

*The FD series* is similar in function to the FL lenses, but FD lenses have two coupling levers at the rear to make full-aperture exposure measurement possible on the FTb QL, F-1 and later cameras. Earlier FD lenses are marked SC (Spectra-Coated), later ones SSC (Super-Spectra-Coated), which was Canon's version of multi-coating. Very early FD lenses, known to collectors as 'white-front' lenses, had a polished-steel filter mount. Reviewers suggested, probably unjustifiably, that this caused unwanted reflections, and Canon quickly changed to black filter mounts. As a result, 'white-front' lenses are scarce and sought after in a modest way. There were, throughout the seventies, two distinct groups of FD lenses, although Canon did not acknowledge this. The more prestigious focal-length/aperture combinations (e.g., 135mm f/2.5) were supplied in a heavy, beautifully finished, shiny black mount with an equally well-engineered shiny metal lens cap with the Canon logo in metallic silver. The 'budget' lenses (e.g., 135mm f/3.5 and 35mm f/3.5) had a duller finish, rubbery focus grips and black plastic lens caps. It has been suggested but not confirmed that Canon sub-contracted the manufacture of the budget lenses.

The Canon EF was the first Canon SLR with automatic exposure – note the A setting on the aperture ring, which caused the camera to operate as a shutter-priority automatic. This example is fitted with a late 50mm f/1.4 Canon FD SSC (Super-Spectra-Coated) lens. This was Canon's term for multi- coating to reduce internal reflections.

*Camera by courtesy of Gerry Cookman. Shot with Minolta SRT101 fitted with 55mm f/1.7 MC Rokkor on Ilford Pan F Plus, developed in Aculux and printed on Jessop Variable Contrast.*

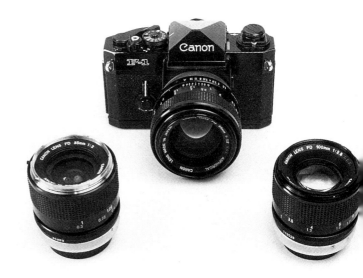

The Canon F-1 is a magnificent beast, made even more impressive in this case by the scarce and expensive 55mm f/1.2 Canon FD SSC Aspherical lens fitted to it. In front on the left is one of the moderately scarce early 'white-face' 35mm f/2 Canon FD lenses. On the right is a later 100mm f/2.8 Canon FD SSC lens.

*Shot with Minolta SRT101 fitted with 55mm f/1.7 MC Rokkor on Ilford Pan F Plus, developed in Aculux and printed on Jessop Variable Contrast.*

## Canon SLR lenses

### Wide-angle lenses

| | Canon-R | FL | FLP | FD | New FD |
|---|---|---|---|---|---|
| 7.5mm f/5.6 Fisheye | | | | ★ | ★ |
| 14mm f/2.8 FD/L | | | | | ★ |
| 15mm f/2.8 | | | | ★ | ★ |
| 17mm f/4 | | | | ★ | ★ |
| 19mm f/3.5 | | ★ | ★ | | |
| 20mm f/2.8 | | | | ★ | ★ |
| 20mm f/3.5 Macrophoto (manual diaphragm) | | | | ★ | ★ |
| 24mm f/1.4 Aspherical | | | | ★ | ★ |
| 24mm f/2 | | | | | ★ |
| 24mm f/2.8 | | | | ★ | ★ |
| 28mm f/2 | | | | ★ | ★ |
| 28mm f/2.8 | | | | ★ | ★ |
| 28mm f/3.5 | | ★ | | ★ | |
| 35mm f/2 | | | | ★ | ★ |
| 35mm f/2.5 | ★ | ★ | | | |
| 35mm f/2.8 Macrophoto (manual diaphragm) | | | | ★ | |
| 35mm f/2.8 | | | | | ★ |
| 35mm f/2.8 (Tilt & Shift) | | | | ★ | |
| 35mm f/3.5 | | ★ | | ★ | |
| 38mm f/2.8 | | | ★ | | |

### Standard lenses

| | Canon-R | FL | FLP | FD | New FD |
|---|---|---|---|---|---|
| 50mm f/1.2 | | | | | ★ |
| 50mm f/1.4 | | ★ | | | ★ |
| 50mm f/1.8 | ★ | ★ | | ★ | ★ |
| 50mm f/3.5 Macro | | ★ | | ★ | ★ |
| 55mm f/1.2 | | ★ | | ★ | |
| 55mm f/1.2 Aspherical | | | | ★ | |
| 58mm f/1.2 | | ★ | | | |

### Long-focus and telephoto lenses

| | Canon-R | FL | FLP | FD | New FD |
|---|---|---|---|---|---|
| 85mm f/1.2 | | | | | ★ |
| 85mm f/1.2 Aspherical | | | | ★ | |
| 85mm f/1.8 | ★ | ★ | | ★ | ★ |
| 85mm f/2.8 (soft focus) | | | | | ★ |
| 100mm f/2 | ★ | | | | ★ |
| 100mm f/2.8 | | | | ★ | ★ |
| 100mm f/3.5 | | ★ | | | |
| 100mm f/4 Macro | | | | ★ | ★ |
| 135mm f/2 | | | | | ★ |
| 135mm f/2.5 | ★ | ★ | | ★ | |
| 135mm f/2.8 | | | | | ★ |

| | Canon-R | FL | FLP | FD | New FD |
|---|---|---|---|---|---|
| 135mm f/3.5 | | ★ | | ★ | ★ |
| 200mm f/2.8 | | | | ★ | ★ |
| 200mm f/3.5 | ★ | ★ | | | |
| 200mm f/4 | | | | ★ | ★ |
| 200mm f/4 Macro | | | | | ★ |
| 200mm f/4.5 | | ★ | | | |
| 300mm f/2.8 | | | | ★ | ★ |
| 300mm f/4 | ★ | ★ | | ★ | ★ |
| 300mm f/5.6 | | ★ | | ★ | ★ |
| 400mm f/2.8 | | | | | ★ |
| 400mm f/4.5 | ★ | ★ | | ★ | ★ |
| 400mm f/5.6 (for focus unit) | | ★ | | | |
| 500mm f/4.5 | | | | | ★ |
| 500mm f/5.6 | | ★ | | | |
| 500mm f/8 Reflex | | | | ★ | ★ |
| 600mm f/4.5 | | | | ★ | ★ |
| 600mm f/5.6 (for focus unit) | | ★ | | | |
| 600mm f/5.6 (full mount) | ★ | ★ | | | |
| 800mm f/5.6 | | | | ★ | ★ |
| 800mm f/8 (for focus unit) | | ★ | | | |
| 800mm f/8 (full mount) | ★ | ★ | | | |
| 1000mm f/11 | ★ | ★ | | | |
| 1200mm f/11 (for focus unit) | | ★ | | | |
| 1200mm f/11 (full mount) | | ★ | | | |

### Zoom lenses

| | Canon-R | FL | FLP | FD | New FD |
|---|---|---|---|---|---|
| 20–35mm f/3.5 | | | | | ★ |
| 24–35mm f/3.5 | | | | ★ | ★ |
| 28–50mm f/3.5 | | | | ★ | ★ |
| 28–55mm f/3.5 | | | | ★ | ★ |
| 28–85mm f/4 | | | | | ★ |
| 35–70mm f/2.8–3.5 | | | | ★ | ★ |
| 35–70mm f/3.5–4.5 | | | | | ★ |
| 35–70mm f/4 | | | | | ★ |
| 35–105mm f/3.5 | | | | | ★ |
| 50–135mm f/3.5 | | | | | ★ |
| 50–300mm f/4.5 | | | | ★ | |
| 55–135mm f/3.5 | ★ | ★ | | | |
| 70–150mm f/4.5 | | | | | ★ |
| 70–210mm f/4 | | | | | ★ |
| 75–200mm f/4.5 | | | | | ★ |
| 80–200mm f/4 | | | | ★ | ★ |
| 85–300mm f/4.5 | | | | ★ | ★ |
| 85–300mm f/5 | | ★ | | | |
| 100–200mm f/5.6 | | ★ | | ★ | ★ |
| 100–300mm f/5.6 | | | | | ★ |
| 150–600mm f/5.6 | | | | | ★ |

Canon have made some delightful wide-angle and special-effect lenses. This picture of the Canon F-1 shows it fitted with a 7.5mm f/5.6 Canon SSC fisheye lens. Beside it on the left is a 20mm f/2.8 Canon FD.

*Shot with Minolta SRT101 fitted with 55mm f/1.7 MC Rokkor on Ilford Pan F Plus, developed in Aculux and printed on Jessop Variable Contrast.*

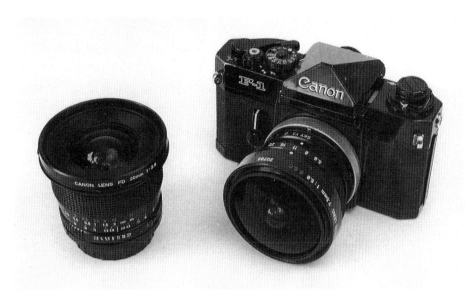

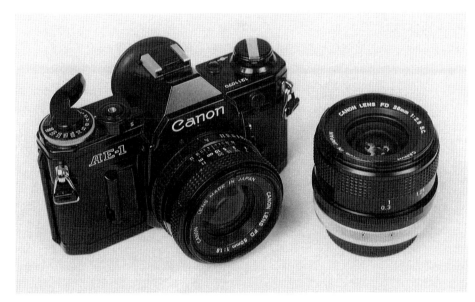

Canon's first lightweight automatic was the best-selling, and therefore very common, Canon AE-1. This example is fitted with one of the first of the 50mm f/1.8 Canon FD lenses with simple bayonet mount rather than the time-honoured Canon breech-lock. The two types can be distinguished at a distance by looking for the distinctive milled chrome ring of the breech-lock. The bayonet mount is all black. Beside the camera is a 28mm f/2.8 FD breech-lock lens, which makes the distinction clear.

*Shot with Minolta SRT101 fitted with 55mm f/1.7 MC Rokkor on Ilford Pan F Plus, developed in Aculux and printed on Jessop Variable Contrast.*

*The new FD series (or bayonet-mount).* For no good reason other than, one suspects, an opportunity to cut costs in a competitive market, Canon suddenly abandoned its mechanically superior true breech-lock mount in the late seventies and offered the same series of FD lens computations with a simple insert-and-twist mount similar in principle to those of most other SLRs. Entirely compatible with all earlier Canon SLRs other than the Canonflex series, the new mount made no difference to the function of camera or lens.

The table opposite summarizes the focal-length and aperture combinations that have been available

and identifies, to the best of my ability, which have been offered in each of the mounts. However, Canon continues to surprise us all and I will not be in the least amazed if a few varieties which I have not listed reside in readers' gadget bags. As is also true of Nikon and all the leading manufacturers, there have been several computations of a number of the longest-lived and most popular lenses, notably the 35mm f/2, which exists with both concave and convex front elements and in at least three different computations.

Note that all FL, FD and New FD lenses of focal length greater than 38mm can be used with the Pellix

– lenses are included in each column by their model designation, not by the cameras they will fit.

Only preset T2 lenses were made for the Canonflex mount by independent manufacturers. I have, for example, encountered a 28mm f/3.5 T2 Soligor contemporary to the Canonflex on a Canonflex RM at a recent camera fair. By the time the FL and FD mounts were current, all the major independent lens brands – Tamron, Vivitar and Soligor – supplied appropriate Canon mounts.

## Choosing and using a Canon

It is arguable that classic Canon equipment offers the best compromise between cost and quality available in classic cameras. All Canon cameras have a smoothness to the touch, a silkiness of operation and a standard of reliability that set them in the first league, and their lenses are difficult to fault except insofar as some tend to excessively warm colour rendition. Yet prices for Canon equipment are well below those for Nikon and Leicaflex, are comparable with or just a little higher than those for Minolta, Pentax and Miranda cameras and lenses and are showing no sign of increasing. In mid-1995 it was common to see Canon FTb cameras with 50mm f/1.8 for around £85 ($128), Canon FTs with 50mm f/1.8 FL for about £60 (£90) and 135mm f/2.8 FD lenses for around £50 ($75).

There are plenty of the more popular Canon cameras and lenses available, Canon equipment is readily (although not necessarily cheaply) repaired and it is straightforward to build a comprehensive outfit by visiting collectors' fairs and events. Canon cameras prior to the A series have very few design faults or problems, and the lens mounts prior to 'New FD' lenses wear extremely well. I have experienced a number of expensive electronics failures with AE-1 equipment, and understand that (as with other electronics and plastics cameras of that generation) such failures are not uncommon.

Which model is for you? If you really like to have interchangeable screens, viewfinders and motor-wind capability, then look for an original F-1. I recently saw (and just saved my bank account from buying) a really nice Canon F-1 with f/1.4 FD lens for £175 ($265).

The best balance of price and performance comes from a Canon FT. The nicest of the Canons to use, in my own opinion, is the Canon FTb. They are all fairly benevolent towards spectacle wearers – I can see the whole screen of my FTb while wearing spectacles and can focus wide-angle lenses quite easily. They all deliver high-quality pictures consistently.

This portrait of Tamsin Joyce was shot in a small cottage sitting room, using a piece of black velvet as a non-reflective backdrop and three elderly Courtenay studio flash units. The camera was a first-type Canon FTb QL of about 1973 with the usual standard 50mm f/1.8 Canon FD lens. The quality of the images delivered by the Canon lenses is superb and both cameras and lenses are extremely reliable. Perhaps because of their considerable weight, the older breech-lock Canon lenses are readily available at quite moderate prices by comparison with (for example) Nikon and are among the best value of all SLR lenses.

*Shot with Canon FTb QL fitted with 50mm f/1.8 Canon FD SSC, electronic flash at f/11, on Ilford FP4 Plus, developed in Aculux and printed on Ilford Multigrade III.*

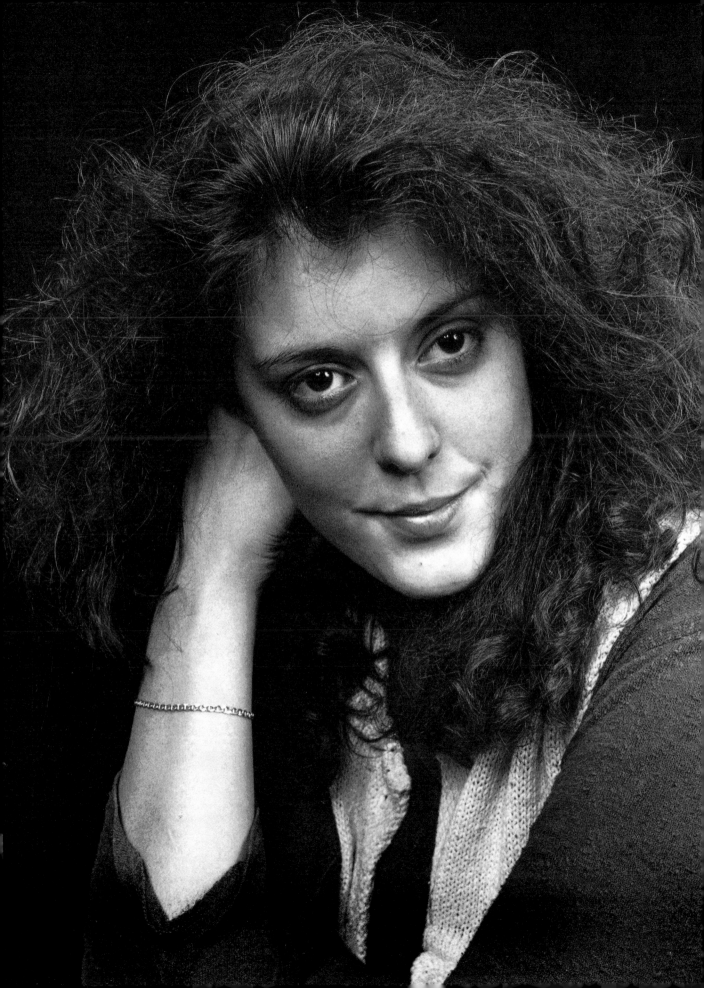

Rehearsals are rarely glamorous. I took this shot of a group led by my wife's nephew Nigel Shefford rehearsing in a pub's upper room in 1979. Lacking any stage or effects lighting, I simply included photographic lights in the picture – the light on the left is a Courtenay studio flash-head synchronizing with the shutter. There was another down beside the drummer in the background.

*Shot with Canon F-1 fitted with 24mm f/2.8 Canon FD on Ilford HP5, printed on Ilford Multigrade.*

Another of the shots from my session with 'The Conspiritors'. Although this negative is very difficult to print, the effect of the flash-head firing into the camera and outlining the profiles of the singers is decidedly unusual.

*Shot with Canon F-1 fitted with 24mm f/2.8 Canon FD on Ilford HP5, printed on Ilford Multigrade.*

During 1979, Princess Alexandra formally opened a primary school at which my son Greg was a pupil. As she made her way to her car past the line-up of pupils, Greg suddenly produced without warning a smart salute.

The Princess saw this out of the corner of her eye, stopped and turned back to talk to him, to the amazement of all the other children. I had planned to shoot a picture of Greg with his friends as the Princess went by, but had no idea that he would steal the show.

*Shot with Canonflex RM fitted with 100mm f/2 Super-Canomatic on Sakuracolor, processed C41 and printed on Jessop Variable Contrast.*

One of the young bridesmaids at a family wedding during 1994, photographed after the ceremony.

*Shot with Canon FX fitted with 50mm f/1.8 Canon lens on Ilford FP4 Plus, developed in Aculux and printed on Ilford Multigrade.*

This shot of Amelia Joyce shows the high standard of resolution and sharpness that the Canon standard lenses can deliver.

*Shot with Canon FTb QL fitted with 50mm f/1.8 Canon FD SC on Ilford FP4 Plus, developed in Aculux and printed on Ilford Multigrade.*

When the Athena B went aground on Brighton beach, the wreck became something of a local side-show. Like hundreds of others, we went as a family to see the Greek ship stranded within a few hundred yards of the pier.

*Shot with Canon AE-1 fitted with 35mm f/3.5 Canon FD on Ilford FP4, developed in Aculux and printed on Jessop Variable Contrast.*

There can be few more intimidating experiences for a boy than being stood before his peers to play a trumpet solo. When my son Greg faced this particular ordeal at Belmont School, Holmbury St Mary, I found a high vantage point on a landing from which a picture could capture the essence of the occasion.

*Shot with Canon AE-1 fitted with 50mm f/1.8 Canon FD SSC on Ilford FP4, developed in Aculux and printed on Jessop Variable Contrast.*

A portrait against a plain Colorama paper background of Nick, a friend of one of my daughter's friends. I find straight studio portraiture of young men difficult – they either look absurdly serious and pretentious or embarrassed. This one more or less works.

*Shot with Canon FTb QL fitted with 50mm f/1.8 FD SC lens on Ilford FP4 Plus, developed in Aculux and printed on Ilford Multigrade.*

# More stars from the East – and some also-rans

Most of the great names of the Japanese camera industry trace their origins to the early years of the twentieth century. Konishiroku Kogaku (Konica), in fact, first began as a materials manufacturer in 1873. There was therefore, despite the disruption of war, a massive fund of photographic design and manufacturing experience in Japan upon which the post-war success of the Japanese SLR could be built.

You may, with some justice, wonder why whole chapters of this book have been devoted to Exakta, Pentax, Nikon and Canon when Minolta, Konica, Olympus, Topcon, Yashica, Petri, Mamiya, Miranda and Ricoh have each only a section of this one, rather longer, chapter. My own subjective and very personal assessment is that Exakta, Pentax, Nikon and Canon were the landmark 35mm SLR brands upon which the transformation of world attitudes to SLR cameras and photography were based. The others, while in many cases innovative, and almost all of very high quality, followed the marketing (not the technical) trend rather than leading it. Since the length of this book must be finite, my treatment of these brands must be shorter than that of others.

To fend off allegations of favouritism, I shall describe the various brands in alphabetical order.

## Fujica

The Fuji Photo Film Co. manufactured a range of 35mm focal-plane-shuttered SLRs throughout the seventies after producing a leaf-shutter SLR during the sixties (see Chapter 10). They were sound, well-built cameras at a price which was simply too high for the market conditions of the time.

The first of the Fujica series was the Fujica ST701 of 1971, a conventional fixed-prism SLR with cloth focal-plane shutter, stopped-down TTL metering and a good-quality 55mm f/1.8 Fujinon EBC (electron-beam-coated) lens. The principal claim of the Fujica ST701 to innovation was its use of silicon-blue cells instead of CdS cells in its exposure meter. This was claimed to provide a more balanced response across the spectrum, obviating the well-documented problem of CdS cells' over-response to scenes with a predominance of strong reds.

During 1973, the Fujica ST801 became the world's first SLR to use LEDs rather than a swinging match-needle system in the viewfinder to indicate correct exposure. It introduced full-aperture TTL metering and a fastest shutter speed of 1/2000th second to the Fujica range. I remember thinking at the time that it should have been a very successful camera, but suspecting that it would not be, simply because of its unfashionable 42mm screw mount.

A year later, the Fujica ST901 appeared, still with the 42mm screw mount, and offering very precise and effective aperture-priority automatic TTL exposure measurement and setting, with the shutter speed displayed by an easily read LED placed centrally above the focusing screen. The cloth focal-plane shutter provided speeds from 20 seconds to 1/1000th second. It looked and handled well, had an excellent range of Fujinon EBC lenses and was overpriced, with a recommended retail price in Britain of £276.50 (then $614) in 1975. Certainly, the discount stores were selling them for £182.20 ($404), but one could at the same time buy a Pentax ESII with 50mm f/1.8 SMC Takumar for £193.81 ($430). If you were buying an automatic SLR with a screw-mount lens at that time, which would you have bought?

In 1977, the Fujica ST605 and ST705 appeared. These were, as was the fashion of the moment, somewhat smaller and much lighter cameras than the previous series, with extensive use of engineering plastics. Unlike other brands, however, the shutter remained mechanically timed. The ST605 had stopped-down TTL metering and a range of shutter speeds reduced to 1/2 second to 1/700th (can anyone think of another SLR with 1/700th on the shutter-speed dial?). The ST705 had full-aperture TTL metering and the fastest speed increased to 1/1500th second (also probably unique). An ST705W of 1978 was a version modified to accept an auto-winder, very fashionable at the time. However, by this time the sun had set on the 42mm lens mount and Fujica embarked on the age of electronics with the Fujica AZ-1, with an electronically controlled shutter and a new lens mount.

Two decades on, Fujica ST cameras are not particularly sought after and very underrated. The

lenses are very crisp, the focusing screens very bright, and the feel of the cameras very taut even after this length of time. There are not many around and, in time, they may be seen as collectible. Certainly, they are effective cameras and good value, but check them carefully, as spares for the '01' series are difficult to find and repairs can be tricky.

## Konica

Konishoroku Kogaku has been in business for over 120 years, and has always been innovative, engineering-orientated and less effective at marketing its cameras than other companies whose quality was lower but whose profile was higher. I am indebted to Ian Dear of the Photographic Collectors Club of Great Britain for his substantial help with information on Konica.

The initial series of Konica SLRs appeared progressively during the first five years of the sixties, and followed a pattern of progressive development and innovation similar to that of other Japanese camera manufacturers of the time, although always with an edge of originality and nonconformity which makes Konica equipment unfailingly interesting.

The Konica F of 1960 was the world's second SLR (after the Canonflex R2000) to have a top shutter speed of 1/2000th and was equipped with a coupled selenium exposure meter. The Konica F introduced the first version of the Konica bayonet mount, usually with a 52mm f/1.8 Hexanon lens which performed well, although not in the first league. The shutter was a vertical-running metal design which was less than quiet in operation. The Konica F is decidedly scarce.

Between 1961 and 1964, Konishoroku marketed the Konica FS, a more conventional camera for the time, with no exposure meter and shutter speeds only to 1/1000th second, and this was joined in 1963 by the Konica FP, a variant with several minor differences, including a modified focusing screen. 1965 brought the Konica FM, another in the same series with a CdS exposure meter within the top-plate and a match-needle window in the manner of the Canon FX or Minolta SR-7.

By comparison, the Konica Auto-Reflex of 1965 was a true landmark camera, for it was the first high-quality single-lens reflex with a focal-plane shutter and automatic exposure control. It was also the first – and so far the only – 35mm SLR whose picture format could be mechanically switched from full-frame to half-frame.

The shutter-priority automatic-exposure system on the Konica Auto-Reflex was unusual by comparison with later automatic SLRs in that the physical pressure on the shutter-release button provided the energy which stopped down the automatic diaphragm to the aperture set by the camera's exposure meter. The user would set a shutter speed appropriate to the subject, whereupon the exposure meter displayed the selected aperture on a scale on the right-hand side of the viewfinder. Substantial pressure was then required on the button to stop down the diaphragm and fire the shutter.

The much-changed Konica Auto-Reflex T of 1968 was a much simpler-looking camera which did not have the half-frame switching system which, one suspects, was expensive to manufacture and had been introduced at a time when interest in half-frame was beginning to decline. Equipped with a Copal Square

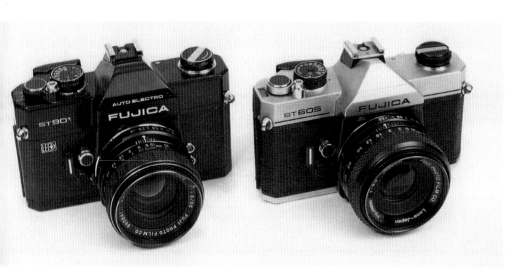

The Fujica ST901, on the left, is representative of the first series of Fujica SLRs – rugged, compact for its time and surprisingly heavy. The automatic-exposure system has a way of being unreliable on this model, and it is wiser to buy an ST801 if you are intending to use the camera heavily. The ST901 in the picture is fitted with a 55mm f/1.8 Fujinon lens. On the right is a Fujica ST605, typical of the later, lightweight series of cameras, here fitted with a 50mm f/2.2 Fujinon.

*Fujica ST901 by courtesy of John Shaw. Shot with Rolleiflex SL66 fitted with 80mm f/2.8 Planar on Ilford FP4 Plus, developed in Aculux and printed on Jessop Variable Contrast.*

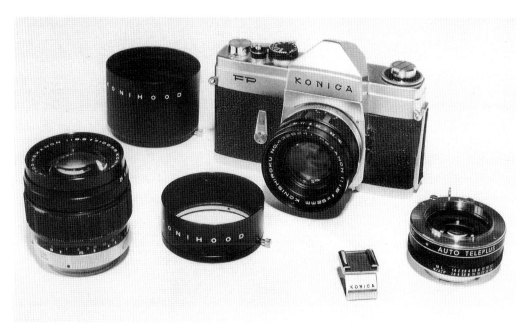

A typical early Konica SLR outfit – an FP and 52mm f/1.8 Hexanon with its lens hood in front of it and a 100mm f/2.8 Hexanon and hood (with which the picture of the bellringer on page 188 was shot). In the foreground on the right is the unique Konica accessory-shoe clipping over the rewind knob and an Auto Teleplus 2x tele-converter in Konica fitting.

*Shot with Minolta SRT101 fitted with 55mm f/1.7 MC Rokkor on Ilford Pan F Plus, developed in Aculux and printed on Jessop Variable Contrast.*

metal shutter, the Auto-Reflex T retained the needle-trapping exposure-setting system of the previous Auto-Reflex, and therefore also the heavy shutter pressure, although the inordinately long shutter-release-button travel of the 1965 Auto-Reflex (7.5mm before the shutter fired) had been reduced to 6mm. In fact, both the shutter travel and the shutter pressure were progressively reduced between 1965 and 1973, when the Auto-Reflex T3 appeared. The 1965 Auto-Reflex required 1,000 grams of pressure and a travel of 7.5mm, the T3 300 grams and 2mm.

Both the original Auto-Reflex and the Auto-Reflex T were much criticized for their heavy shutter release. However, Geoffrey Crawley of the British Journal of Photography pointed out in his review of the Auto-Reflex T (29 May 1970) that '…with greater experience of the camera the objections seem to be forgotten and the user's reactions become tuned to this special feature'.

Three types of exposure measurement were possible with the TTL meter of the Auto-Reflex T and the subsequent A, T2 and T3 – fully automatic shutter priority (termed by Konishoroku 'EE' or electric eye), manual aperture priority, for which the user set an aperture, then turned the shutter-speed dial until the needle in the viewfinder lined up with that aperture on the scale, or manual shutter priority, for which the shutter speed was set first and the aperture ring was

turned to line up the needle. This was and remains a sensible, flexible arrangement which provided the user with versatility in return for a little thought – automation, rather than mindless automation.

The key to this flexibility was what was probably the most sophisticated lens-throat mechanism of any camera built during the seventies. On the rear of each lens was a radius flange just above the auto-diaphragm trigger lever. As the lens was inserted into the three-tongue bayonet mount, a feeler lever in the camera throat engaged a cut-out on the radius flange. The cut-out was of a different depth for each maximum aperture available in the range of lenses, and thereby communicated the maximum aperture to the exposure meter within the camera.

When the camera was to be used for automatic exposure measurement, the lens-diaphragm ring was turned beyond f/16 (the universal minimum aperture throughout the range of Auto-Reflex Hexanon lenses) to 'EE'. This caused a further cam on the lens mount to engage a pin within the lens mount and switch on the automatic-exposure system.

One minor though sometimes important benefit of the Konica design is that the flange-to-film register is unusually short at only 40.5mm, whereas most of the major SLRs have registers of around 44 to 45mm (only Alpa is well under 40mm). This made possible a range of adaptors to enable lenses of other fittings to be fitted

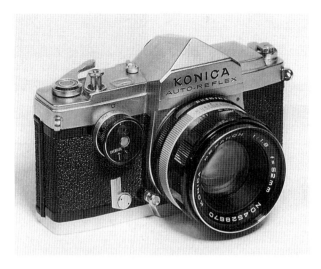

A true landmark camera. The first Konica Auto-Reflex might have been expected to sweep the board in 1965 but, probably more for marketing reasons than photographic, never achieved dominance. The first SLR to offer switchable half-frame or full-frame format, this is an excellent camera to use. This one has a 52mm f/1.8 Hexanon lens.

*Camera by courtesy of Len Corner. Shot with Praktina IIA (by courtesy of Mike Rees) fitted with 135mm f/3.5 Tele-Ennalyt on Ilford Pan F, developed in Aculux and printed on Jessop Variable Contrast.*

Inside the Konica Auto-Reflex, in this case set to half-frame mode, one can see the sliding masks which alter the size of the picture aperture. This is controlled by the lever on the top-plate between the wind lever and the prism housing. The exposure-meter switch is at the left-hand end of the top-plate, next to the rewind crank.

*Camera by courtesy of Len Corner. Shot with Praktina IIA (by courtesy of Mike Rees) fitted with 135mm f/3.5 Tele-Ennalyt on Ilford Pan F, developed in Aculux and printed on Jessop Variable Contrast.*

to the Konica cameras and achieve infinity focus. Konishoroku made adaptors for Exakta, Pentax/Praktica M42 screw and Nikon, and one for the earlier lens bayonet of the F series cameras. Various independent manufacturers and workshops made other adaptors for other lens fittings.

The Konica Auto-Reflex A of 1969 was a simplified version of the T without a delay-action mechanism or depth-of-field preview system. The T2 of 1971 and the T3 of 1973 progressively introduced design improvements and new features but were essentially similar, and the range continued with the A3 of 1974, the T3N (with flash hot shoe) of 1976, the TC of 1977 and the T4 of 1978.

By 1973, there were twenty-three different lenses in the Hexanon lens range, in focal lengths from 21mm to 1,000mm and including three zooms.

### Should you go for Konica?

Konica cameras are well engineered and quite reliable, although spares are not particularly easy to obtain. The cameras are fairly easy to find in good condition, but perseverance is needed to track down a reasonable set

of lenses. The quality of the Hexanon lenses is good but not outstanding, and the lens mounts feel less well finished than those of the better-known brands of the period. As an example of interesting engineering applied to photography, Konica is in the first league. However, it has to be said that I would personally prefer several other types of camera for long-term photography.

### Mamiya

Best known among classic-camera enthusiasts for its folding rollfilm Mamiya 6 and for its twin-lens reflex cameras, the Mamiya Camera Company of Tokyo was a comparative latecomer to 35mm single-lens reflexes and concentrated for several years on various leaf-shutter SLRs (see Chapter 10). Nonetheless, Mamiya's first excursion into focal-plane-shuttered SLRs came during 1963 with the 'Mamiya SLR', also sold as the Reflexa with no apparent Mamiya identity. This camera, whose body was made by Mamiya, sported a Canon f/1.9 lens of very high quality in, of all things, an Exakta bayonet mount. It had a fixed prism, no exposure meter and a conventional cloth

focal-plane shutter with speeds of 1 second to 1/1000th (see page 151).

During the following year, the 'Mamiya/Sekor' appeared – this being the name of the camera, not as might have been expected by those accustomed to Mamiya optics, the name of the lens. Marketed in the USA as the CWP, the Mamiya/Sekor had a CdS meter with its cell window in the front of the top-plate, a conventional cloth focal-plane shutter and a 58mm f/1.7 Mamiya-Sekor lens of surprisingly good quality. Manufactured from 1964 until 1967, the Mamiya/Sekor is quite scarce, perhaps simply because it did not sell very well.

Meanwhile, in 1966, Mamiya had launched two versions of a very much better and more innovative camera, the Mamiya/Sekor 500TL and 1000TL, differing primarily in their fastest shutter speed. These were Mamiya's first TTL exposure cameras, equipped with a sensitive and effective CdS exposure meter and sold with a variety of standard 42mm screwmount lenses, including 50mm f/2.8 and 55mm f/1.8 optics of excellent quality. A range of other focal lengths of Mamiya-Sekor lenses made its appearance – see the 1968 picture of my father using a Prakticamat fitted with a 35mm Mamiya-Sekor, on page 143.

The major innovation came in 1968 with the advent of the Mamiya/Sekor 500DTL and 1000DTL. Derived from the earlier TL cameras, these had a TTL exposure meter which was switchable between spot and averaging metering, thus providing great versatility for photographers prepared to understand the significance of spot metering for colour work. The meter was, and usually is, very accurate and extremely easy to use, and I believe the Mamiya 500DTL and 1000DTL to have been very underrated, or possibly just badly marketed. Certainly, they did not catch the imagination of the amateur market, despite a competitive price.

The trend to automatic exposure brought forth the Mamiya/Sekor Auto XTL in 1971, which was advanced, effective and a sales disaster, and the further improved Mamiya/Sekor Auto X1000 of 1975, which fared little better. Meanwhile, Mamiya had further developed the match-needle TTL range to produce the DSX500 and DSX1000 of 1974, both of which retained the switchable spot and averaging metering, and the MSX500 and MSX1000 of 1975, which dispensed with the averaging metering and had spot metering only.

The Mamiya/Sekor 500 DTL, first marketed during 1968, was a significant camera in that its exposure meter offered switchable spot or averaging metering. The switch for this can be seen low on the right-hand side of the mirror box of the camera as we look at it in this picture.

*Shot with Minolta SRT101 fitted with 45mm f/2 MD Rokkor on Ilford Pan F, developed in Aculux and printed on Jessop Variable Contrast.*

*A good buy?*

All these Mamiya/Sekor cameras performed well and sold badly. All are readily available at very modest prices and are well worth trying, particularly if you like the idea of readily available spot metering built into the camera. Most of the range of Mamiya-Sekor lenses perform well and are good value. The camera bodies are usually reliable if clean and little worn – the external condition is usually a fair guide, since these were cameras rarely bought by professionals. As an interesting aside, I was told recently by a camera dealer of many years' experience that, when the Mamiya/Sekor range became obsolescent, he bought a 'job lot' of 100 cameras. He sold them all, and had none returned under guarantee or later for repair. Such a record of reliability is very unusual.

However, do check shutter performance on focal-plane Mamiya cameras more than usually carefully. The shutters are inclined to taper and can be expensive to service – so refer to Chapter 2 and check that the shutter is opening at the high speeds and staying open throughout its travel. Also be sure to check that the metering system is working properly without any wavering, since the parts for the meters are largely unavailable other than from scrap cameras.

## Minolta

Founded, controlled and built from its foundation in 1928 until 1982 by one man, Kazuo Tashima, the Minolta camera company launched its first SLR, the Minolta SR-2 in 1958. It was from the outset a refined and reliable camera with excellent handling, an accurate cloth focal-plane shutter with speeds of 1 second to 1/1000th second, and extremely high-quality lenses. These were manufactured throughout by Minolta, which was at that time the only camera company in the world to manufacture its own optical glass. The first-type 'rounded' SR-1, so called because of its rounded profile and smoothly curved corners, appeared the following year. The SR-1 shutter speeds extended only to 1/500th second. This first-type SR-1 was progressively upgraded through five different versions, with the addition of a bracket and modified speed knob for a coupled external exposure meter in 1961, and the incorporation of a depth-of-field preview button in about 1960. In the United States, an SR-3 model was marketed with a 1/1000th-second shutter speed during 1960.

During 1962, Minolta became the first company in the world to incorporate a CdS exposure meter into a 35mm SLR with the launch of the SR-7. This was essentially a first-type SR-1 with a small circular meter cell in the front of the top-plate, a swing-needle meter-display window adjacent to the rewind knob and a shutter speeded to 1/1000th second.

In 1964, new-style squarer Minolta SR-1 and SR-7 models appeared, with the low-profile prism housing and body styling later to become familiar when the SRT series was launched. The technical specifications of these cameras were identical to those of the earlier SR-1 and SR-7, although the mounting bracket for the SR-1 meter is more compact and the meters for the two types of SR-1 are different and not cross-compatible. The new range also had the rectangular viewfinder ocular of the later SRT series instead of the circular eyepiece of the first-type 'rounded' cameras. An additional SR1-s model with a top shutter speed of 1/1000th second was added to the range at the same time.

Minolta's major step forward came with the launch in 1966 of the SRT101 which, unlike the earlier cameras, was available in either black or chrome finish. Great play was made by Minolta at the time on the 'CLC' (Contrast Light Compensation) characteristic of the full-aperture TTL exposure meter of the SRT101, claimed to enable the meter to allow for backlit and contrasty subjects. In practice, this was and

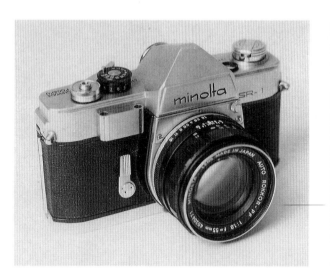

A Minolta SR-1 of the first, 'rounded' type, here fitted with the 55mm f/1.8 Auto Rokkor. The hefty bracket on the front of the top-plate is for the fitting of a coupled clip-on exposure meter. The milled button at 1 o'clock to the lens mount is the lens release.

*Shot with Minolta SRT101 fitted with 55mm f/1.7 MC Rokkor on Ilford Pan F, developed in Aculux and printed on Jessop Variable Contrast.*

The back view of the first-type Minolta SR-1. The circular viewfinder ocular is a sure means of identifying the first type from the second, which has a rectangular viewfinder like an SRT101.

*Shot with Minolta SRT101 fitted with 55mm f/1.7 MC Rokkor on Ilford Pan F, developed in Aculux and printed on Jessop Variable Contrast.*

is remarkably effective, although modern electronics have found better ways of achieving similar results. The SRT101 was a TTL development of the SR1-s, and had match-needle exposure setting in the viewfinder, a display of the set shutter speed at the foot of the screen, microprism focusing, mirror lift, delay action and both FP (focal-plane bulb) and X (electronic) flash synchronization.

The Minolta SRT101 won considerable and well-deserved success. The range of lenses was enlarged almost to parallel the ranges offered by Canon and Nikon at the time and, although the engineering 'feel' of Minolta lenses is not as fine as that of Canon lenses, their performance, at the shorter focal lengths in particular, is very similar and in some cases better (try the 28mm f/3.5 MC Rokkor). Not until 1971 did commercial pressures for a 'budget version' bring about the SRT100, essentially an SRT101 without

delay action, the 1/1000th shutter speed and the display of shutter speeds in the viewfinder. In 1973, a fuller-featured model, the SRT303, was marketed in Europe and some other areas of the world, though not in the USA. This was like an SRT101, but had a noticeable additional protruding housing on the front of the pentaprism which enclosed an optical system for displaying the set aperture at the top of the viewfinder. The SRT303 also had a split-image rangefinder screen, hot-shoe synchronization (in addition to standard X and FP sockets) and provision for multiple exposures.

A series of further SRT models followed, most of which were specific to particular geographical markets – the SRT202 was sold only in the USA, the SRT Super and the SRT505 only in Japan. In 1975, Minolta extended the life of the by then ageing SRT design by offering both the SRT100B and SRT303B

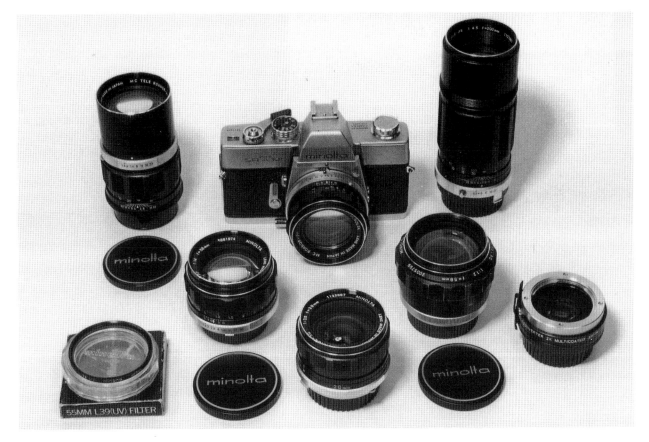

One of my Minolta SRT101 cameras, fitted with the 55mm f/1.7 MC Rokkor with which many of the pictures of cameras in this book were taken. *Back row:* (l. to r.) 135mm f/2.8 MC Tele Rokkor, the camera, 200mm f/4.5 MC Tele Rokkor. *Centre row:* 58mm f/1.4 MC Rokkor, 58mm f/1.2 MC Rokkor. *Front row:* A typical Minolta uv filter and its box, an early 28mm f/3.5 MC Rokkor and a 2x teleconverter in Minolta fitting.

*Shot with Pentax S1a fitted with 55mm f/1.8 Super-Takumar on Ilford Pan F Plus, developed in Aculux and printed on Jessop Variable Contrast.*

The exposure-meter switch on the Minolta SRT series is this milled button on the base of the camera. Forgetting to switch it off causes rapid battery drain unless there is a lens cap fitted, and even then is not advisable. The battery compartment is also in the base, behind the coin screw visible here. The large chrome plunger at the base of the lens mount is the depth-of-field preview facility – depressing it and releasing it leaves the lens stopped down to the preset aperture. Pressing it again restores automatic-diaphragm operation.

*Shot with Pentax S1a fitted with 55mm f/1.8 Super-Takumar on Ilford Pan F, developed in Aculux and printed on Jessop Variable Contrast.*

Many Vivitar and Soligor T4 interchangeable-mount automatic-diaphragm lenses in a wide variety of focal lengths were sold for the major brands of SLR. This huge 70mm–260mm f/4.5 Vivitar T4 lens is fitted with a Minolta mount, with a Canon FL mount standing behind it. The sheer size of the lens by comparison with current lenses of similar specification is an index of the extent to which optical design has advanced in twenty years.

*Lens by courtesy of Bill O'Keefe. Shot with Minolta SRT101 fitted with 55mm f/1.7 MC Rokkor on Ilford Pan F, developed in Aculux and printed on Jessop Variable Contrast.*

models at reduced prices. These B models were still being offered extensively in the early eighties, and many were then sold with a compact, part plastic-mounted 45mm f/2 MD Rokkor which, although it looks unpromising, is an extremely good lens.

### The Minolta partnership with Leitz

A camera dealer of my acquaintance offered me quite recently a Minolta XE-1 with the laconic comment that it was good value because 'it's a Leica R3 in a skin'. In a way he was right – a Minolta XE-1 is a lot of camera for the money one pays for it – but in fact it was the Leica R3 which was, in part at least, an XE-1 by another name.

In 1975, Minolta revealed the fruits of a partnership agreement with Leitz of Germany by which the shutter and mirror assembly of their XE-1 was used by Leitz to develop and produce quickly a Leica reflex with automatic exposure – the Leica R3. At the same time, Minolta-designed zoom lenses were offered for the Leica reflex range.

The quid pro quo was that Minolta also gained the production of the rangefinder Leica CL and its lenses – sold in Japan as the Minolta CL. The partnership undoubtedly benefited Minolta more than it did Leitz. Minolta gained enormously in worldwide reputation simply by having been thought good enough to manufacture equipment for Leitz.

The XE-1 (XE-5 in the USA) was the first Minolta SLR to offer a choice of fully automatic or manual exposure setting. It used the same series of MC Rokkor lenses as the SRT cameras, and is completely cross-compatible with SRT equipment. It is big, heavy and nice to use.

Sadly, the partnership with Leitz ended after only a few years when the Leica R4 was developed and the Leica CL became a part of history. Smaller and more automated cameras were now being demanded and Minolta moved into the plastics and electronics era with the XD-7 (in Europe), XD-11 (in the USA) and XD (in Japan), all of which are the identical camera under different nomenclatures for marketing and trade-mark reasons. The XD-etc. was the world's first multi-mode-exposure 35mm SLR, and ushered in the Minolta MD range of lenses, with the necessary extra coupling for multi-mode function. MD lenses are, however, entirely compatible with all earlier Minolta SLRs.

One of my Minoltas stands up manfully to the weight of the Vivitar T4 zoom shown in the picture opposite. There is so little demand for T4 lenses, even those of more reasonable proportions, that they can be bought very cheaply at camera fairs – I saw three, two zooms and a 135mm f/2.8 – offered for £25 (about $38) the lot at a fair recently. They were not bought. Collector/investors would see that as a reason for not buying them. Users short of cash would see such a bargain as an opportunity to acquire substantial picture-shooting ability for a very small sum. In truth, the zooms of this period are disappointing by comparison with those of the early and mid-eighties, but at the middle apertures they do deliver pictures of good quality.

*Shot with Minolta SRT101 fitted with 55mm f/1.7 MC Rokkor on Ilford Pan F, developed in Aculux and printed on Jessop Variable Contrast.*

### Is Minolta a goodie for classic photography?

At the time of writing this book, I use a Minolta SRT101 outfit for most of my professional 35mm photography. This surprises, even horrifies, some of my Nikon- and Canon-using professional acquaintances, who see Minolta as an amateur range of equipment. My main reason for this choice is that I find SRT cameras easy to focus and use with my spectacles on. But there are other points worth considering.

I have built an outfit consisting of two SRT101 cameras, f/1.7, f/1.4 and 45mm f/2 standard lenses, 28mm f/3.5 MC, 135mm f/2.8 MC, 200mm f/4.5 MC and a 24mm f/2 Vivitar lens in fixed Minolta mount (a surprisingly good lens that gets me out of all sorts of difficult situations) for a total of roughly £170 ($260). I have done this by building the outfit gradually and buying selectively at collectors' fairs, and could do much the same again if required. At those prices one worries little about the danger of theft and more about getting the picture.

I used to say, some ten or fifteen years ago, that the only type of frequently encountered camera that I had never had to send for repair was a Minolta SRT. That is no longer the case, and time has shown that the weakest part of any SRT is its exposure meter, which is inclined sometimes to give electrical trouble. However, I still maintain that Minolta mechanical SLRs give less trouble than any others except Canon, Nikon and Leicaflex and are optically almost on a par with Canon and Nikon. Since a two-camera, five-lens outfit in Canon, Nikon or Leicaflex would cost a good deal more than £170, Minolta is good value.

### Miranda

As readers may have gathered from comments in an earlier chapter, I have considerable respect for Miranda cameras and lenses. Although not perhaps intended for the rough and tumble of professional photography, they look good, feel good and perform well if in generally sound condition.

The Miranda Camera Company of Tokyo began its existence as the Orion Seiki Company during 1946, and by 1950 had developed its first prototype SLR, initially called the Phoenix, then renamed Miranda

after a trade-mark problem. Although manufactured only as a prototype, this original camera was probably the first Japanese eye-level pentaprism SLR. None still exists.

The first production Miranda was the Miranda T of 1954, the earliest of which have 'Orion Camera Company' engraved on the front, 'Miranda T' engraved on the back and the name 'Miranda' engraved on the front of the pentaprism housing. Even at this stage, the prism was removable and the lens mount was the unique Miranda 44mm screw. The camera had a non-return mirror, no provision for automatic diaphragm and a cloth focal-plane shutter with speeds of 1 second to 1/500th in two ranges. Early versions had preset 50mm f/1.9 Zunow or 50mm f/1.9 Ofunar lenses, later examples an early preset version of the 50mm f/1.9 Miranda Soligor featured on later models. The first type of Miranda T, engraved as above, is rare, highly collectible and expensive, and prices approaching £1,000 ($1,500) have been paid in Japan.

In 1956, with the change of name of the company, the Miranda T was produced with 'Miranda Camera Company' engraved above the lens and below the 'Miranda' on the front of the prism. These fetch a little less, but still too much for most people. A further version, the Miranda TII, was produced during 1956 with a fastest shutter speed of 1/1000th second and a folding rewind crank. This one is probably the rarest of all Mirandas (about 600 made) and sells for between £400 and £600 ($600–$900).

The earliest Miranda model that most enthusiasts will see is the Miranda A of 1957, which was the first Miranda with lever-wind and a split-image rangefinder in the focusing screen, and the first to be supplied with a lens (usually a 50mm f/1.9 Miranda Soligor) in the 4-tongue Miranda bayonet mount. Despite this, the Miranda A and all later (genuine) Mirandas retained the 44mm lens-mounting thread, and are thus the only brand of SLR to be equipped with both bayonet and screw lens mounts on the same camera. The Miranda A was supplied either with a preset 50mm f/1.9 Miranda Soligor, or a similar lens with external automatic-diaphragm coupling in the manner of the Exakta. The original lens can be identified by its polished-metal lens barrel and by its having a 'Y' before the serial number.

In the same year came the Miranda B, which was essentially the A but with an instant-return mirror.

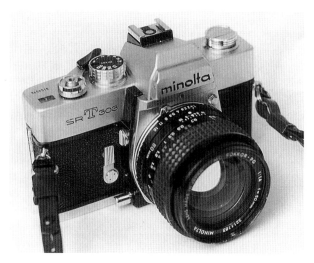

The Minolta SRT303 is probably the most desirable of the SRT series cameras because of its excellent display of the aperture in use in the viewfinder and the presence of a useful hot shoe which the SRT101 lacks. This example has the late recomputed 50mm (as distinct from 58mm) f/1.4 MC Rokkor with rubberized focusing grip. The Minolta strap on this example is probably totally thief-proof, since I struggled for ages to get it off for this photograph and eventually gave up.

*Camera by courtesy of Jim Anderson. Shot with Minolta SRT101 fitted with 55mm f/1.7 MC Rokkor on Ilford FP4 Plus, developed in Aculux and printed on Jessop Variable Contrast.*

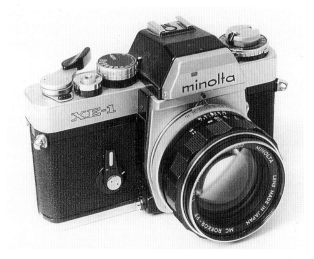

The Minolta XE-1 shares its shutter and mirror assembly with the Leica R3 and, given the choice, I prefer the Minolta. This one is fitted with a 58mm f/1.4 MC Rokkor of earlier vintage than the camera – it would normally be found with a rubberized-grip lens like that on the SRT303 on the left.

*Camera by courtesy of Len Corner. Shot with Minolta SRT101 fitted with 55mm f/1.7 MC Rokkor on Ilford FP4 Plus, developed in Aculux and printed on Jessop Variable Contrast.*

The business end of the Minolta XE-1 is compact, clearly marked and easy to understand. The shutter has electronically timed speeds from 4 seconds to 1/1000th second in manual mode, plus an aperture-priority automatic mode. The ASA/ISO film-speed scale extends to 3200, making its automatic function entirely usable with the full range of modern fast films.

*Camera by courtesy of Len Corner. Shot with Minolta SRT101 fitted with 55mm f/1.7 MC Rokkor on Ilford FP4 Plus, developed in Aculux and printed on Jessop Variable Contrast.*

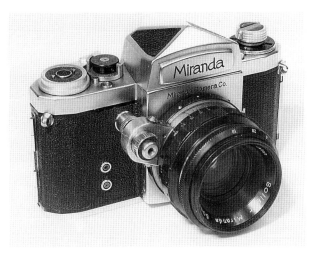

The Miranda C is uncommon in Britain and Europe because it was exported only to the USA. This example, fitted with a 50mm f/1.9 Miranda Soligor with externally coupled automatic diaphragm, is typical in user terms of the early series of Mirandas, most of which still perform well.

*Camera by courtesy of Laura Thomas. Shot with Minolta SRT101 fitted with 55mm f/1.7 MC Rokkor on Pan F Plus, developed in Aculux and printed on Jessop Variable Contrast.*

This camera was not imported into Europe or the USA, and, because Miranda was overrun with orders, many Miranda B bodies were assembled by Riken in the Ricoh factory. Two years later, in 1959, came the Miranda C, which was like the B but with a delay-action mechanism below the rewind knob. Correctly fitted with a 50mm f/1.9 Miranda Soligor in a black barrel and with a 'K' serial-number prefix, the Miranda C was sold extensively in the USA but not in Europe, other than through US services PX stores.

The Miranda D, manufactured between 1960 and 1962, is found in two distinct types, for Miranda changed the shape of the Miranda camera body from its previous angular form to a more rounded shape during the run of this camera. It can be identified by its having its exposure counter on a small dial on the top-plate in front of the wind lever (some examples also have 'Miranda D' engraved on the back). The Miranda DR of 1962 was similar, but introduced a microprism focusing screen as standard. At some point during production of the DR, the style of engraving the camera name on the front of the prism was changed to 'MIRANDA' (all in capitals).

The Miranda F of 1963 was the first to have internal automatic-diaphragm actuation and a single-range shutter-speed dial, plus the option of a prism with built-in non-TTL CdS exposure meter. The shutter-speed dial was removable, and could be replaced with an alternative, snap-on CdS exposure meter which coupled to the shutter – the camera thus became a Miranda Fv, and from 1966 onwards was often sold as such with the meter installed and without the standard shutter-speed dial. The F was the first Miranda generally available in black finish as an alternative to chrome.

In 1966, the Miranda G added user-interchangeable screens to the Miranda specification, with eight alternative screens available. Identifiable by its having a large 'G' engraved on the front, the Miranda G is often found with the Fv clip-on exposure meter or the prism with non-TTL exposure meter usually supplied for the F. It also turns up with a plain prism or with a later TTL prism, which makes the camera into the comparatively scarce Miranda GT, selling for around twice the price of an example without meter.

Meanwhile, as the A to G series of cameras had developed, Miranda had produced a series of cameras with coupled built-in exposure meters. The first, the Miranda Automex, appeared in 1959 with a selenium-cell exposure meter whose ASA settings extended only

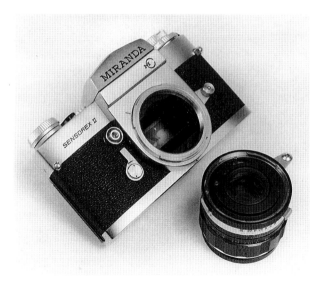

The Miranda Sensorex II is an extremely usable camera. This one has the lens removed to show the unique characteristic of Miranda cameras – a 44mm screw lens mount (visible in the throat of the camera) and an outer bayonet, by which the standard and most other routinely used lenses are fitted.

*Shot with Minolta SRT101 fitted with 45mm f/2 MD Rokkor on Ilford Pan F Plus, developed in Aculux and printed on Jessop Variable Contrast.*

The top-plate layout of the Miranda Sensorex II is simple in the extreme, since the shutter release is on the front of the camera (see picture above). Sliding the catch immediately to the left of the prism in this picture unlatches the viewfinder, which then slides back as shown to be replaced by the waist-level viewfinder.

*Shot with Minolta SRT101 fitted with 45mm f/2 MD Rokkor on Ilford Pan F Plus, developed in Aculux and printed on Jessop Variable Contrast.*

to 400 ASA. The camera had a large array of selenium cells occupying the whole front area of the prism, and the camera name was relegated to the front plate above the shutter release. An improved Automex, still with selenium meter, was introduced during 1963 as the Automex II, and had ASA settings to 1600 ASA. By 1965, the need for a CdS meter to meet market demands brought about the Automex III, which is engraved 'Automex CdS' on the front of the body.

In 1969, the Automex series was replaced by the Sensomat series, with conventional match-needle stopped-down CdS TTL metering within the viewfinder, and these were followed by the quite delightful open-aperture TTL metering Sensorex and Sensorex II, my personal favourites among the Miranda models. Space does not permit a fuller detailing of these later models, on which whole books could be written.

However, if you check out a Miranda carefully, paying particular attention to correct operation of all the shutter speeds, it will prove a rewarding classic camera to use. The only significant drawback is that of finding a full range of Miranda bayonet lenses – they are available and should not cost too much once found, but to track them down you will have to attend collectors' events regularly or find a collector prepared to sell an outfit en masse.

## Olympus

Founded in 1919 to manufacture microscopes and optical instruments, Olympus made its first camera in 1936, its first SLR in 1963. This was the revolutionary Pen-F, the world's first purpose-designed half-frame SLR, the world's first SLR with a rotary shutter and the world's first eye-level SLR with a porroprism rather than a pentaprism. For a first try, the Pen-F was a dazzling success.

Tiny by comparison with contemporary full-frame SLRs, it produced startlingly bright, sharp and contrasty negatives or transparencies just 18mm × 24mm, reaping the benefit of the great improvement in film quality and technology that had characterized the late fifties and early sixties. Although the negative was so very small, it was and is possible, with good darkroom technique, to obtain faultless 15" × 12" enlargements. It was a Pen-F that finally persuaded my father to abandon his Leica for routine photography. It was, he said, the new incarnation of the Leica ideal – small camera, big picture.

Imported into Britain by the Pullen Optical Company and launched by them in September 1964, the Pen-F was normally sold with a 38mm f/1.8 lens – the f/2.8, f/1.4 and f/1.2 lenses came later. At that time, the Pen-F could be fitted with a compact 25mm f/4 wide-angle, a neat 100mm f/3.5 long-focus or the renowned 50–90mm f/3.5 zoom. A separate clip-on CdS exposure meter fitted over the shutter-speed dial on the front face of the camera and enabled the user to read off the appropriate aperture for the shutter speed that was set. The film transport was a beautifully smooth double-stroke action with a short lever which protruded from the back of the top-plate.

The range of lenses grew rapidly, and eventually a total of eighteen different Olympus bayonet-mount lenses was available for the Pen-F system, from 20mm f/3.5 through to 800mm f/8 mirror. In 1968, the Pen-F was discontinued, and the new Pen-FT with TTL CdS metering was introduced. Essentially similar in construction, the Pen-FT was afflicted (in my view) with a redesigned single-stroke film transport, with a longer lever and a higher-geared gritty action. The exposure meter could also be said not always to be an advantage.

Unlike other TTL meters of the period, the meter in the FT was not coupled. A needle on the left-hand side of the viewfinder screen moved up and down over a scale of 'T' numbers, from 1 to 7. The number against which the needle settled had to be manually transferred to the 'T' numbers on the aperture ring, diametrically opposite across the ring from the normal aperture numbers. Although, on the series of lenses produced for the Pen-FT, the aperture ring could be lifted and twisted through 180 degrees to set either the aperture numbers or the 'T' numbers uppermost, depending on the photographer's preference, the system was and remains clumsy.

Having discontinued the Pen-F, Olympus reinvented an inferior wheel by producing the Pen-FV, which was simply a meterless Pen-FT, complete with gritty single-stroke film transport. Like its predecessor, this had the necessary lugs for the fitting of the separate exposure meter. Its sole advantage over the Pen-F (in my view) was the larger mirror, which it shared with the Pen-FT and which improved the screen presentation with the long-focus lenses.

An impressive range of accessories was marketed for the Pen-F/FT series of cameras, including two alternative bellows units, two kinds of slide copier, two camera sliders and a copying stand. A whole range of filters, extension tubes and close-up lenses fitted the lens mount, straight and angled viewfinder magnifiers and eyesight-correction lenses fitted the viewfinder – in short, everything that camera enthusiasts love.

You will have gathered that I like the original Pen-F and am less than enthusiastic about its younger brothers. As a second compact camera, a Pen-F with the 25mm and 100mm lenses takes a lot of beating. However, do check carefully that everything works properly before you buy, and don't use it too heavily. All Pen-F equipment is getting a little old for its design specification and cannot be classed as wholly reliable for general photography. Spares are difficult to come by and repairs are not cheap.

By the early seventies, public enthusiasm for half-frame cameras waned as more and more photographers abandoned black-and-white and doing their own processing for colour. Processors charged extra for producing prints from half-frame colour negatives and frequently would not mount half-frame transparencies. To the majority of amateur photographers these were reasons for returning to full-frame 35mm, if they had ever left it. The Pen-FT finally went out of production during 1972. The Pen-F series remains the only purpose-designed family of half-frame SLRs.

### The full-frame Olympus SLRs

Before the final demise of the Pen-FT, Olympus had launched its first full-frame SLR, the Olympus FTL, which appeared during 1971. Olympus seem to have taken their marketing and design inspiration from Asahi, perhaps not realizing that, by 1971, the Pentax Spotmatic was already behind its times and losing the universal appeal it and earlier Pentax SLRs had had during the mid-sixties. The camera was designed with the 42mm × 1mm M42 screw-thread mount, full-aperture through-the-lens metering, a cloth focal-plane shutter with speeds 1 second to 1/1000th and was, as most reviews at the time noted, totally unrevolutionary except for the fact that it was the first camera to offer full-aperture TTL exposure measurement with the 42mm screw lens mount.

The sole unusual feature was the provision of a ball catch at the point where the lens is fully screwed home, making the Olympus FTL one of the few M42 cameras with a lens catch (the others are the Fujica reflexes of the seventies).

The original Olympus Pen-F is easily identified by its large gothic F on the front of the camera. The camera here is fitted with the 38mm f/1.8 Zuiko, the commonest of the standard lenses. In front is a 25mm f/4 Zuiko, while to the left is the 100mm f/3.5 Zuiko lens.

*Shot with Bronica EC fitted with 75mm f/2.8 Nikkor during the early eighties on Ilford HP5, developed in Aculux and printed on Jessop Variable Contrast.*

The Pen-FT with TTL exposure meter is identified by the normal capital F on the front and by 'PEN-FT' on the top-plate. This example is fitted with the surprisingly good (for its extreme aperture) 42mm f/1.2 Zuiko lens.

*Camera by courtesy of Dave and Julie Todd. Shot with Pentax Spotmatic fitted with 55mm f/1.8 Super-Takumar on Ilford Pan F, developed in Aculux and printed on Jessop Variable Contrast.*

However, although the Olympus FTL was not a commercial success, it was a considerable photographic success, and by failing commercially while being such a superb camera to use, perhaps marked the point when the amateur camera market finally became a market influenced by style and street credibility rather than by photographic capability. Itself compact and light by comparison with even a Pentax, the Olympus FTL was marketed with a range of lenses whose extreme neatness, small size and light weight echoed the Pen-F series. The 135mm f/3.5 in particular is a first-rate lens in a smaller package than virtually any other auto-diaphragm SLR 135mm lens.

By the very nature of its market failure, the Olympus FTL is scarce and its lenses are even scarcer. Thus far it is an unrecognized gem. I suspect that in a year or two those which are available will have disappeared into collectors' cabinets – which is a pity, since the FTL is a camera to enjoy using.

In 1973, Olympus recovered their position magnificently with the launching of a camera which the amateur market almost immediately took to its heart and which some professionals, particularly in the currently trendy 'action fashion' area of photography, also decided was for them. The Olympus OM-1, initially called the M-1 until Leitz politely reminded Olympus that the Leica M1 had established their ownership of that mark almost twenty years before, was very small, very light, very quiet and quickly became very trendy.

The OM-1 established the wide-throat Olympus bayonet mount, which remained the lens mount for all Olympus SLRs until the autofocus boom of the nineties. It was offered with an almost complete range of high-quality interchangeable lenses from the outset, and provided those in the habit of using very short and very long focal lengths with the great benefit of interchangeable focusing screens. Its match-needle TTL metering was, and usually remains, fast and effective and the screen brightness is particularly good, even with the usual standard 50mm f/1.8 Zuiko lens – as with other systems, 50mm f/1.4 and f/1.2 lenses were also available. However, it is worth noting that the OM-1 was an expensive camera. With 50mm

f/1.8 lens, the price was almost £200 (then about $490) in Britain when a Canon FTb with f/1.8 lens cost less than £136 (about $330).

By 1974, Olympus had realized that they were at last on to a good thing and met the primary gap in their professional market specification by offering the OM-1 MD, identical to the OM-1 but with the capability of accepting a similarly compact motor-drive unit.

In 1975, Olympus had ready the OM-2, which was essentially similar to the OM-1 but provided fully automatic aperture-priority exposure or the normal manual exposure setting. The OM-2 took its light readings from the focal plane, which proved an effective and accurate means of metering. Like the OM-1 MD, the OM-2 could accept the Olympus motor-drive unit. Like the OM-1, it was expensive – in 1976, an OM-2 with 50mm f/1.8 lens was only a few pence short of £300 (then about $540) in Britain. A Nikon F2 Photomic with 50mm f/2 Nikkor was less than £340 ($610).

Four years later, the OM-1 and OM-2 were up-graded by the addition of an LED flash indicator in the viewfinder and one or two other minor changes. These models became known as the OM-1n and the OM-2n. At the same time, there appeared the OM-10, a fully automatic derivative of the OM-2 without the option of manual exposure setting – although a neat extra plug-in 'manual adaptor' was available to take users back to the dark ages when required.

### Should you scale the heights of Olympus?

So devoted are followers of the OM-1 series of cameras that it is almost politically incorrect to say anything against Olympus in public. However, most professional photographers of my acquaintance who have tried Olympus returned to their Nikon or Canon equipment after a while. Their reasons were primarily concerned with picture quality and reliability. Most Olympus lenses deliver startlingly high contrast, and this tends to mask any marginal lack of resolution that may be present. Really demanding professional workers have found that the performance of some of the wide-angle and medium-long-focus lenses in practical use is not as good as that of the equivalent Nikon or Canon lenses.

This problem may sometimes arise as much from the lightness and smallness of the cameras as from any lack of lens performance – I find it very difficult

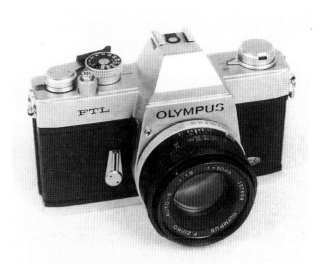

The Olympus FTL is compact, simple to use and delivers top-quality pictures with a high standard of reliability. The bad news is that there are not too many around. The good news is that nobody is looking for them, so the prices have stayed reasonable. Buy one while you can. They are almost always found with the 50mm f/1.8 Zuiko Auto-S as shown here. Apart from the small piece of black infill missing from the nameplate, this camera was almost as new.

*Shot with Minolta SRT101 fitted with 45mm f/2 MD Rokkor on Ilford Pan F Plus, developed in Aculux and printed on Jessop Variable Contrast.*

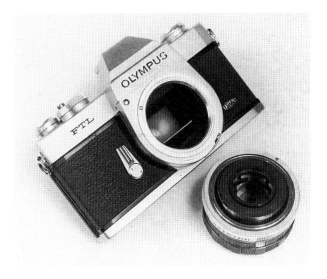

The Olympus FTL is one of the few M42 cameras with a lens lock. The small inner pin at 10 o'clock to the lens mount engages with the small indentation in the black flange at the back of the lens when it is screwed home. The lock is released by pressing the larger outer button at 10 o'clock.

*Shot with Minolta SRT101 fitted with 45mm f/2 MD Rokkor on Ilford Pan F Plus, developed in Aculux and printed on Jessop Variable Contrast.*

to hand-hold an OM-1 comfortably, and much prefer a substantial heavy camera.

Professionals have also found that the tripod bush on the OM series does not stand up to too heavy a hand, and that, quite simply, you cannot drop an OM-1 and expect it to survive as you can (with luck) a Nikon or Canon.

However, the OM series produces fine results in careful and (preferably) small hands. Their second-hand prices are low by comparison with Nikon and comparable with Canon. I would not choose one.

### Petri

The Kuribayashi Camera Works, from which all Petri SLRs came, was established in Tokyo as long ago as 1907 to make photographic accessories, and marketed its first camera during 1919. This was not a Petri – that name did not appear until after the Second World War – but was a single-lens reflex, making Petri probably the only Japanese camera company to have manufactured SLRs from the outset. The Kuribayashi Speed Reflex, similar to Britain's Houghton-Butcher large-format reflex cameras, was, like the many pre-war Kuribayashi folding rollfilm cameras, made in small numbers and marketed only in Japan. It is therefore rare and much sought after, particularly by Japanese collectors.

After the Second World War, Kuribayashi marketed its cameras under the Petri name and, like other Japanese camera manufacturers, sold its products mainly to US Army personnel and to export markets. A large number of folding rollfilm, TLR and 35mm fixed-lens Petri camera models was followed in 1959 by the Petri Penta, Kuribayashi's first 35mm SLR. This had a cloth focal-plane shutter with speeds of 1/2 second to 1/1000th second and a preset screw-mount 50mm f/2 Petri Orikkor.

By 1961, a much-improved version of the camera, known in Japan as the Petri Penta V2 and elsewhere as the Petri Flex V, had been launched. This now had the neat breech-lock bayonet lens mount, not unlike that of the Canon reflexes, which became a feature of most subsequent Petri SLRs. By 1963, Kuribayashi had changed its name to the Petri Camera Company and had launched the Petri Flex V3, equipped with 55mm f/2 or 55mm f/1.4 lenses with fully automatic diaphragm. The Petri Flex V3 had an external lug for a clip-on Petri CdS exposure meter, although the meter

The Olympus OM-1 was the first successful full-frame Olympus SLR, and was such a huge success that its descendants, in a virtually identical body, are still on sale well over twenty years later. This camera has the usual 50mm f/1.8 Zuiko. A vast range of high-quality lenses is available to fit it.

*Camera and picture by courtesy of Mike Rees. Shot with Contarex Cyclops fitted with 50mm f/2 Planar on Ilford Pan F, developed in Aculux and printed on Jessop Variable Contrast.*

is now very difficult to find. Subsequent non-TTL models included the Petri Flex V6 of 1965 and the V6-II of 1970.

In 1964, Petri went out on a limb with a camera quite unlike the Penta series which seems to have been a determined, if unsuccessful, attempt to crash into the professional market dominated by Nikon. The Petri Flex 7 looks curiously like a Contarex 'Cyclops', with an external circular CdS exposure-meter cell directly above the axis of the lens, and is more ruggedly built than other Petri cameras of the time. Its cloth shutter is speeded 1 second to 1/1000th, and its (usually) f/1.4 lens has the Petri breech-lock lens mount. It was not very successful, is scarce and is much sought after by Japanese collectors.

Petri introduced TTL exposure measurement with the Petri FT of 1967 and the FT-II (with hot shoe) of 1970, both of which had stop-down metering and retained the Petri breech-lock lens mount. In 1969, Petri were for once rather ahead of the market with the Petri FT-EE, the company's first shutter-priority fully automatic SLR, based on the Petri Flex V, which was followed in 1973 by the virtually identical Petri FTE. Both had the Petri breech-lock lens mount, as had the more advanced Petri FA-1 of 1975, arguably the best of the Petri SLRs.

The Petri Flex V series – this is a V6 dating from 1965 – and the earlier Petri Penta all had the distinctive forward-inclined front to the pentaprism housing. Most were fitted, like this one, with the 55mm f/1.8 Petri lens.

*Shot with Praktina IIA (by courtesy of Mike Rees) fitted with 135mm f/3.5 Tele-Ennalyt on Ilford Pan F Plus, developed in Aculux and printed on Jessop Variable Contrast.*

However, things were not going particularly well for Petri, and the company had evidently decided that its unique lens mount was disadvantageous to its sales in a market increasingly dependent upon compatibility with independent lenses. Therefore, in 1974, a series of Petri SLRs with 42mm Pentax/Praktica screw lens mount was initiated with the launch of the Petri FTX. This stop-down metering match-needle SLR, closely followed by the similar FT 1000 and FT 500 (1/500th second minimum shutter speed) of 1976, was less than successful, and the two latter models were own-branded to various large retail organizations in Europe and the USA in an attempt to boost flagging sales. Compact models, the Petri MFT 1000 of 1976 and the Petri MF-1 of 1977, failed to improve matters, and Petri became bankrupt and went out of business in 1977.

## Is Petri a sound choice?

Problems with Petri automatic diaphragms are quite common. There seem to have been design faults in the mechanism which reopens the diaphragm after an exposure, and, if intending to use Petri cameras at all intensively, it pays to have more than one of any lens that is important to you. The cameras are not quiet,

and the lenses, while of a good general standard, are by no means exceptional. If you can acquire (as one often can) a fairly complete Petri outfit with a camera or two and several lenses for a moderate price, then it is an enjoyable experience to shoot some pictures with it. However, the later 42mm screw-mount Petri reflexes are not readily sold unless the price is very low, and lenses for the earlier breech-lock cameras are not particularly easy to locate, although they do turn up at camera fairs.

In short, I would not go out of my way to buy and use Petri equipment, but I can well understand the collector interest in Petri because of the unusual design of the earlier cameras.

## Ricoh

Riken Optical began making cameras before the Second World War and first used the Ricoh name during the mid-fifties. The first Ricoh SLR to appear on the market was the (original) Ricoh Singlex, a massive, beautifully engineered non-TTL SLR with a Nikon bayonet lens mount, which appeared during 1964. I used one of these professionally for a while during the late sixties after buying it as a second body to my Nikkormat FT and subsequently discovering that I liked it better than the Nikkormat.

Just who made the Ricoh Singlex camera and lens is a matter for debate. I have never quite got to the bottom of its origins, but the following is clear.

As mentioned in the chapter on Nikon, the Ricoh Singlex is virtually identical to the Nikkorex F. There are cosmetic differences, but nobody handling and examining both a Nikkorex F and an original Ricoh Singlex will be in much doubt that they are one and the same camera. The 55mm f/1.4 Auto Rikenon lens with which the Ricoh Singlex was sold (no options were available) looks like, feels like, performs like and has similar internal reflections to a 58mm f/1.4 Nikkor of the period – the difference in marked focal length is probably irrelevant.

The Nikkorex F was marketed by Nippon Kogaku (Nikon) at a time when the company needed a modestly priced camera for the amateur market (i.e., before the advent of the Nikkormat) and when their factory was heavily committed to the production of the Nikon F and the Nikon rangefinder cameras. I believe that Riken Optical and Nippon Kogaku co-operated in arranging for the production of the Nikkorex/Ricoh

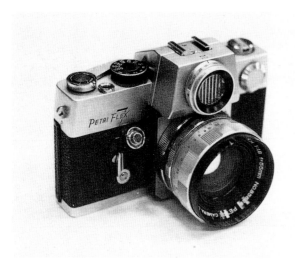

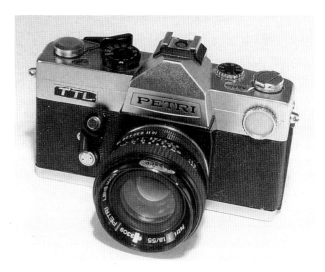

The Petri Flex 7, which looks more like a Contarex Cyclops than a Petri SLR, actually predated the Petri Flex V6 by two years. Dating from 1964, the Petri Flex 7 had a built-in non-TTL CdS exposure meter with its cell above the axis of the lens and the same breech-lock lens mount as the later V series cameras (the early Petri Penta had a screw lens mount). The Petri Flex 7 is classified in some collectors' guides as rare, but turns up with surprising frequency for a rare camera at camera fairs. I would classify it as scarce. This example has a 55mm f/1.8 Petri lens.

*Camera by courtesy of Paul Farrell. Shot by available light at a camera fair (hence the limited depth of field) with Zenit-B fitted with 58mm f/2 Helios lens on Ilford FP4 Plus, developed in Aculux and printed on Jessop Variable Contrast.*

During the seventies, Kuribayashi switched from breech-lock lens mount to M42 screw, just as it was going out of fashion, and produced a bewildering variety of Petri models. This one, the Petri TTL, feels cheap by comparison with the Petri Flex cameras of the sixties, but actually performs quite well. The lens is the screw version of the 55mm f/1.8 Petri.

*Shot with Minolta SRT101 fitted with 45mm f/2 MD Rokkor on Ilford Pan F Plus, developed in Aculux and printed on Jessop Variable Contrast.*

Singlex, either at the Ricoh factory or (as is often said) at Yashica, and that second-grade 58mm f/1.4 Nikkors (those that failed the very stringent quality control on Nikkor lenses) were made available to Riken as 55mm f/1.4 Rikenon lenses. The Nikkorex F is usually found, and was usually sold, with a 50mm f/2 Nikkor similar to that fitted to the Nikon F at the time.

Consequently, this original Ricoh Singlex is a very satisfactory hunk of machinery with a very fine lens. Because it is less than common, collector interest has pushed the price up a little, but it remains true that an original Ricoh Singlex is a superb camera for use at a very modest price – I have seen them available at UK fairs during 1995 for less than £100 ($150). If you can find one with the optional clip-on coupled CdS exposure meter, that is even better.

The next Ricoh Singlex was a very different piece of equipment. Smaller, lighter and with a 42mm screw lens mount, the Ricoh Singlex TLS was relatively unglamorous and decidedly ordinary. The camera was in fact a Chinon design, licensed to Riken, and simi-

lar cameras made by Chinon were own-branded for Dixons in Britain and marketed as the Prinzflex TTL. Similar own-branding deals were struck in other countries, and the camera is therefore one which can be found with several different names.

The Ricoh Singlex TLS featured a CdS TTL averaging exposure meter, a vertically running metal Copal Square shutter like that in the Nikkormat and either a 50mm f/2 or 50mm f/1.4 lens. It sold well through the larger retailers so is comparatively common and very reasonably priced – a Ricoh Singlex TLS with f/2 lens can easily be obtained for about £30 ($45) at the time of writing. The improved Ricoh Singlex II of 1976, which has a hot shoe among other minor changes, is less common and may cost a little more. The Ricoh Singlex SLX 500, also of 1976, was a simplified budget-price version with a maximum shutter speed of 1/500th and no delay-action mechanism.

Few collectors would rate the camera as one worth displaying in a cabinet or flourishing at club meetings – and yet, if it is results you want, the Ricoh Singlex can provide them at a very favourable price.

The most innovative and interesting Ricoh SLR of the classic period was probably the Ricoh TLS401

of the early seventies. This camera is, as far as I know, the only SLR yet made with a switchable viewfinder system. A knob on the side of the prism housing directs the viewfinder image either to the usual eyepiece, parallel with the axis of the lens, or to an eyepiece magnifier on top of the prism at 90 degrees to the lens axis. This neat device obviates the need for a separate waist-level finder for most purposes and is perfect for use with the camera on a copying stand. Usually fitted with a 50mm f/1.7 Rikenon, which seems to be quite different to other Rikenon lenses of the period, the TLS401 was available in black or chrome and has a CdS TTL exposure-meter system like that of the Singlex TLS. Unfortunately, it is scarce and attracts collector interest because of its unique viewfinder system. As a result, it usually costs a good deal more than the ordinary Singlex models.

Following the Singlex series of cameras, Riken again changed lens mounts. Having begun with the Nikon mount and moved on to the 42mm Pentax/Praktica screw, Ricoh cameras of the late seventies and later were equipped with the Pentax K bayonet lens mount of the Pentax K and M series cameras. However, the very successful Ricoh KR-1 and others of its family are really outside the scope of this book.

### Topcon

When I began the task of preparing and writing this book, Topcon was the only major brand of post-war SLR that I had never used. I had handled them when dealing in cameras during the seventies, but had never actually toted a Topcon with film in it. Early in the writing of the book, I bought a Topcon RE-2 and discovered how much I liked it. However, one Topcon does not create experience. The Photographic Collectors Club of Great Britain came to my aid in the person of Don Baldwin, Committee Chairman of the club's famous annual Photographica camera fair in London, and Topcon collector and expert. Don kindly lent me an extensive Topcon outfit from his own collection, and I sallied forth.

My own view is that the pictures taken with Don's RE Super, my RE-2 and his 25mm, 100mm and 250mm RE-Topcor lenses are among the best in the book. Several of the shots included here came from my first film with the RE Super. This is a tribute to the ease of handling and quality of the equipment – usually just about everything goes wrong when you are using an unfamiliar camera. Everyone should at least try one Topcon.

The Topcon SLRs manufactured by the Tokyo Optical Company began in 1957 with the Topcon R, first of a series of cameras whose lenses had the then extremely popular Exakta bayonet mount. The Topcon R was equipped with external automatic-diaphragm coupling rather like that of an Exakta. However, on the Topcon, the shutter button, and therefore the diaphragm-actuating button coupling to it, were at 10 o'clock to the lens mount, looking from

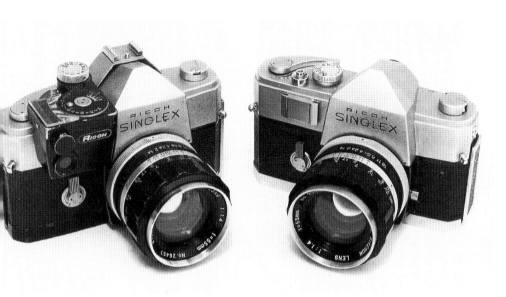

The original Ricoh Singlex is a big heavy camera with a big heavy 55mm f/1.4 lens, reputedly made by Nippon Kogaku. The example on the left, although rather scruffy, works perfectly. It has the scarce coupled clip-on CdS exposure meter and the separate optional accessory shoe. The camera on the right, in almost perfect condition, shows how the camera looks without the add-on accessories.

*Shot with Yashica FX-1 fitted with 55mm f/2 Yashica DSB on Ilford FP4 Plus, developed in Aculux and printed on Jessop Variable Contrast.*

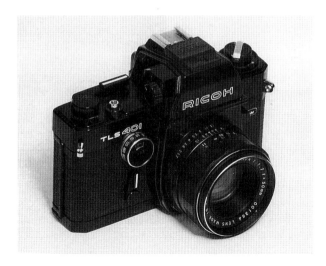

The Ricoh TLS401 has a conventional pentaprism viewfinder. If, however, the plastic cover on top of the prism is slid back, as shown here, and the knob on the left (as seen in this picture) is turned, the image is redirected to a finder at 90 degrees to the lens axis. The lens, a 50mm f/1.7 Rikenon, performs very well.

*Camera by courtesy of Len Corner. Shot with Praktina IIA (by courtesy of Mike Rees) fitted with 135mm f/3.5 Tele-Ennalyt on Ilford Pan F Plus, developed in Aculux and printed on Jessop Variable Contrast.*

the front, rather than at 2 o'clock as on the Exaktas – it was conventionally designed for right-hand shutter actuation rather than left-hand as on the Exakta. The specification was unremarkable – a cloth focal-plane shutter with speeds from 1 second to 1/1000th, interchangeable pentaprism, single-stroke lever-wind and a 58mm f/1.8 standard lens.

By 1960, the externally coupled diaphragm was clearly outdated, and the Topcon RII (B in the USA) and RIII (C in the USA) appeared with internal automatic-diaphragm coupling, totally incompatible with auto-diaphragm Exakta lenses, although the bayonet mount remained identical to that of the Exakta. The RIII differed from the RII in that a clip-on coupled exposure meter could be fitted. Thus far Topcon had not produced an SLR that was in any way remarkable.

That came in 1963, when the camera marketed in Europe as the Topcon RE Super and in the USA as the Topcon Super D made its appearance. This totally redesigned and beautifully engineered camera was the first in the world to offer full-aperture through-the-lens match-needle exposure metering. The design of the exposure-measurement system was quite unlike most that followed in that the meter cell was actually

built into the mirror. The benefit of this was that TTL exposure measurement was maintained whatever viewfinder was in use, unlike (for example) a Nikon F, whose TTL exposure meter was part of its Photomic viewfinder.

An extremely good series of Exakta mount, internally coupled automatic-diaphragm lenses in satin-chrome finish reminiscent of those of early Zeiss Contarex lenses, was launched with the RE Super/Super D and the camera seemed set for stardom. However, its price and timing were against it. The appearance of the Pentax Spotmatic and the Nikkormat FT a year later, offering similar performance for substantially less money, prevented it ever achieving market leadership, despite successive improvements and updates in 1970, 1971 and 1972.

In a bid to provide Topcon quality at a substantially lower price, Tokyo Optical launched in 1965 the Topcon RE-2 (D-1 in the USA). This very agreeable camera had a vertical-running metal-blade Copal Square shutter like that of the contemporary Nikkormat series and retained the Exakta mount and Topcon internal diaphragm coupling. The shutter speeds were set on a dial on the front of the camera, in the position of the slow-speeds dial on a screw-mount Leica. The RE-2 is fast and easy to focus, chunky and comfortable to hold and has a feel of solid quality. The downside is that, like most cameras with Copal Square shutters, it is comparatively noisy. Definitely not suitable for funeral photography.

The last of the main series of Topcon SLRs with the Exakta bayonet mount was the Super DM of 1973, an improved version of the RE Super/Super D with auto-winder included as standard equipment and a GN lens with a flash-guide-number facility like that of the 45mm GN Nikkor. This extremely expensive camera was less than commercially successful simply because of its price, and is comparatively scarce. It is, however, desirable if you can find one.

The Exakta bayonet was not quite done with at Tokyo Optical, however. In 1977, the Topcon RE-200 (also marketed as the Exakta EDX 2, and as the Carena K SM with Pentax K bayonet lens mount) appeared with a Copal Square shutter and LED full-aperture TTL metering. This camera sported a new compact 55mm f/1.7 RE-Topcor (called 'Exaktar' on the Exakta EDX 2 version). A version with auto-wind capability was launched as the Topcon RE-300 during 1978, and this became the Exakta EDX3 (with

Exaktar version of the lens) and the Topcon RM-300 with Pentax K bayonet lens mount during 1979.

## The Topcon UV bayonet

In 1965, after producing three successive Topcon fixed-lens cameras (the PR, the Wink Mirror and the Wink E Mirror) with front lens attachments for additional focal lengths, Tokyo Optical suddenly launched a completely new interchangeable lens mount concurrent with its Exakta-mount RE lens range. This was the UV mount, which, in fitting the Topcon Wink S Mirror and the Topcon IC-1 of eight years later, has the curious distinction (I believe – please don't all shout at once) of being the only lens range to fit both focal-plane-shuttered SLRs and non-focal-plane-shuttered SLRs.

In 1965, the new lens range was launched with both the Topcon Wink S Mirror, which had a behind-lens leaf shutter, and the Topcon Auto 100 (USA) or UNI (in Europe), which has a shutter mechanism using the mirror as the main shutter component. In 1970, the best-known of this series of cameras, the Topcon Unirex, appeared, featuring selectable spot or averaging metering and a hot shoe, and in 1973 this was followed by the IC-1 with cloth focal-plane shutter speeded 1 second to 1/500th.

Topcon UV bayonet lenses in focal lengths from 28mm to 200mm provide remarkably good performance considering their low original and current prices. The cameras they fit are, however, not inspiring.

The multiple versions and lens mounts of the final flurry of Topcon RM cameras referred to above brought to a confused end a fine and famous brand which marketed some of the most expensive and finest cameras of the period, and some of the least attractive and cheapest. Only the Topcon RE-2 ever managed to combine moderate price with true quality.

## Yashica

Among collectors, Yashica is a name associated more readily with twin-lens reflex cameras than with single-lens reflexes, although a number of Yashica SLRs were manufactured and marketed during the classic period. Yashica entered the SLR market later than most of its rivals, perhaps because of its preoccupation with its very effective range of TLRs, and it was not until 1962 that the Yashica Penta J appeared. The camera was a conventional fixed-pentaprism full-frame 35mm SLR with 50mm f/2 Yashinon M42 screw-mount lens with automatic preset diaphragm, a cloth focal-plane shutter with speeds from 1/2 second to 1/500th second and an accessory clip-on exposure meter which coupled to the shutter-speed dial. By comparison with the other SLRs available at the time, even in its comparatively lowly price bracket, it was a fairly poor effort of which the lens was by far the best feature.

In the following year, the Yashica J-3 appeared, essentially an upgraded version of the Penta J but with a built-in uncoupled CdS exposure meter with a meter window in the top-plate. This camera was sold with the same automatic preset 50mm f/2 lens as that of the Penta J – the diaphragm had to be cocked open for focusing against spring pressure with a lever on the lens mount, but closed automatically to the preset aperture when the shutter button was pressed.

1964 saw the advent of the Yashica JP, a simpler version of the J-3 without meter, and the scarcer J-5, which had a new 55mm f/1.8 Yashinon lens with fully automatic diaphragm.

It was not until the end of the sixties and the launch of the Yashica Electro series of SLRs that Yashica began to make a modest impact upon the 35mm SLR market. The TL-Electro, the first to appear, retained the M42 Pentax/Praktica screw lens mount and had

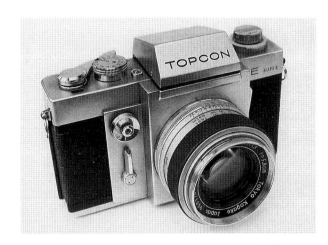

The Topcon RE Super is essentially the same camera as the Topcon Super D, and is superbly engineered. In use, it feels precise, predictable and reliable. This example is fitted with the 58mm f/1.8 RE.Auto-Topcor.

*Camera by courtesy of Don Baldwin. Shot with Topcon RE-2 fitted with 58mm f/1.8 RE.Auto-Topcor on Ilford Pan F Plus, developed in Aculux and printed on Jessop Variable Contrast.*

a conventional mechanical flexible neoprene-blind focal-plane shutter with speeds of 1 second to 1/1000th second, with stop-down TTL metering in the manner of the Pentax Spotmatic, except that the sliding switch on the left-hand side (as you use the camera) of the mirror box was moved down to switch the meter on, not up. Actuating the switch stopped down the lens to the set aperture and illuminated one of two horseshoe-shaped diodes in the viewfinder on the right-hand side of the focusing screen. Illumination of the horseshoe *over* the centre point indicated over-exposure, that *under* the centre point equalled under-exposure. When the exposure was correctly set, both were illuminated.

The TL-Electro looked good, handled well and had one of the 'snappiest' microprism focusing screens on the market. The 50mm f/1.9 Yashinon DS lens with which it was usually sold was a superb performer with a light, smooth focusing mount. Yet the camera was comparatively inexpensive. In 1974, when a Pentax Spotmatic 1000 with f/2 lens could be bought in Britain for £94.50 (then about $220), an Olympus OM-1 with f/1.8 Zuiko was £148.50 ($347) and a Minolta SRT101 with f/1.7 cost £118.50 ($277), a Yashica TL-Electro with f/1.9 was only £77.50 ($181).

In 1970, Yashica announced the Yashica TL-Electro X. This was the first camera to use the then new Copal Square SE electronically controlled vertically running metal shutter, and was endowed with an entirely new solid-state exposure-measurement system with no moving parts. Commonplace now, this was sensational at the time. Despite the trend of the time to full-aperture TTL metering, Yashica opted to stay with stopped-down metering. From a practical photographer's point of view this was a good decision, since it enabled the TL-Electro X to utilize the enormous number of screw lenses on the market with its latest-technology exposure measurement. From a marketing standpoint, it was not so clever, since, as has been mentioned before, 1970 was a turning point when fashion and a desire for gadgetry began to dominate amateur photographers' aspirations more than the ability to shoot high-quality pictures. The TL-Electro X was categorized unjustly by the reviewers as 'only a stopped-down metering camera'.

Even this paragon of technology cost British photographers less than £100 ($234) in 1974 – just a few pounds more than a Pentax Spotmatic 1000. It was good value, despite the reviews.

In 1974 came the Yashica Electro AX, described somewhat over-enthusiastically by advertisements at the time as 'the most advanced automatic electronic SLR in the world'. Retaining the neat 'over and under' horseshoe diodes, and the same general design and appearance, the TL-Electro AX was a very versatile and effective camera at a very reasonable price – only £129.30 (then $302) in Britain with f/1.7 lens in 1974.

The rapid advance of electronics and camera design brought about several co-operative manufacturing

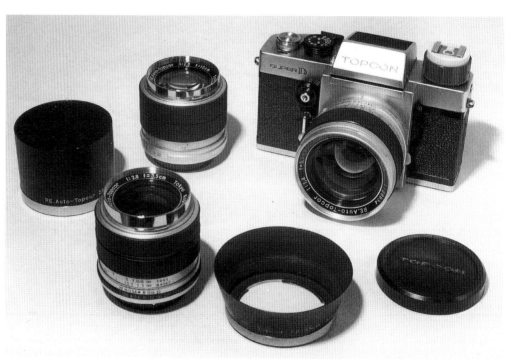

A Topcon outfit consisting of a Topcon Super D with the magnificent 5.8cm f/1.4 RE.Auto-Topcor with, to the left of the camera as we look at it, a 10cm f/2.8 RE.Auto-Topcor and its lens hood. In the foreground is a 3.5cm f/2.8 RE.Auto-Topcor and its lens hood.

*Equipment by courtesy of Don Baldwin. Shot with Topcon RE-2 fitted with 58mm f/1.8 RE.Auto-Topcor on Ilford Pan F Plus, developed in Aculux and printed on Jessop Variable Contrast.*

Lifting the lens out of a Topcon RE-2 shows the Exakta bayonet lens mount clearly. From this angle it is also possible to see the exposure-meter switch low down on the side of the mirror housing.

*Shot with Pentax Spotmatic fitted with 55mm f/1.8 Super-Takumar on Ilford Pan F Plus, developed in Aculux and printed on Jessop Variable Contrast.*

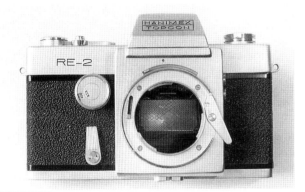

Look down the lens throat of a Topcon with TTL exposure meter and you will see the exposure-meter cell actually on the mirror of the camera. This system is unique to Topcon and is very effective. The camera here is a Topcon RE-2.

*Shot with Pentax Spotmatic fitted with 55mm f/1.8 Super-Takumar on Ilford Pan F Plus, developed in Aculux and printed on Jessop Variable Contrast.*

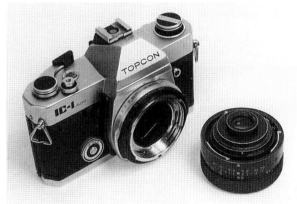

The late series of Topcon cameras are of very much lower quality and have the UV Topcor lens mounts and lens series. This Topcon IC-1 Auto provides automatic or manual exposure control and has a 50mm f/2.8 Hi-Topcor lens, here removed to show the UV Topcor lens mount.

*Shot with Minolta SRT101 fitted with 55mm f/1.7 MC Rokkor on Ilford Pan F Plus, developed in Aculux and printed on Jessop Variable Contrast.*

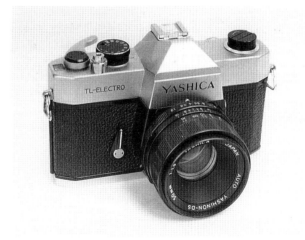

The Yashica TL-Electro, if you can find a really good one with a reliable exposure meter like this example, is excellent value and handles extremely well. The lens is very crisp and has a light positive focusing action.

*Shot with Pentax Spotmatic fitted with 55mm f/1.8 Super-Takumar on Ilford Pan F Plus, developed in Aculux and printed on Jessop Variable Contrast.*

The excellent 2.5cm f/3.5 RE.Auto-Topcor with which several photographs in this book were taken came packed in this rather grand zip-up leather case with a Series 9 filter-retaining ring and several filters in the lid of the case. The outfit was enclosed in the strong box shown here – quality all the way.

*Camera by courtesy of Don Baldwin. Shot with Topcon RE-2 fitted with 58mm f/1.8 RE.Auto-Topcor on Ilford Pan F Plus, developed in Aculux and printed on Jessop Variable Contrast.*

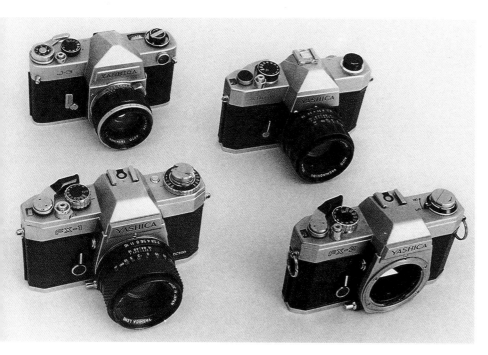

The Yashica family – or, at least, representative members of it. Top left is the Yashica J-3, one of the sixties generation of Yashica SLRs without TTL exposure meter, but with a built-in uncoupled CdS meter in the top-plate. Top right is the Yashica TL-Electro with TTL meter. Both of these cameras have M42 screw lens mount. In front are the Yashica FX-1, on the left, with shutter-priority or manual exposure measurement and control, and the simpler FX-2, which has no automatic mode and has match-needle TTL metering. The FX-1 is fitted with a 55mm f/2 Yashica DSB lens. The FX-2 has the lens removed to show the Contax/Yashica bayonet lens mount.

*Shot with Minolta SRT101 fitted with 55mm f/1.7 MC Rokkor on Ilford FP4 Plus, developed in Aculux and printed on Jessop Variable Contrast.*

and marketing arrangements between German and Japanese camera and lens manufacturers during the mid-seventies. One of these was the successful co-operation, destined to last many years, between Zeiss and Yashica. The Contax RTS, launched during 1976, was an undeniably expensive camera (costing more with f/1.4 lens than a Canon F-1 with f/1.4 lens) intended for the professional market. As well as the great Contax name, provided by Zeiss, the RTS was designed by the Porsche Design Group of Germany and equipped with a formidable range of bayonet-mount Zeiss lenses – Planars, Distagons and Sonnars of superb quality and performance (and astronomical prices). But it was manufactured by Yashica, and marked the transition of Yashica from perpetual association with budget-priced cameras to the big time.

An important part of the deal with Zeiss was the provision for Yashica to manufacture and market a range of lower-priced cameras benefiting from the development of the RTS, equipped with the RTS/Yashica bayonet lens mount, and able to accept either the Zeiss lenses of the RTS or a less expensive range of Yashinon lenses.

Thus were born the Yashica FR, the FR-1, the FR-2, the FX-1 and the FX-2. The FR cameras were fully automatic SLRs with open-aperture TTL metering, centre-weighted light measurement and infinitely variable electronically governed shutter speeds from 4 seconds to 1/1000th second. The FX-1 provides optional fully automatic operation or fully manual working with TTL exposure measurement. The FX-2 was a more conventional open-aperture TTL metering camera with speeds from 1 second to 1/1000th second.

After the launch of the bayonet-mount F cameras, the screw-mount TL-Electro series was closed out, and Yashica was set for steady if moderate success in the SLR market of the eighties.

### Should you buy Yashica?

Yashica SLRs of the J series are less than reliable and really not to be recommended for everyday use thirty-odd years after their manufacture. The TL-Electro cameras, as well as being younger, are inherently better designed and manufactured. Find one that has not had too much use and you will have a fine camera at a very moderate price. I bought the TL-Electro with f/1.9 lens featured on these pages at the Hailsham Camera Centre in Sussex for only £35 ($53) during 1995. It is almost as new and performs beautifully. However, the 'over and under' diodes do have a way of failing, and can usually not be replaced if they do. So make sure that the exposure-measurement system works properly before you buy.

This stalwart of the steam fraternity was happy to be photographed beside one of the traction engines at the Bluebell Railway Steam Fair in Sussex during August 1994.

*Shot with Minolta SRT101 fitted with 55mm f/1.7 MC Rokkor on Ilford FP4 Plus, developed in Aculux and printed on Ilford Multigrade.*

I had seen this view of the River Ouse at Lewes, beside the A26 spur to the Cuilfail Tunnel, many times, but had never got around to photographing it. During the autumn of 1994 I stopped and finally took the shot for this book, but actually found it surprisingly difficult to find an effective angle.

*Shot with Miranda Sensorex II fitted with 50mm f/1.9 Miranda Soligor on Ilford FP4 Plus, developed in Aculux and printed on Ilford Multigrade.*

As the wedding guests filed out of the church after the ceremony, my wife pointed out to me that the bellringers could be seen from the nave. Hastily fitting a 100mm lens to a Konica that was one of the cameras in my bag that day, I managed to get this shot (below) at 1/30th at f/2.8.

*Shot with Konica FP fitted with 100mm f/2.8 Hexanon on Ilford FP4 Plus, developed in Aculux and printed on Ilford Multigrade.*

In shooting the pictures for this book, I bought and sold quite a few cameras and was lent many more. One of the ones I sold a little too quickly was the Olympus FTL and, particularly, its 135mm f/3.5 Zuiko lens. The picture of my wife's friend Sibby Joyce (below right) was shot with that combination but not printed until after the scarce 135mm Zuiko had been snapped up by a Photographic Collectors Club acquaintance. The stunning sharpness of the negatives from the FTL made me wish I had kept it.

*Shot with Olympus FTL fitted with 135mm f/3.5 M42 Zuiko on Ilford FP4 Plus, developed in Aculux and printed on Ilford Multigrade.*

I was early for a meeting near Margate on the Isle of Thanet, so spent a few minutes seeing what photographic opportunities lurked in the nearby lanes. I found these men harvesting brassicas with the low winter sun just right to illuminate the foreground leaves.

*Shot with Olympus FTL fitted with 85mm f/1.8 Auto-Takumar on Ilford FP4 Plus, developed in Aculux and printed on Ilford Multigrade.*

Another of those unexpected snapshots. With more opportunity to set the shot up, I would have tried not to shoot it with a car in the background – but there was no opportunity and the chance lasted only a moment or two.

*Shot with Topcon RE Super fitted with 25mm f/3.5 RE.Auto-Topcor on Ilford Pan F Plus, developed in Aculux and printed on Ilford Multigrade. Camera and lens by courtesy of Don Baldwin.*

Olivia Horlick photographed using a simple studio set-up and a light-brown Colorama paper background. Long light-coloured hair can be wonderful to photograph.

*Shot with Petri TTL fitted with the usual 55mm f/1.8 Petri standard lens on Ilford FP4 Plus, developed in Aculux and printed on Ilford Multigrade.*

I love this picture. Laura Joyce grins direct to the camera and proves herself a natural model. This was shot with an unnamed (literally) 135mm f/2.8 M42 auto-diaphragm lens which is probably one of those sold cheaply by the Derek Gardner Camera Company in the mid-seventies. It performs really well – but is probably worth no more than £10 ($15) in current market conditions.

*Photographed with Ricoh Singlex TLS fitted with 135mm f/2.8 on Ilford FP4 Plus, developed in Aculux and printed on Jessop Variable Contrast.*

Just before Guy Fawkes Day 1994 – well, about five weeks before, actually – this group of lads were collecting for their fireworks in Shoreham-by-Sea, West Sussex. They were happy to let me photograph them in return for a small donation.

*Shot with Miranda Sensorex II fitted with 50mm f/1.9 Miranda Soligor on Ilford FP4 Plus, developed in Aculux and printed on Ilford Multigrade.*

Every generation in a school produces its star athlete, and Jane Smith was the star of St Nicholas School, Uckfield, during the mid-seventies. She loved running, loved winning and went on to greater things. This shot of Jane in action was framed in a place of honour in the school for many years.

*Shot with Olympus Pen-F fitted with 50mm–90mm f/3.5 Zuiko zoom lens on Ilford HP5, developed in Aculux and printed on Ilford Multigrade.*

A Jaguar D-Type Replica sets at least my pulse racing at the Pestalozzi Hillclimb in August 1994. I was looking for shots further down the hill with the 250mm f/5.6 RE.Auto Topcor and followed this one through, managing to hold focus as it swept by too close for the whole car to be in the frame. Nonetheless, it makes a nice shot.

*Shot with Topcon RE-2 fitted with 250mm f/5.6 RE.Auto-Topcor on Pan F Plus, developed in Aculux and printed on Ilford Multigrade.*

# Chapter 10

# Leaf shutters and just plain weird shutters

The perspective of the nineties upon the many non-focal-plane-shuttered SLRs of the 1950s and 1960s is often to wonder why anybody ever bought them. In a world whose focal-plane shutters usually fail only when the battery runs out, it is easy to forget that the behind-lens Compur shutter of 1952 promised a trouble-free future to photographers beset with the unreliability of focal-plane shutters of the period. When Zeiss Ikon announced in 1953 their first single-lens Contaflex, it was to a world in which the great majority of photographers did not expect to need interchangeable lenses and whose standards of pictorialism were orientated to standard focal lengths. Thus, the non-interchangeability of the lens of the early Contaflexes and the limited interchangeability of those that followed were not seen as the major disadvantages that they would be regarded as now.

The reflex Synchro-Compur was a great deal quieter than most focal-plane shutters, and offered flash synchronization at all shutter speeds – a feature which was to become more important with the general use of electronic flash during the sixties. Compur shutters had a justified reputation for longevity and reliability dating from before the Second World War, and a single-lens reflex with a Compur shutter made a lot of sense to people who wanted a quiet, reliable camera which provided the benefits of reflex composition on a focusing screen.

Although Zeiss were first, others were not far behind. In Europe, Kodak, Agfa and Voigtländer all launched major ranges of Compur-shuttered reflexes during the fifties. The orient was slow in responding simply because the Reflex Compur was protected by

I came upon these folks braiding little girls' hair in the area of Brighton known as The Lanes. Even at f/8, the Topcon 25mm f/3.5 lens illustrated on page 185 has provided almost total depth of field and excellent sharpness corner to corner.

*Shot with Topcon RE-2 fitted with 25mm f/3.5 RE.Auto-Topcor on Ilford Pan F Plus, developed in Aculux and printed on Ilford Multigrade. Lens by courtesy of Don Baldwin.*

patents and time was needed to develop either shutters capable of staying open for focusing until the shutter was fired or new kinds of shutter operating in the focal plane but not, strictly, focal-plane shutters. When Japanese cameras began to compete for the budget-price fixed-lens and simple-interchangeability market, not all of them had Compur-type leaf shutters.

For the sake of convenience, this chapter covers cameras which either had leaf shutters – Compur, Prontor, etc. – or sector shutters, or mechanisms in which the mirror doubled as the shutter. Instead of tackling them in alphabetical order, I will, as best I can, discuss them in chronological order of the first models in the various series.

## The Zeiss Contaflexes

The post-war Zeiss Contaflex SLR cameras bore no resemblance to the pre-war Contaflex, which was the first 35mm twin-lens reflex. Compact, light, reliable and of very high quality, the Contaflex I (catalogue code 861/24) was first available in 1953 and remained available until 1958 (and later in camera stores which discounted close-out lines). The Contaflex I was simple in every way in which later Contaflexes became complex – it had no exposure meter, no lens interchangeability, no lever-wind, no interchangeable backs. But the impression of simplicity was deceptive.

For the key achievement of the reflex version of the Synchro-Compur shutter, later adopted by Hasselblad for the legendary 500C, was the ability to stay closed after the exposure was made until the winding of the camera lowered the mirror back into place, in which position it acted as a dark slide, protecting the film from light. As the wind-on was completed, the shutter and diaphragm opened completely, allowing light to pass through the lens at full aperture for focusing. When the shutter was fired, the shutter closed completely, the diaphragm stopped down to the working aperture, the mirror was raised – and only then was the shutter triggered at the set shutter speed. All this happened very quickly indeed, and the Contaflex was almost, but not quite, as fast to use as a conventional between-lens-shuttered camera. The 45mm f/2.8 Tessar delivered results which, for the time, were first-rate, and the camera achieved a major following where it was freely available.

The initial success of the Contaflex I induced Zeiss Ikon to add a neat selenium built-in exposure meter

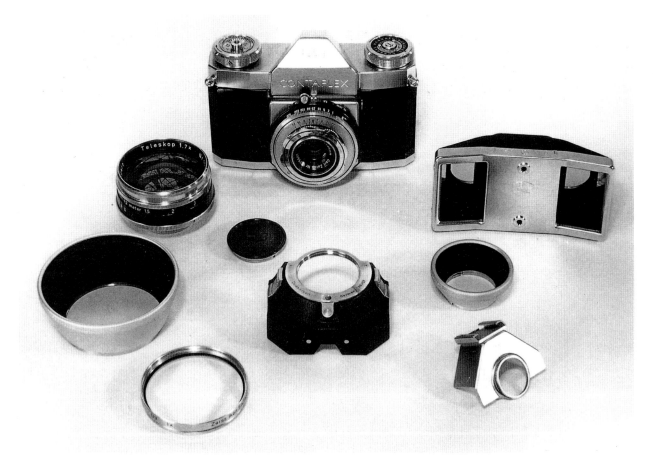

The Zeiss Contaflex I was a beautifully simple, classically engineered camera capable of superb results from its 45mm f/2.8 non-interchangeable Tessar. To make possible the benefits of at least a moderately long-focus lens, Zeiss offered the Teleskop 1.7x supplementary lens (on the left of the camera) which provided a focal length of roughly 76mm. This was fitted using the black-and-chrome adaptor directly in front of the camera and its lens hood – never buy the Teleskop unless it has the adaptor. Stereo (3D) photography was popular during the fifties, and Zeiss offered the Steritar beam-splitter attachment to fit the Contaflex (to the right of the camera). Only a Steritar B with two linked circles (in the manner of the Olympic Games logo) engraved on the top works with the Contaflex. A similar-looking beam splitter/prism unit with two separate circles is a Steritar C, intended for the Zeiss Contax Steritar twin-lens stereo lens. The latter is much more valuable – if you find one, do not reject it! Also in this picture are Zeiss satin-chrome lens hoods for the two lenses and the Zeiss accessory shoe which fitted over the viewfinder eyepiece.

*Equipment by courtesy of Malcolm Glanfield. Shot with Topcon RE-2 fitted with 58mm f/1.8 RE.Auto-Topcor on Ilford Pan F Plus, developed in Aculux and printed on Jessop Variable Contrast.*

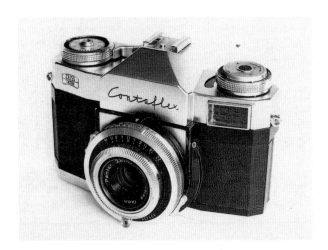

A Contaflex Beta of 1958. This camera was the up-market version of a Contaflex Alpha, the difference being the presence of the selenium-cell exposure meter with the needle cell on the front of the camera (right) and the needle visible under the curved window in the top-plate. The 45mm f/2.8 Pantar was interchangeable, 30mm and 75mm Pantars being offered. These replaced the front element of the lens, removed by pressing the spring-loaded button at six o'clock to the lens mount. The Alpha and Beta were the first lever-wind Contaflex cameras.

*Shot with Minolta SRT101 fitted with 55mm f/1.7 MC Rokkor on Ilford Pan F, developed in Aculux and printed on Jessop Variable Contrast.*

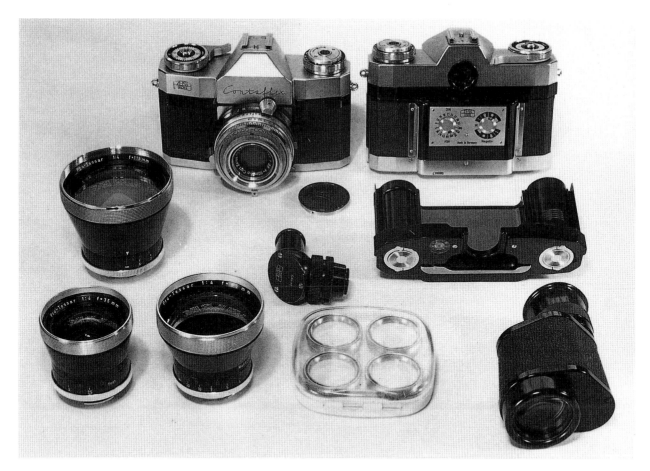

The Contaflex Rapid, Prima, first and second type Super and the subsequent automatic cameras all had lever-wind and the facility for both interchangeable lenses and interchangeable film backs. In this picture are, at the back, a Contaflex Rapid (no meter) facing the camera and a Contaflex Super with its back to the camera. The Super is fitted with an interchangeable film back. In the middle row, on the right, is another Contaflex interchangeable back, this time in black finish. The bright strip visible in the baseplate is the dark slide. In the centre is the screw-in magnifying viewfinder, on the left a 115mm f/4 Pro-Tessar, the longest focal length available for the Contaflex cameras with interchangeable Tessar. In front (l. to r.) are a 35mm f/4 Pro-Tessar, an 85mm f/4 Pro-Tessar, a set of Zeiss close-up lenses and the Zeiss monocular which fitted the Contaflex as a supplementary lens.

*Equipment by courtesy of Malcolm Glanfield. Shot with Topcon RE-2 fitted with 58mm f/1.8 RE.Auto-Topcor on Ilford Pan F Plus, developed in Aculux and printed on Jessop Variable Contrast.*

and to market, during 1954, the Contaflex II (862/24), identical, but for the meter, to the Contaflex I. For the models I and II, Zeiss offered a curious add-on lens called the Zeiss Teleskop 1.7 which was fitted with an accessory clamp. This clamp is often missing – don't buy a Teleskop without it, as you will never find another! The Contaflex II also lasted until 1958, by which time Zeiss Ikon had launched, the previous year, the comparatively scarce Contaflex III (863/24) without meter, and the commoner Contaflex IV (864/24) with meter. Both were endowed with a new 50mm f/2.8 Tessar with interchangeable front element, alongside which were launched the first of the Pro-Tessar interchangeable lenses to replace the front element, the 35mm f/4 and 85mm f/4 Pro-Tessars.

It is important to note that these lenses were front-element units only – the rear components of the 50mm lens stayed put behind the shutter. The reflex Synchro-Compur was therefore used in the Contaflex series as a between-lens rather than behind-lens shutter. The Voigtländer Bessamatic and its successors, and all the Retina Reflex models after the first (see below), had fully interchangeable complete lenses, all of which were in front of the shutter blades. This latter system permitted much greater versatility and more variety of focal lengths.

The advent of the Contaflex III and IV with their interchangeable Tessars had begun to make the Contaflex more expensive than had originally been intended, and with the passing of the fixed-lens models

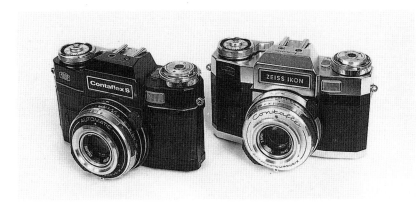

The Contaflex Super BC (right) and Contaflex S both provided automatic or manual exposure via a CdS exposure meter whose battery was concealed behind a door in the front left-hand side of the camera (as we look at them here).

*Cameras by courtesy of Dave and Julie Todd. Shot with Canon FTb QL fitted with 50mm f/1.8 Canon FD on Ilford Pan F, developed in Aculux and printed on Jessop Variable Contrast.*

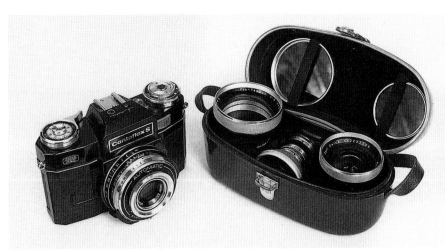

Zeiss marketed beautifully manufactured leather accessory cases for the Contaflex series. Beside the Contaflex S in this picture is the case for the 85mm and 35mm lenses with their uv filters in the lid and space in the centre for the lens hood and filters for the standard 50mm f/2.8 Tessar.

*Equipment by courtesy of Dave and Julie Todd. Shot with Canon FTb QL fitted with 50mm f/1.8 Canon FD on Ilford Pan F, developed in Aculux and printed on Jessop Variable Contrast.*

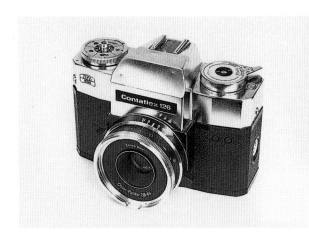

The Contaflex 126 was a lightweight camera in every sense of the word by comparison with earlier Contaflex equipment. Originally a Voigtländer design, it was manufactured by Zeiss Ikon/Voigtländer after the takeover, but did not remain on the market for long.

*Camera by courtesy of Dave and Julie Todd. Shot with Canon FTb QL fitted with 50mm f/1.8 Canon FD on Ilford Pan F, developed in Aculux and printed on Jessop Variable Contrast.*

I and II, Zeiss Ikon introduced a budget-priced range of interchangeable lenses. Thus were born in 1958 the Contaflex Alpha (10.1241) which had no meter and an interchangeable 45mm f/2.8 Pantar, and the Contaflex Beta (10.1251) which was an Alpha with an added selenium exposure meter. Both still had knob-wind and no accessory shoe. With them was launched a second range of interchangeable front-element lenses, the 30mm f/4 Pantar and the 75mm f/4 Pantar, plus the Steritar D for 3D stereo photography. These lenses had been launched during 1955 with the Contina III, a non-reflex viewfinder camera, which was phased out as the two Contaflex models with Pantar lenses were phased in.

In 1959, the growing importance of lever-wind and flash to amateur photographers caused Zeiss Ikon to add lever-wind and an accessory shoe on the prism housing to the Contaflex III and to call the result the Contaflex Rapid (10.1261) – a decidedly scarce model with interchangeable 50mm f/2.8 Tessar and no

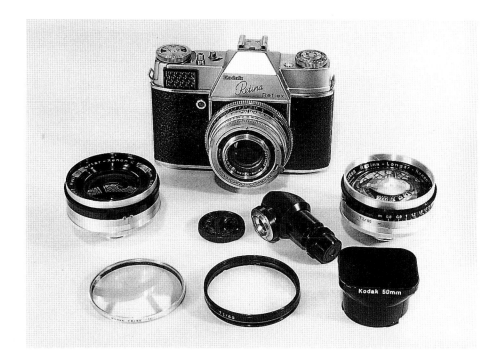

The original Retina Reflex utilized the existing front-element interchangeable lens system of the Retina IIc and IIIc folding cameras. The camera here is fitted with the 50mm f/2 Retina-Xenon with, to the left, the 35mm f/4 Retina-Curtar-Xenon C and to the right the 80mm f/4 Retina-Longar-Xenon C. The viewfinder magnifier and cap for the standard lens are in the centre. In front are (l. to r.) a Kodak FII uv filter for the 80mm f/4, a Kodak TI close-up lens for the same lens and the Kodak hood for the 50mm Xenon.

*Equipment by courtesy of Malcolm Glanfield. Shot with Topcon RE-2 fitted with 58mm f/1.8 RE.Auto-Topcor on Ilford Pan F Plus, developed in Aculux and printed on Jessop Variable Contrast.*

exposure meter. At the same time they produced a version of the new camera with the cheaper 45mm f/2.8 Pantar and an exposure meter with no cover (unusually, on the right-hand side) and called it the Contaflex Prima (10.1291).

Finally came the most significant of the three new Contaflex cameras of 1959 – the Contaflex Super (10.1262). This had the specification of the Contaflex Rapid but with a built-in *coupled* selenium exposure meter mounted with its cell in the middle of the front of the prism housing. A finger wheel adjacent to the left hand made it possible to align a pointer and set the correct exposure. The Contaflex Super is the commonest of the Contaflex models and, if you can find one whose shutter and diaphragm operation is snappy and sweet-running, one of the most enjoyable to use. Made for only three years, this first-type Contaflex Super was probably the most commercially successful of all Compur-shuttered SLRs.

In 1962 there appeared a new version of the Contaflex Super (10.1271) with no finger wheel and the name 'Zeiss Ikon' imprinted on the front of a larger meter cell. The shutter was now described on the camera as a Synchro-Compur X. The most significant feature of this new camera was one which was little remarked upon or publicized at the time, which was the use of a completely recomputed version of the

50mm f/2.8 Tessar, using high-refractive-index rare-earth elements. The results from this redesigned Tessar were and are bitingly sharp. Unfortunately, the mechanical design of the new type of Contaflex Super seems to have been inferior to that of the earlier model, and it is not easy to find examples which work well, despite its being manufactured until 1967.

With the new Contaflex Super were launched two further Pro-Tessar lenses, the 35mm f/3.2 and the 115mm f/4. Later still, Zeiss offered the Pro-Tessar M 1:1, a high-resolution close-up copying and macro lens for the Contaflex cameras with recomputed Tessar (i.e., from second-type Super onwards).

A year later, in 1963, came the Contaflex Super B (10.1272), almost indistinguishable in appearance from the second-type Super, but with automatic-exposure control based on a selenium-cell exposure meter mounted in the prism, just as with the Super. Look in the viewfinder for a numbered exposure scale and at the shutter-speed ring for an 'A' setting to identify the Super B from the Super. The exposure-meter system in Super B cameras rarely works properly thirty-odd years on, and this model is more subject to sluggishness of the diaphragm and shutter than most, perhaps due to greater accessibility for dust and grime.

In 1967, Zeiss Ikon brought the exposure measurement system right up to date with the Contaflex Super

| Contaflex SLR lenses | | Fits | Star rating |
|---|---|---|---|
| **Wide-angle lenses** | | | |
| 25mm f/4 Distagon (ultra-rare) | | Contaflex 126 | NDA |
| 30mm f/4 Pantar | | Int. Pantar cameras | ★★★ |
| 32mm f/2.8 Distagon | | Contaflex 126 | NDA |
| 35mm f/3.2 Pro-Tessar | | Int. Tessar cameras | ★★★★ |
| 35mm f/4 Pro-Tessar | | Int. Tessar cameras | ★★★ |
| **Standard lenses** | | | |
| 45mm f/2.8 Color Pantar | | Contaflex 126 | NDA |
| 45mm f/2.8 Tessar | | Contaflex 126 | ★★★★ |
| 45mm f/2.8 Pantar | | Int. Pantar cameras | ★★★ |
| 50mm f/2.8 Tessar | | Int. Tessar cameras up to and including 1st-type Super | ★★★★ |
| 50mm f/2.8 Tessar (recomputed) | | Contaflex Super B, 2nd-type Super, Super BC and S | ★★★★+ |
| **Long-focus lenses** | | | |
| 75mm f/4 Pantar | | Int. Pantar cameras | ★★★ |
| 85mm f/2.8 Sonnar | | Contaflex 126 | NDA |
| 85mm f/3.2 Pro-Tessar | | Int. Tessar cameras | ★★★★ |
| 85mm f/4 Pro-Tessar | | Int. Tessar cameras | ★★★★ |
| 115mm f/4 Pro-Tessar | | Int. Tessar cameras | ★★★★ |
| 135mm f/4 Tele-Tessar | | Contaflex 126 | NDA |
| 200mm f/4 Tele-Tessar | | Contaflex 126 | NDA |
| **Special-purpose lenses** | | | |
| Pro-Tessar M-1:1 (macro close-up) | | Int. Tessar cameras (2nd-type Super onwards) | ★★★★ |
| Monocular 8x30B | | All models with 27mm filter | ★★★ |
| Steritar B (stereo 3D unit) | | Int. Tessar cameras | NDA |
| Steritar D (stereo 3D unit) | | Int. Pantar cameras | NDA |

BC (10.1273). This was equipped with a CdS through-the-lens exposure meter and therefore had no external exposure-meter cell. It is readily identified by having a battery-compartment door on the front of the camera. In 1970, an automatic-exposure version of the CdS metered camera was launched as the Contaflex S Automatic, and, for once, Zeiss identified the model on the camera itself, with 'Contaflex S' on the prism housing. A few Contaflex S cameras were made in black and are much sought after by Zeiss cognoscenti.

The final Contaflex is one most collectors would rather forget – the Contaflex 126, designed to take Kodak 126 cartridge films and made more cheaply than the other models in the range. Despite its poor engineering, the Contaflex 126 had automatic-exposure control, an interchangeable 45mm f/2.8 Tessar and three special lenses designed for it alone.

### Contaflex lenses

The table on the left summarizes the lenses that were available and details the cameras they were designed to fit. For space reasons, I have referred to 'Int. (interchangeable) Pantar cameras' or 'Int. Tessar cameras' rather than listing the models repeatedly.

### Should you buy a Contaflex to use?

To use Contaflex equipment on a regular basis, you need to be fairly devoted to the marque and prepared to own several and meet repair bills as they arise, since the shutters and automatic-exposure systems are inclined to be troublesome. If you can put up with those requirements, they are rewarding cameras to use, have a feel of true quality and deliver superb images, particularly if you can find a camera with the late recomputed Tessar. It's best to persevere and hunt for a Contaflex Super BC or Contaflex S, both of which are more likely to be reliable than the earlier cameras with the recomputed lens. The original Contaflex Super with the finger-wheel meter is the best bet if your budget is constrained – but check the operation of the shutter and diaphragm at small apertures and slow speeds carefully. Also look through the back of the camera after the shutter has been fired and make sure that the shutter is fully closed.

### The Retina Reflex series

Three years after the advent of the first of the Contaflex SLRs, Kodak responded with the Retina Reflex which, unlike the Contaflex, had interchangeable lenses from the outset. By 1956, the folding Retina IIc and IIIc coupled-rangefinder cameras with interchangeable lenses were established and successful, and, faced with the need to compete with Zeiss Ikon in the new between-lens-shutter SLR market, Kodak naturally used existing resources as much as possible. Because of the existence of the Retina-C lens system, they were able to introduce an interchangeable-lens leaf-shutter SLR a year before Zeiss Ikon's first interchangeable-lens Contaflex.

Thus the first Retina Reflex (Type 025) of 1956 shared its interchangeable-lens system with the Retina IIc and IIIc, the camera being sold with either a 50mm f/2 Retina-Xenon C from Schneider or (not in the USA) a 50mm f/2 Retina-Heligon C from Rodenstock.

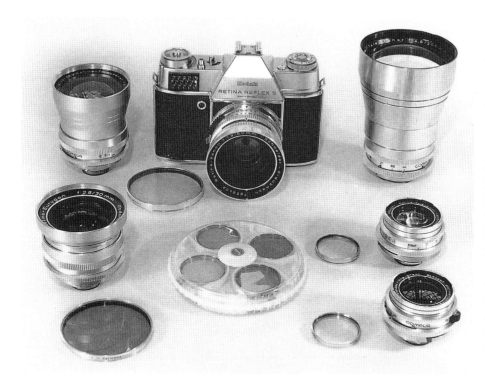

The advent of the Retina Reflex S ushered in a new fully interchangeable lens system. The camera on the left is fitted with a 50mm f/1.9 Retina-Xenon, with its uv filter beside it. On the left of the camera is the 135mm f/4 Retina-Tele-Xenar, on the right at the back the 200mm f/4.8 Retina-Tele-Xenar, a scarce lens. On the left in front is the 30mm f/2.8 Rodenstock Retina-Eurygon, with a colour filter to fit it in the foreground. On the right are the 85mm f/4 Retina-Tele-Arton (middle row) and the 28mm f/4 Retina-Curtagon. In the centre are a set of colour filters and two uv filters for the 50mm f/2.8 Retina-Xenar with which this camera is usually found.

*Equipment by courtesy of Malcolm Glanfield. Shot with Topcon RE-2 fitted with 58mm f/1.8 RE.Auto-Topcor on Ilford Pan F Plus, developed in Aculux and printed on Jessop Variable Contrast.*

The Retina Reflex III (right) had its shutter release on the front of the camera. This example is fitted with a 50mm f/2.8 Retina-Xenar with Kodak close-up lenses R1:2 and R1:4.5 in front of it. On the left are the 30mm f/2.8 Retina-Eurygon and the 85mm f/4 Retina-Tele-Arton, on the right a 135mm f/4 Retina-Tele-Xenar.

*Equipment by courtesy of Malcolm Glanfield. Shot with Topcon RE-2 fitted with 58mm f/1.8 RE.Auto-Topcor on Ilford Pan F Plus, developed in Aculux and printed on Jessop Variable Contrast.*

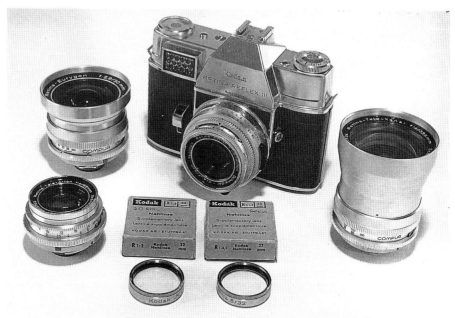

In both cases, the front elements (i.e., the part of the lens in front of the shutter) were removable with a simple bayonet catch, making it possible for the 80mm f/4 Retina-Longar-Xenon C (or Retina-Heligon C) or the 35mm f/4 Retina-Curtar-Xenon C wide-angle (or Retina-Curtar-Heligon C) to be inserted in its place. Also available were tiny 35mm f/5.6 Retina-Curtar-Xenon C or Retina-Curtar-Heligon C wide-angle lenses, which are fine on the rangefinder cameras but produce a very dim screen on the SLR.

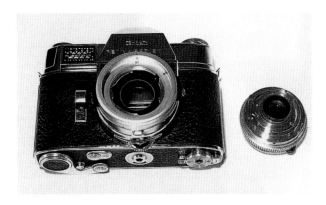

Removing the lens of the Retina Reflex III shows the intricacy of its bayonet mount. The camera is seen here with the shutter wound, and therefore open to permit light from the lens to reach the mirror. This rather strange viewpoint also enables one to see the base of the camera, and the lever-wind which is one of the best features of the Retina Reflex. The wing levers either side of the tripod bush are twisted to open the camera. The serrated wheel beneath the lens mount is used to rotate the aperture ring free of the coupled shutter-speed ring when setting exposures.

*Shot with Topcon RE-2 fitted with 58mm f/1.8 RE.Auto-Topcor on Ilford Pan F, developed in Aculux and printed on Jessop Variable Contrast.*

Note that cameras with a 50mm Heligon will accept only Heligon accessory lenses, and that 50mm Xenon lenses can be interchanged only with Xenon C lenses – you cannot fit Heligons to a Xenon camera or vice versa. The shutter was a Synchro-Compur MXV, the M and X being bulb and electronic-flash synchronization, respectively, and the V the delay-action facility. An uncoupled selenium-cell exposure meter was fitted within the top-plate of the camera.

The first Retina Reflex was probably a stopgap measure, introduced to secure a marketing lead over Zeiss while the real Retina Reflex was developed. The development process at Kodak was made that much more complex by the intention to maintain cross-compatibility between the Retina Reflex of the day and the flagship rangefinder Retina, and it was not until 1959 that the Retina Reflex S (Type 034) appeared, the Retina IIIS rangefinder camera (Type 027) having made its debut during 1958. These cameras represent the peak of lens compatibility between reflex and rangefinder camera designs.

The key benefit was the much larger range of wider-aperture interchangeable lenses, which were now complete lenses, not interchangeable front elements. Lenses available extended from a 28mm f/4 through 35mm f/2.8, 50mm f/1.9 or 50mm f/2.8, 85mm

f/4, 135mm f/4 and 200mm f/4.8. The focusing screen was brighter than that of the earlier Retina Reflex and the picture quality delivered by the lenses was somewhat improved. Once again, there were ranges of lenses from both Schneider and Rodenstock (see table), but this time they were totally compatible and interchangeable. Only cameras with Schneider (Xenon or Xenar) standard lenses were sold new in the USA.

The Retina Reflex S retained the conventional shutter release on the top of the camera and was equipped with a coupled selenium exposure meter. To my mind it is the best of the Retina Reflex cameras, with the least unnecessary complication and a shutter release which is where most people expect to find it.

Only a year later, during 1960, Kodak announced the Retina Reflex III (Type 041). This had the minor advantage of an exposure-meter needle visible in the viewfinder, and the major disadvantage of a sliding shutter release on the front face of the camera. It was superseded in 1964 by the Retina Reflex IV (Type 051), which had the added benefit of the aperture scale being visible in the viewfinder via a small prismatic optical system above the lens mount.

### The Instamatic Reflex

By the end of the decade, as something near to panic was setting in around the German camera industry,

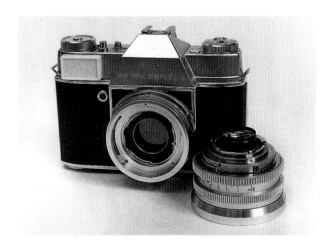

This Retina Reflex S has had the lens removed with the shutter fired and not rewound – so the shutter is closed and the screen would be black. The lens is the 50mm f/1.9 Retina-Xenon. The camera is fitted with the white incident-light diffuser over the exposure-meter cell.

*Shot during the seventies – no data available.*

Kodak AG in Stuttgart, where all the Retina Reflex cameras were made, clutched at the same straw as Zeiss Ikon and marketed an SLR for 126 cartridge film. This was perhaps not surprising, since it was Eastman Kodak which had introduced and was promoting the 126 'Instamatic' cartridge, and considerable investment was therefore available to ensure that Kodak AG did the job well. The result was the Kodak Instamatic Reflex.

This was in many ways a more advanced camera than the earlier Retina Reflexes, since it was an early example (in 1970) of a fully automatic camera with electronic exposure control, providing shutter speeds of from 20 seconds to 1/500th second. On the other hand, it was not a TTL camera – at that stage manufacturers had not figured out means of combining TTL metering with electronic control without excessive complication and unreliability – and had no provision for manual exposure setting.

The normal standard lens was the 50mm f1.9 Xenon often found on Retina Reflexes, but there was also a very interesting 45mm f/2.8 Xenar with linked focusing and aperture scales for automatic-flash exposure, in the manner of the 45mm GN Nikkor sold for the Nikon cameras. Unlike Zeiss Ikon, whose Contaflex 126 had a separate set of lenses, Kodak used the same lens mount and register for the Instamatic Reflex, so the full family of Retina Reflex S series lenses will fit.

## Retina lenses

As outlined above, there are two fundamental types – interchangeable front components for the Retina IIc and IIIc rangefinder cameras and the original Retina Reflex, known as the 'C' range, and the complete interchangeable lenses for the Retina IIIS and Retina Reflex series other than the original Reflex, which are together known as the 'S' range. All except the 200mm lens and the 90mm lens are relatively common, although some can take a few weeks of walking to track down. The 50mm f/3.5 Xenar for the series is listed in several reference books, but I have never seen one. This suggests that it is common in the USA but scarce in Europe.

## Is it wise to buy Retina Reflex?

The first type of Retina Reflex with C lenses is relatively hard to find and rather limited in its application when you find it. The Reflex S, III and IV models are, in photographic terms, a much better bet. They are moderately priced, most of the lenses are fairly easy to find and the results are first-class if the camera is correctly set up. The catch is the reliability problem and the availability and cost of repairs.

The faults to look for are slow and 'sticky' shutter operation or halting slow speeds, and meter failure. As with the Contaflex, watch out particularly for the shutter that does not quite close after exposure. The Retina Reflex was designed in a very odd way, so that, to service the shutter, the repairer has virtually to strip the entire camera. Rebuilding it and setting it up is then tricky and time-consuming. The result is that almost any shutter work costs more than the camera is worth. This causes so many arguments that most repairers simply refuse to handle Retina Reflex equipment. So be warned.

### Retina Reflex lenses

| | | | Fits | Maker | Star rating |
|---|---|---|---|---|---|
| **Wide-angle lenses** | | | | | |
| 28mm | f/4 | Retina-Curtagon | S/III/IV | Schneider | ★★★ |
| 30mm | f/4 | Retina-Eurygon | S/III/IV | Rodenstock | ★★★★ |
| 35mm | f/2.8 | Retina-Xenar | S/III/IV | Schneider | ★★★★ |
| 35mm | f/4 | Retina-Curtar-Xenon C | Original/Xenon | Schneider | ★★★ |
| 35mm | f/4 | Retina-Curtar-Heligon C | Original/Helig. | Rodenstock | ★★★ |
| 35mm | f/5.6 | Retina-Curtar-Xenon C | Original/Xenon | Schneider | ★★★ |
| 35mm | f/5.6 | Retina-Curtar-Heligon C | Original/Helig. | Rodenstock | ★★★ |
| **Standard lenses** | | | | | |
| 50mm | f/1.9 | Retina-Xenon | S/III/IV | Schneider | ★★★★ |
| 50mm | f/2 | Retina-Xenon C | Original/Xenon | Schneider | ★★★ |
| 50mm | f/2 | Retina-Heligon C | Original/Helig. | Rodenstock | ★★★ |
| 50mm | f/2.8 | Retina-Xenar | S/III/IV | Schneider | ★★★★ |
| 50mm | f/3.5 | Retina-Xenar | S/III/IV | Schneider | NDA |
| **Long-focus lenses** | | | | | |
| 80mm | f/4 | Retina-Heligon C | Original/Helig. | Rodenstock | ★★★ |
| 80mm | f/4 | Retina-Longar-Xenon C | Original/Xenon | Schneider | ★★★ |
| 85mm | f/4 | Retina-Tele-Arton | S/III/IV | Schneider | ★★★★ |
| 85mm | f/4 | Retina-Rotelar | S/III/IV | Rodenstock | ★★★★ |
| 90mm | f/4 | Retina-Tele-Arton | S/III/IV | Schneider | NDA |
| 135mm | f/4 | Retina-Tele-Xenar | S/III/IV | Schneider | ★★★ |
| 135mm | f/4 | Retina-Rotelar | S/III/IV | Rodenstock | ★★★★ |
| 200mm | f/4.8 | Retina-Tele-Xenar | S/III/IV | Schneider | ★★★ |
| Stereo attachment C | | | Original | | ★★★ |

## The Voigtländer Bessamatic and Ultramatic

Of all the leaf-shutter SLRs that I have used, the Bessamatic is, in my opinion, by far the most practical, comfortable and effective. It is the only one which, for me, handles as well as a focal-plane SLR and which lets you concentrate on photography rather than the camera.

The original Bessamatic appeared in 1958/9 and was very advanced for its time. As well as lever-wind and a built-in coupled selenium exposure meter, it offered the option of the world's first zoom lens designed for a 35mm SLR, the 36–82mm f/2.8 Zoomar. More commonly, the Bessamatic was sold with a 50mm f/2.8 Color-Skopar X or an excellent 50mm f/2 Septon. The Synchro-Compur shutter, like that of the later Retina Reflexes, was behind the lens, making possible a full range of complete interchangeable lenses. Regrettably, there was never a wide-angle lens wider than 35mm for the Voigtländer cameras, and this can be a disadvantage.

By 1963, many Bessamatics had been sold and the design was looking dated in the face of Zeiss Contaflex innovations and the marketing pressure of Japanese focal-plane SLRs. While working on a version with a CdS meter, Voigtländer updated the Bessamatic to produce the Bessamatic De Luxe, which is essentially similar to the original camera, but has a T-shaped prismatic optic above the selenium meter cell on the front of the camera which projects an image of the aperture and shutter-speed rings into the viewfinder area. In 1964, the Bessamatic M appeared, a reduced-price version with no exposure meter and a three-element 50mm f/2.8 Color-Lanthar lens instead of the excellent Color-Skopar. Because it is scarce, the Color-Lanthar fetches twice as much from collectors as the Color-Skopar. It is not worth it.

Meanwhile, Voigtländer had succumbed to market pressure for automation and had launched during 1963 the Ultramatic, an unexpectedly heavy and cumbersome camera with the option of automatic-exposure control. This original Ultramatic had a selenium exposure meter and was, in the technology of the age, entirely electro-mechanical in its automation. It was an extremely complex mechanism, far more so than the similarly electro-mechanical Contaflex Super B with which it competed, and quickly proved unreliable and expensive to repair. Relatively few were sold; even fewer operate correctly now.

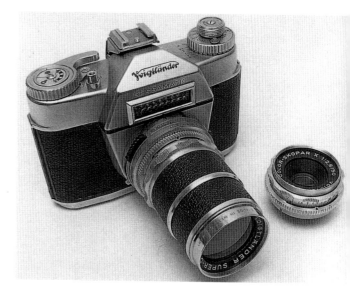

The original Bessamatic, with its standard 50mm f/2.8 Color-Skopar X on the right and a 135mm f/4 Super-Dynarex mounted on the camera. This was the camera I used for a number of pictures in my last book, *Collecting and Using Classic Cameras*.

*Shot with Nikon F2 Photomic fitted with 50mm f/2 Nikkor on Ilford HP5, developed in Aculux and printed on Jessop Variable Contrast.*

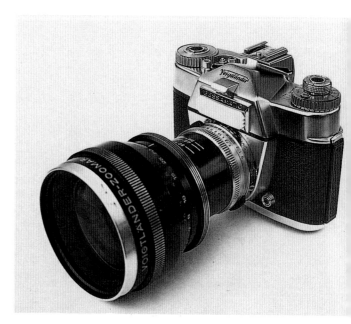

Another early Bessamatic, this time with the optional accessory shoe which can be hard to find. Even harder to find is the lens shown here – the celebrated 36–82mm f/2.8 Zoomar, the world's first zoom lens for a 35mm still camera.

*Camera, lens and picture by courtesy of Mike Rees. Shot with Contarex Cyclops fitted with 50mm f/2 Planar on Ilford Pan F, developed in Aculux and printed on Jessop Variable Contrast.*

The Bessamatic m was an original Bessamatic without a built-in exposure meter. This example is fitted with 50mm f/2.8 Color-Lanthar.

*Camera by courtesy of Dave and Julie Todd. Shot with Canon FTb QL fitted with 50mm f/1.8 Canon FD on Ilford Pan F, developed in Aculux and printed on Jessop Variable Contrast.*

A CdS exposure meter replaced the selenium-cell meter in the Bessamatic late in the life of the design, producing the Bessamatic CS shown here. This also has fitted a 36–82mm f/2.8 Zoomar. The hockey-match picture on page 214 was shot with this camera and lens.

*Camera and lens by courtesy of Len Corner. Shot with Minolta SRT101 fitted with 45mm f/2 MD Rokkor on Ilford Pan F, developed in Aculux and printed on Jessop Variable Contrast.*

In 1965, Voigtländer produced the Ultramatic CS, a substantially redesigned version of the Ultramatic with a CdS exposure meter providing TTL exposure measurement. The Ultramatic CS was one of the earliest, if not the earliest, TTL SLRs to have full aperture and speed information displayed in the viewfinder, and an example which works well is a formidable camera, particularly if equipped with the Zoomar. The Ultramatic CS was more successful and has proved to be rather more reliable than its predecessor.

Meanwhile, back in Brunswick, the Voigtländer engineers at last produced a CdS version of the Bessamatic. Launched in 1967, the Bessamatic CS was a beautiful design which was a delight to use – but it was too late and too expensive. It did not sell well and is now scarce. If you can find a good one, buy it.

### Voigtländer lenses

The range of lenses produced for the Bessamatic and Ultramatic was of consistently high quality mechanically and optically. They are less common than Contaflex or Retina Reflex lenses, and therefore tend to be more expensive, but are worth a good price.

Although the same range of lenses was offered for the Bessamatic and Ultramatic cameras, only lenses with a yellow/orange dot on the rear flange (where the

The Ultramatic CS was the later version of the Ultramatic with TTL exposure meter and full aperture and speed information displayed in the viewfinder. This example is fitted with the 50mm f/2 Septon, which performs extremely well.

*Camera and picture by courtesy of Mike Rees. Shot with Contarex Cyclops fitted with 50mm f/2 Planar on Ilford Pan F Plus, developed in Aculux and printed on Jessop Variable Contrast*

## Voigtländer lenses

### Wide-angle lenses

| | | |
|---|---|---|
| 35mm | f/3.4 | Skoparex |
| 40mm | f/2 | Skopagon (rare) |

### Standard lenses

| | | |
|---|---|---|
| 50mm | f/2 | Septon |
| 50mm | f/2.8 | Color-Skopar X |
| 50mm | f/2.8 | Color-Lanthar |

### Long-focus lenses

| | | |
|---|---|---|
| 90mm | f/3.4 | Dynarex |
| 100mm | f/4.8 | Dynarex (scarce) |
| 135mm | f/4 | Super-Dynarex |
| 200mm | f/4 | Super-Dynarex (scarce) |
| 350mm | f/5.6 | Super-Dynarex (rare) |

### Zoom lenses

| | | |
|---|---|---|
| 36–82mm | f/2.8 | Zoomar |

lens fits the camera) have the necessary coupling for the Ultramatic auto-exposure system. Lenses without the dot can, however, be used on the Ultramatic in manual-exposure mode. All, with or without dot, can be used on the Bessamatic models.

The Voigtländer Zoomar – which was manufactured by Zoomar Corporation of USA and was available mounted for several other SLRs as well as the Voigtländer series – is surprisingly effective in use. Although large, heavy and clumsy by modern zoom-lens standards, once fitted to a Bessamatic it balances and handles well. It is easy to focus and zoom, holds its focus through the zoom range and delivers remarkably good contrast and resolution. I used one for the first time during the production of this book and was amazed at the quality of the results.

### Is the Bessamatic a good buy?

Provided that you check the functions of the camera carefully, you cannot go far wrong with a Bessamatic, for they are reliable and effective. They are not as expensive to service as Contaflex or Retina Reflex cameras. An odd fault that is common is the sudden detachment and loss of the chrome bezel around the selenium meter cell of the original Bessamatic – it is worth checking periodically whether this is loose.

The Ultramatic is not a sound buy if your intention is to take photographs. You would do better to buy another Bessamatic.

### The Agfa SLRs

During 1959, Agfa became the fourth European manufacturer to enter the leaf-shutter SLR market with the Agfaflex. The initial model, the Model I, had a non-interchangeable lens, a 50mm f/2.8 Color-Apotar (3-element) and a non-coupled selenium-cell exposure meter built into the prism housing. It was supplied with an interchangeable waist-level viewfinder, with a prism available as an optional extra. Shortly afterwards, the Model II was announced – but was simply the same camera sold with the prism as standard.

The Agfaflex III and IV were launched during 1960 and were much-improved cameras, mainly because they were equipped with an interchangeable 50mm f/2.8 Color-Solinar, which was a Tessar-type 4-element lens, and had a coupled exposure meter. The III had the waist-level viewfinder, the IV the prism.

Shortly afterwards again, the Agfaflex Model V appeared with the excellent 55mm f/2 Color-Solagon and the prism viewfinder. This and the other models continued in production together until 1963. All the Agfaflex cameras have a true focusing screen, making it possible to focus the image right across the screen, and they are very pleasant cameras to use. The snag is that they seem to be poorly sealed against the ingress of dirt and it is almost normal to find them with shutter problems, usually non-running slow speeds. Like the

One of the simpler Agfa Colorflex cameras with non-interchangeable lens, in this case a 50mm f/2.8 Color-Apotar. Squeezing the chrome-plated buttons on either side of the prism detaches it from the body.

*Camera by courtesy of Peter Loy. Shot with Minolta SRT101 fitted with 55mm f/1.7 MC Rokkor on Ilford FP4 Plus, developed in Aculux and printed on Jessop Variable Contrast.*

Retina Reflex, they are expensive to repair and unpopular with repairers.

Probably for trade-mark reasons, Agfa marketed the Agfaflex I and II as the Colorflex I and II in some markets and the Agfaflex III, IV and V, without modification, as Ambiflex cameras. Thus an Ambiflex I is the same as an Agfaflex III, an Ambiflex II is an Agfaflex IV and an Ambiflex III is an Agfaflex V.

The various Agfaflex, Colorflex and Ambiflex models were phased out during 1963, when they were replaced by the Selecta-Flex. This provided the choice of automatic or manual exposure, still with a selenium exposure meter, in the manner of the Contaflex Super B or the Voigtländer Ultramatic, and was probably the first 35mm SLR with the automatically set Prontor Reflex P shutter, which is not noted for its reliability.

## Agfa SLR lenses

During the Agfaflex/Ambiflex era, Agfa marketed three additional lenses for the cameras – the 35mm f/3.4 Color-Ambion, the 90mm f/3.4 Color-Telinear and the 135mm f/4 Color-Telinear. When the Selecta-Flex was launched, a 180mm f/4.5 Color-Telinear was added to the range. These are all very good-quality lenses and deliver excellent images. It is unfortunate that the cameras they fit are not more reliable.

## The Savoy Reflexes

Comparatively little known outside their native France, the Savoy reflex cameras manufactured by the company owned by René Royer in Fontenay-sous-Bois hold an important place in the history of the SLR camera. During 1959, the company launched both the basic Savoyflex and the innovative Savoyflex Automatic, the world's first 35mm SLR with automatic exposure, controlled by a selenium exposure meter mounted above the lens. The camera had a high-quality 50mm f/2.8 Som-Berthiot lens in a helical focusing mount and a Prontor Reflex B leaf shutter with speeds of 1 second to 1/300th second. Som-Berthiot supplementary lenses with focal lengths of 35mm and 80mm were available, and were akin to the Zeiss Pro-Tessars for the Contaflex.

The simpler Savoyflex had no exposure meter but the same lens and shutter. The first version used front-cell focusing, but was soon replaced by the Savoyflex II with helical focusing like that of the Savoyflex Automatic.

I have no experience of using the Savoyflex cameras beyond picking them up at collectors' fairs. They are undoubtedly well made and have fine lenses. I am told, however, that they are profoundly unreliable. I suspect that their Prontor Reflex shutters are likely to be subject to similar problems of jamming and

The Agfa Ambiflex was offered with an impressive range of high-quality interchangeable lenses. This camera is fitted with the 50mm f/2.8 Color-Solinar, a four-element lens of high performance.

*Camera by courtesy of Peter Loy. Shot with Minolta SRT101 fitted with 55mm f/1.7 MC Rokkor on Ilford FP4 Plus, developed in Aculux and printed on Jessop Variable Contrast.*

The last of the Agfa SLR line was the Selecta-Flex, with automatic and manual exposure options.

*Camera by courtesy of Dave and Julie Todd. Shot with Pentax Spotmatic fitted with 55mm f/1.8 Super-Takumar on Ilford Pan F, developed in Aculux and printed on Jessop Variable Contrast.*

slow-speed failure as afflict them when mounted in Agfa SLRs.

### The Paxette Reflexes

Carl Braun of Nuremberg manufactured and marketed throughout the fifties a series of 35mm cameras under the name Paxette. Beginning in 1952 with a fixed-lens viewfinder camera, the Paxette I, the range expanded to include versions with built-in exposure meters, models with interchangeable lenses and coupled rangefinder cameras, some with automatic exposure and all with between- or behind-lens Prontor or Pronto shutters.

In 1959, following the European fashion of the time, Braun announced their venture into leaf-shutter SLR territory, the Paxette Reflex. This first model was a non-interchangeable lens design, versions being offered with a 50mm f/2.8 Enna-Reflex-Ultralit or a 50mm f/1.9 Steinheil Quinon. Another version of the camera, the Paxette Reflex Ib, had a built-in selenium exposure meter, with a match-needle window in the top of the camera, but was otherwise identical.

Four years later, during 1963, Braun launched the more advanced Paxette Reflex Automatic, which, as the name suggests, offered automatic or manual exposure using a selenium meter. This camera had an interchangeable bayonet lens mount, and was usually sold with the Enna 50mm f/2.8 Ultralit. Two additional Enna lenses were available, a 35mm f/3.5 Lithagon and a 135mm f/3.5 Tele-Ultralit.

Since I wrote in *Collecting and Using Classic Cameras* that my experience of Paxette Reflex cameras was not good, I have been berated by a number of Paxette enthusiasts who insist that they are reliable and effective cameras. Certainly, I have no quarrel with the Enna lenses. Although not of particularly high contrast, their resolution is excellent. My problem is that I have never yet had a Paxette Reflex that remained operational for long if one took pictures with it. Maybe I am just unlucky. On your own head be it.

### Nippon Kogaku

As mentioned briefly in Chapter 7, Nippon Kogaku were among the earliest of the Japanese manufacturers to market a leaf-shutter SLR, and made a fairly determined attempt to establish their models during the early sixties. The first was the Nikkorex 35,

The Pentina was the only leaf-shutter SLR from Eastern Europe to be regularly sold in the West during the Cold War years. Fitted with a 50mm f/2.8 Tessar in a breech-lock mount somewhat like that of the Praktina, the Pentina was, in commercial and practical terms, one of Pentacon's poorer products, since they rarely worked well and now rarely work at all. Nonetheless, it was an important and innovative design in SLR history. This particular example is, believe it or not, gold-plated and is in spectacularly mint condition.

*Camera by courtesy of Peter Loy. Shot with Minolta SRT101 fitted with 55mm f/1.7 MC Rokkor on Ilford FP4 Plus, developed in Aculux and printed on Jessop Variable Contrast.*

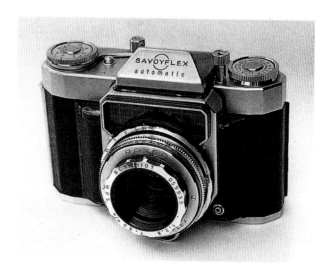

The Savoyflex Automatic from Royer of France, the world's first 35mm SLR camera with automatic exposure. While important to the history of the SLR, this is not a camera to be bought to use.

*Camera by courtesy of Peter Loy. Shot with Minolta SRT101 fitted with 55mm f/1.7 MC Rokkor on Ilford FP4, developed in Aculux and printed on Jessop Variable Contrast.*

The rare French Focaflex II is even more rarely found with its lenses. This example has the 5cm f/2.8 standard lens plus, in the foreground, the 3.5cm f/4 Retroplex wide-angle and behind it the 9cm f/4 Teleoplex. Notice the flat top of the Focaflex, a characteristic it shares with the Olympus Pen-F.

*Camera by courtesy of Peter Loy. Shot with Minolta SRT101 fitted with 55mm f/1.7 MC Rokkor on Ilford FP4, developed in Aculux and printed on Jessop Variable Contrast.*

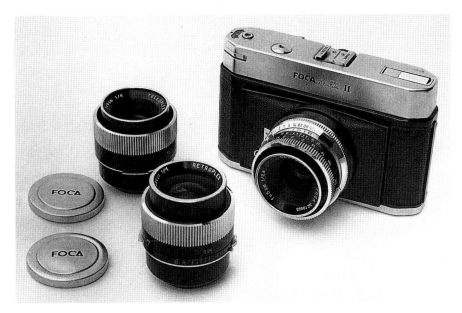

launched during 1960, which had a fixed-mount 50mm f/2.5 Nikkor with a between-lens leaf shutter with speeds of 1 second to 1/500th second. A coupled selenium exposure meter was mounted in the front of the prism.

In 1964, a developed version of the same camera with automatic exposure appeared. This was the Nikkorex Auto 35, which had a wider-aperture 50mm f/2 Nikkor but still a fixed lens mount and the same between-lens shutter. In between had come, in 1963, the Nikkorex Zoom 35, the world's first 35mm camera with a fixed zoom lens, a 43–86mm f/3.5 Nikkor.

Unusually for such an illustrious manufacturer, none of the Nikkorex leaf-shutter cameras can be called reliable, and they are fairly expensive to repair.

## Kowa

A whole series of budget-priced 35mm Kowa SLRs was marketed throughout the sixties, all with leaf shutters. The first was the Kowa (sometimes Kowaflex) E of 1962 through to 1966, usually found with a 50mm f/2 Prominar non-interchangeable lens. This camera had a coupled selenium exposure meter, and could be fitted with wide-angle or telephoto supplementary lenses, sold in neat kits of two in a fitted case. The shutter was a between-lens Seikosha SLV with speeds of 1 second to 1/500th second.

In the following year, 1963, an automatic-exposure version of the camera appeared. This was the Kowa H,

fitted with the decidedly inferior 48mm f/2.8 Kowa lens in a shutter without slow speeds and with a top speed of 1/300th second.

In 1964, a version of the Kowa H with a CdS exposure meter appeared, known as the Kowa SE and usually supplied with a non-interchangeable 50mm f/2 lens. This camera still had the between-lens leaf shutter and automatic exposure. The SE is one of the commonest of the Kowa cameras, having been available for six years from 1964 through to 1970.

Interchangeable lenses came to the Kowa range in 1965 with the advent of the Kowa SER, in which the leaf shutter was moved behind the lens. The standard lens was a 50mm f/1.9 and the camera had a cross-coupled match-needle CdS meter with aperture scales visible in the viewfinder. A range of additional lenses from 28mm to 200mm was available.

In 1967, the Kowa SET appeared. This was a fixed-lens SLR with TTL exposure meter and a 50mm f/1.8 lens in a Seikosha-SLV shutter with speeds of 1 second to 1/500th second. In the following year, all the features to date came together in the Kowa SETR. This one had both full-aperture TTL metering and interchangeable lenses with the Seikosha behind-lens leaf shutter. It was usually supplied with a 50mm f/1.9 standard lens. Finally, in 1970 came the Kowa SETR2 with 50mm f/1.8 lens and, reputedly, a major internal redesign to overcome the constant mechanical problems that had beset Kowa cameras and their users for a decade.

Those mechanical problems are even worse a quarter of a century on, and it is comparatively unusual to find a Kowa 35mm SLR which works well in all respects. Even the ones that do are not to be trusted.

### The Edixa Electronica

In 1962, the Wirgin company of Wiesbaden paid brief lip service to the European fashion for leaf-shutter SLRs with the Edixa Electronica, among the early fully automatic-exposure SLRs. The camera had a selenium exposure meter, a Synchro-Compur shutter and either a 50mm f/2.8 Culminar or a 50mm f/2.8 Xenar, in either case in fixed mount. The camera was not a success, did not remain on the market for long and is now both scarce and expensive. For use it is best avoided.

### Fujica

Fuji was never a major contender in the leaf-shutter SLR market, but did briefly enter the lists with the Fujicarex cameras of the early sixties.

The first Fujicarex, of 1962, had selenium-cell match-needle metering, a 50mm f/2.8 interchangeable lens and a between-lens leaf shutter with speeds of 1 second to 1/500th. Interchangeable 35mm and 80mm front lens components were available, in the manner of the Contaflex cameras. The interesting part was the

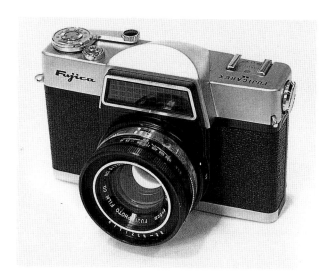

The nicely designed Fujicarex II of 1963 with selenium-cell exposure meter and 50mm f/2.8 interchangeable lens. Note the rewind crank on the end of the camera, at 90 degrees to the axis of the cassette spool.

*Camera by courtesy of John Paterson. Shot with Minolta SRT101 fitted with 58mm f/1.4 MC Rokkor with a No. 1 close-up lens on Ilford FP4 Plus, developed in Aculux and printed on Jessop Variable Contrast.*

unusual way in which the controls were arranged. Two thumb wheels below the wind-on lever controlled the diaphragm and the focus, somewhat like the focusing wheel on the back of a Vitessa.

In the following year, one suspects in the face of poor sales figures, Fuji announced the Fujicarex II, essentially a facelift of the earlier camera. This is the version illustrated above.

I cannot claim direct experience of either camera, although Fuji design and engineering are generally quite good. Nonetheless, the inherent complexity and design weaknesses of leaf-shutter cameras will probably have made both Fujicarex cameras unreliable by now.

### Mamiya

Also during 1962, Mamiya of Japan announced the Prismat, a behind-lens leaf-shutter SLR with a selenium-cell exposure meter mounted in the front of the prism housing and an interchangeable 48mm f/1.9 lens. This camera was more reliable than most of its kind and was offered with a limited range of interchangeable lenses. The camera is now scarce and the lenses even scarcer.

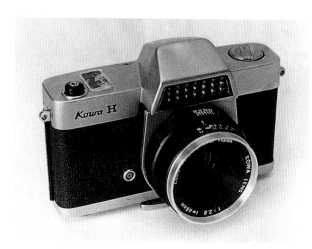

The Kowa H, one of a series of extremely unreliable between-lens and behind-lens-shuttered cameras produced during the sixties.

*Shot with Minolta SRT101 fitted with 55mm f/1.7 MC Rokkor on Ilford FP4, developed in Aculux and printed on Jessop Variable Contrast.*

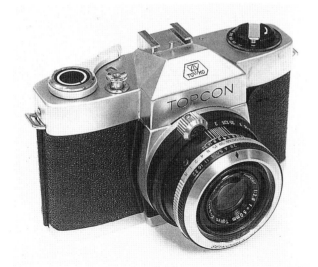

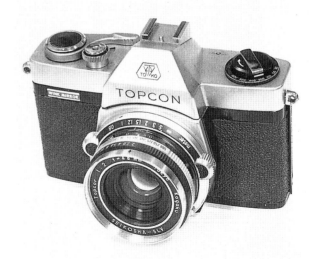

The Topcon between-lens-shuttered SLR with non-interchangeable lens which functions in the same way as an early Contaflex.

*Camera by courtesy of Bob Davey. Shot with Minolta SRT101 fitted with 58mm f/1.4 MC Rokkor with a No. 1 close-up lens on Ilford FP4 Plus, developed in Aculux and printed on Jessop Variable Contrast.*

The Topcon Wink Mirror, with 48mm f/2 Topcor in a Seikosha-SLV shutter. As the name suggests, this camera had an instant-return mirror, something of an innovation at the time in a non-focal-plane-shuttered SLR.

*Camera by courtesy of Barry and Angela Spencer. Shot with Minolta SRT101 fitted with 58mm f/1.4 MC Rokkor with a No. 1 close-up lens on Ilford FP4 Plus, developed in Aculux and printed on Jessop Variable Contrast.*

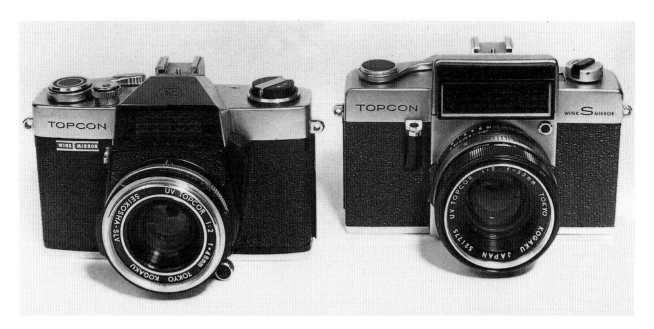

Two more of the Topcon Wink Mirror series – the Wink E Mirror on the left and the Wink S Mirror on the right. The Wink E has a non-interchangeable lens, the Wink S takes UV Topcor interchangeable lenses.

*Topcon Wink E by courtesy of Len Corner. Shot with Praktina IIA (by courtesy of Mike Rees) fitted with its 50mm f/2 Flexon standard lens on Ilford Pan F Plus, developed in Aculux and printed on Jessop Variable Contrast.*

Much commoner is the simple and comparatively poorly engineered Mamiya Family, also known as the Saturn and the Korvette, among other names, as a result of extensive own-brand marketing by retailers. This camera had a fixed 45mm f/2.8 lens of surprisingly good quality in a leaf shutter, with a two-blade diaphragm controlled by a selenium exposure meter in the prism. If an example of the camera works properly, it delivers good results, but is hardly to be recommended, since its engineering standards were very low and its reliability is poor.

### Ricoh

By 1963, Riken had applied the Ricoh name to a leaf-shutter SLR, the Ricoh 35 Flex. Much like many others of its ilk, the camera had a coupled selenium exposure meter within the prism housing and a fixed 50mm f/2.8 Rikenon lens in a leaf shutter with speeds from 1/20th second to 1/300th second. It is not common nor particularly desirable.

Much later, Riken manufactured a more advanced SLR made for the 126 Instamatic film cartridge. The Ricoh 126C-Flex TLS of 1969 had aperture-priority automatic exposure and a fixed-mount 50mm f/2.8 Rikenon lens in a leaf shutter. Like many of its kind, relatively few were sold. Like all SLRs for 126 film, its usability is limited by the non-availability of 126 film.

### Minolta

In 1963, even Minolta, who were well-established with successful focal-plane-shuttered SLRs, dipped a toe briefly in the leaf-shutter SLR market with the Minolta ER. This was a very nicely built camera, with a fixed-mount 45mm f/2.8 Rokkor of first-class performance and a between-lens leaf shutter with speeds of 1/30th to 1/500th second. Very effective wide-angle and telephoto supplementary lenses were available, and, if you can find one, and want a Japanese leaf-shutter SLR, the Minolta ER is one of the better prospects. It is commoner in the USA than in Europe.

### Topcon

There is much confusion in camera collectors' reference books about the shutters in Topcon SLRs which do not have conventional cloth focal-plane shutters. The tendency is to categorize all of them as having between-lens or behind-lens leaf shutters.

The Aires Reflex 35 is a relatively uncommon Japanese between-lens-shuttered fixed-lens SLR which looks and feels beautifully engineered but can be unreliable now. The camera usually comes with a 50mm f/2.8 Coral lens, although engravings on the accessory lenses reveal that a 45mm lens was also available.

*Camera by courtesy of Len Corner. Shot with Praktina IIA (by courtesy of Mike Rees) fitted with 135mm f/3.5 Tele-Ennalyt lens on Ilford Pan F Plus, developed in Aculux and printed on Jessop Variable Contrast.*

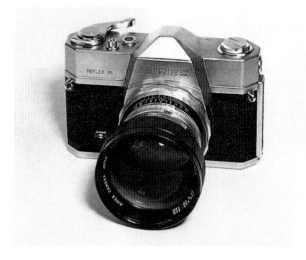

The same Aires Reflex, fitted here with the supplementary lens which simply screws into the filter mount, making a 50mm standard lens effectively a 90mm lens. Engravings on the front bezel indicate that, when screwed into the filter mount of a 4.5cm lens, the resulting focal length is 8cm.

*Camera by courtesy of Len Corner. Shot with Praktina IIA (by courtesy of Mike Rees) fitted with 135mm f/3.5 Tele-Ennalyt lens on Ilford Pan F Plus, developed in Aculux and printed on Jessop Variable Contrast.*

In fact, the Topcon Uni and Auto 100 have sector shutters not unlike that used on the Exa I series, and the Topcon IC-1 has a cloth focal-plane shutter.

There were, however, Topcon cameras with between-lens shutters, and, curiously, the one usually seen does not have a model designation – just the maker's name – and is rarely included in reference books. This camera looks and operates like a fixed-lens Contaflex SLR – see the picture on page 209.

The Topcon Wink S Mirror, a much more frequently found camera, has the Topcon UV interchangeable lens mount, so uses the same lenses as the focal-plane Topcon IC-1, but has a behind-lens leaf shutter, with the mirror acting as light-trap when the shutter is open for focusing, as it does on all behind- and between-lens shuttered SLRs.

The Topcon Wink E Mirror, confusingly, is fitted with what is described as a 48mm f/2 UV Topcor, but this one is not interchangeable. In addition to the mirror, the Wink E Mirror has a shutter flap which blocks and light-traps the exposure area at the focal plane until the shutter is fired. The flap then drops down into the base of the mirror housing as the mirror flips up, exposing the film.

All these non-focal-plane Topcon SLRs are unreliable, and, while interesting as examples of camera development during the sixties, are not to be recommended for photography. Their engineering quality is in stark contrast to the superb engineering of the Exakta-mount Topcon focal-plane SLRs.

## Rollei

Unlike the other leading West German camera manufacturers of the fifties and sixties, Franke and Heidecke never became involved in 35mm leaf-shutter single-lens reflexes – until, that is, the fashion for SLR cameras using the Kodak 126 film cartridge began in the late sixties. In 1968, Franke and Heidecke launched the strange-looking Rollei SL26, with an interchangeable 40mm f/2.8 Tessar in a Synchro-Compur shutter and through-the-lens metering. Two other lenses were available, the 28mm f/3.2 Pro-Tessar wide-angle and the 80mm f/4 Pro-Tessar. Like most other 126 SLRs, the Rollei SL26 was not a major success, although it performed well and was of typically Rollei quality. It is quite scarce.

So should you buy 35mm leaf-shutter SLRs at all?

There is no one answer to the above question. If your objective is simply that of shooting high-quality pictures with the highest standard of reliability and versatility for your money, the answer has to be 'No'. A good – even quite an inexpensive – focal-plane SLR can provide a lot more reliability and versatility for your money.

On the other hand, cameras like the Bessamatic and Contaflex have an attraction and are enjoyable to use once in a while. My preference remains with the Bessamatic, but others like the Retina Reflex S or the Contaflex Super have a certain style and feel that are all their own.

Some people have the self-confidence to pursue their own style regardless of the world around them. Shot on a beach in Yorkshire during the summer of 1984.

*Shot with Contaflex Super B fitted with 50mm f/2.8 Tessar on Ilford HP5, developed in Aculux and printed on Jessop Variable Contrast.*

One of the guests at my daughter Holly's sixth birthday party seemed to have found the chocolate cake a shade powerful. Holly, as always, found it funny. I usually photographed the children at birthday parties and, once in a while, would be rewarded with an unusual expression or situation. This was a direct-flash picture.

*Shot with Contaflex Super (first version) fitted with 50mm f/2.8 Tessar on Ilford FP4, developed in Aculux and printed on Jessop Variable Contrast.*

This picture of my daughter Holly, aged twenty during the autumn of 1995, demonstrates that a Retina Reflex III can provide crisp and attractive images, especially when used with studio flash, which eliminates virtually all risk of poor definition due to camera movement. This is an important consideration with a late Retina Reflex, since the shutter release on the front face of the camera is very difficult to use smoothly so as not to shake the camera.

*Shot with Retina Reflex III fitted with 50mm f/2.8 Retina-Xenar, using three Courtenay flash heads, on Ilford FP4 Plus, developed in Aculux and printed on Jessop Variable Contrast.*

It can be lonely on a beach in October. I like the graphic quality of shots like this and never tire of looking for them. This was Brighton beach in 1984.

*Shot with Bessamatic fitted with 50mm f/2.8 Color-Skopar X on Ilford HP5, developed in Aculux and printed on Jessop Variable Contrast.*

At the flower stall in Burgess Hill market I tried the wide-angle performance of the Voigtländer Zoomar and again was surprised at just how good it was. Crisp definition and contrast are maintained out to the edge of the image with minimal obvious distortion.

*Shot with Bessamatic CS fitted with 36–82mm f/2.8 Zoomar on Ilford FP4 Plus, developed in Aculux and printed on Jessop Variable Contrast. Camera and lens by courtesy of Len Corner.*

Shoppers in Burgess Hill market, West Sussex, study the merchandise – and the visible quality of the image from the Voigtländer Zoomar at the long end of its zoom range makes the texture of the clothes sharp and clear and all the tickets contrasty and easy to read.

*Shot with Bessamatic CS fitted with 36–82mm f/2.8 Zoomar on Ilford FP4 Plus, developed in Aculux and printed on Jessop Variable Contrast. Camera and lens by courtesy of Len Corner.*

Hockey is a fast sport which is not easy to photograph. I took a borrowed Bessamatic and Zoomar lens to a hockey match and was pleasantly surprised by the quality of the results. Although big and heavy, the Zoomar delivers good contrast and resolution.

*Shot with Bessamatic CS fitted with 36–82mm f/2.8 Zoomar on Ilford FP4 Plus, developed in Aculux and printed on Ilford Multigrade. Camera and lens by courtesy of Len Corner.*

# Chapter 11

# The big guns

The rollfilm SLR effectively began with the VP Exakta, although it was possible before 1933 to put rollfilm behind a large-format SLR's lens by using a rollfilm back. By the mid-thirties, there was clearly a market for easily carried rollfilm SLRs, and a number of cameras appeared to compete for it.

In 1934, a camera called the Noviflex, manufactured by Eichapfel of Dresden, became the world's first 6cm × 6cm SLR. The first model had a fixed lens, usually an 80mm f/2.8 Schneider Xenar or 75mm f/3.5 Meyer Trioplan, with a cloth focal-plane shutter with speeds of 1/20th to 1/1000th second. A later version, available in 1937, was offered with interchangeable versions of the same standard lenses, and a 150mm f/5.5 Tele-Megor as an optional long-focus lens. I have never managed to lay hands on a fully operational example of either version.

### The Reflex-Korelle

During 1935, Franz Kochmann, also of Dresden, whose Korelle strut-folding cameras were already well known and respected, launched the Reflex-Korelle. This curiously front-heavy and rather cumbersome camera was very successful, and was the inspiration after the Second World War for the English Agiflex 6cm × 6cm SLR.

The very first version, the Korelle I, is very scarce, had shutter speeds of 1/10th second to 1/1000th, and is worth looking for as a potentially sound investment. The Korelle IA, with shutter speeds from 1/25th second to 1/500th, emerged soon afterwards, followed by the Korelle IIA, which had additional slow speeds (1/10th, 1/5th, 1/2, 1 second, 2 seconds) and a delay-action mechanism. A simpler budget-priced version, the Korelle B, was marketed in small numbers with separately wound shutter and film transport and no frame finder.

All these models were finished in black enamel with nickel- or chromium-plated bright parts and a black-leather body covering. All had a 40.5mm screw lens mount, far too narrow a throat for very long-focus

lenses, and causing vignetting with lenses of focal length greater than about 180mm.

During (I believe) 1938, the Korelle III appeared. This is easily identified by its satin-chrome camera top-plate and reflex hood, and by its much wider lens throat, with a 55mm-diameter thread and a top shutter speed of 1/1000th second. Obviously, this called for a separate range of lenses, and it seems from a study of leaflets and advertisements of the time that only the better-quality Zeiss and Schneider lenses were at first offered in the new larger lens mount. Both 40.5mm and 55mm thread lenses were on sale at the same time.

Because the European war began during 1939, the Korelle III is comparatively uncommon in Britain, but is more frequently available in the USA. After the war, the models with the 40.5mm screw mount seem to have been discontinued, but a further version of the Korelle III appeared under the name Meister Korelle and is again, because of British import controls of the fifties, more common in the USA than in Britain.

The principal reliability problems around sixty years after the cameras were made are a tendency to shutter-tape breakage, which disables the shutter, and an even more common tendency to breakage of a cord which links the winding of the shutter to the film-transport lever-wind. Perhaps the designers foresaw this problem and marketed the Korelle B, without the linkage and the infamous cord, as a means of providing professionals with greater reliability.

### Reflex-Korelle lenses

The Reflex-Korelle was available at one time or another with almost every range of German lenses on the market, plus British lenses by Dallmeyer and American lenses in the US market. Many of these were 'unofficially' marketed by distributors. The six models of Reflex-Korelle are commonly found with any one of ten standard lenses. There were 75mm f/3.5 or f/2.8 Tessars and Xenars, an 80mm f/2.8 Tessar and a large and not particularly effective 80mm f/1.9 Primoplan. At the lower end of the price range were 75mm f/3.5 and f/2.9 Schneider Radionars and Ludwig Victars. I have also seen an example with an f/2.9 Trioplan, which, like the 3-element Radionar and (particularly) Victar options, is a poor deal by comparison with the 4-element lenses.

Because retrofocus lenses were not available at the time, and the requirement for a large moving mirror

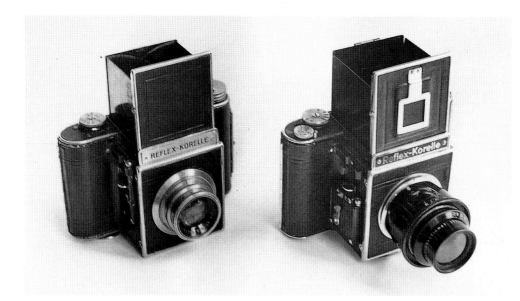

Two pre-war Reflex-Korelle cameras. On the left is a Reflex-Korelle B, the simplest model with no slow speeds, separate winding of film and shutter and no frame finder. This is fitted with a 75mm f/2.9 Victar. On the right is a Reflex-Korelle IIA with a 150mm f/5.5 Tele-Megor.

*Shot by available light at a camera fair with Zenith 80 fitted with 80mm f/2.8 Industar 29 on Ilford XP2, processed C41 and printed on Jessop Variable Contrast.*

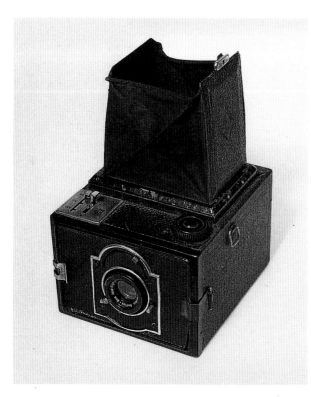

The KW Reflex-Box of the early thirties was a true SLR, although with little more than a box-camera specification. This one has an f/6.3 Anastigmat in a 3-speed shutter, shooting 8 exposures on 120 film.

*Camera by courtesy of Don Baldwin. Shot with Minolta SRT101 fitted with 58mm f/1.4 MC Rokkor on Ilford Pan F Plus, developed in Aculux and printed on Jessop Variable Contrast.*

imposed a minimum back-focus, no wide-angle lenses were or are available for the Reflex-Korelle series. In the 'official' lists, there were 105mm f/4.5, 135mm f/4.5, 180mm f/5.5, 240mm f/4.5, 300mm f/5.5 and 360mm f/5.5 Tele-Xenar lenses and 105mm f/4.5, 135mm f/4.5 and 180mm f/6.3 Tessars, plus a 400mm f/5.5 Tele-Megor. However, many other lenses can be found, including 150mm f/5.6 Dallon and 230mm f/4.5 Adon lenses from Dallmeyer.

### Using the Reflex-Korelle

By modern standards, the focusing screen of a Reflex-Korelle is not bright and the camera has an odd balance. The shutter release is, however, in the right place for the way the camera sits in the hand, and focusing with the left hand and firing and winding with the right becomes easy with experience. In practice, the Reflex-Korelle is at its best on a tripod and used for static subjects. I used Reflex-Korelle cameras a great deal some thirty years ago for studio portraiture. If you come across a 150mm Triotar mounted in the top of an Austin Seven piston with a flange at the back end for a BPM bellows unit, please let me know. I used it on Korelles and Agiflexes, focused and mounted via a BPM bellows, for years during the sixties and shot many excellent portraits with it.

While they could not be accused of being totally reliable, a good Reflex-Korelle is still capable of first-class work and is enjoyable to use.

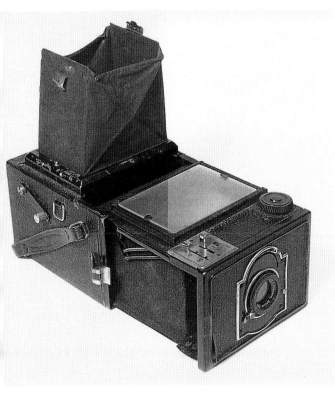

Separating the two halves of the KW Reflex-Box as though to load it shows more of its construction. The 6cm × 9cm focusing screen is clearly visible.

*Camera by courtesy of Don Baldwin. Shot with Minolta SRT101 and 58mm f/1.4 MC Rokkor on Ilford Pan F Plus, developed in Aculux and printed on Jessop Variable Contrast.*

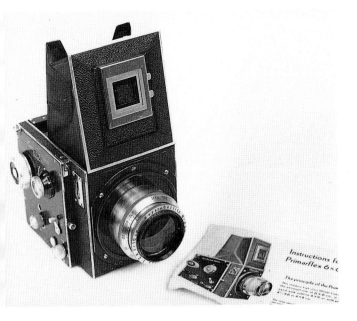

### The Pilot Reflexes

During 1936 the innovative and ever-resourceful KW company (Kamera Werkstätten Guthe & Thorsch of Dresden) which had earlier produced the beautifully compact Patent Etui 6.5cm × 9cm non-reflex plate camera, suddenly branched out with a metal-bodied cube-shaped rollfilm SLR producing twelve square exposures approximately 6cm × 6cm on 120 film. This was the Pilot 6, and was (alongside the much more

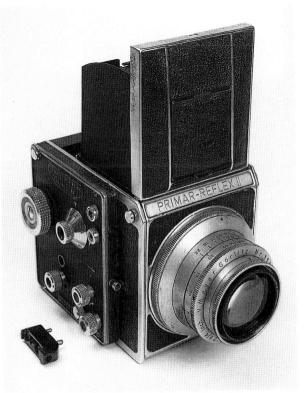

After the war, the Primar-Reflex II (above) was marketed. This was a much-developed camera and considerably different from the pre-war Primarflex. The lens on this example is a 4-inch f/2.8 Primoplan. The small object beside it is a 2-pin flash plug to fit the twin flash synchronization sockets on the side of the camera.

*Camera by courtesy of Philip Mason. Shot with Zenith 80 fitted with 80mm f/2.8 Industar 29 on Ilford FP4 Plus, developed in Aculux and printed on Jessop Variable Contrast.*

One of the two types of pre-war Primarflex, fitted with a 10cm f/2.8 Primoplan. An instruction leaflet for the camera is beside it.

*Camera by courtesy of Dave and Julie Todd. Shot with Pentax Spotmatic fitted with 55mm f/1.8 Super-Takumar on Ilford Pan F Plus, developed in Aculux and printed on Jessop Variable Contrast.*

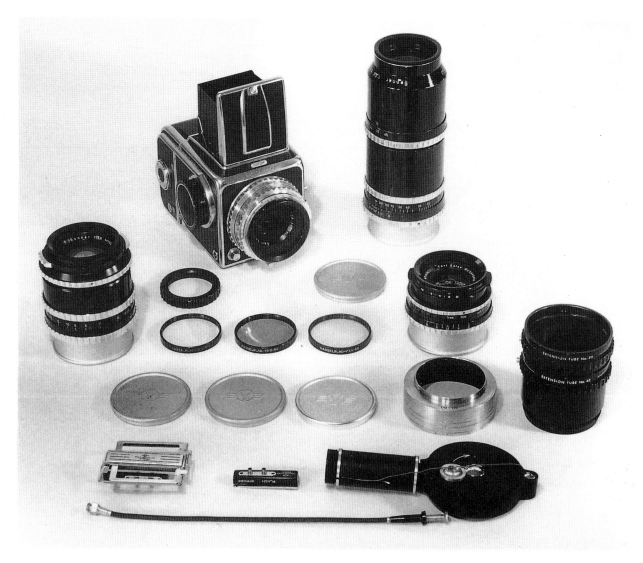

An impressive Hasselblad 1000F outfit. Taking the picture as being four rows, from the back, it shows (l. to r.): *Back row:* Hasselblad 1000F fitted with 80mm f/2.8 Tessar, 250mm f/5.6 Sonnar. *2nd row:* 135mm f/3.5 Sonnar, three Hasselblad Series-7 filters and the typical Hasselblad lens cap, 60mm f/5.6 Distagon. *3rd row:* Hasselblad lens caps with the V logo in the centre, the Hasselblad lens hood for the 80mm f/2.8 Tessar and a set of Hasselblad extension tubes. *4th row:* The Hasselblad folding frame finder with electronic and bulb-flash synchronization sockets, and the Hasselblad flash shoe – you need one or the other to use flash with a 1000F. The large object to the right is a remote string release. *In front:* The special Hasselblad cable release.

*Shot with Topcon RE-2 fitted with 58mm f/1.8 RE-Topcor on Ilford Pan F Plus, developed in Aculux and printed on Ilford Multigrade.*

expensive and better-engineered Primarflex) undoubt-edly, like the VP Exakta, a landmark camera.

Most examples of the Pilot 6, which turns up with a wide variety of lenses, have a non-interchangeable lens, usually a KW Anastigmat f/6.3 (the budget-priced option) or an f/3.5 Pololyt. From 1938, the Pilot 6 was produced with an interchangeable lens mount,

and the camera used for the picture featured on page 19, and illustrated on page 15, is an example of this version. In 1939 it was superseded by the Pilot Super with a built-in extinction meter.

Any Pilot SLR now feels old, somewhat flimsy and not really fit for use. I have tried, but I don't recommend it.

### The Primarflex

Much bigger, heavier and apparently tougher than the Pilot were the two pre-war versions of the Primarflex, announced by Curt Bentzin of Görlitz during 1936. Fitted with a 105mm f/3.5 Tessar and a focal-plane shutter, the Primarflex was equipped to use either 120 rollfilm or glass plates and had a non-interchangeable viewfinder. From the start it was an unreliable camera, and most examples that turn up now do not work properly. If you find one that does, do not abuse your luck – if you use it to any significant degree, it will fail.

After the Second World War, a developed and rather more reliable version of the camera appeared in 1951 under the name Primar-Reflex. Aside from the name, this is identifiable by its interchangeable viewfinder hood. The same camera was also marketed as the Astraflex II. Even this version is not to be relied upon, although it is an important and interesting collectible.

The Hasselblad 1000F in more detail, with 80mm f/2.8 Tessar and flash-synchronization shoe in position. Note the pedantic (but delightfully accurate) engraving on the lens mount '22" from film'. The control above the flash shoe varies the delay in firing the flash when using flash bulbs. The button at 5 o'clock to the lens mount is the lens release catch.

*Shot with another Hasselblad 1000F during the seventies. No other data available.*

Two Hasselblads of the post-1000F generation. The Hasselblad 500C on the left has a black (and slightly bent!) 80mm f/2.8 Planar T* (indicating multi-coating). The Hasselblad 2000FC on the right also has an 80mm f/2.8 Planar T*, but without the Compur shutter, since the camera has a focal-plane shutter. However, the 50mm f/4 Distagon T* wide-angle lens between them can be used on either, since the 2000FC has facilities for locking out the focal-plane shutter and using the Compur in the lens instead.

*Shot with Rolleiflex SL66 fitted with 80mm f/2.8 Planar on Ilford FP4 Plus, developed in Aculux and printed on Jessop Variable Contrast.*

### The Hasselblad

The major advance in rollfilm SLR design emerged during 1948. The Hasselblad company of Sweden, which had spent the war years manufacturing innovative aerial and military cameras designed by Victor Hasselblad (and also producing fine clock movements) launched Victor Hasselblad's long-dreamed-of 'civilian camera', the Hasselblad 1600F. The Hasselblad originated the 4-module principle upon which the majority of successful professional rollfilm SLRs have since been based.

The four modules were, of course:

(1) the body, containing the mirror mechanism, focusing screen and (at that stage) the shutter

(2) the interchangeable rollfilm magazine at the back

(3) the interchangeable lens at the front

(4) the interchangeable viewfinder on top.

The Hasselblad 1600F featured a stainless-steel-foil focal-plane shutter only 0.016mm thick, which was thinner than a human hair and should never be touched. It provided shutter speeds from 1 second to 1/1600th second, although the accuracy of the highest speed was always in some question. The lens was either an 80mm f/2.8 Ektar or (at the end of the production run) an 80mm f/2.8 Tessar, in either case with preset diaphragm. The lens mount was a unique coarse screw thread which effectively functioned as a bayonet – a short twist and the lens locked home with a definitive click. Just 2,859 Hasselblad 1600F cameras were made.

By 1952, the unreliability and high price ($548 [then about £195] in the USA) of the 1600F were becoming an embarrassment to the Victor Hasselblad organization and their dealers, and the Hasselblad 1000F was launched with significant mechanical improvements, and a less-stressed though fundamentally similar shutter with a top speed of 1/1000th second. The price came down to $400 (the 1600F apparently continuing to be 'closed out' at $500) which, as professionals began to trust Hasselblad reliability, improved sales dramatically in the USA. With the 1000F was launched a fine range of Zeiss

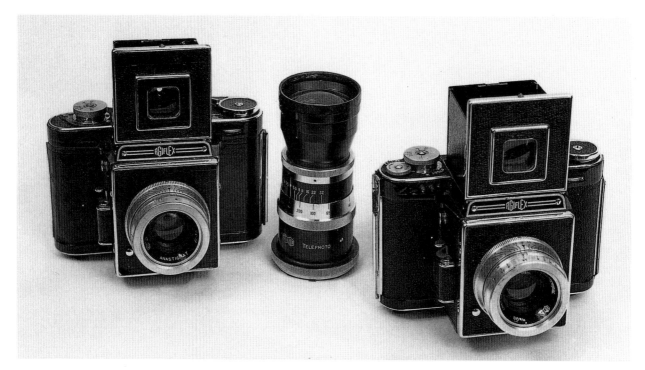

The early Agiflex cameras – an Agiflex I on the left and the Agiflex II with slow speeds on the right – with, between them, a 24cm f/5.5 Agilux Anastigmat in Agiflex II fitting. Both cameras have the 80mm f/3.5 Agilux lens and left-handed lever-wind.

*Shot with Rolleiflex SL66 fitted with 80mm f/2.8 Planar on Ilford FP4 Plus, developed in Aculux and printed on Jessop Variable Contrast.*

lenses in black mounts, from 65mm wide-angle to 250mm telephoto. Since British professionals could obtain an import licence, sales were also good in the UK, and the 1000F is consequently less scarce than one might expect in Britain, although relatively few examples of the 1000F, and even fewer of the 1600F operate well.

One of the reasons for this is the disregarding by many users of a simple but vital rule. The shutter speeds of an F series Hasselblad (or of any of the Zenit/Kiev cameras derived from them) must *never* be reset while the camera is unwound. Always wind first, reset speeds after. Hasselblad recommended that F cameras be stored with their shutters wound, the opposite to the rule for virtually every other camera.

By the mid-fifties, Hasselblad design engineers were thinking again. To lead the professional medium-format camera market, Hasselblad knew that reliability, as well as superlative performance, just had to be achieved. By close co-operation with West German Zeiss and Friedrich Deckel of Munich, whose Compur Reflex shutter was the basis of the success of the Contaflex 35mm SLR, Hasselblad developed the 500C, the landmark of landmarks among professional medium-format SLRs.

Looking remarkably like the 1000F, but in fact almost totally different, the Hasselblad 500C was designed to utilize a unique range of Zeiss lenses, each with automatic diaphragm and its own built-in between-lens Synchro-Compur shutter with speeds of 1 second to 1/500th second. The standard lens was the superlative Zeiss 80mm f/2.8 Planar with a bayonet 52mm filter mount, a major improvement on the 80mm f/2.8 Tessar of the 1000F, although that is itself a fine lens.

The C lens mount, a bayonet with the necessary linkages to enable the camera film-transport mechanism to cock the shutter and open the automatic diaphragm, was quite different to the coarse screw mount of the 1000F. The interchangeable film backs, looking almost identical to those of the F series cameras, were also different – you can use C backs on an F camera, but not F backs on a C camera. Unlike F backs, most of which give you no clue other than the exposure counter that the film has run out, C backs prevent the camera being fired again after exposure 12 (on a 12-exposure back). With the 500C, Hasselblad made available a 16-exposure back for negatives 6cm × 4.5cm (nominal) and, later, a 16S back for 16 exposures

of superslide format, 4cm × 4cm. A 70mm back for perforated 70mm film in cassettes was also launched, and, during the late sixties, a Polaroid back for flat film packs appeared. Note well that the Polaroid backs must *never* be fitted to an F camera, as they can do terminal damage to the flimsy shutter curtain.

The viewfinders remained the same – same fitting, same folding hood with magnifier, same magnifying hood with adjustable eyepiece. Soon after the launch of the 500C a prism finder was added to the range, which was a major advance for professional users.

The most important benefit of the Hasselblad 500C to professional users, which secured its position as the leading professional medium-format camera, was the ability to synchronize with flash at any shutter speed – the F series focal-plane shutter was synchronized only at 1/30th second, and then only via an easily lost flash-synchronization shoe or the sports finder with flash contacts. The combination of flash synchronization at high shutter speeds with interchangeable magazines (and therefore a constant supply of ready-loaded film) and interchangeable lenses made the Hasselblad 500C the ultimate workhorse for fashion photography and other studio work with moving subjects.

Initially, C film backs, like the F backs which preceded them, were somewhat laborious to load. After threading the film through the removable charger and replacing it in the back, a hinged metal cover in the centre of the rear surface had to be opened. This revealed a polished-steel tunnel at the end of which the numbers on the film backing paper could be seen. By winding the right-hand key on the magazine, the film could be wound through until the number 1 was visible. The metal cover was then closed, and the winding key flipped in the opposite direction to activate the exposure counter at 1. From then on, exposure counting was automatic. Winding the shutter and film operated the exposure counter and provided accurate exposure positioning.

Much later, the A series of backs appeared (A12, A16, etc.). These require only the arrow on the backing paper to be lined up with a marker dot, and the time-consuming system with the door at the back is unnecessary – you just wind through to number 1, either with the camera wind if the magazine is on the camera, or with the right-hand key on the magazine.

During the seventies, Hasselblad updated the 500C to produce the 500CM, with mainly cosmetic differences, and then made a surprising move back to

focal-plane shutters with the 2000FC, though without discontinuing the 500 series. The 2000FC had the same lens mount, viewfinder system and backs as the 500C and 500CM, but had an electronically timed focal-plane shutter with shutter speeds to 1/2000th second. The standard lens remained the 80mm f/2.8 Planar, but without the Compur shutter.

### Hasselblad lenses

The lenses for 1600F and 1000F were all preset, all coated and all, aside from the alloy mounts of the standard 80mm lenses, in black-enamel mounts. The correct lens caps are simple push-on caps in dull cadmium-plated metal finish, with the Hasselblad V logo in the centre. The initial series of C lenses were all in satin-chrome finish and all coated but not T* (Tee-Star) multi-coated. By the seventies, C lenses were available in either chrome or black. The T* lenses are much preferred by professional users and fetch higher prices. The Hasselblad lenses are summarized in the table on the right.

### Should you buy and use Hasselblad?

I used an outfit consisting of three Hasselblad 1000F cameras and a complete set of lenses for all my medium-format work between 1974 and 1979, and during that time had one of the cameras returned repaired from Hasselblad GB at Wembley with a note saying that there were very few shutter spares left. My good friend Colin Glanfield went one better – he actually had the last set of shutter spares from Wembley, a year or two later. Hasselblad F shutters never were reliable, are now very old, and, even if you can find (and afford) an example that works, you should not expect it to stand up to steady use.

The exact opposite is true of the C cameras. Certainly, one has to buy a 500C with care, for most of them started life as professionally owned cameras, and some of them are more or less worn out. But find a 500C that looks good, sounds sweet, and whose shutter and diaphragm snap open and shut in the right order with the right degree of asthmatic wheeze, and you could be on to a winner. Nothing, repeat nothing, produces better photographic quality.

The snag is that the C series lenses fit the current cameras and are always in demand, which keeps the price high. So, bought privately after haggling, a three-

#### Hasselblad lenses

| Wide-angle lenses | | | 1600/1000F | C chrome | C black |
|---|---|---|:---:|:---:|:---:|
| 30mm | f/3.5 | F-Distagon | | | ★ |
| 40mm | f/4 | Distagon | | ★ | ★ |
| 50mm | f/2.8 | Distagon | | | ★ |
| 50mm | f/4 | Distagon | | ★ | ★ |
| 55mm | f/6.3 | Wide Ektar | ★ | | |
| 60mm | f/5.6 | Distagon | ★ | ★ | |
| 60mm | f/4 | Distagon | | ★ | |
| 60mm | f/3.5 | Distagon | | | ★ |
| **Standard lenses** | | | | | |
| 80mm | f/2.8 | Ektar | ★ | | |
| 80mm | f/2.8 | Tessar | ★ | | |
| 80mm | f/2.8 | Planar | | ★ | ★ |
| 100mm | f/3.5 | Planar | | ★ | ★ |
| 105mm | f/4.3 | UV Sonnar | | ★ | ★ |
| 110mm | f/2 | Planar F | | | ★ |
| **Long-focus and telephoto lenses** | | | | | |
| 120mm | f/5.6 | S-Planar | | ★ | ★ |
| 135mm | f/3.5 | Sonnar | ★ | | |
| 135mm | f/3.5 | Ektar | ★ | | |
| 135mm | f/3.5 | Dallac | ★ | | |
| 135mm | f/5.6 | S-Planar | | ★ | ★ |
| 150mm | f/4 | Sonnar | | ★ | ★ |
| 250mm | f/4 | Sonnar | ★ | | |
| 250mm | f/5.6 | Sonnar | ★ | ★ | ★ |
| 254mm | f/5.6 | Ektar | ★ | | |
| 350mm | f/5.6 | Tele-Tessar | | | ★ |
| 432mm | f/5.6 | Dallon | ★ | | |
| 500mm | f/8 | Tele-Tessar | | ★ | ★ |
| 500mm | f/8 | Tele-ApoTessar | | | ★ |
| 508mm | f/5.6 | Dallon | ★ | | |

lens, two-magazine outfit will set you back between £1,500 and £2,000 ($2,250–$3,000). From a dealer with a guarantee it will cost substantially more.

### Britain's contribution – the Agiflex

During the Second World War, one of the major manufacturers of allied aerial-reconnaissance cameras was Aeronautical and General Instruments Ltd (AGI), based at Purley Way, Croydon, England, close to where I lived as a child. Although most of their production was of large-format (usually 9" × 9") non-reflex aerial cameras, they also made a hand-held aerial camera, the ARL which, although not a reflex, used the Reflex-Korelle as the basis of its design.

In 1947, with import controls limiting the availability of new imported cameras in Britain and defence orders at a minimum, AGI adapted the ARL to become an even closer replica of the pre-war Reflex-Korelle IA, and the Agiflex I was launched on to the UK, and subsequently overseas, camera markets.

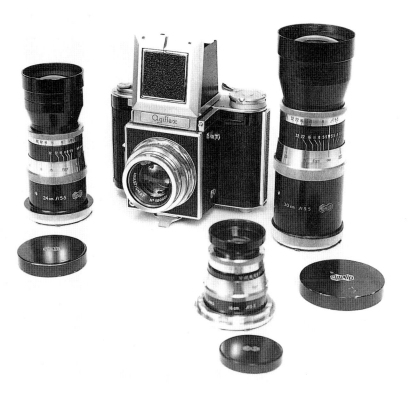

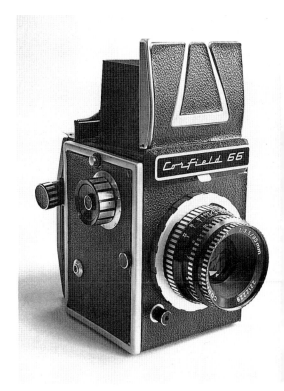

The much-improved (and scarcer) Agiflex III of 1954 with the 80mm f/2.8 lens. Note the neat fold-out foot under the mirror box which made it possible for the camera to stand level on any horizontal surface. To the left of the camera is the 24cm f/5.5 Agilux, to the right the 30cm f/5.5 Agilux. In front is the 16cm f/5.5 Agilux. All the lenses are in the Agiflex III fitting.

*Equipment by courtesy of Dave and Julie Todd. Shot with Pentax Spotmatic fitted with 55mm f/1.8 Super-Takumar on Pan F Plus, developed in Aculux and printed on Jessop Variable Contrast.*

The British Corfield 66 of the late fifties was a brave attempt at success in the minefield of rollfilm SLRs which foundered when confronted with lower prices and new developments from other countries. Equipped with a 95mm f/3.5 Corfield Lumax, it was not a commercial success and is now scarce.

*Camera by courtesy of Dave Ellis. Shot with Zenith 80 fitted with 80mm f/2.8 Industar 29 on Ilford FP4 Plus, developed in Aculux and printed on Jessop Variable Contrast.*

The big difference between the Korelles and the Agiflex cameras was the lens mounts. Whereas all Reflex-Korelles have screw-mount lenses, all Agiflex cameras have a 3-tongue bayonet. However, just as the Korelle III and the subsequent Meister Korelle had a larger-diameter throat, and therefore lens mount, than those of the earlier Reflex-Korelles, so the Agiflex III of 1954 had a larger-diameter throat and larger bayonet than the Agiflex I and II.

The three models of Agiflex closely paralleled those of the Reflex-Korelle series. The Agiflex I of 1947 had an 80mm f/3.5 AGI lens, with brilliant-blue coating, shutter speeds from 1/25th to 1/500th second and no flash synchronization (although many examples have been subsequently synchronized for flash, either with twin-pin plugs or with the standard 3mm coaxial socket). This first model rapidly acquired a reputation for breaking shutter tapes, which were very flimsy considering the mass of the fabric focal-plane shutter,

and also for breakage of the cord connecting the lever-wind film transport to the shutter so that the shutter could be wound at the same time as the film.

The Agiflex II, which followed in 1949 or 1950 (nobody seems to be able to agree on this date), looked similar except for the additions of a slow-speeds setting dial providing slow speeds down to 2 seconds and twin-pin-plug flash synchronization as standard. However, I am reliably informed that the Agiflex II was significantly redesigned, more reliable and easier to service than the Agiflex I. The new camera was fitted with the same 80mm f/3.5 standard lens.

Both the Agiflex I and II were unusual for having a reflex mirror of polished copper rather than glass, which had the considerable disadvantage of being shiny on the underside. This tended to cause reflections which degraded the photographic image.

When the Agiflex III appeared during 1954, not only did it have the larger throat and lens bayonet, it

also offered a new 80mm f/2.8 lens and standard 3mm coaxial-socket flash synchronization. The considerably brighter focusing screen made it a faster and more precise camera to use.

### Agiflex lenses

As with the Reflex-Korelle, no wide-angle lenses were supplied for the Agiflex series of cameras, which considerably inhibits their range of usefulness in modern photography. A range of three British-made AGI-branded long-focus lenses was marketed, first in the smaller bayonet fitting for the Agiflex I and II, then in the larger Agiflex III fitting. These were a 16cm f/5.5, a 24cm f/5.5 and a 30cm f/5.5.

All these lenses are surprisingly effective if stopped down to a reasonable working aperture with the camera on a tripod and with time to get the focus right. For slow and deliberate photography, the Agiflex, preferably an Agiflex III, is both enjoyable and effective. The earlier models are regrettably unreliable, and while fun to use once in a while, are not really to be recommended for regular photography.

### KW and the Praktisix

The next major line of European rollfilm SLRs to appear (other than the Exakta 66, discussed in an earlier chapter) was the Praktisix, which emerged in 1957. With its right-thumb lever-wind and optional prism, the Praktisix was the first of the 'big 35mm' rollfilm SLRs.

Arguably the ancestor of the Pentax 6×7, which eclipsed it in the seventies, the Praktisix nonetheless owed much in its fundamental design to the Reflex-Korelle. Shaped and with handling characteristics much like a Praktica or Praktina, it was and is fast to use, excellent for hand-held rollfilm photography and the basis of an effective system.

The Praktisix appeared in a succession of models all with very minor differences – the Praktisix I, II and IIA – followed, after the acquisition of KW by VEB Pentacon, by a version of the IIA renamed the Pentacon Six. Its interchangeable lenses were fitted via a breech-lock mount similar to that of its stablemate, the Praktina. The shutter was a horizontally running cloth focal-plane unit with speeds from 1 second to 1/1000th second. It had interchangeable viewfinders.

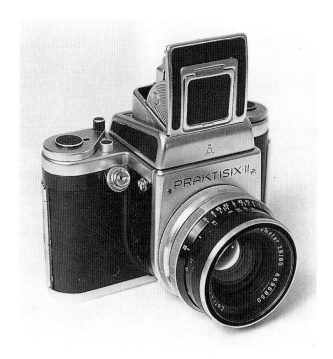

A rather handsome Praktisix II with the standard 80mm f/2.8 Biometar which is common to all but the very earliest of the Praktisix series. Notice the sturdy breech-lock ring at the back of the lens mount – a quick twist and the lens is free.

*Camera by courtesy of Jim Anderson. Shot with Minolta SRT101 fitted with 55mm f/1.7 MC Rokkor on Ilford Pan F Plus, developed in Aculux and printed on Jessop Variable Contrast.*

The great disadvantage of the Praktisix by comparison with the Hasselblad was the lack of interchangeable backs, so professionals using the camera for rapid action had to have two cameras and switch bodies when the film ran out. The photographer's sweating assistant had to be fast at changing lenses as well as films.

The great advantage was the price. In 1957, a Praktisix was half the price of a Hasselblad 500C, and a spare camera body cost little more than a Hasselblad magazine back. Although the reliability of the Praktisix, particularly in the film-transport department, was not as good as that of the Hasselblad, photographers carried two or three bodies instead of two or three Hasselblad backs – and if one failed, each body had its own shutter, film transport and viewing system and little was lost. For sports photographers particularly, the Praktisix was good because two bodies could be equipped with different focal-length lenses to be ready for use at the same time.

By 1970, the price differential with Hasselblad and other comparable medium-format SLRs was even more pronounced, particularly where the lenses were concerned. The UK price in 1970 of a 50mm f/4 for Hasselblad was £364.5s.0d (then about $875). The 50mm f/4 Flektogon for Pentacon Six was priced at £129.8s.9d (about $310). By this time, a version known as the Pentacon Six TL was available. This had a mighty eye-level prism containing a CdS TTL exposure meter. The ultimate development came at the end of the eighties, when essentially the same camera, in black with Schneider lenses, reappeared as the Exakta 66, a camera completely unrelated to the Exakta 66 of the fifties.

## Praktisix/Pentacon Six lenses

All the lenses of the original Praktisix were East German, the majority being made by Zeiss in Jena, and some by Meyer. Initial deliveries were equipped with a Meyer 80mm f/3.5 Primotar of indifferent quality or with a rather better, but less than brilliant, 80mm f/2.8 Tessar. The quality of these lenses was not adequate for the professional market at which the camera was aimed, and it was not long before KW standardized during 1958 on the much better 80mm f/2.8 Biometar.

From the outset, an excellent range of interchangeable lenses for the Praktisix was offered at comparatively affordable prices, and the more commonly used focal lengths remain quite easy to find at collectors' fairs. My particular favourite lens for this range of cameras is the 120mm f/2.8 Biometar, which is both easy to handle and capable of crisp, contrasty, exciting results.

The 180mm f/2.8 Sonnar is the direct descendant of the famous pre-war Olympia-Sonnar supplied for the Contax, and, when supplied for Praktisix, is in fact an adapted Exakta-mount lens. You will find that the Praktisix lens mount clicks off, leaving a standard Exakta mount – one of the only examples I know of a lens deliberately supplied to fit 35mm and 6cm × 6cm cameras from different manufacturers (although, of course, by the sixties the ties between Ihagee and VEB Pentacon in Dresden were already close).

When the various trade-marks disputes between Zeiss in Jena (East Germany) and Zeiss in Oberkochen were resolved, rights to the name 'Sonnar' were gained by West German Zeiss. At this point, the 180mm f/2.8

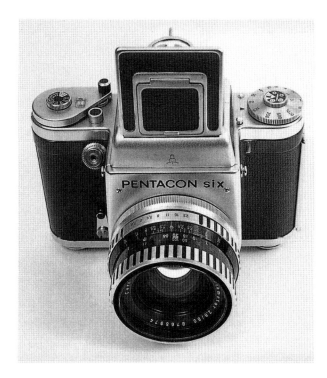

The only visible differences between the Praktisix II of the last picture and this Pentacon Six are the addition of a delay-action mechanism to the camera and a new design for the mount of the 80mm f/2.8 Biometar, whose number is more than 200,000 later than that on the Praktisix.

*Shot with Zenith 80 fitted with 80mm f/2.8 Industar 29 on Ilford FP4 Plus, developed in Aculux and printed on Jessop Variable Contrast.*

### Praktisix/Pentacon Six lenses

| | | | Diaphragm | Elements | Closest focus |
|---|---|---|---|---|---|
| **Wide-angle lenses** | | | | | |
| 50mm | f/4 | Flektogon | FAD | 7 | 18in. |
| 65mm | f/2.8 | Flektogon | FAD | 6 | 30in. |
| | | | | | |
| **Standard lenses** | | | | | |
| 80mm | f/2.8 | Biometar | FAD | 5 | 30in. |
| 80mm | f/2.8 | Tessar | FAD | 4 | NDA |
| 80mm | f/3.5 | Primotar | Preset | 3 | NDA |
| | | | | | |
| **Long-focus and telephoto lenses** | | | | | |
| 120mm | f/2.8 | Biometar | FAD | 5 | 3ft 9in. |
| 180mm | f/2.8 | Sonnar (later Jena S) | FAD | | 7ft 3in. |
| 300mm | f/4 | Sonnar (later Jena S) | FAD | 5 | 13ft 0in. |
| 300mm | f/4 | Orestegor | Preset | 5 | 12ft 0in. |
| 500mm | f/5.6 | Orestegor | Preset | 4 | 20ft 0in. |
| 1000mm | f/5.6 | Catoptric | None | NDA | NDA |

Sonnar and 300mm f/4 Sonnar lenses, as supplied by Zeiss in Jena for various East German cameras, became 'Jena S' lenses. There is no difference between the lenses marketed under the two names.

### Is the Praktisix or Pentacon Six a sensible buy to use?

It is true that the lever-wind mechanism of the Praktisix/Pentacon Six has to be treated gently and with respect, but care will usually be rewarded with reliability if previous owners were also reasonably careful. The lenses, while not quite of the standard of the West German Zeiss lenses shared by the Hasselblad and the Rollei SL66, are capable of delivering consistent top-quality professional results. It is still possible to pick up Pentacon Six outfits with a camera, standard lens and two other lenses for around £350 ($525) or less, and at that price one gets a lot of rollfilm capability for the money.

If you happen to have plenty of money to spend on a Hasselblad 500C outfit or a Rolleiflex SL66 and

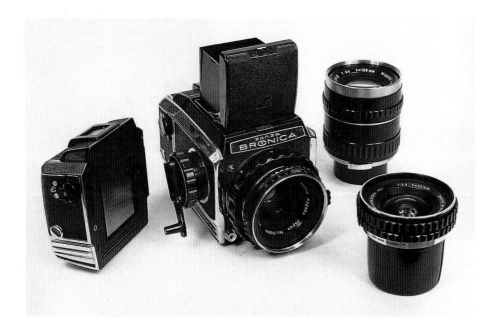

The Bronica S2A changed public perception of Japanese 6x6 single-lens reflexes worldwide. This was a camera with which one could earn one's living – and many did. This fine example has the 75mm f/2.8 Nikkor standard lens and (at the back) the 135mm f/3.5 Nikkor long-focus. In the foreground is a 50mm f/3.5 Zenzanon. All are fine lenses. The additional film back on the left has been turned to show the 12/24-exposure switch for converting the back from 120 to 220 film – a great benefit for photography with models, when many exposures are often needed to provide enough choice for a client.

*Shot with Rolleiflex SL66 fitted with 80mm f/2.8 Planar on Ilford FP4 Plus, developed in Aculux and printed on Jessop Variable Contrast.*

After the Bronica S2A and its predecessors came the total redesign of the Bronica EC. The camera on the right is a black example of the original EC, that on the left the EC-TL, capable of utilizing the TTL exposure-meter prism. The lens on the right-hand camera is the 80mm f/2.8 Zenzanon, engraved 'by Carl Zeiss Jena DDR' – an unusual example of Euro-Japanese co-operation in rollfilm equipment. The left-hand EC has the more usual 75mm f/2.8 Nikkor.

*Shot with Rolleiflex SL66 fitted with 80mm f/2.8 Planar on Ilford FP4 Plus, developed in Aculux and printed on Jessop Variable Contrast.*

its lenses, there is no doubt whatever that the more expensive purchase will yield greater reliability and better results under full-aperture conditions. But, you must ask yourself, is that worth four or five times the expenditure?

### Bronica. The Japanese strike back

Until 1958 there was no credible Japanese professional rollfilm SLR. After 1958, and particularly after 1965 when the Bronica S2 appeared, there was real competition for Hasselblad from Zenza of Tokyo, named after its founder, Zenzaburo Yoshino.

For the Bronica Z of 1958 in many ways mimicked the Hasselblad 1000F, looked somewhat similar to it and, although not 100% reliable, was probably more so than the focal-plane-shuttered Hasselblads. The Bronica Z, now distinctly rare, was the world's first medium-format camera to have an instant-return mirror, and the first to have a mirror that flipped downwards into the floor of the camera rather than upwards to the screen. It was the only medium-format SLR other than the Bronica De Luxe of 1960 (as far as I know) to have a shutter speed of 1/1250th second. Unlike the Hasselblad F series, the focal-plane shutter was made of cloth and was relatively quiet. Like them it had interchangeable backs. The lens, a 75mm f/2.8 Nikkor made by Nippon Kogaku, was superb.

The camera was sufficiently successful for Zenza to improve its mechanical design in various ways to increase reliability and to relaunch it as the Bronica De Luxe (or Bronica D) in 1960, although the Z apparently continued in production until 1961. The major difference from the user's standpoint was a simpler film magazine which was faster to load.

The seeds of Bronica success were really sown during 1961 when a completely restyled camera, the Bronica S appeared. This no longer looked like a Hasselblad, although it retained the accepted four-module design, with interchangeable lenses, viewfinders and magazine backs. The major innovation of the S, abandoned in later cameras of the S series, was rack-and-pinion focusing, whereby turning a knob on the right-hand side of the camera body racked the lens in and out. The shutter, still focal-plane, had a top shutter speed of 1/1000th second, and a full range of magnificent Nikkor lenses was by this time available, in focal lengths up to 600mm, the lenses bayoneting into the common focusing mount.

The Bronica C of 1964 was notable for having only removable film chargers rather than interchangeable magazines, a feature designed to reduce the price and embrace an economy market. It was the first Bronica to have the very useful feature of being switchable from 120 to 220 film. This camera had helical focusing and by 1966 could be bought with considerably less expensive, but very effective, Komura lenses.

During 1965, the launch of the Bronica S2 provided professionals worldwide with a camera they could begin to take seriously. Although still with a focal-plane shutter, and therefore with limited studio flash-synchronization potential, the S2 was comparatively reliable for hard professional use, although it still had not gained the near-unstoppability of the Hasselblad 500C. The Nikkor lenses were wholly comparable with the West German Zeiss lenses of the Hasselblad, although the latter had still an undeniable edge. The interchangeable magazines were switchable from 120 to 220 like the film chamber of the Bronica C.

Experience showed, however, that Bronica S2 cameras that were really put through the professional

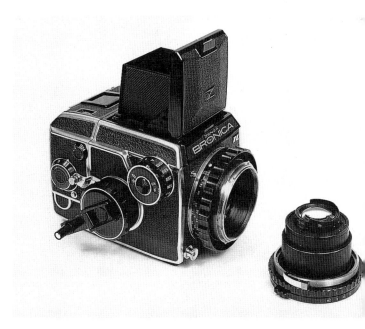

Removing the standard lens from a Bronica EC (or S2A) shows the separate focusing mount which provides not only for the standard lens but for wide-angles too. This in turn can be removed from the body for the fitting of long-focal-length lenses and accessories such as extension tubes.

*Shot with Rolleiflex SL66 fitted with 80mm f/2.8 Planar on Ilford FP4 Plus, developed in Aculux and printed on Jessop Variable Contrast.*

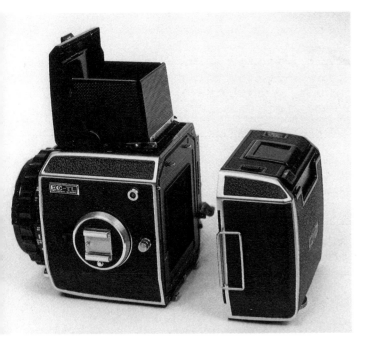

Removing the film back from a Bronica EC-TL reveals the cloth focal-plane shutter. Note the metal handle of the dark slide – when taken out, this is stowed in the sleeve visible at the back of the magazine so that it does not get mislaid while shots are being taken.

*Shot with Rolleiflex SL66 fitted with 80mm f/2.8 Planar on Ilford FP4 Plus, developed in Aculux and printed on Jessop Variable Contrast.*

mill experienced problems with the film- and shutter-transport gearing. So the Zenza design engineers reworked the design and produced the Bronica S2A, with nitrided gears for additional hardness and durability. A very large number of Bronica S2A cameras were sold between 1969 and about 1975, when it was finally closed out, although production reputedly ceased in 1972.

The S2A retained the innovative 'falling mirror' design, but Zenza had yet another surprise waiting when they launched the bigger, heavier and altogether nicer Bronica EC in 1972 and 1973 (depending where you were in the world at the time). For as well as being the world's first medium-format camera with an electronically controlled shutter, the Bronica EC was designed around a two-part reflex mirror, which split into two parts when the shutter was fired, one part going up to the focusing screen and the other down into the floor of the camera. This feature greatly increased the space available for the rear projection of wide-angle lenses.

The Bronica EC was a total redesign, with different magazine backs and a new back fitting and a new range of viewfinders in a different fitting. The electronically controlled shutter, still a focal-plane unit, provided speeds from 1 second to 1/1000th. Only the lens mount remained the same. In 1975, a development of the EC, the Bronica EC-TL added to Zenza's impressive list of firsts by becoming the world's first medium-format SLR with built-in TTL automatic-exposure measurement.

Not until the end of the seventies did Bronica abandon the focal-plane shutter, as Hasselblad had done in 1957, and launch a camera and a range of lenses with between-lens shutters. This was the Bronica SQ, in developed form still in production as I write this book nearly twenty years later. Everything about the SQ was different – lens mount, backs, finders, even the price – and it has been hugely and justifiably successful.

### Bronica lenses

The Bronica cameras were equipped with Nikkor lenses only until 1965, the standard lens being a five-element 75mm f/2.8 Nikkor, which is a top-quality lens by any standard. The first additional lenses to appear were the 50mm f/3.5 Nikkor wide-angle and a 135mm f/3.5 Auto Nikkor, although these were soon augmented by the launch of a 180mm f/2.5 Nikkor. Preset lenses of 250mm, 350mm and 500mm focal lengths were also available in a special mount which fitted only the outer bayonet of the Bronica Z, De Luxe and S cameras. Later cameras did not have this outer bayonet, but an adaptor was supplied which enabled them to be used on the S2 and later cameras.

Meanwhile, during 1961, 150mm f/3.5, 200mm f/4 and 300mm f/4.5 auto Nikkors appeared, with 400mm and 600mm Nikkors launched shortly afterwards. All these lenses were comparatively expensive, and Zenza seemed anxious to provide economical options. Thus were launched first the Komura range of lenses, in 1965/66, then the Zenzanon range, more expensive than the Komura lenses but less so than the Nikkor optics. Some of the early Zenzanon lenses were made by Carl Zeiss in Jena.

The Komura range included 45mm f/4.5 and 50mm f/3.5 wide-angles, 135mm f/3.5 and 150mm f/3.5 medium-long-focus lenses, 200mm f/3.5 and 300mm f/4.5 telephotos and a very long 500mm f/8 lens.

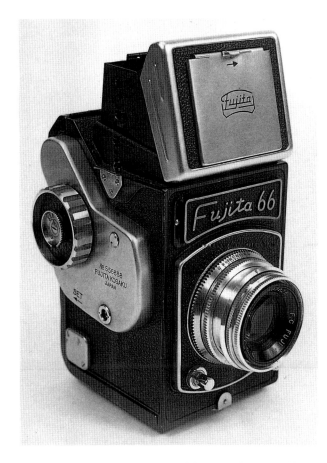

The Zenzanon range added a 50mm f/2.8, a screen-brightening 80mm f/2.4, a 100mm f/2.8, a 150mm f/3.5 and a 200mm f/4. None of the lenses in these economy ranges should be regarded as an unsatisfactory alternative. The Nikkors *are* better, but only marginally so under most circumstances.

### Should you buy Bronica to use?

If you buy any Bronica prior to the EC with the intention of using it at all frequently, make sure it is an S2A (which is marked as such in front of the film magazine). These, if you find one which has not had heavy use, are still reasonably reliable and deliver top-quality results. Earlier models are unreliable in the film-transport mechanism and in the shutter area.

Although it sounds almost like a recommendation not to buy a classic camera when a modern camera will do, the safest approach to buying a focal-plane Bronica for regular hard use is to stick out for a really nice EC or EC-TL. Being electronically controlled, the EC might be argued by some not to have classic status, but they are usually sound, are nice to use and deliver the quality most people seek but do not always find when they buy a medium-format camera. The only snag with buying a secondhand EC is finding spare film backs. They are available if you look hard enough, but

The Fujita 66 with its scew-mount f/3.5 lens. Although frequently offered at temptingly low prices, these are not a safe buy for frequent use.

*Shot with Zenith 80 fitted with 80mm f/2.8 Industar 29 on Ilford FP4 Plus, developed in Aculux and printed on Jessop Variable Contrast*

The Kalimar/Six Sixty came from the same factory as the Fujita 66 and has the same lens mount and the same unreliability problems. With this one are the 150mm f/3.5 lens, which performs well, and the 52mm f/3.5 wide-angle which has the distinction of delivering the worst edge definition I have ever seen when used at full aperture. At f/8, however, it is quite crisp.

*Equipment by courtesy of Bob Davey. Shot by available light at a camera fair with Zenit-B fitted with 58mm f/2 Helios at f/2 on Ilford FP4 Plus, developed in Aculux and printed on Jessop Variable Contrast.*

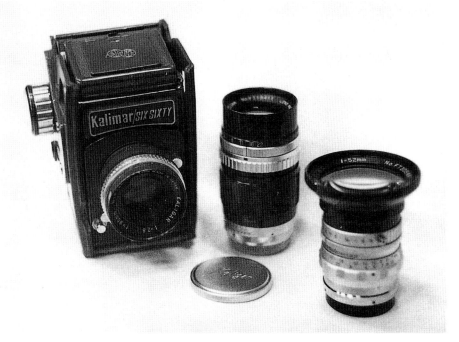

are not as common as S2A backs. It therefore pays to try and find an EC outfit that already includes two or three magazines.

### The Fujita 66 and Kalimar reflexes

These two brands of camera were both manufactured by Fujita Optical Industries Ltd of Japan, and various models exist, although they are all basically similar apart from minor differences of specification. All accept the same screw-mount lenses and do not have interchangeable film backs.

The first to appear was the Fujita 66ST, marketed in 1956 with an 80mm f/3.5 lens and a focal-plane shutter with speeds from 1/25th second to 1/500th second. In 1958, the Fujita 66SL with slow speeds to 1/5th second was launched.

Meanwhile, Fujita had been making for Kalimar of Japan an essentially similar camera, but with full slow speeds to 1 second. This was the Kalimar Reflex, marketed from 1956 to 1962. However, two versions exist – early models without an instant-return mirror and later ones (after 1960) with instant-return mirror.

The Fujita line continued with the appearance in 1960 of the Fujita 66SQ, with an 80mm f/2.8 lens instead of the f/3.5 lens, and the instant-return mirror

The Komaflex-S was, as far as I know, the only 12 on 127 single-lens reflex camera. This one works well although, when it was loaned to me, I hesitated to use it very much in case it joined most of its contemporaries in the SLR's graveyard. With the camera are the auxiliary wide-angle and telephoto lenses and their leather case.

*Equipment by courtesy of Gerry Cookman. Shot with Minolta SRT101 fitted with 55mm f/1.7 MC Rokkor on Ilford Pan F Plus, developed in Aculux and printed on Jessop Variable Contrast.*

that appeared on the Kalimar Reflex in the course of the same year.

By 1963, when the Kalimar/Six Sixty, probably the best known of the series, was made available, only the Kalimar cameras were in production. The Six Sixty had the 1/5th to 1/500th second shutter, the 80mm f/2.8 preset lens and a pleasant two-tone grey finish.

For both ranges, two additional lenses were available – a 52mm f/3.5 and a 150mm f/3.5. The f/3.5 aperture of the 52mm lens is strictly for viewing only, since if you shoot pictures at f/3.5, they will be literally blurred around the edges, so great are the aberrations. However, when stopped down to about f/8, the 52mm Kalimar/Fujita delivers reasonably crisp images. The 150mm lens is much better. It is quite common to encounter examples of the 52mm lens remounted for Hasselblad 1000F, since this was a popular cheap means of getting an ultra-wide angle (as it was then seen) for the Hasselblad in the late fifties.

All the Fujita/Kalimar 6cm × 6cm SLRs are unreliable and give mediocre results. They are interesting to own, but better on a shelf than in your camera bag.

### The Komaflex

The Komaflex-S was manufactured by Kowa and is an extremely unreliable camera which is rarely found in full working order, but is noteworthy for being probably the only SLR ever made producing twelve exposures 4cm × 4cm on 127 rollfilm. I had the good fortune to be lent the example illustrated on the left while I was writing this book. This camera actually worked properly, but I was hesitant about making much use of it because it was borrowed and because it was likely to stop working if encouraged.

The Komaflex-S had a 65mm f/2.8 Kowa Prominar lens in Seikosha-SLV between-lens shutter with speeds of 1 second to 1/500th second.

### The Kowa Six series

In 1968, after making a series of less than reliable budget-priced 35mm cameras, Kowa suddenly burst upon the world with a very respectable 6cm × 6cm SLR – the Kowa Six. Rather more upright in its appearance than a Hasselblad or Bronica, and with more than a passing resemblance to a post-war Exakta 66, the Kowa Six sported an impressively large interchangeable 85mm f/2.8 breech-lock-mounted lens

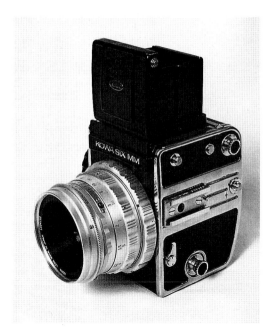

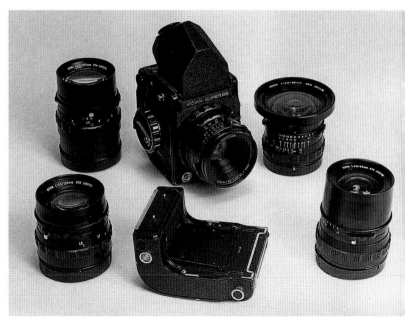

The Kowa Six was a compact box-shaped camera with between-lens shutters in a range of lenses of good quality. The mechanical design was not as good as the lenses, although one photographer of my acquaintance claims to have worked out the fundamental fault which causes them to jam occasionally, and to be able to fix it. The Kowa Six did not have interchangeable film backs.

*Shot at a camera fair with Zenith 80 fitted with 80mm f/2.8 Industar 29 on FP4 Plus, developed in Aculux and printed on Jessop Variable Contrast.*

The Kowa Super 66 was much superior to the Kowa Six. The range of lenses was expanded and the system had L-shaped interchangeable magazine backs. In this picture are: *Back row:* 200mm f/4.5 Kowa lens, Kowa Super 66 with 85mm f/2.8 standard lens, 35mm f/4.5 Kowa wide-angle. *Front row:* 150mm f/3.5 Kowa, 12/24 exposure 120/220 interchangeable film back, 55mm f/3.5 Kowa wide-angle.

*Equipment by courtesy of Gerry Cookman. Shot with Minolta SRT101 fitted with 55mm f/1.7 MC Rokkor on Ilford Pan F Plus, developed in Aculux and printed on Jessop Variable Contrast.*

with its own between-lens shutter in the manner of the Hasselblad 500C. The Kowa Six was the first Japanese 6cm × 6cm SLR to have between-lens shutters in each of its lenses, the 55mm f/3.5 and 150mm f/3.5 lenses each being in a peculiarly bright satin-chrome finish like that of the standard 85mm lens. Unlike the Hasselblad and Bronica, the Kowa Six did not have interchangeable film backs.

Despite the poor reputation of 35mm Kowa cameras, the Kowa Six sold well, although persistent faults with the mirror-lift mechanism began to sully its name fairly soon after its launch. Perhaps as a result, a much-redesigned successor camera, the Kowa Super 66, appeared only four years after the launch of the Kowa Six. The big obvious difference was the fact that the Super 66 had interchangeable 120/220 backs in an unusual L-shaped design, but in fact the camera was almost totally reworked and was a much more reliable (and also more expensive) piece of equipment.

With the new camera appeared a new expanded range of lenses in black finish, still with the same breech-lock mount (which incidentally works in the opposite direction to those of Canon, Pentacon Six and

Praktina, and has a tendency to confuse people), and still with fully speeded between-lens shutters. As well as the 55mm and 150mm f/3.5 lenses, there were now a 200mm f/4.5 and a startlingly wide 35mm f/4.5 wide-angle, at that time the widest-angle lens available for any 6cm × 6cm SLR. Other accessories were gradually added to the range, including a 45-degree prism and a magnifying finder with dioptric adjustment of the eyepiece and a built-in TTL exposure meter. 16-exposure 6cm × 4.5cm magazine backs (32-exposure with 220 film) made the Kowa Super 66 even more versatile and practical as a professional or advanced amateur camera, and they were frequently seen being used as wedding-photography cameras during the seventies and eighties.

However, the hard facts were and are that the Kowa Super 66 never achieved the high standard of reliability needed for the relentless transporting of film demanded of a professional studio 6cm × 6cm camera (sometimes up to 100 films a week), and was too expensive to achieve volume amateur sales. In a sense, it fell between two requirements, never quite meeting the specification demanded by either.

## Should you buy Kowa?

The original Kowa Six, without interchangeable magazine backs, can be bought reasonably cheaply if you shop around or buy privately. But it is not a camera to be relied upon for heavy use and getting spares can be difficult. The Super 66 is a much better bet, and will probably serve you well with amateur use. The lenses are quite scarce but should be found for low three-figure sums where owners or dealers take a realistic view of the market. The problem is that many dealers who take Kowa outfits in part exchange seem to have little idea of their market value. I recently saw a Kowa Six outfit – the camera, standard lens, 55mm and 150mm – advertised for £600 ($900) in Britain. A more realistic price would have been about £350 ($525).

Of the Kowa lenses, the 85mm f/2.8 is the most effective, the 55mm and 150mm in chrome finish performing very well other than at full aperture. The black versions of these lenses seem to deliver sharper results, although this may be due simply to improved coating, and the later black 200mm and 35mm lenses are excellent value, though not up to Hasselblad standards. For studio work or medium-format landscape photography, for which full aperture operation is rarely needed, the Kowa may be just what you need.

### The Zenith 80 and Kiev 80

In 1969, the various Soviet-made 35mm SLRs being marketed in Western countries were joined by the Zenith 80 (usually so spelt), a 6cm × 6cm four-module SLR with a metal-foil focal-plane shutter. It was clearly modelled on the Hasselblad 1000F, which it resembled quite closely both inside and out, but was manufactured to poorer standards and is subject to all the same problems as the 1000F, only rather sooner. During the seventies, a second, very similar, camera appeared, known as the Kiev 80. These are for all practical purposes the same camera, manufactured to a common design by two different factories, one in Moscow, the other in Kiev.

The Zenith 80 was, in fact, a development of an earlier camera, the Salut, which was based on the Hasselblad 1600F and had a fastest shutter speed of 1/1500th second. The Salut design apparently suffered the same fate as the 1600F – hasty redesign to eliminate shutter unreliability, and reduction of the fastest speed to 1/1000th. The result was the Zenith 80.

The 80mm f/2.8 Industar 29 lens with which the Zenith 80 was universally fitted performed surprisingly well, even at full aperture, and was fully up to professional standards when stopped down a little. Its automatic preset diaphragm (which had to be cocked open after the shutter was wound) was fast and effective, although it was not possible to reset the aperture until it was cocked, and the only way of viewing depth of field after it was cocked was to take up the first pressure on the shutter button to fire the diaphragm without firing the shutter – after which the diaphragm had to be recocked if further focusing was required. The lens was deeply recessed in its mount, and thereby needed no lens hood.

The lens mount looked at first sight identical to that of the Hasselblad 1000F, but the lenses were not cross-compatible. I am told by friends who have tried it that very modest machining of a Zenith 80 lens mount makes it fit a Hasselblad 1000F. I know of nobody who has been mad enough to try machining a Hasselblad lens to fit a Zenith! The magazine backs also seemed to be identical to Hasselblad backs, but were not cross-compatible. They are, however, loaded in exactly the same way. Like the original Hasselblad 'F' magazine back, the Zenith 80 back does not prevent further exposures being made after twelve have been shot. I recently proved accidentally that this feature makes it possible to get thirteen exposures from a 12-exposure 120 film.

The metal-foil focal-plane shutter had speeds of 1/2 second to 1/1000th second, but was noisy and made curious and alarming scrunching noises as it was wound. The winding knob, which, as on the Hasselblad 1000F was also the shutter-speed-setting knob, bore an impressive red warning label with 'IMPORTANT' across the middle. This warned that the shutter *must* be fully wound before the shutter speed is reset, otherwise the mechanism will jam. Not 'might jam' you notice. This is a warning which users ignore at their peril, because unjamming a Zenith 80 is an expensive exercise.

Stapled into many Zenith 80 instruction books is a typewritten addendum asking users to keep the shutter button depressed until the exposure is completed when using the slow speeds. Releasing the button before the shutter has closed can damage the shutter.

A further point to note is that the magazine of a Zenith or Kiev 80 (like that of a Hasselblad) should be removed only when the little circular colour-indicator

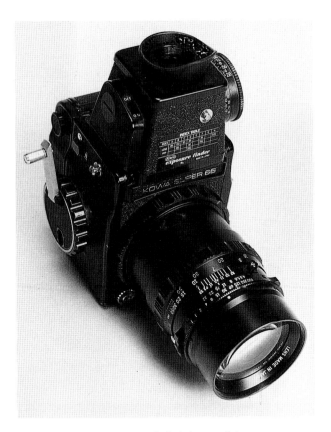

The Zenith 80 outfit, as supplied in its curiously Russian-smelling leather outfit case.

*Shot with Minolta SRT101 fitted with 55mm f/1.7 MC Rokkor on Ilford Pan F Plus, developed in Aculux and printed on Jessop Variable Contrast.*

The Kowa Super 66 system also included a magnifying exposure-meter finder, shown here with the 200mm f/4.5 lens. This shot shows clearly the easily read shutter, aperture and focus data on the lens mount.

*Equipment by courtesy of Gerry Cookman. Shot with Minolta SRT101 fitted with 55mm f/1.7 MC Rokkor on Ilford Pan F Plus, developed in Aculux and printed on Jessop Variable Contrast.*

windows on camera and magazine back are both showing white signals. This indicates that the camera and film are wound after the last exposure. Before winding, both will be showing red signals. Never attach a back to the camera with dissimilar signals showing. Finally, it should be noted that the Zenith 80 instruction book, unlike the Hasselblad 1000F book, suggests that the camera should be stored with the shutter unwound.

The Zenith 80 was always sold as an outfit, in a neat leather outfit case containing the camera, fitted with 12-exposure magazine back, a spare 12-exposure back, a Hasselblad-fitting camera strap, an instruction book and a set of three 40.5mm filters. Note that, when new, the magazine back on the camera bore the camera's body number and the second back of the outfit was engraved with the camera's number followed by an 'A'. This suggests that the backs were individually matched for register to the cameras, and that backs

bearing a number other than that of the camera may not be a perfect match.

The Zenith 80 outfit case, while neat, is gloriously impractical, since the camera cannot be lifted from it without first putting the case on a flat surface. Attempting to get at the camera in any other way results in the entire contents of the case being spilled on the ground. Most users transferred the camera and its accessories to a more practical camera bag.

At first sight, the 40.5mm filters seemed far too small for the camera. However, the Zenith 80 filter fitting was one of the rather more innovative ideas to emerge from Eastern European camera manufacturers. Instead of being required to screw large-diameter (and expensive) filters into the front of the lens mount, the user unscrewed a conical tube from the inner lens mount forward of the front element of the lens, revealing a 40.5mm filter thread on the back of the cone. This small filter (the same size as was required for the various lenses of the Zorki and Fed rangefinder cameras) was and is cheap to buy and small to carry. 40.5mm close-up lenses can be fitted in the same way, although with the odd result that they finish up being mounted back to front in relation to the lens. This seems not to affect the results in any discernible way.

233

The Zenith 80 and standard lens with, beside it, a magazine back turned with its rear to the camera to show the door through which the backing-paper numbers are observed to get the film to exposure no. 1. The alloy lever or protrusion at 10 o'clock to the lens circumference, near the back of the lens mount, is the diaphragm cocking lever.

*Shot with Minolta SRT101 fitted with 55mm f/1.7 MC Rokkor on Ilford Pan F Plus, developed in Aculux and printed on Jessop Variable Contrast.*

The Zenith 80 and standard lens with the other two lenses that were supplied for it. On the left is the 65mm f/3.5 MIR-3, on the right the 300mm f/4.5 TAIR-33. Both are impressive performers although feeling mechanically rough by comparison with the lenses of more expensive systems. Both lenses come in leather cases with orange and yellow filters fitted into slots inside the lid.

*Shot with Minolta SRT101 fitted with 55mm f/1.7 MC Rokkor on Ilford Pan F Plus, developed in Aculux and printed on Jessop Variable Contrast.*

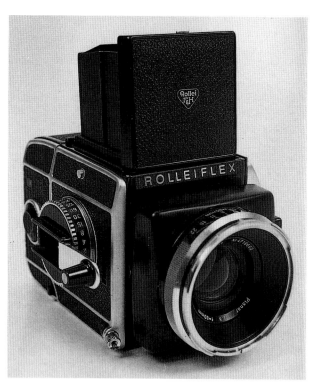

The Rolleiflex SL66 is a beautiful, impressive and expensively manufactured instrument capable of results equal to those of the Hasselblad 500C and its successors. Unlike the Hasselblad, it has been subject to some unreliability problems with film magazines, but this should not be overstated. A lightly used SL66 is a camera well worth buying at the fairly low prices they currently fetch.

*Shot with Zenith 80 fitted with 80mm f/2.8 Industar 29 on Ilford FP4 Plus, developed in Aculux and printed on Jessop Variable Contrast.*

The complete Zenith 80 outfit was being marketed in Britain during 1970 at the remarkably low price of only £157.15s (then about $380).

### Zenith 80/Kiev 80 lenses

During the classic-camera period – i.e., up to about 1980 – there were only two lenses of focal lengths other than 80mm available for the Zenith 80/Kiev 80. These were the 65mm f/3.5 MIR-3 wide-angle and the 300mm f/4.5 TAIR-33. Both were supplied in their own brown-leather cases, in the lid of each of which was a separate compartment containing yellow and orange filters. The 65mm f/3.5 had a similar spring-loaded automatic preset diaphragm to that of the 80mm lens; the 300mm f/4.5 had a straightforward preset diaphragm.

Both, like the 80mm lens, were surprisingly good, although both were also alarmingly large and weighty for their focal lengths by modern standards. Provided

that you have a Zenith or Kiev 80 that is performing reliably upon which to mount them, both lenses will deliver extremely good results for the money you pay, which is currently around £85 ($128) per lens.

Since the classic period of which I am writing, the Kiev 88, an updated version of the Kiev 80, has appeared with automatic diaphragm. A substantially greater range of lenses is available for this camera, and the prism sold for it fits both the older Zenith/Kiev 80 cameras and also all Hasselblads.

### Should you buy the Zenith 80 or Kiev 80?

I suspect that most failures of Zenith and Kiev 80 cameras are due to users (or enthusiastic but ill-informed visitors to camera shops) resetting them without winding, firing the slow speeds without holding the button down or other similar misuse. Treat them well and they usually keep going, albeit while making some odd noises.

No Russian 6cm × 6cm SLR that I have used is suitable for a perfectionist. They are pragmatists' cameras, appropriate to photographers who believe that, if they finished up with a good shot, the camera worked well, whatever the problems encountered during the process. If you can live with their eccentricities and the significant risk of their going wrong, you get a great deal of camera and lens for your money.

### The Rolleiflex SL66

Launched in 1968, the Rolleiflex SL66 was a major departure for its German manufacturers, Franke and Heidecke, previously best known for their twin-lens Rolleiflex and Rolleicord cameras.

At the time of its launch, the Rolleiflex SL66 threatened to become a major force in the professional camera market, a promise never realized. This was, I believe, primarily because it had a focal-plane shutter and because so many photographers were by now totally dependent upon studio flash systems. It was partly because there were reports of unreliability of the magazine backs quite soon after the camera's launch. And it was also because the SL66 was the most expensive 6cm × 6cm SLR available – not a satisfactory platform from which to launch an attack on the dominance of the Hasselblad – although the lenses were cheaper. In 1970, a 50mm f/4 Distagon for Rolleiflex SL66 (i.e., without shutter) was priced at

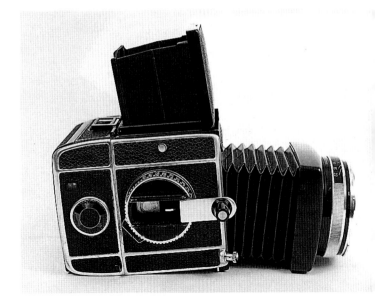

The most unusual characteristic of the Rolleiflex SL66 is its bellows and drop-and-tilt front facility, giving the camera some of the movements of a monorail for control of depth of field in close-up work.

*Shot with Zenith 80 fitted with 80mm f/2.8 Industar 29 on Ilford FP4 Plus, developed in Aculux and printed on Jessop Variable Contrast.*

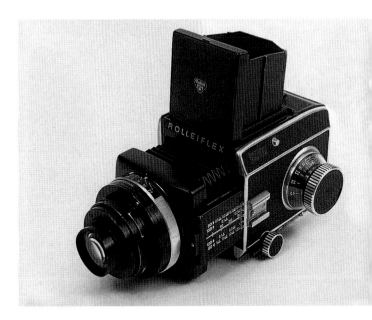

Also unexpected is the fact that the front end of the standard 80mm f/2.8 Planar lens is able to bayonet into the lens mount to reverse the standard lens for macro work. Coupled with the bellows extension, this makes the Rolleiflex SL66 uniquely suited to top-quality extreme close-up work.

*Shot with Zenith 80 fitted with 80mm f/2.8 Industar 29 on Ilford FP4 Plus, developed in Aculux and printed on Jessop Variable Contrast.*

£238.18s.5d (then about $575). The same lens for Hasselblad (with shutter) was £364.5s.0d (about $875).

The Rolleiflex SL66 was original and innovative in many ways. It was the only rollfilm SLR to have its lens panel mounted on bellows providing built-in close-focusing capability; the only rollfilm SLR with front-lens panel movements; the only rollfilm SLR whose lens could be reversed, using its filter mount as an alternative lens mount, for the ultimate close-up lens performance.

It was a four-module SLR, but with a difference later emulated by other manufacturers – alternative shutters as well as alternative lenses, backs and finders. By 1970, there were ten lenses for normal photography plus a range of four Luminars for macro photography available for the SL66. Of the normal lenses, two, versions of the 50mm f/4 Distagon and the 150mm f/4 Sonnar, were listed with built-in Synchro-Compur shutters – but were still marked 'price to be announced' and stayed that way for too long for the confidence of the professional market to be earned.

The result was that sales were disappointing, and the SL66 is not now available in large numbers. Equally, it is not much sought after, and does not command a high price by comparison with its quality. The lenses, on the other hand, are very scarce and do cost a great deal.

The SL66 is a camera ideally to be used on a tripod. While it can be used hand-held, it never feels right and is clumsy by comparison with a Hasselblad. It is easy to load, relatively foolproof in use, and has the endearing feature of telling when the last exposure on a film has been used by causing the wind-through knob on the magazine to pop out with a loud click. The quality of the results is absolutely superb.

### Rolleiflex SL66 lenses

All lenses for the SL66 were manufactured by West German Zeiss and closely matched the range available for the Hasselblad during the early seventies.

### Should you buy an SL66?

I know of an SL66 which recently changed hands at a camera fair for £350 ($525), which is to my mind a bargain – and yet probably a fair if slightly low price. I do not know of an instance where a non-standard lens for an SL66 has changed hands for as little as that.

---

**Rolleiflex SL66 lenses**

**Wide-angle lenses**

| | | | Diaphragm | Elements |
|---|---|---|---|---|
| 40mm | f/4 | Distagon | Automatic | 10 |
| 50mm | f/4 | Distagon | Automatic | 7 |

**Standard, long-focus and telephoto lenses**

| | | | | |
|---|---|---|---|---|
| 80mm | f/2.8 | Planar | Automatic | 5 |
| 120mm | f/5.6 | S-Planar | Automatic | 6 |
| 150mm | f/4 | Sonnar | Automatic | 5 |
| 250mm | f/5.6 | Sonnar | Automatic | 4 |
| 500mm | f/5.6 | Tele-Tessar | Preset | 5 |
| 1000mm | f/8 | Tele-Tessar | Manual | NDA |
| 1000mm | f/5.6 | Mirotar | None | Mirror lens |

**Macro lenses**

| | | | | |
|---|---|---|---|---|
| 63mm | f/4.5 | Luminar | NDA | 3 |
| 40mm | f/4.5 | Luminar | NDA | 3 |
| 25mm | f/3.5 | Luminar | NDA | 4 |
| 16mm | f/2.5 | Luminar | NDA | 3 |

---

The moral is that, if you are prepared to use only the standard 80mm f/2.8 Planar, and can find a camera which has not had a great deal of hard professional use, the SL66 is extremely good value and a joy to use for studio work. If you want to buy and use other focal lengths, you will need deep pockets.

### The classic medium-format choice

All old medium-format cameras are prone to problems, and it never pays to rely on one camera of any type. Try to budget for two, so that you have a spare when something goes wrong.

However, if you are determined to chance your arm with one of the moderately priced classic rollfilm SLRs (which excludes on price grounds the Hasselblad 500C, the Rolleiflex SL66 and the Bronica EC), the Pentacon Six (i.e., one of the later cameras in the series) or the Bronica S2A are probably the best buys. There will be enthusiasts who disagree with me on this, citing the Kowa Six or even one of the Russian SLRs, but that's life.

If you can afford it and the implications of its lens costs, buy a Hasselblad 500C. If you can almost afford it but want lower-cost lenses, buy a Bronica EC. If you want Hasselblad quality for less money and are definitely not going to worry about finding other lenses, buy a Rolleiflex SL66.

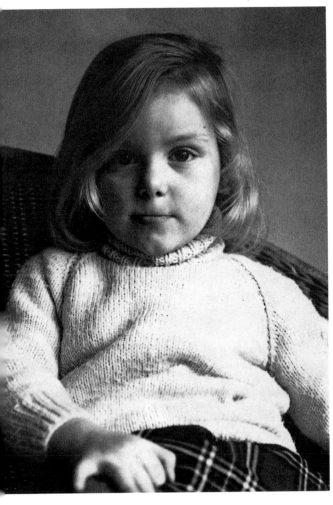

My wife's niece Zoë, now the mother of three sons, photographed in 1965 with a Reflex-Korelle. This is a perfect example of the soft quality which older European lenses provide and which became profoundly out of fashion when the Japanese optical industry captured the imaginations and allegiance of photographers around the world.

*Shot with Reflex-Korelle IIA fitted with 75mm f/3.5 Tessar on Ilford HP4, printed at the time on a matt chlorobromide paper – probably Agfa Portriga Rapid.*

Inside one of the halls of the old Covent Garden market, musicians entertain customers at the café and wine bar. This picture again demonstrates that long-held prejudices against relatively low-cost wide-angle lenses can be quite unjustified.

*Shot with Zenith 80 fitted with 65mm f/3.5 MIR-3 on Ilford FP4, developed in Aculux and printed on Jessop Variable Contrast.*

This picture of my MPP Mark VII 5" × 4" camera was taken to illustrate an article for the MPP User's Club's *MPP Gazette* on the adaptor in the foreground. This clever device, designed and made by Dr A. Neill Wright, enables me to put the lenses mounted for my 6cm × 9cm Linhof Technika on to the MPP, which is particularly useful in the case of the 65mm f/8 Super Angulon shown on the left.

*Shot with Praktisix IIA fitted with 80mm f/2.8 Biometar on Ilford FP4, developed in Aculux and printed on Jessop Variable Contrast. Camera and lens by courtesy of Jim Anderson.*

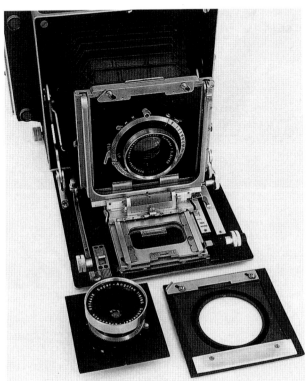

The London skyline looking north-east from the South Bank, near the National Theatre. This shot, taken with the Kowa Super 66 and 150mm lens, is beautifully sharp.

*Shot with Kowa Super 66 fitted with 150mm f/4.5 Kowa on FP4 Plus, developed in Aculux and printed on Jessop Variable Contrast.*

The Pantiles in Tunbridge Wells, Kent, on a cold, wet evening in autumn. The Praktisix IIA was on a tripod, enabling me to stop down to obtain good depth of field while achieving sharpness at 1/30th second. Fortunately, the elderly lady walked only very slowly, so her image was not blurred by the comparatively slow shutter speed.

*Shot with Praktisix IIA fitted with 80mm f/2.8 Biometar on Ilford FP4, developed in Aculux and printed on Jessop Variable Contrast. Camera by courtesy of Colin Glanfield.*

This delightful lady let me photograph her while she fed the pigeons in London's Trafalgar Square. I found the Kowa Super 66 a delight to use.

*Shot with Kowa Super 66 fitted with 150mm f/4.5 Kowa on FP4 Plus, developed in Aculux and printed on Jessop Variable Contrast.*

The picture above right is chiefly notable for having been shot with a 12 on 127 Komaflex-S – the camera illustrated on page 230. There is not much going for a Komaflex-S, because it is fiddly to handle, difficult to focus and unreliable. I regarded getting some sort of a result from it as a minor triumph.

*Shot with Komaflex-S fitted with 65mm f/2.8 Kowa Prominar on Jessop 200 ASA 127 black-and-white film, developed in Aculux and printed on Jessop Variable Contrast.*

My wife Anne with a friend by the name of Mica, an amiable beast who had been working all day and objected to being kept away from her evening meal by the photographic session – hence the rather bored expression.

*Shot with Praktisix IIA fitted with 80mm f/2.8 Biometar on Ilford FP4, developed in Aculux and printed on Jessop Variable Contrast. Camera and lens by courtesy of Jim Anderson.*

Anne in country mode, perched on a stile in rural Sussex. This shot was less spontaneous than it looks, having been set up laboriously with a huge Russian 300mm f/4.5 TAIR-33 on the Zenith 80, with the whole weighty contraption mounted on a Linhof tripod. I think it was worth the effort.

*Shot with Zenith 80 fitted with 300mm f/4.5 TAIR-33 on Ilford FP4 Plus, developed in Aculux and printed on Jessop Variable Contrast.*

Anne putting me to shame on a day when we were invited, during 1966, for a day's shooting at Bisley. I had shot for my school and was confident of natural male supremacy in such things. She picked up a service rifle and scored higher than anybody else on the range.

*Shot with Hasselblad 1000F fitted with 50mm f/2.8 Ektar on Ilford FP3, printed on Ilford Multigrade.*

This street musician who performs in London's Covent Garden has taught his dog to 'sing' to the music of the saxophone. The delighted expression of the lady in the background shows that the result is not all bad. Bearing in mind that this shot was taken with one of the widest-angle lenses available for a 6cm × 6cm camera, the print is beautifully sharp.

*Shot with Kowa Super 66 fitted with 35mm f/4.5 Kowa ultra-wide-angle on FP4 Plus, developed in Aculux and printed on Jessop Variable Contrast.*

## Chapter 12

# Using the really old ones

The first two chapters of this book outlined the history of the single-lens reflex and discussed the ailments of elderly cameras in some detail. This final chapter, unlike the preceding ones, will not attempt to define which manufacturers' cameras are most to be relied upon, since, when dealing with equipment that is seventy, eighty or even more years old, there is simply no reliable basis for judgment other than assessment of the individual camera's condition. Nor will it attempt to be a complete listing of large-format SLRs, any more than the earlier chapters have been. The design and characteristics of early single-lens reflexes is a subject for a book in itself, and I can do no more than look at some of the better-known types and comment upon their potential for use.

Whether any camera more than sixty years of age can actually be used at all depends far more on whether means can be found to put film behind the lens and shutter in light-tight conditions, and on whether the way in which the camera has been looked after has allowed the fundamental mechanism of the camera to remain working, than on the original design standards of the manufacturer. Obviously enough, well-built fine cameras (Adams, Soho, Mentor Reflex, etc.) will be more likely to be in running order than lesser equipment, but there is no hard-and-fast rule.

In general terms, to be able to shoot pictures with an elderly large-format SLR you will need either a camera which both works and has a reliable rollfilm back which takes 120 film, or one which works and for which you have plate or cut-film holders of 6cm × 9cm, $2\frac{1}{2}" \times 3\frac{1}{2}"$, ¼-plate or 5" × 4" format. It is at the time of writing still possible to buy black-and-white cut film in 6cm × 9cm and 5" × 4" as normal commercial items from a professional photographic supplier, and of course, all types of colour emulsion are available in the universal professional 5" × 4" format. ¼-plate cut film manufactured by Ilford Limited in Britain is available to special order.

Types of camera to watch for, which will provide a reasonable chance of finding one which works well, are the various types of Graflex from the USA, British-made Houghton-Butcher and Ensign reflexes (made by the same manufacturer) such as the Popular Pressman, Mentor Reflexes from Germany and the endearing British Thornton-Pickard reflexes. Almost any collectors' camera fair will provide the opportunity to see several SLRs of these types, particularly in Britain, but do check them carefully if you intend trying to use them.

### Greater love hath no man...

While writing this book, I spotted in a photographic shop which I know well a ¼-plate Thornton-Pickard Junior Reflex with a Taylor-Hobson 15cm f/4.5 lens and a RADA 6cm × 9cm rollfilm back. It looked fairly worn externally, although the RADA back seemed much smarter than the rest of the camera – perhaps not surprisingly, since it was half the camera's age.

Asking to check it, I was very surprised to find that the camera seemed to work perfectly – by which I do not mean just that the shutter flopped through the aperture when the shutter lever was operated, but that the shutter delivered something very like the marked shutter speeds, that the lens was in correct focus and that all the light-traps looked good. Having bought it, I stepped out of the shop, walked 100 yards to the main road and crossed the road to my car, swinging the camera nonchalantly by its leather handle, as a bus approached. To my horror, the RADA rollfilm back suddenly fell off in the middle of the road – I had not latched it properly. The bus was getting closer. It was clearly me or the rollfilm holder.

There was only one decision to make. I stopped, held up my hand to the bus and bent down to retrieve the rollfilm holder. The bus stopped suddenly, the amazed driver enquiring solicitously after my parentage. Still crouching, I looked up and said "It's my rollfilm back!"

"I should see a doctor if it's that bad", he replied.

It was as well that I did pick up the back, since good rollfilm backs for Thornton-Pickards are not easy to find. Never buy a rollfilm back for a camera you already have without first trying it to see if it fits, for there are several fittings, plus many rollfilm backs which have been adapted with varying degrees of skill to fit cameras for which they were never intended.

The following week, I took the Thornton-Pickard to a camera fair, hoping to buy a telephoto lens to fit it. Unscrewing the standard 150mm f/4.5 Taylor-Hobson

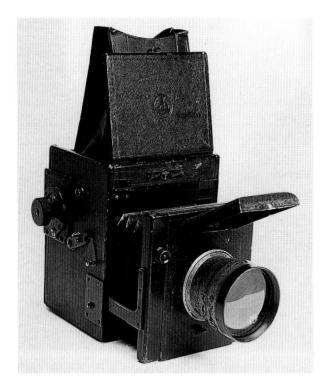

Several pictures taken with this camera are included at the end of this chapter. They demonstrate that the quality which can be obtained from these elderly lenses, if one exercises care, is really very good.

## The Altrincham connection – Thornton-Pickard

The Thornton-Pickard Junior Reflex, referred to above, is quite common in Britain, less so elsewhere, and was made at Altrincham, near Manchester. It was one of the more commercially successful models from a range of field, hand-and-stand and reflex cameras which developed and prospered between 1888 and the 1920s, and continued with increasing precariousness until 1940, when Thornton-Pickard ceased production, although the name continued in existence until 1963.

The Thornton-Pickard SLRs had their heyday during the 1920s and 1930s, and were in most cases made of wood covered with black leather, although a number of different 'tropical' models were made, as is the way with tropical cameras, in brass-bound teak.

The ¼-plate Thornton-Pickard used for many of the pictures accompanying this chapter, here fitted with the grim-looking 12" f/4.5 Dallmeyer with which the shot of the blue tit beside the nesting box (page 253) was taken. The shutter release is the lever towards the front of the side of the camera. The knob behind it winds the shutter and sets a pointer to the shutter speed. The bellows extension on large SLRs of this type makes it straightforward to experiment with fitting lenses of any number of types – it is not uncommon, for example, to find ex-military 7" f/2.5 Aero Ektar lenses at camera fairs, which can provide excellent results on black-and-white, although their colour correction is suspect. They are also decidedly radioactive due to early use of rare-earth glasses, so should not be kept under the bed!

*Shot with Minolta SRT101 fitted with 55mm f/1.7 MC Rokkor on Pan F Plus, developed in Aculux and printed on Jessop Variable Contrast.*

lens revealed a thread which looked normal enough. But none of the telephoto lenses of the right age and provenance at the fair would fit. They all had 2" or 2½" diameter mounts. My Thornton-Pickard was 2¼".

Two or three weeks later, a friend found for me a 12" f/4.5 Dallmeyer lens with the correct 2¼" lens thread, externally scruffy but optically good. I now had an outfit, and sallied forth to take photographs. Almost immediately I started getting really exciting results. I was hooked. I also started getting strange comments from bystanders, one of whom threw money into my camera bag in the belief that I was part of the Brighton street-entertainment scene.

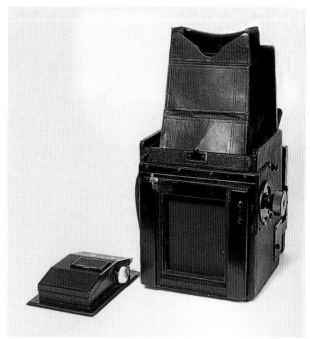

A back view of the Thornton-Pickard with the RADA rollfilm holder removed. The catch at the top left holds the plate holder or rollfilm back in place, but is flimsy for the task. Take care that it is properly latched or you too may risk being run over by a bus (see page 241).

*Shot with Minolta SRT101 fitted with 55mm f/1.7 MC Rokkor on Pan F Plus, developed in Aculux and printed on Jessop Variable Contrast.*

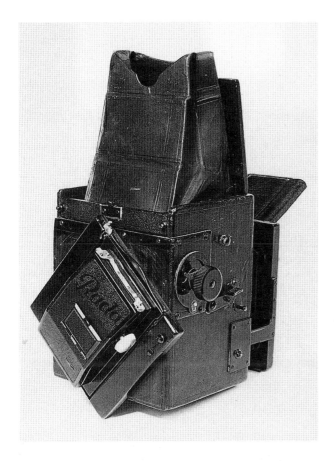

I set up this shot to show how the components of a RADA rollfilm back relate to one another. The inner film holder comes out of the back by pulling out the wind knob (which usually puts up stout resistance), lifting the holder at the wind-knob end, and pulling it to release the other end from under the projection carrying the felt light-trap. The unexposed film is put in where the film is in this picture, and the paper leader goes to the left, under the holder and up on the right into the take-up spool. The holder is then replaced into the back and the wind knob pushed back in to retain it.

*Shot with Minolta SRT101 fitted with 55mm f/1.7 MC Rokkor on Pan F Plus, developed in Aculux and printed on Jessop Variable Contrast.*

The camera back of the Thornton-Pickard revolves to permit vertical or horizontal shots, and the tripod bush is positioned so that this can be done while the camera is on a tripod.

*Shot with Minolta SRT101 fitted with 55mm f/1.7 MC Rokkor on Pan F Plus, developed in Aculux and printed on Jessop Variable Contrast.*

All had cloth focal-plane shutters, some had double-extension bellows (the Duplex Reflex).

Models included the Horizontal Reflex of 1923, the Victory Reflex of 1925 and the Ruby Reflex and Junior Special Ruby Reflex of 1928. Most were fitted with Dallmeyer, Taylor-Hobson or Ross lenses and a substantial number of interchangeable lenses could be bought from these manufacturers.

### The Soho deerhunter

The Photographic Collectors Club of Great Britain has been enriched by many colourful and immensely knowledgeable members. One of these is Tom Holliday, whose not wholly serious dissertations on the use of extremely elderly cameras are accompanied by quite extraordinarily good examples of photography which prove that he was not joking after all.

Tom has a ¼-plate Soho Reflex, a British plate single-lens reflex which was manufactured by A. Kershaw and Sons Ltd and marketed by Marion &

Looking at the rollfilm holder from the other side, this shot shows the film wound through so that the arrows on the leader paper are showing through the slots between the spools. At this point, the rollfilm holder is closed (with the dark slide inserted) and the film is wound through until no. 1 on the backing paper shows through the appropriate red window in the back. Remember to stick a piece of gaffer tape or Blu-Tack over the red window to prevent fogging of modern fast panchromatic films.

*Shot with Minolta SRT101 fitted with 55mm f/1.7 MC Rokkor on Pan F Plus, developed in Aculux and printed on Jessop Variable Contrast.*

Co. of London. The Soho Reflex was one of the earliest commercially successful cameras of its type, being launched initially during 1905. Living near a deer park in the English Midlands, Tom decided during the autumn of 1994 to try shooting credible pictures of deer with his seventy-odd-year-old Soho.

To appreciate the magnitude of his task, it is worth considering the sequence of operations necessary to expose a frame of film using a Soho Reflex with a rollfilm back – the process is little different for other similar early SLRs. Tom describes the sequence as follows:
- Determine exposure
- Set shutter speed and mentally note aperture to be set
- Set the mirror in the 'down' position
- Open lens aperture to fullest extent (to make the screen bright enough for focusing)
- Focus and frame the subject, noting the positions of prominent or contrasting elements of the picture to assist with keeping the picture framed after stopping down (when the screen image almost vanishes)
- Remove the dark-slide (which has to be in during film transport because the shutter is not self-capping)
- Set the working aperture
- Check the framing of the picture as best you can, given that you cannot see much on the screen with the lens stopped down
- Release the shutter
- Replace the dark-slide
- Wind to the next frame.

Going through that process while trying to photograph a creature as unlikely to stand about waiting to be photographed as a deer clearly has its problems.

The first time Tom visited the park, he had a stationary deer nicely lined up for photography, with the Soho's longest lens, an 11½" Ross Teleros, poking through the wire fencing and resting on the wire. Just as he was about to fire the shutter, the lens fell off.

This proved to be because, to detach the lens on a Soho Reflex, you push it upwards to compress a spring which holds the lens panel in place. Pressing the camera down on the wire had done exactly that. The deer had, of course, made its excuses and left.

Undeterred, the indomitable Holliday returned days later and managed by a combination of stealth and luck to get so close to a stag that the head filled the

6cm × 9cm frame. The result is the impressive picture which Tom has kindly allowed me to use in this book (see page 253).

## Kershaw by any other name

Identifying large-format single-lens reflex cameras made in the first quarter of the twentieth century is not always easy, particularly since identical cameras will frequently be found bearing a range of different names, and many cameras do not bear any name at all, not even that of the manufacturer.

Although Marion & Co.'s Soho Reflex name is the best known to be found on the single-lens reflexes

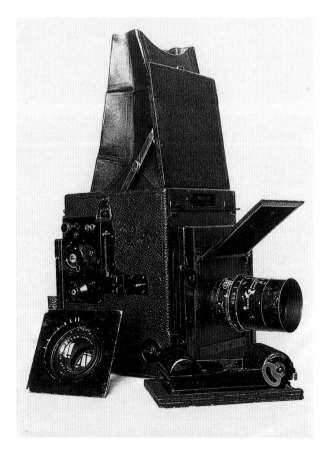

Tom Holliday's ¼-plate Soho Reflex with which he shot the picture of the stag on page 253. In the foreground on the left is the 6" f/4.5 Ross Xpres standard lens in its sunken panel. On the right is the Rollex rollfilm holder which Tom used for his pictures. The lens fitted to the camera is an 11½" f/5.5 Ross Teleros and it is easy to see why this lens caught in the wire fence and was lifted out of its lower retaining recess when Tom was photographing the deer.

*Picture by Tom Holliday. No technical details available.*

manufactured by A. Kershaw and Sons Ltd, you may also encounter virtually identical cameras marketed under their own names by Ross, Beck, Jonathan Fallowfield and the London Stereoscopic and Photo Co. Most Soho Reflexes are of black leather-covered wood, but there are also magnificent brass-bound teak Soho Tropical Reflexes, which command very high prices at auction.

One of the more unusual features of the Soho Reflex is its range of shutter speeds – T, 1/16th, 1/24th, 1/36th, 1/75th, 1/150th, 1/300th and 1/800th second. All these speeds were achieved by varying only the width of the gap between the two blinds of the focal-plane shutter, while the tension remained constant. The firing of the shutter release also raised the mirror of the camera.

Another peculiar aspect of the camera's design, much discussed among collectors, is the unusual mirror mechanism. When the shutter release is depressed, this causes the mirror pivot to move back towards the rear of the camera as the mirror is lifted, so that the leading edge of the mirror describes a much flatter curve as it rises and leaves appreciably greater room between itself and the rear of the lens than would normally be the case. This gave users the scope for using lenses with more rear projection than would have been possible with other reflexes of similar size and format.

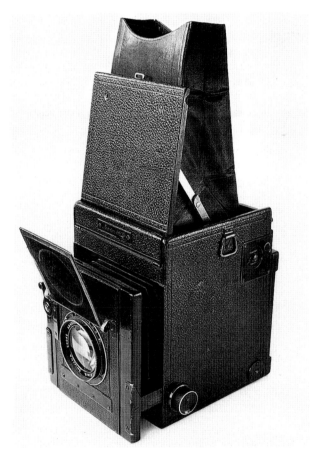

This ¼-plate Soho Reflex has obviously seen a great deal less use than Tom Holliday's, and carries the nameplate of Marion & Co. (the company which marketed the camera) rather than the word 'SOHO' as on Tom's camera. The lens is a 6" f/3.5 Cooke.

*Camera and picture by courtesy of Mike Rees. Shot with Nikon F fitted with 55mm f/2.8 Micro-Nikkor on Ilford Pan F Plus, developed in Aculux and printed on Jessop Variable Contrast.*

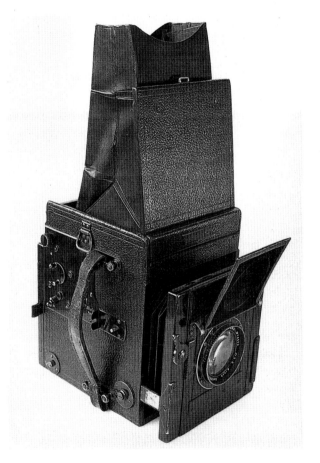

Looking at the other side of Mike Rees's Soho, and comparing it with the similar view of Tom Holliday's, it becomes apparent that the design went through many changes during the almost forty years of its manufacture.

*Camera and picture by courtesy of Mike Rees. Shot with Nikon F fitted with 55mm f/2.8 Micro-Nikkor on Ilford Pan F Plus, developed in Aculux and printed on Jessop Variable Contrast.*

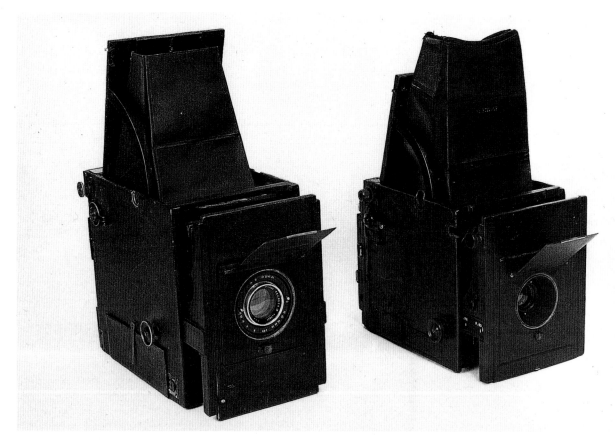

One does not often have the chance to photograph two Adams Reflex cameras together. The one on the left is an original Adams Reflex of 5" × 4" format, fitted with a 7.2" f/5.8 Isostigmar lens, with iris diaphragm calibrated to f/64. This camera has a square plate holder to hold the 5" × 4" plates, this making it possible for the plate holder to be inserted into the camera with the plate either vertical for portrait shots or horizontal for landscapes. The right-hand camera is an Adams Videx 5" × 4" with a Ross Zeiss patent f/6.3 convertible lens providing focal lengths of either 5¾" or 11¼". This camera has a conventional revolving back.

*Cameras by courtesy of Bob White. Shot with Pentax SV fitted with 55mm f/1.8 Super-Takumar on Ilford FP4 Plus, developed in Aculux and printed on Jessop Variable Contrast.*

Inside the hood recess of the Original Adams Reflex is this beautiful embossed gold logo. It reads 'Adams & Co. 26, Charing Cross Rd. London, W.C.'

## The Adams Reflexes

Perhaps the premier British manufacturer of large-format single-lens reflex cameras in quality terms during the early years of the century was Adams & Co. of 26 Charing Cross Road, London, W.C. Adams made a considerable range of cameras, all of them of the very highest quality and all very expensive. Not surprisingly, they were sold in modest numbers and are therefore scarce and much sought after both privately and at auction.

The single-lens reflex cameras were the Adams Videx, manufactured from 1901 until 1909; the Minex, made continuously from 1909 until the 1950s; the Minex Tropical, which seems not to have been introduced until well after the First World War; and the rare and very beautiful Minex Tropical Stereoscopic Reflex, with two matched lenses and shutters for stereo pairs.

The Adams Videx was the world's first single-lens reflex to have a revolving back, enabling the user to

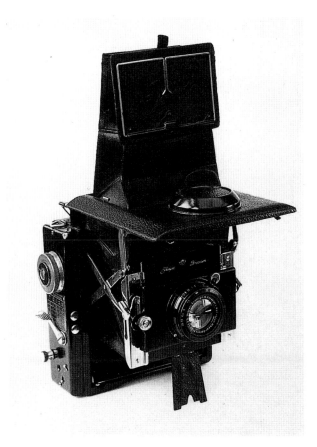

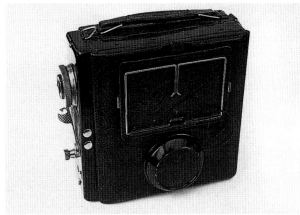

The remarkable Ihagee Patent Folding Reflex (left), the only large-format camera of my acquaintance whose baseboard finishes up above the lens rather than below it when the camera is unfolded. This beautiful example is fitted with a 12cm f/4.5 Meyer Veraplan Doppel-Anastigmat.

*Camera and picture by courtesy of Mike Rees. Shot with Nikon F fitted with 55mm f/2.8 Micro-Nikkor on Ilford Pan F Plus, developed in Aculux and printed on Jessop Variable Contrast.*

All the folding bits of the Ihagee Reflex in the picture on the left vanish when folded into this compact and easily carried package (above). Note the Ihagee logo embossed into the leather – the same logo as was later to be emblazoned upon so many Exaktas.

*Camera and picture by courtesy of Mike Rees. Shot with Nikon F fitted with 55mm f/2.8 Micro-Nikkor on Ilford Pan F Plus, developed in Aculux and printed on Jessop Variable Contrast.*

swivel the focusing back from horizontal to vertical format without moving the camera. In this, Adams were in 1901 at least a year ahead of the American Graflex Corporation.

The Minex of 1909 followed this by being the first single-lens reflex to have a revolving back directly coupled to viewfinder masks. When the back was turned from landscape to portrait format, the viewfinder masks changed with it. It was also the first SLR to have a spring-loaded mirror mechanism which propelled the mirror quickly out of the light path when the shutter was fired, and subsequently returned the mirror to the viewing position when the shutter was rewound. The shutter, too, was full of innovative features, not least that of providing shutter speeds from 3 seconds to 1/1000th – in 1910.

In 1910, there were sixteen makes of British SLRs advertised in the *British Journal of Photography Almanac*, with an average price of about £11 (then about $53.50). In the same *Almanac*, the Adams Minex was priced at £34 ($165.50). Adams Minex SLRs were

available, like most other single-lens reflex cameras of their day, in negative formats from $2\frac{1}{2}'' \times 3\frac{1}{2}''$ through to $\frac{1}{2}$-plate. If you find one, and can afford to buy it when you have found it, you will probably find that it delivers impressive results if in good order.

Most expensive of all large-format SLRs at auction are Adams Tropical Reflexes, magnificent examples of craftsmanship in teak and brass. Good examples sell for several thousands of pounds on the international market.

## The early Ihagee reflex cameras

Chapter 3 of this book discussed at some length the Exakta cameras manufactured by Ihagee of Dresden from 1933 onwards. Much of the experience which made the success of the Exakta family possible had earlier been gained from the successful manufacture of large-format reflex cameras.

The first of these, although equipped with a reflex-style viewing screen, was not strictly a single-lens

reflex, since the lens was of fixed focus. This was the Paff, a camera which looked like a box camera with a fold-out hood on the top and came, when launched in 1921, in two basic versions, the Plan Paff for plates and the Roll Paff for rollfilm. Each was available in formats from VP (4.5cm × 6cm) to 6.5cm × 11cm. The lens was either a simple achromat with an aperture of approximately f/11, or an f/6.8 Trioplan.

By 1925, focusing versions of the two types of Paff had appeared, the top of the range having an f/6.3 Goerz Doppel-Anastigmat.

However, 1925 was more notable for the appearance of the Ihagee Patent Folding Reflex, a wooden camera which unfolded like a drunken contortionist and appeared to be upside down when it was the right way up, since what in most cameras would be the baseboard finished up above the lens. The Patent Folding Reflex was made of wood and had a focal-plane shutter with speeds of 1/15th to 1/1000th second. It was available in several formats, from 6.5cm × 9cm through 9cm × 12cm to a 10cm × 15cm version which appeared during 1927.

All Ihagee Patent Folding Reflexes have interchangeable high-quality objectives, examples turning up with Tessar, Xenar and Dogmar standard lenses.

More conventional, and a great deal less expensive, was the Ihagee Serien Reflex of 1928. This was a wooden camera of broadly the same appearance as a Mentor Reflex and with features similar to those of a Thornton-Pickard or Soho, except for the use of a helical focusing mount rather than bellows focusing. It was made in 6.5cm × 9cm, 9cm × 9cm and 9cm × 12cm formats.

Finally, there is the rare and remarkable Ihagee Nacht Reflex of 1930. Heralding the Night Exakta of the mid-thirties and rivalling the extremely scarce Ernemann Ermanox Reflex of 1926, the Ihagee Nacht Reflex was a box-shaped reflex camera equipped with an enormous f/1.5 or f/2 Plasmat lens in the VP version or an f/2 Plasmat in the 6.5cm × 9cm size. You are unlikely to find one, and unlikely to be able to use it if you do, but mentioning the beast at least forestalls those who would otherwise write and tell me that I had left it out.

## The Houghton-Butcher reflexes

One of the earliest companies in photography, Houghtons began in 1834, when George Houghton went into

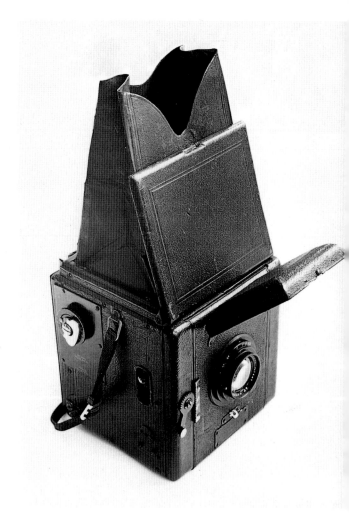

A Butcher Pressman ¼-plate reflex of the First World War period. This is one of the German-manufactured Ica reflexes imported by Butcher. It is fitted with a 6" f/4.5 Ross Xpres. Note the fast-action rising-front mechanism.

*Camera by courtesy of Dave Miller. Shot with Zenith 80 fitted with 80mm f/2.8 Industar 29 on Ilford XP2, processed C41 and printed on Ilford Multigrade III.*

partnership with Antoine Claudet to sell glass. In 1839, they secured the British rights to the Daguerreotype process. By the turn of the century, George Houghton and Sons were making a huge range of cameras, and importing almost as many from other manufacturers to sell under the Houghton name. The company became Houghtons Limited in 1904, merged with W. Butcher for manufacturing purposes in 1915 and finally became, in 1926, Houghton-Butcher (Great Britain) Limited. Ensign Limited was set up as a subsidiary

marketing company in 1930, although the name Ensign had been used by Houghtons to brand their cameras for years previously.

Houghton-Butcher and Ensign were the most important camera companies in Britain during the thirties, and were the greatest British photographic casualty of the Second World War, for their London premises were totally destroyed by enemy action in 1940, an event from which the company never really recovered. Camera production continued in a modest way during the 1950s and the company finally ceased to exist in 1961.

During the 1910–1925 period, W. Butcher were the UK importers of German Ica reflex cameras, and after the 1926 merger which made Ica a part of Zeiss Ikon, Houghton-Butcher negotiated arrangements to brand the Ica camera for the British market as the Ensign Pressman Reflex. These were available in the usual 6cm × 9cm, ¼-plate and 5" × 4" formats and were usually fitted with f/4.5 Tessar lenses. As one would expect of Ica/Zeiss Ikon products, they are well designed, strongly made, and can be found in good running order.

Quite different in design, although superficially similar in appearance are the Houghton, Houghton-Butcher and Ensign (depending on when they were made) Popular and De Luxe Reflex cameras. These were British-made by Houghton-Butcher themselves in 2½" × 3½" and ¼-plate sizes, and were usually fitted with Ross or Dallmeyer lenses, although some had Tessars. I have seen a ¼-plate Ensign Popular Reflex fitted with an f/4.5 Xenar, although this may not have been original, since the lenses are interchangeable.

There was also, during the 1920s, an Ensign Rollfilm Reflex, looking much like a horizontal box camera with a hood on the top and equipped with various permutations of comparatively simple lenses and shutters. This was an 8-on-120 camera, also sold by W. Butcher as the Reflex Carbine.

## A little more about Graflex

The advent and importance of the American-made cameras of Folmer & Schwing Manufacturing Co., Folmer-Graflex Corporation and Graflex Inc. which successively produced a very extensive range of Graflex equipment between 1902 and 1963 was touched upon in Chapter 1 and can only be developed to a modest extent here. Probably the world expert on

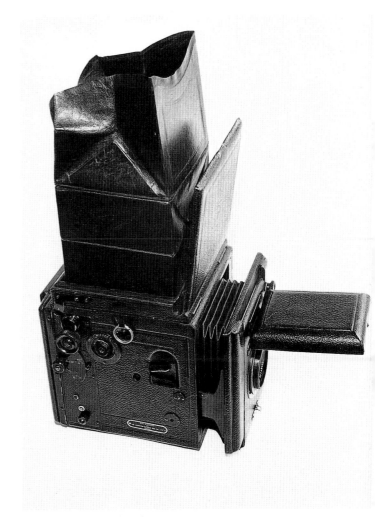

A comparatively late example of the British-made Ensign Popular Reflex, fitted here with a 6" f/4.5 Ross Xpres. Of quite different design to the German-made Butcher Pressman of the picture opposite (later called the Ensign Pressman), this camera bears a plate which reads 'Made in England by the Houghton-Butcher Manuf. Co. Ltd. London'. The fact that this plate can be clearly read (with a magnifier) from a 5" × 7" print is a tribute both to the Russian Industar 29 lens of the Zenith 80 and to Ilford XP2 film.

*Camera by courtesy of Dave Miller. Shot with Zenith 80 fitted with 80mm f/2.8 Industar 29 on Ilford XP2, processed C41 and printed on Ilford Multigrade III.*

Graflex is Roger Adams, who has written the very substantial definitive book, called *Graflex*. He can be contacted at W.D. Service, 675 Fairview Drive, #246–249, Carson City, NV 89701, USA. Richard Paine's 1981 book *A Review of Graflex* (Alpha Publishing Co., Houston, Texas) should also be consulted.

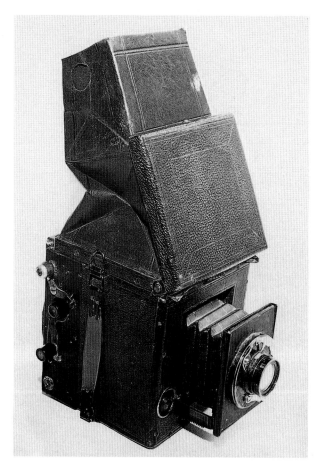

Identification of this camera, encountered at a camera fair, eluded the regulars at successive collectors' events for weeks. Eventually it was revealed as a Murer & Duroni 6.5cm × 9cm Reflex with a focal-plane shutter, made in Milan in the 1920s. It should have a 120mm f/4.5 Murer Anastigmat, but has (because of failure of the focal-plane shutter) been fitted with a lens and shutter from an old rollfilm camera.

*Camera by courtesy of Bernard Platman. Shot with Zenith 80 fitted with 80mm f/2.8 Industar 29 on Ilford XP2, processed C41 and printed on Jessop Variable Contrast.*

An early Auto Graflex ¼-plate with pleated focusing hood and Goerz lens. This version of the Auto Graflex was made between 1907 and 1910. The ornate wind key seems typical of an even earlier period.

*Camera by courtesy of Dave Miller. Shot with Zenith 80 fitted with 80mm f/2.8 Industar 29 on Ilford XP2, processed C41 and printed on Ilford Multigrade III.*

Unlike virtually all other manufacturers of single-lens reflex cameras during the first quarter of the century, Folmer & Schwing included rollfilm SLRs as part of their range, and these, if you can find an example, offer substantial potential for occasional use, although the film is expensive.

The Graflex 1A, made from 1907 to about 1925 was designed to shoot eight pictures 2½" × 4¼" on 116 film, while the Graflex 3A, of the same period, used 'postcard' 122 film. Black-and-white film in both these sizes can (1995 information) be obtained from Classic Collection, London. Contact them to check availability and the current price before ordering.

During the thirties, when the VP Exakta and the Pilot Reflex were indicating the trend towards rollfilm and away from plates in Europe, Folmer-Graflex Corporation offered the National Graflex Series 1 (1933–35) and Series 2 (1934–41). These were 120 rollfilm SLRs for twelve exposures 2¼" × 2½" equipped with 75mm f/3.5 Tessar lenses, non-interchangeable on the Series 1 and interchangeable on the Series 2. A 140mm f/6.3 telephoto lens was also available for the Series 2.

I have not had the opportunity to use any of the rollfilm Graflex cameras, but understand that good

examples, particularly of the later National Graflex models, are quite likely to remain fully functional. The advantage of these is that 120 film in black-and-white and a full range of colour emulsions is, of course, readily available.

Aside from these rollfilm cameras, and their obvious attractions for enthusiasts wanting to use their classic SLRs, there was and remains a bewildering array of Graflex plate cameras. Models which are frequently available at reasonable prices are the Auto Graflex, the Auto Graflex Junior and the R.B. (revolving back) Graflex Series B and D.

The Auto Graflex, made between 1907 and 1923, appeared first with a pleated hood (see opposite), and examples with this hood date from before 1911. From then until 1915, the camera had a folding hood with the hinge at the front, thereafter a folding hood with the hinge at the back. The pleated hood adds about £40 ($60) to the value of an Auto Graflex, which is usually on sale for something over £120 ($180).

The Auto Graflex Junior was the $2\frac{1}{4}'' \times 3\frac{1}{4}''$ version – the word 'Junior' usually means the small-format model of a camera normally made in $\frac{1}{4}$-plate or larger format. The first version had a stationary back, so the user had to turn the camera on its side to shoot vertical-format pictures. In 1915, a revolving back was introduced. The R.B. Graflex Junior was made continuously from then until 1941 and is comparatively common, particularly in the USA.

The R.B. Graflex Series B, made in three formats from 1923 until 1942, is sometimes to be found in good running order, but check the light trapping carefully. The Series D, with a built-in fold-up lens hood is commoner and was made from 1928 until 1942, when the flash-synchronized R.B. Super D superseded it and was manufactured until 1963.

## Rollfilm backs

Many of these Graflex cameras surface at camera collectors' meetings and fairs complete with a rollfilm back. These backs are almost all of more recent manufacture than the cameras, and date from the period of some twenty-five years between the mid-thirties and early sixties when owners of plate cameras did not want to stop using the cameras they loved, but recognized the convenience and economy of shooting (usually) smaller negatives on rollfilm. By 1955, the availability of some sizes and types of glass plate was

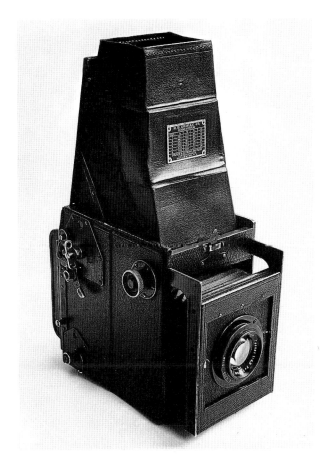

The R.B. Graflex Junior $\frac{1}{4}$-plate reflex is a comparatively rare camera dating from between 1915 and 1923 which was also made in a $2\frac{1}{4}'' \times 3\frac{1}{4}''$ version. The distinguishing feature is the way in which the lens panel 'hangs' from focusing rails above it. The lens is a fixed 15cm f/4.5 Tessar. Note the metal plate on the hood which provides data for setting shutter speeds by a total of twenty-four different combinations of curtain aperture ($\frac{1}{4}''$, $\frac{3}{8}''$, $\frac{3}{4}''$ and $1\frac{1}{2}''$) and tension (numbered settings from 1 to 6). Thus a $1\frac{1}{2}''$ aperture at tension no. 1 produces a shutter speed of 1/10th second, whereas a $\frac{1}{4}''$ aperture at tension no. 6 produces 1/1000th second. Between are exotic speeds of 1/135th, 1/680th and 1/825th.

*Camera by courtesy of Dave Miller. Shot with Zenith 80 fitted with 80mm f/2.8 Industar 29 on Ilford XP2, processed C41 and printed on Ilford Multigrade III.*

becoming limited, and this too acted as a spur to the production and sale of rollfilm holders.

Rollfilm backs (Graflex, Rollex and RADA are three of the commonest types) usually offer alternative formats on 120 film, normally by the insertion of metal masks into the standard 6cm × 9cm (8-exposure on 120) film aperture to mask the format down to 6cm × 6cm (12-on) or 6cm × 4.5cm (16-on). Two or three alternative red windows are then provided, and the

user selects the window which reveals the correct set of numbers on the film backing paper for the format in use.

The metal masks are flimsy and easily lost. Usually they have been, and the first check when assessing a rollfilm holder is whether it still has its mask(s). I discovered a particular hazard recently when I bought a RADA rollfilm holder whose film aperture was 6cm × 9cm and which had two red windows. It had no mask, but looked eminently usable, so I bought it, assuming that one of the two red windows would indicate the 8-on numbers on the film. Too late did I discover that the two windows were positioned to read the 12-exposure and 16-exposure numbers on the film backing paper, and that I had to estimate the position of the next 6cm × 9cm exposure by using the 16-on numbers.

Always carry a couple of scrap 120 films with you when looking for a camera with a rollfilm back. There are so many minor yet significant problems which can arise with old rollfilm backs that it pays to load the back, and wind the film through, exposure by exposure, drawing around the film aperture direct on to the film emulsion with a pencil for every exposure until the end of the film. Take the film out, and you can check whether the spacing of exposures is correct, and also (by holding the film with the light glancing across it) whether there are any visible 'tramline' scratches on the emulsion. Negative overlap caused by worn transport gears is the commonest fault in rollfilm backs; scratches caused by damaged or corroded parts are almost as common.

If you are looking to buy a Graflex, or any other plate-era SLR, to use with a rollfilm back, it is best to look for a $2\frac{1}{4}'' \times 3\frac{1}{4}''$ Junior model, whose intended format and viewing screen is approximately the same as a 6cm × 9cm negative from an 8-on rollfilm back. I have taken pictures for this chapter using a ¼-plate

camera (the Thornton-Pickard) with a 6cm × 9cm back, and this works well, but putting a 6cm × 9cm rollfilm back on anything larger inhibits the range of pictures that can be shot, since the standard lens becomes, effectively, a long-focus lens for the negative format in use.

## And so, to sum up

Buying and using early large-format SLRs, particularly those made of leather-covered wood, is not easy and rarely an effective use of time if you measure effectiveness by results. But it can be fun and immensely rewarding, for this is a challenge that can be overcome only by a real photographer who understands the process. It is also the only branch of classic SLR photography to be subject to woodworm.

Hold and focus a number of different types before you decide which to look for in really serviceable condition. Do not give up easily, because some 90% of all large-format SLRs to be found at collectors' events do not work well enough for practical use. Prepare to be derided for expecting to find one that does work properly, for camera collectors are frequently little interested in photography, and those that are rarely try to use large-format SLRs. As one of a Photographic Collectors Club of Great Britain party attending the Bièvres camera fair in France during the summer of 1995, I was regarded as something of a curiosity for carrying a camera bag full of equipment loaded with film and actually setting out to shoot pictures.

As a postscript to the whole book, I hope that you and others who read this and my previous book *Collecting and Using Classic Cameras* will encourage collectors to use their cameras and expand interest in classic cameras and knowledge of what they can do. Using them effectively is immensely satisfying. I hope you enjoy the experience.

Tom Holliday's close-up picture of the stag, the arduous process of photographing which is described on page 244. Some would say that the job could be done more easily and better with a modern 35mm camera – but that is a little like saying that playing a compact disc is easier than learning to play Chopin on the piano. Getting results as good as this from a camera as large and as old as a Soho of around 1930 is an achievement of which anyone can be proud.

*Picture by Tom Holliday. Shot with his 1930s ¼-plate Soho Reflex fitted with 11¾" Ross Teleros f/5.5, exposure 1/75th second at f/8 at about 5 feet range, on Ilford HP5.*

Nesting blue tits held up building operations when we moved to our new house during the spring of 1995. I took the opportunity of photographing them with my recently acquired 12" f/4.5 Dallmeyer lens and was surprised how effective the results were.

*Shot with ¼-plate Thornton-Pickard Junior Reflex fitted with 12" f/4.5 Taylor-Hobson and RADA rollfilm holder on Ilford FP4, developed in Aculux and printed on Jessop Variable Contrast.*

The clarinettist was quite prepared to be photographed and I was very pleased with the results, bearing in mind that I was using a camera some seventy or more years old. Shot in The Lanes in Brighton. Music seems not to work its magic on everybody. How could such artistry be so ignored?

*Shot with ¼-plate Thornton-Pickard Junior Reflex fitted with 150mm f/4.5 Taylor-Hobson and RADA rollfilm holder on Ilford FP4, developed in Aculux and printed on Ilford Ilfobrom Grade 3.*

I saw this excellent street entertainer set up to perform and stayed to take some photographs. The boys arrived soon after and the makings of a picture were there. I was concentrating so much on the performer that I did not notice that one of the boys had been mimicking his pose until after I had processed the film.

*Shot with ¼-plate Thornton-Pickard Junior Reflex fitted with 150mm f/4.5 Taylor-Hobson and RADA rollfilm holder on Ilford FP4, developed in Aculux and printed on Ilford Ilfobrom Grade 3.*

I took this photograph of Mike Smith, Secretary and joint founder of the Magic Lantern Society, a few days before he gave a talk to the Southern Area meeting of the Photographic Collectors Club of Great Britain on magic lantern history. It subsequently appeared in *Photographica World*, the Club's quarterly magazine, with the report of a really first-class presentation.

*Shot with ¼-plate Thornton-Pickard Junior Reflex fitted with 150mm f/4.5 Taylor-Hobson and RADA rollfilm holder on Ilford FP4, developed in Aculux and printed on Ilford Ilfobrom Grade 3.*

This is a detail of a statue which rises above a fountain in a tiny square in Brighton's Lanes. Everybody I show it to remarks on the sharpness and quality of the picture, coming as it does from an elderly ¼-plate SLR.

*Shot with ¼-plate Thornton-Pickard Junior Reflex fitted with 150mm f/4.5 Taylor-Hobson and RADA rollfilm holder on Ilford FP4, developed in Aculux and printed on Ilford Ilfobrom Grade 3.*

# Books and Directories

This appendix is not a conventional bibliography, since I could not begin to list the huge number of books about cameras which I have read over the years and which will all, to some degree, have contributed to the sum of knowledge from which this book has been written. Any good bookshop or large lending library can provide a better list than I can of new and out-of-print (respectively) books on camera collecting, photographic history, photography and the various major brands of SLR cameras. The following is simply a summary of some books and series of books which every classic SLR enthusiast should, in my view, at least see and preferably own.

*McKeown's Price Guide to Antique and Classic Cameras*, published by Centennial Photo, 11595 State Road 70, Grantsburg, WI 54840, USA. By far the best, largest and most complete collector's guide to all types of antique and classic cameras, giving brief details and an indication of value for thousands of cameras. Updated and published annually, it is available from distributors in Great Britain, Germany, The Netherlands and Austria as well as the USA. For details, phone the publishers in USA on ++1 715 689 2153, fax ++1 715 689 2277, or one of the specialist bookshops detailed in Appendix 3.

*The Hove International Blue Book*, published by Hove Foto Books, 34 Church Road, Hove, East Sussex BN3 2GJ, UK. In many ways similar to McKeown's Price Guide; however, it is much smaller, more pocketable and offers more information about fewer cameras.

*Kennedy's International Price Guide* is another excellent guide similarly priced to the Hove volume above but with different content – you pay your money and make your choice. Available from photographic bookshops.

*Fotosaga Camera Collector's Handbook* is the collector's address book – more than 1,500 addresses worldwide of museums, second-hand camera shops, camera fair organizers, auction houses, photographic booksellers, repair workshops and photographic collectors' organizations. With text in French and English, it is published by Fotosaga, Flassy, 58420 Neuilly, France, from whom free information and the latest price details are available if you send your name and address.

*Discovering Old Cameras 1839–1939* and *Discovering Old Cameras 1945–1965*, both by Robert White, are published by Shire Publications Ltd, Cromwell House, Church Street, Princes Risborough, Buckinghamshire HP27 9AA, UK. These are slim inexpensive pocket-sized books outlining the development of

classic cameras of all types. The latter book, particularly, includes much SLR information.

*Collecting and Using Classic Cameras* by Ivor Matanle was published originally in 1986 and is now available in Spanish and Italian as well as English. The sister volume to this book and in a broadly similar format, it provides an overview of the characteristics, history and usability of all types of classic cameras from (approximately) 1925 to 1975. Like this book, it is published by Thames and Hudson in London and New York. Details from Thames and Hudson Ltd, 30–34 Bloomsbury Street, London WC1B 3QP, UK, or from any good bookshop.

*Lutton's List* is an invaluable soft-covered book providing a mass of detail on collectible cameras. Available from UK specialist bookshops – see Appendix 3.

*Spiegelreflexcameras aus Dresden* by Richard Hummel was published in a very limited edition in 1994 and, at the date of publication of this appendix, is available only in German. It is important and unusual in that the author worked in camera production at Ihagee and knew the camera industry in Dresden throughout the period from 1936 until the sixties. Details from Classic Collection Photo Books, 4 Galen Place, London WC1A 2JR, UK. Telephone: ++44 (0)171 831 6000.

*Exakta Cameras* by Clement Aguila and Michel Rouah is one of the best books for collectors on the complexity of the Exakta system. Published by Hove Foto Books, 34 Church Road, Hove, East Sussex BN3 2GJ, UK, it is well worth considering if you are particularly interested in Exakta.

*Asahiflex and the pre-1959 Asahi Pentax Cameras* by Frederick C. Sherfy is the most detailed work available on the early Asahi reflexes. Details from Fred Sherfy, PO Box 11801, Harrisburg, PA 17108–1801, USA.

*Zeiss Compendium, East and West 1940–1972* by Marc James Small and Charles M. Barringer covers in detail the history of the two Zeiss organizations in East and West Germany from 1940 until the end of camera production in Stuttgart, including the acquisition of Voigtländer. The book claims to list every Zeiss and Zeiss/Voigtländer camera made during the period. Details from Hove Foto Books, 34 Church Road, Hove, East Sussex BN3 2GJ, UK.

*A History of the 35mm Still Camera* by Roger Hicks was published by Focal Press, Borough Green, Sevenoaks, Kent TN15 8PH, UK, in 1984. This book, now out of print, looks at the history of the 35mm camera in an entirely original way, reviewing the development of (for example) viewfinders, lens mounts, shutters, film-transport systems and lenses as separate technologies, quoting individual cameras as examples throughout.

*Lea's Register of 35mm SLR Cameras* by Rudolph Lea claims to be a historical reference guide to all 35mm SLR cameras ever sold, with data on more than 1,000 camera models from 1936 through to the present day. This book is a valuable guide to dating cameras. Available from Lea's Register, Elkins Park, PA, USA, or from Saunders Group, USA (++1 716 328 7800), Wittig Books in Germany (++2433 84412), or Fountain Press in UK (++44 (0)181 541 4050), or the specialist bookshops in Appendix 3.

*The Voigtländer Collector's Checklist* by Dr A. Neill Wright is a detailed list of all classic Voigtländer cameras, lenses and accessories together with descriptions of all the known variants, from a collector's standpoint. The original book has been much developed and expanded through research by the members of the Voigtländer Verein (see Appendix 4), and is now available only from the Verein. For details contact Mike Rees, 6 Clerics Walk, Shepperton, Middlesex TW17 8JQ, UK.

*Collecting Old Cameras* by Cyril Permutt has sadly been out of print for many years but was published in Britain by Angus and Robertson in 1975. It includes many excellent pictures of rare early cameras, including a substantial number of single-lens reflexes, plus a great deal of useful information on them. Well worth seeking secondhand.

The Focal 'Way' Books and The Focal Guides. A long series of substantial hardback books entitled *The Asahi Pentax Way*, *The Hasselblad Way*, *The Contaflex Way*, etc., has been published by Focal Press in Britain since the fifties. Alongside them were published the Focal Guides, slim paperback pocket books which functioned as expanded instruction manuals for the particular type of camera. Thus there were *The Exakta Guide*, *The Nikkormat Guide* and so on. Some of these books are still available new, many are readily available secondhand from camera fairs and photographic shops dealing in secondhand books. Originally published by Focal Press, Borough Green, Sevenoaks, Kent TN15 8PH, UK, details of reprinted copies of the Focal Guides can be obtained from Oldtimer Cameras Ltd, PO Box 28A, Elstree, Hertfordshire WD6 4SY, UK. Telephone: ++44 (0)181 953 5479.

*150 Classic Cameras* by Paul-Henry van Hasbroeck is a beautiful large-format hardback volume which provides a detailed view of each camera discussed from a collector's rather than a user's viewpoint. It provides useful information and top-quality pictures of a number of key classic SLRs and is particularly good on the subject of Contarex and Leitz SLRs. It was published in 1989 for Sotheby's Publications by Philip Wilson Publishers Ltd, 26 Litchfield Street, London WC2H 9NJ, UK.

SLR Yearbooks, 1970 and 1971. The publishers of the magazine SLR, published monthly in Britain during the late sixties and early seventies, produced just two of what was intended to be an annual yearbook devoted to SLR photography. Although long out of print, these two yearbooks are well worth hunting down at camera collectors' fairs because of their extraordinarily detailed reviews of the new SLRs of 1969 and 1970 (respectively) and the lenses available for the SLRs of the time which feature towards the backs of each volume. They were published by Haymarket Publishing Group in London.

Other books to look out for include the British Journal Almanacs, published annually by the British Journal of Photography for well over a century; Geoffrey Crawley's books on the Canon F1 System and Accessories and the Nikon F System and Accessories, both published by Henry Greenwood of London; Jacob Deschin's The Alpa Reflex Manual, published in 1959 by the Kinografik Publishing Corporation of New York; Leica and Leicaflex Lenses by Gianni Rogliatti, published by Hove Foto Books of 34 Church Road, Hove, East Sussex BN3 2GJ, UK; and various Amphoto books, including The Nikon F and Nikkormat Manual.

## APPENDIX 2

# Magazines and Periodicals

Camera Shopper, published ten times a year in English, carries articles on classic images as well as cameras. Contact Camera Shopper, PO Box 1086, New Canaan, Connecticut, CT 06840. Telephone: ++1 203 972 5700. Fax: ++1 203 972 5702.

Classic Camera, edited by Paolo Namias, published quarterly in Italian (and also in English from 1997) by Editrice Progresso in Milan. Contact Paolo Namias at Editrice Progresso, Viale Piceno 14, Postal 20129, Milan, Italy. Telephone: ++39 (0)2 70002222. Fax: ++39 (0)2 713030.

Classic Camera Collector, published quarterly in English by Terence Sheehy, 39 Beechwood Avenue, Orpington, Kent BR6 7EZ, UK. Telephone: ++44 (0)1689 851717.

Déjà-View, the newsletter of the Photographic Collectors Association of New Zealand. Contact Ronald Melvin, 24 Otumoetai Road, Tauranga 3001, New Zealand.

Exakta Times, published quarterly in English for members by the Exakta Circle, edited by Peter Longden, 30 Kenilworth Gardens,

Westcliff-on-Sea, Essex SS0 0BH. Telephone/Fax: ++44 (0)1702 345395.

Photographic Collector, published quarterly in English by Peter and Valerie Wallage, 48 Albert Road, Ashford, Kent TN24 8NU, UK. Telephone/Fax: ++44 (0)1233 627225.

Photo Deal, published quarterly (March, June, September, December) in German (one English edition was published) by Rudolf Hillebrand, Kiefernweg 21, D-41470 Neuss, Germany. Telephone: ++49 (0)2137 7 76 76. Fax: ++49 (0)2137 7 76 35.

Photographic Trader, published six times a year (February, April, June, etc.) in English, edited by Neil Smith. Contact PO Box 95, Carina, QLD 4152, Australia. Telephone/Fax: ++61 (0)7 843 2319.

Photographica World, published quarterly (March, June, etc.) for members by the Photographic Collectors Club of Great Britain. Editor Michael Pritchard, 38 Sutton Road, Watford, Hertfordshire WD1 2QF, UK. Telephone: ++44 (0)1923 468356. Fax: ++44 (0)1923 468509.

Photographica, edited by George Gilbert, published in English for members by the American Photographic Historical Society, 1150 Avenue of the Americas, New York, NY 10036, USA. Telephone: ++1 212 575 0483.

Shutterbug is perhaps less devoted to classic cameras and collecting than it once was, but is a fascinating read. Published in English by Patch Publishing, PO Box F, Titusville, Florida, FL 32781, USA.

Spotmatic, published quarterly for members in Italian and English by Asahi Optical Historical Club. Contact Dario Bonazza, Via Badiali 138, 48100 Ravenna, Italy. Telephone: ++39 (0)544 464633.

Voigtländer Matters, published quarterly for members by the Voigtländer Verein. Contact Mike Rees, 6 Clerics Walk, Shepperton, Middlesex TW17 8JQ, UK. Telephone: ++44 (0)1932 253965.

## APPENDIX 3

# Photographic Booksellers

## Australia

Photographic Book Society, 211 Bay Street, Brighton, VIC 3186
Telephone: ++61 (0)3 596 8742
Fax: ++61 (0)3 596 8743

Dave Green, PO Box 29, Kelmscott, WA 6111
Telephone: ++61 (0)9 495 1574
Fax: ++61 (0)9 390 6149

## Germany

Lindemanns Buchhandlung, Nadlerstrasse 10, D-70173, Stuttgart
Telephone: ++49 711 233499
Fax: ++49 711 2369672

Wittig Books, 10 Chemnitzerstrasse, D-41836, Huckelhoven
Telephone: ++49 2433 84412
Fax: ++49 2433 86356

## United Kingdom

Andrews Cameras, 16 Broad Street, Teddington, Middlesex TW11 8RF
Telephone: ++44 (0)181 977 1064
Fax: ++44 (0)181 977 4716

Classic Collection Photo Books, 4 Galen Place, London WC1A 2JR
Telephone: ++44 (0)171 831 6000

Jessop Classic Photographica, 67 Great Russell Street, London WC1B 3BN
Telephone: ++44 (0)171 831 3640
Fax: ++44 (0)171 831 3956

Jill Howell, Flat 3, 103 Blackheath Park, Blackheath, London SE3 0EU
Telephone: ++44 (0)181 318 0856

Oldtimer Cameras Ltd, PO Box 28, Elstree, Hertfordshire WD6 4SY
Telephone: ++44 (0)181 953 2263
Fax: ++44 (0)181 905 1705
Instruction books, Focal Guides, reprints of Amateur Photographer camera test reports.

The Royal Photographic Society's Bookshop, The Octagon, Milsom Street, Bath, Avon BA1 1DN
Telephone: ++44 (0)1225 462841

Wallage Reprints, 48 Albert Road, Ashford, Kent TN24 8NU
Telephone/Fax: ++44 (0)1233 627225
Reprints of catalogues, etc., e.g., Houghton's Catalogue of Cameras, Photographic Accessories and Supplies, 1922.

## United States of America

ACR Books, 8500 La Entrada, Whittier, California, CA 90605
Telephone: ++1 310 693 8421
Fax: ++1 310 945 6011

A Photographer's Place, 133 Mercer Street, New York, NY 10012
Telephone: ++1 212 431 9358
Fax: ++1 212 941 7920

Hoffman's Bookshop, 211 East Arcadia Avenue, Columbus, Ohio, OH 43202
Telephone: ++1 614 267 0203
Fax: ++1 614 267 7737

Pawprint Books, 259 Continental Avenue, Riveredge, New Jersey, NJ 07661
Telephone: ++1 201 967 7306

Ed Romney, Box 96, Emlenton, Pennsylvania, PA 16373
Telephone: ++1 412 867 0314

# Photographic Collectors' Organizations

## Australia

Camera Collectors' Society of Western Australia, PO Box 29, Kelmscott 6111, WA
Telephone: ++61 (0)9 495 1574

Photographic Collectors' Society (Australia), 14 Warne Street, Eaglemont 3084, Melbourne, VIC
Telephone: ++61 (0)3 457 1050

## Belgium

Photo Retro Camera Club de Belgique, Rue Ferdinand Nicolay 180, B-4420 St. Nicholas
Telephone: ++32 (0)41 53 06 65

Photographica – ASBL, Chaussée de la Hulpe 382, B-1170 Brussels
Telephone: ++32 (0)2 673 84 90

## Canada

Calgary Photographic Historical Society, PO/CP 24018 Tower Postal Outlet, Calgary, Alberta T2P 4K6

Edmonton Photographic Historical Group, 6307 34, B Avenue, Edmonton, Alberta
Telephone: ++1 403 463 8127

Photographic Historical Society of Canada, 1712 Avenue Road, Box 54620, Toronto, Ontario M5M 4N5
Telephone: ++1 416 243 1576

Western Canada Photographic Historical Association, 2606 Commercial Drive, PO Box 78082, Vancouver, British Columbia V5N 5WI
Telephone/Fax: ++1 604 254 6778

## Denmark

Danish Photography Society, Teglgardsvej 308, 3050 Humlebek
Telephone: ++45 42 19 22 99

## France

Club Niepce Lumière, c/o Jean-Paul Francesch, Résidence Bonnevay, 1-B rue Pr Marcel, Dargent F69008, Lyon
Telephone: ++33 78 74 84 22

## Germany

Leica Historica e.V., Klaus Grothe, Bahnhofstrasse 55, DW-3252 Bad Munder
Telephone: ++49 (0)50 42 4444

Agfa Interest Group, Jürgen Nau, An der Fliesch 18, D-47259 Duisburg
Telephone/Fax: ++49 (0)203 78 97 55

## Italy

Classic Camera Collectors Photocircle, Roberto Antonini, Strada Respoglio 8, I-01100 Viterbo
Telephone/Fax: ++39 (0)761 306655

Asahi Optical Historical Club, Dario Bonazza, Via Badiali 138, 48100 Ravenna
Telephone: ++39 (0)544 464633

## Japan

All Japan Classic Camera Club, c/o Monarch Mansion Kohrakuen, Room 802, No. 24–11, 2-chome Kasuga, Bunkyo-ku, Tokyo 112
Telephone: ++81 (0)3 815 6677

## The Netherlands

Ihagee Historiker Gesellschaft, H.D. Ruys, Tesselschadelaan 20, NL-1217 LH Hilversum

Dutch Society of Fotografica Collectors, PO Box 4262, NL-2003 EG Haarlem
Telephone: ++31 15 610 234

## New Zealand

Photographic Collectors' Association of New Zealand, Ronald Melvin, 24 Otumoetai Road, Tauranga 3001

## United Kingdom

European Society for the History of Photography, Acorn House, 74–94 Cherry Orchard Road, Croydon, Surrey CR0 6BA

The Exakta Circle, Secretary Marc Bramson, 6 Maxwell Road, Southampton SO2 8EU
Telephone: ++44 (0)1703 329794

The Half-Frame Group, Fred Adcock, 16 Havelock Road, Hucclecote, Gloucester GL3 3PG
Telephone: ++44 (0)1452 610709

Leica Historical Society, June Ainslie, Membership Secretary, Auchenlea, Fireball Hill, Sunningdale, Berkshire SL5 9PJ
Telephone ++44 (0)1344 27869

Minolta Club of Great Britain, Adrian Paul, PO Box 125, Doncaster DN4 6UU
Telephone: ++44 (0)1302 370462

Olympus Camera Club, Ian Aston, PO Box 222, Southall, Middlesex UB2 4SB
Telephone: ++44 (0)171 250 4583
Fax: ++44 (0)181 574 1415

Pentax Club, Peter Cox, PO Box 58, Godalming, Surrey GU7 2SE

Photographic Collectors Club of Great Britain, Membership Secretary, 5 Station Industrial Estate, Prudhoe, Northumberland NE42 6NP

Royal Photographic Society Historical Group (open only to members of RPS – apply to same address), The Octagon, Milsom Street, Bath, Avon BA1 1DN
Telephone: ++44 (0)1225 462841

Russian Camera Collectors' Club of Great Britain, David Tomlinson, 128 Henwood Green Road, Tunbridge Wells, Kent TN2 4LR

Voigtländer Verein, Mike Rees, 6 Clerics Walk, Shepperton, Middlesex TW17 8JQ

## United States of America

American Photographic Historical Society, 1150 Avenue of the Americas, New York, NY 10036
Telephone: ++1 212 575 0483

American Society of Camera Collectors Inc., 4918 Alcove Avenue, North Hollywood, California, CA 91607
Telephone: ++1 818 769 6160

Arizona Photographic Collectors Inc., PO Box 14616, Tucson, Arizona, AZ 85732- 4616

Bay Area Photographica Association, 2538 34th Avenue, San Francisco, California CA 94116
Telephone: ++1 415 664 6498

Chicago Photographic Collectors' Society, PO Box 303, Grayslake, Illinois, IL 60030

Delaware Valley Photographic Collectors' Association, PO Box 74, Delanco, New Jersey, NJ 08075

Graflex Historical Society, PO Box 710692, Houston, Texas, TX 77271-0692.

Historical Society for Retina Cameras, 51312 Mayflower Road, South Bend, Indiana, IN 46628

Leica Historical Society of America, 7611 Dornoch Lane, Dallas, Texas, TX 75248-2327

Michigan Photographic Historical Society, Box 2278, Birmingham, Michigan, MI 48012-2278
Telephone: ++1 313 540 7052

Miranda Historical Society, Box 2001, Hammond, Indiana, IN 46323
Telephone: ++1 219 844 2462

Nikon Historical Society, Robert Rotoloni, PO Box 3213, Munster, Indiana, IN 46321
Telephone: ++1 708 895 5319
Fax: ++1 708 868 2352

Ohio Camera Collectors, PO Box 282, Columbus, Ohio, OH 43216
Telephone: ++1 614 885 3224

Pennsylvania Photographic Historical Society Inc., PO Box 862, Beaver Falls, Pennsylvania, PA 15010-0862
Telephone: ++1 412 843 5688

Photographic Collectors of Houston, PO Box 70226, Houston, Texas, TX 77270-0226
Telephone: ++1 713 868 9606

Photographic Collectors of Tucson,
PO Box 18646, Tucson, Arizona, AZ 85731
Telephone: ++1 602 721 0478

The Photographic Historical Society,
PO Box 39563, Rochester, New York,
NY 14604

Photographic Historical Society of New
England Inc., PO Box 189, West Newton
Station, Boston, Massachusetts, MA 02165
Telephone: ++1 617 731 6603
Fax: ++1 617 277 7878

The Photographic Historical Society of
the Western Reserve, PO Box 25663,
Garfield Htg, Ohio, OH 44125
Telephone: ++1 216 382 6727

Puget Sound Photographic Collectors
Society, 10421 Delwood Drive,
SW Tacoma, Washington, WA 98498
Telephone: ++1 206 582 4878

Western Photographic Collectors'
Association Inc., PO Box 4294,
Whittier, California, CA 90607
Telephone: ++1 310 693 8421

Zeiss Historica Society, PO Box 631,
Clifton, New Jersey, NJ 07012
Telephone: ++1 201 472 1318

## APPENDIX 5

# Dealers in Classic Cameras

There are certainly hundreds, possibly even thousands of dealers throughout the world who specialize in classic cameras. The following is a list only of some of which I have a degree of personal knowledge. There is no suggestion that this is a complete list, nor that these dealers are any more reliable or knowledgeable than others I happen not to know.

## Australia

The Camera Trader, 295 Bridge Road,
Richmond, VIC 3121
Telephone: ++61 (0)3 428 3110

Dave Green, PO Box 29, Kelmscott,
WA 6111
Telephone: ++61 (0)9 495 1574
Fax: ++61 (0)9 390 6149

John Mason, PO Box 56, Cleveland,
QLD 4163
Telephone: ++61 (0)7 286 1636
Fax: ++61 (0)7 286 1420

James Place Cameras, 8 James Place,
Adelaide, SA 5000
Telephone: ++61 (0)8 231 2464
Fax: ++61 (0)8 212 2610

## Austria

Fachfoto Royal GmbH, Hans Brandstätter,
Link Glanzeile 19, A-5020 Salzburg
Telephone: ++43 662 435336
Fax: ++43 662 435337

## France

Occasion Photo, Thierry Rebours,
18 rue de Lepante, F-06000 Nice
Telephone: ++33 93 80 71 70
Fax: ++33 93 13 89 73

## Germany

Foto-Bazaar Mail Order, Ulrich Konopatzky,
PO Box 208, D-82051, Sauerlach
Telephone: ++49 (0)8104 22 32
Fax: ++49 (0)8104 21 82

Photo Antik Bodenheimer,
Rosenbergerstrasse 6, 60313 Frankfurt/Main
Telephone: ++49 69 28 77 95
Fax: ++49 69 28 83 59

Secondhand Camera Shop, Klenzestrasse 45,
D-80469 Munich
Telephone: ++49 (0)89 201 32 14

Foto Brell, Kaiserstrasse 64,
60329 Frankfurt/Main
Telephone: ++49 (0)69 23 14 19
Fax: ++49 (0)69 23 14 15

## Italy

Classic Camera, PO Box 15, Martellago,
30030 Venice
Telephone: ++39 41 449858
Fax: ++39 41 448562

## United Kingdom

Andrews Cameras, 16 Broad Street,
Teddington, Middlesex TW11 8RF
Telephone: ++44 (0)181 977 1064
Fax: ++44 (0)181 977 4716
Stocks a huge range of classic equipment
from fine collectibles to comparatively
common affordable classics.

Arundel Photographica, 51 High Street,
Arundel, West Sussex BN18 9AJ
Telephone: ++44 (0)1903 882749

Bryan Cowley Photographics, 27 High
Street, Canterbury, Kent CT1 2AZ
Telephone: ++44 (0)1227 451480
An extremely knowledgeable photographic
shop which always has some interesting
classic cameras and lenses to show.

Camera Centre Hailsham, 53 High Street,
Hailsham, East Sussex BN27 1AR
Telephone: ++44 (0)1323 840559
Fax: ++44 (0)1323 442295
The author's local classic camera shop – one
of those 'real' camera shops that experienced
collectors will sniff out from a hundred miles
away.

Classic Camera Company Ltd (Marion and
Christoph Trestler), 45 Ainger Road,
London NW3 3AT

Telephone/Fax: ++44 (0)171 722 9417
Specialists in Nikon equipment.

Classic Collection, 2 Pied Bull Yard,
Bury Place, London WC1A 2JR
Telephone: ++44 (0)171 831 6000
Fax: (0)171 831 5424
A genuinely international dealer close to the
British Museum, with a computer camera
search service to trace elusive equipment.

Collectors Cameras, PO Box 16, Pinner,
Middlesex HA5 4HN
Telephone: ++44 (0)181 428 4773

Fieldgrass and Gale Ltd, 203 Welsbach
House, The Business Village, Broomhill
Road, Wandsworth, London SW18 4JQ
Telephone: ++44 (0)181 870 7611
Fax: ++44 (0)181 870 6551
Extremely knowledgeable about Contarex,
Alpa, Nikon, Leica and Bronica among many
others. Vast stock.

Grays of Westminster, 40 Churton Street,
Pimlico, London SW1V 2LP
Telephone: ++44 (0)171 828 4925
Fax: ++44 (0)171 976 5783
Dealers exclusively in Nikon, Grays can
offer excellent advice on the most obscure
Nikon topics.

Stuart Heggie, 58 Northgate, Canterbury,
Kent CT1 1BB
Telephone: ++44 (0)1227 470422
A very knowledgeable specialist dealer in
collectible cameras.

Jessop Classic Photographica,
67 Great Russell Street,
London WC1B 3BN
Telephone: ++44 (0)171 831 3640
Fax: ++44 (0)171 831 3956
Always a huge range of classic equipment to
see, close to the British Museum.

Mr Cad, 68 Windmill Road,
Croydon, Surrey CR0 2XP
Telephone: ++44 (0)181 684 8282
Fax: ++44 (0)181 684 8835
A very large general photographic store with
considerable classic stock.

Paul van Hasbroeck, Photo-Historical
Publications, 34 Bury Walk,
London SW3 6QB
Telephone: ++44 (0)171 352 8494
Fax: ++44 (0)171 823 9058

Shutters, The Clockhouse, High Street,
Cuckfield, West Sussex RH17 5JX
Telephone: ++44 (0)1444 458833
Fax: ++44 (0)1444 455291
An international dealer very strong in Canon,
Nikon, Hasselblad and Bronica.

Stephens Classic Cameras, 6 St Anne's
Arcade, 12 St Anne's Square,
Manchester M2 7HW
Telephone: ++44 (0)161 834 7754
Specialists in Leica, both rangefinder and
reflex.

Vintage Cameras Ltd, 256 Kirkdale,
London SE26 4NL
Telephone: ++44 (0)181 778 5416
Fax: ++44 (0)181 778 5841
Probably the longest established specialist
in classic cameras in the world.

## United States of America

Adorama, 42 West 18th Street,
New York, NY 10011
Telephone: ++1 212 741 0052
Fax: ++1 212 463 7223

Beverly Hills Camera Shop Inc.,
PO Box 7727, Beverly Hills,
California, CA 90212-7727
Telephone: ++1 310 396 2192
Fax: ++1 310 396 9931

Brooklyn Camera Exchange, 549 East 26th
Street, Brooklyn, New York, NY 11210
Telephone: ++1 718 462 2892
Fax: ++1 718 941 4226

Guild Camera, 737 West Camelback Road,
Phoenix, Arizona, AZ 85013
Telephone: ++1 602 234 0221

Koh's Camera Sales and Service Inc., 2 Heitz
Place, Hicksville, New York, NY 11801
Telephone: ++1 516 933 9790
Fax: ++1 516 933 7799

Tamarkin & Company, 198 Amity Road,
Woodbridge, Connecticut, CT 06525
Telephone: ++1 203 397 7766
Fax: ++1 203 397 7765

Wall Street Camera, 82 Wall Street,
New York, NY 10005
Telephone: ++1 212 344 0011
Fax: ++1 212 425 5999

Woodmere Camera Inc., 337 Merrick Road,
Suite 7, Lynbrook, New York, NY 11563
Telephone: ++1 516 599 6013
Fax: ++1 516 599 3369

---

## APPENDIX 6

# Repairers and Restorers of Classic Cameras

Remember to check with whichever photographic collectors' club or society you belong to whether they have members providing specialist repair services. I know of several in Britain who are expert but want repair work only at the rate at which they can handle it comfortably. For that reason, they prefer not to have their names generally publicized in a book like this. Instead, they accept work principally from club members. Most classic camera dealers (see Appendix 5) have access to specialized repairers and can accept work through their shops.

Neither the author nor the publisher can accept any responsibility for the quality of repair or restoration work placed with the following repairers. The UK repairers mentioned are well known to the author.

## Australia

Frank Morand, 7 Sunset Avenue,
Forster, NSW 2428
Telephone: ++61 (0)65 554734
A camera restorer specializing in vintage cameras.

Brisbane Photographic Repairs, PO Box 698,
33 Steptoe Street, Chapel Hill,
Kenmore, QLD 4069
Telephone: ++61 (0)7 3784862

## Germany

Dipl. Ing. Dirk Bergmann, Seeblick 11,
42399 Wuppertal
Telephone: ++49 202 611516
Fax: ++49 202 611813
Both a restorer and a repairer of classic and antique cameras.

Grah Optik, Goldstrasse 4–6,
47051 Duisburg
Telephone: ++49 (0)203 2 13 27
Fax: ++49 (0)203 2 13 27

## United Kingdom

Grays of Westminster, 40 Churton Street,
Pimlico, London SW1V 2LP
Telephone: ++44 (0)171 828 4925
Fax: ++44 (0)171 976 5783
Specialist Nikon repair service.

Ed. G. Trzoska, 150 Harrowgate Drive,
Birstall, Leicester LE4 3GP
Telephone: ++44 (0)116 2674247
Fax: ++44 (0)116 2677712

David Vicks, Unit 33H, Princes Estate,
Summerleys Road, Princes Risborough,
Buckinghamshire HP27 9PX
Telephone: ++44 (0)1844 274434
A specialist Bronica repairer.

Wickford Camera Repairs, 85 Vicarage Road,
Watford, Hertfordshire WD1 8EJ
Telephone: ++44 (0)1923 800588
Expert classic camera repairs, particularly to Exakta.

## United States of America

Active Camera, 1501 Avenue U, Brooklyn,
New York, NY 11229
Telephone/Fax: ++1 718 645 3147
Promotes his service for repair of collectibles and Kiev rollfilm SLRs.

J. Albert & Co., 1015 Casitas Pass Road #210,
Carpinteria, California, CA 93013
Telephone: ++1 805 684 4533
Fax: ++1 805 684 8444

Flexible Products Corp., 14504 60th Street
North, Clearwater, Florida, FL 34620
Telephone: ++1 800 551 3766

Specialists in replacement camera bellows of all sizes and types.

Fotocamera Repair Inc., 3095 South Military
Trail, Lake Worth, Florida, FL 33463
Telephone: ++1 407 433 8434
Nikon F and Photomic finder specialist, also Nikon lenses.

Saul Kaminsky Lens Exchange,
36 Sherwood Avenue, Greenwich,
Connecticut, CT 06831
Telephone: ++1 203 869 3883
Specialists in the repair of Russian equipment.

Negri's Camera Repair, 287 Main Street,
Farmingdale, New York, NY 11735
Telephone: ++1 516 249 8307
A specialist Nikon repairer.

Photography on Bald Mountain, Ken, Ruth
and Terry Terhaar, PO Box 113, 113 Bald
Mountain, Davenport, California, CA 95017
Telephone: ++1 408 423 4465
Classic and antique camera repairs including design and manufacture of obsolete parts. Prepared to work on Alpa.

John van Stelten, 1017 South Boulder Road,
Suite E-1, Louisville, Colorado, CO 80027
Telephone/Fax: ++1 303 665 6640
Lens repair, repolishing, recoating including cement separation repairs.

W.W. Umbach Z-V Service,
1410 Seafarer Drive, Box 754, Oriental,
North Carolina, NC 28571
Telephone: ++1 919 249 2576
Specializes in Zeiss and Voigtländer, and repairs Contarex, Contaflex, Bessamatic, etc.

Vintage Camera and Clock Repair,
Dan McCabe, 136 West Mountain Avenue,
Fort Collins, Colorado, CO 80524
Telephone: ++1 303 482 8529
Specializes in older SLRs – Alpa, Canon, Exakta, Konica, Minolta, Miranda, Nikon, Pentax, Voigtländer, Zeiss.

Ross Yerkes Camera Repair, 342 Kirby
Street, Los Angeles, California, CA 90042
Telephone: ++1 213 256 1018
Specialist in Kowa and Norita repairs.

---

Author's note: These appendices have been prepared from various sources, including the author's own address book, the US magazine *Shutterbug*, the UK magazines *Amateur Photographer* and *Photographic Collector*, the German magazine *Photo Deal*, *Photographica World*, the magazine of the Photographic Collectors Club of Great Britain, and *McKeown's Price Guide to Antique and Classic Cameras*, in which the authors themselves acknowledge *Le Foto Saga, the Camera Collector's New Handbook* and the work of the Western Photographic Collectors' Association, all of whose copyrights are duly acknowledged.